ART APPRECIATION

S0-BBJ-367

Bassim Hamadeh, CEO and Publisher
Michael Simpson, Vice President of Acquisitions
Jamie Giganti, Managing Editor
Jess Busch, Graphic Design Supervisor
Marissa Applegate, Acquisitions Editor
Jessica Knott, Project Editor
Luiz Ferreira, Licensing Associate
Mandy Licata, Editorial Associate

Copyright © 2014 by Cognella, Inc. All rights reserved. No part of this publication may be reprinted, reproduced, transmitted, or utilized in any form or by any electronic, mechanical, or other means, now known or hereafter invented, including photocopying, microfilming, and recording, or in any information retrieval system without the written permission of Cognella, Inc.

First published in the United States of America in 2014 by Cognella, Inc.

Trademark Notice: Product or corporate names may be trademarks or registered trademarks, and are used only for identification and explanation without intent to infringe.

Printed in the United States of America

ISBN: 978-1-62661-848-0 (pbk)/ 978-1-62661-849-7 (br)

www.cognella.com 800-200-3908

ART APPRECIATION

Revised First Edition

FERDINANDA FLORENCE

SOLANO COMMUNITY COLLEGE

cognella
academic publishing

CONTENTS

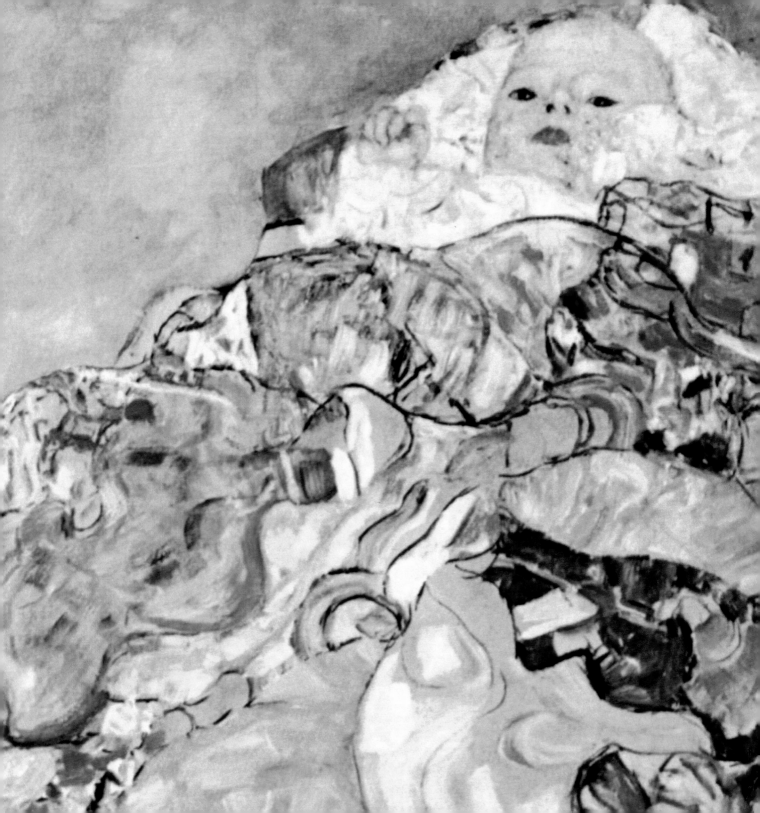

INTRODUCTION

INTRODUCTION

ART AS PROBLEM-SOLVING

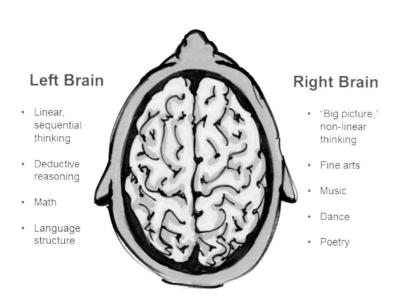

Left Brain

- Linear, sequential thinking

- Deductive reasoning

- Math

- Language structure

Right Brain

- "Big picture," non-linear thinking

- Fine arts

- Music

- Dance

- Poetry

To test your "brain dominance," see the Middle Tennessee State University page, http://frank.mtsu.edu/~studskl/hd/learn.html.

The creation of art requires entire brain functioning. However, the driving force behind creative thought lies in the **right brain.** The right side of the brain is more adept at making the kinds of decisions that creative work demands. The right brain can see the big picture, making connections between distant, scattered threads. The left brain, in contrast, is better at linear thinking—following a chain of thought down the line, step by step.

The creative process thrives on right-brain skills, and is tripped up when the left brain tries to hold the reins. Notice that when you engage in creative work, you lose track of time. Scientists experience this phenomenon as well as artists—both groups need to juggle physical and mental processes, while being closely attentive to ever-changing variables in their environment. This is the kind of exercise that demands heavy, full-brain function, with the right brain in full throttle. So, take the chart at left with a "grain of salt"—the categories listed to the right and left of the exposed brain are simplified to give you an overall sense of the two brains' functions. For example, note the placement of "language" in the left category. The left brain is responsible for the logical assembly of words that makes speech possible; however, the right brain makes poetry happen—the creative assembly of words that transforms a mere sentence into a transportive experience for the reader. The division of labor within the brain allows you to multitask, to a certain extent—you can draw and talk at the same time—but you probably can't talk and solve math equations at the same time, unless you are talking your way through the numbers.

The left brain controls the motor functions on the right side of the body (the movement of the right arm, leg, etc.), and the right brain controls the left side of the body. Left-handed people depend on strong right brain functioning, and many lefties are right-brain dominant; this is why you might find more left-handed artists than lefties in the general population. This does not mean that lefties are automatically more creative than righties; creative activity still requires whole-brain problem-solving.

MAKING – AND SEEING – ART

What's Behind the Artwork?

There are three main factors that determine how art is made, and also determine how any given viewer interprets (sees or "reads") the artwork.

Universal Experience

These are the basic, human experiences understood by virtually all people. Being cheered by the sun, being afraid of the dark, telling an angry face from a sad or happy face—the knowledge of simply *being human* affects both art-making and art-viewing.

Cultural Influence

The influence of one's own culture is sometimes hard to recognize; something that you might consider "universal" is actually not shared by all cultures, but rather just something considered "normal" for *your* culture. Our cultural background—shaped by where and when we were born, and the society in which we grew up—acts as a sort of filter through which we see the world. This influences us as artists, and as viewers. We look at the world through a pair of "culture goggles;" although we can (and should) learn about other cultures, and empathize with others as human beings, we cannot fully remove our "culture goggles" when we look at others—or their art. Being *aware* of our own culture goggles, and understanding how culture influences vision—these are essential skills for art appreciation.

Personal, Individual Perspectives

We are each products of our culture. However, you are an individual, and your individual experiences—combined with a unique brain, a unique body, a unique combination of genes inside—give you unparalleled perspectives on your world. You are shaped by your environment, but your vision is always, essentially, *personal*.

CASE STUDY: THE BABY

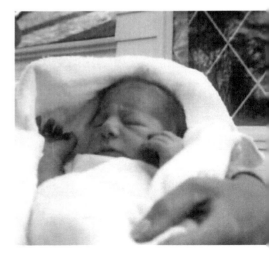

The author's sister Paulette as a newborn, 1965.

Imagine a work of art—a painting, or a sculpture, say—that shows a baby. What do you picture? What image comes to mind? As you formulate your mental image, you might pull from your own experiences with a little baby, or something from TV or the movies. Do you imagine a mother and child? A baby sleeping peacefully, or wailing fitfully? Do you picture just the head, or the whole body? Is it bundled up? —in what? What colors, textures do you imagine? All your visual choices are impacted by the three factors above. Babies in general are very universal subjects! But if you imagined a baby boy wrapped in "baby blue," then your choice is culturally-influenced: a hundred years ago in Europe, baby boys were wrapped in pink—a gentler version of red, which was considered a bold and "manly" color. If you picture a baby with a specific outfit, with specific skin color and features, or in a particular setting—these choices may have come from your own,

specific history, linked to where (and when) you specifically come from. Although the type of outfit or features or setting is still linked to cultural influence, that *particular* choice is an individual, personal one.

What is Art?

There are three essential aspects to art. From cooking to fashion design to sculpting, at the highest level of visual creativity, these three aspects work in perfect concert to give the viewer a transformative, transportational experience. Such an experience invites the viewer to make connections, either consciously or subconsciously, between his or her own, personal experience, and the broader human experience, in the wider world.

Visual Vocabulary

The visual vocabulary works much like a verbal vocabulary; you have the **visual elements** (such as line, light, color, etc.) that act like the "parts of speech" in language (noun, verb, adjective). The visual elements are arranged in a composition in a logical, persuasive order—the way that the components of language are arranged to communicate effectively, to "make sense." The different ways in which the elements can be arranged are called the **principles of design.** The visual vocabulary also includes the **style** of the art—whether it looks clear and detailed, or simplified and distorted. The visual vocabulary acts like a computer operating system, the Linux or Windows of the artwork, running behind the scenes to enable and optimize visual performance.

Media

The media are the materials of the artwork, and the physical process of making and shaping those materials. An example of a **medium** is fired-clay sculpture. The artist might model the clay, molding it to the desired shape. When the clay is "leather-hard," the artist could carve details into the surface. To make a lasting sculpture, the artist would then fire the clay—that is, subject it to high heat in a kiln. The clay might be "low-fired" first, then coated with a glaze and re-fired at a higher temperature. This entire process, from modeling and carving through removal from the kiln, is all part of the artwork. Decisions that the artist makes throughout the process will affect its ultimate visual and tactile (touch) qualities.

Concept

In essence, the concept is the idea behind the work—the artist's interest or intended point. The concept is what the artist believes is essential about the work; this might be as simple as a feeling, or as complex as a political agenda. The artist must be clear about what he or she is trying to do. Without clarity, the artwork "falls down" for the viewer. Note that lack of clarity is not the same as ambiguity. Ambiguity can present an interesting challenge for the viewer, forcing the viewer to struggle with what they believe or want to see.

In the best art, these three aspects "agree" with each other, working together to communicate meaning to the viewer. The choice of medium and visual vocabulary each reinforce the concept; the medium and the visual arrangement of that material must complement each other. Concept is no more or less important than the other two aspects of art; however, it can often be the most challenging aspect for artists to balance with the others. In college classes, art students are often asked (especially in more traditional academic programs) to focus on the first two aspects: learning the visual vocabulary, and experimenting with a range of conventional art media. At this level, art students learn to control the media, to get the best results and see which medium is most agreeable for the kind of art they wish to make. Students try to create engaging visual compositions, applying theoretical knowledge of **elements and principles** to actual practice. Their training involves developing the physical and

mental discipline necessary to create art: learning proper work habits and procedures; developing hand-eye coordination; and paying close attention to the world around them.

Both works of art below feature a baby as the main subject. However, the intentions of the artists are quite different from each other, and the results are likely different from what *you* picture as a typical baby. Clearly, neither artist is interest in the cute, cuddly softness of a newborn. What, then, *are* they interested in? What is each artist trying to say? To understand these artworks and why they look the way they do, it is necessary to consider the "where and when" of their creation: the specific cultural circumstances that shaped the individual concerns of each artist.

First, let us look at Federico Fiori Barocci's painting of little Federigo di Urbino. Notice how much emphasis Barocci gives to the richness of the fabrics wrapped around the baby. Gold thread and red velvet, an intricately-embroidered pillow—all these symbols of wealth and status suggest that Federigo is not just any baby boy. Not only is he the newest member of one of the most powerful families in the city of Urbino, Italy—he is also the future duke. The boy's family paid Barocci to commemorate, with this painting, the successful birth of a healthy heir. Since they are paying for the work, the **patrons** have a strong influence on the choices the artist makes. Showing the child as stoic, immobile, and resplendent, the artist is telling the viewer that little Freddy will be ready when he eventually inherits the authority that is his birthright. The viewer is reassured that, although he is now just a baby, when Federigo grows up he will possess the discipline and wisdom necessary to be a strong and effective civic leader.

Fast forward three hundred years to Gustav Klimt's little baby, peeking from the top of a patchwork pyramid of colors and textures. Indeed, this baby is even more overwhelmed by its swaddling clothes than little Federigo. Yet here, Klimt is not interested in using a wealth of fabric to celebrate the baby's lineage (indeed, we don't even know the baby's name). Klimt was a leading member of a group of Austrian artists at the turn of the last century. Although still subjects of the old Austro-Hungarian Empire, Klimt and his contemporaries lived in a time when

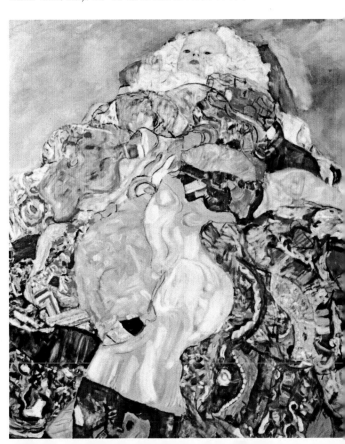

Gustav Klimt, *Baby*, 1917-18. Oil on canvas. Private collection.

Federico Barocci, *Portrait of the Newborn Federigo Di Urbino*, 1605. Palazzo Pitti, Florence.

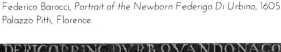

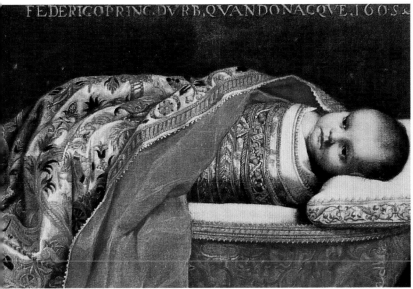

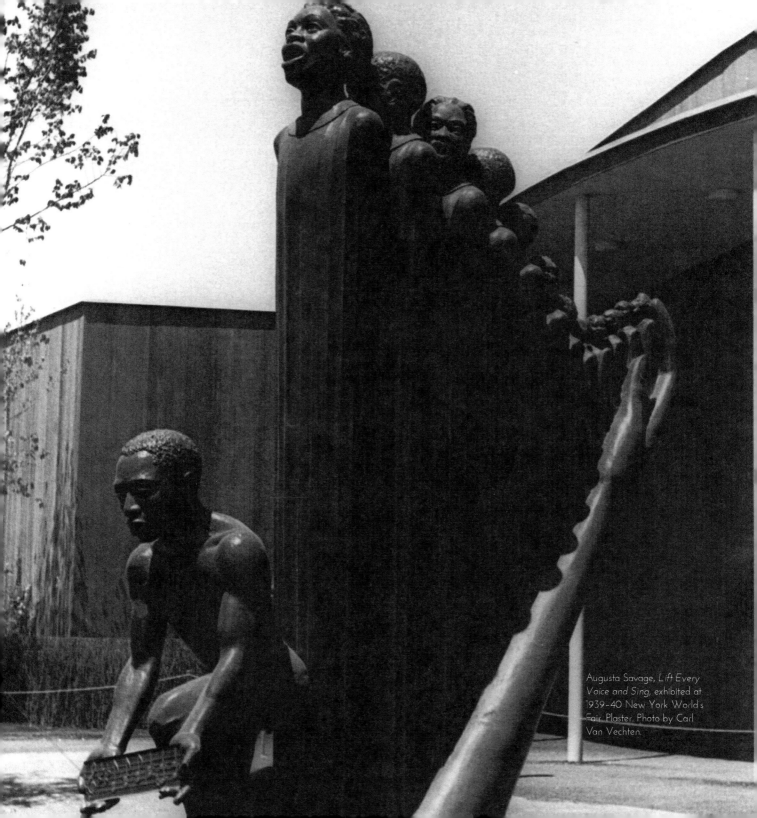

Augusta Savage, *Lift Every Voice and Sing*, exhibited at 1939–40 New York World's Fair. Plaster. Photo by Carl Van Vechten.

many old ideas were being challenged. Known as the Vienna Secessionists, these artists were trying to break away (or secede) from the old, confining traditions of art-making. Fellow Austrian Sigmund Freud had introduced the concept that many human motivations lie concealed beneath the surface, resting in the subconscious mind. Similarly, the Secessionist painters believed there was more to painting than just showing fine surface details. Here, Klimt has given the patterns and colors of the baby's quilt a life of their own. The vitality of his brushstrokes suggest a sea of possibilities; unlike Federigo, whose life is already laid out for him, this little child is wrapped in a vivid symbol of freedom, exploration, and discovery.

WHAT IS ART?—A CASE STUDY WITH AUGUSTA SAVAGE

Visual Vocabulary

The great arm embraces and supports the figures in a smooth, diagonal line. Another diagonal rises from the palm of this hand; our eyes are drawn upwards, from head to head, to the dramatic apex of Augusta Savage's human harp. The figures have become the strings of the instrument—their voices appearing to build in strength with the repetition of taught vertical lines. The crouching figure, displaying musical notes on a plaque, appears youthful and poised. The dominance of clean, strong lines in Savage's *Lift Every Voice and Sing* is matched by its grand scale; at 16 feet tall, the sculpture presents a heroic monument to perseverance and hope.

Medium

Savage sculpted this work—custom-made for display at the 1939 New York World's Fair—in plaster, which is a common (and inexpensive) sculpting medium. However, Savage intended to cast the work eventually in bronze, an expensive and labor-intensive medium used by ancient societies (such as the ancient Greeks and Romans) for important subjects. In choosing bronze, Savage intended to make a statement about the worthiness of her subjects, as well as her own worthiness as a sculptor. Her bronze sculpture of an African-American boy, called *Gamin*, had won her national acclaim. As a woman of color in a segregated and male-dominated art world, Savage was particularly keen to establish herself as a legitimate artist, equal to her better-recognized (and better-funded) contemporaries. Despite the popularity of Savage's sculpture at the Fair, the artist could not raise sufficient money to have a bronze version cast. *Lift Every Voice* was demolished with the rest of the exhibits when the Fair closed.

Concept

The title of Savage's sculpture is based on a song, "Lift Every Voice and Sing," written at the turn of the century to honor African-Americans' struggles and successes, both past and present. The subject of Savage's sculpture is more than just singing figures or music. Her work reflects the unified strength of African-American communities, from the times of slavery to today—expressed through music and symbolized by the harp into which the figures are formed. This is Savage's **concept.** The sculptor's choice of eye-grabbing visual vocabulary,

Augusta Savage. Harmon Foundation.

together with her intended medium of bronze, all complement and reinforce this concept. However, there is more to understanding Savage's work than these three elements alone. There is also **context.**

Context

Augusta Savage's work reflects universal, human concerns about freedom, opportunity, and hope. However, Savage did not work in a neutral environment; her life was shaped by factors both within and beyond her control. Her work was shaped by unique personal experiences, informed and impacted by her cultural background—including geographic, ethnic, and socio-economic factors. Also, as we have seen in the painting of little Federigo, **patronage** can play an enormous role in what an artist makes and sells, and what a viewer ultimately sees.

Working in Harlem in the early 1900s, Savage had the opportunity to show her work through the Harmon Foundation, which supported many African-American artists in New York. This support presented something of a double-edged sword for Savage and her contemporaries. The Harmon Foundation gave artists a venue to show their work, at a time when galleries were virtually closed to artists of color; however, the Harmon shows were not integrated, so African-American artists never got to show their work alongside European or European-American artists' work.

The Harmon Foundation tried to secure patrons for the artists, but these patrons (who were predominately European-American) were unlikely to purchase art that seemed "negative" or "too serious." They expected African-American art to be amusing, light-hearted, and entertaining; although not much art sold from Harmon shows, the popular art featured jazz playing, singing, dancing, etc. The Harmon patrons weren't the only group to demand uplifting, positive imagery, however. African-American artists who wanted to raise difficult or troubling subjects were rebuffed on two fronts. Many leading African-American scholars, such as W.E.B. DuBois, were concerned about the pervasiveness of negative stereotypes, and wanted African-Americans to put their best faces forward as much as possible. Artists of color were pressured to present their subjects in a positive light—as noble, decent, and industrious.

Langston Hughes addressed this double-bind in his essay, "The Negro Artist and the Racial Mountain" (1926):

> The Negro artist works against an undertow of sharp criticism and misunderstanding from his own group and unintentional bribes from the whites. "Oh, be respectable, write about nice people, show how good we are," say the Negroes. "Be stereotyped, don't go too far, don't shatter our illusions about you, don't amuse us too seriously. We will pay you," say the whites. *

Consider Augusta Savage's *Lift Every Voice and Sing* against this contextual backdrop. Savage had learned some bitter lessons by the time she sculpted the work in 1939. The Great Depression had begun ten years earlier, undermining what little success the Harmon Foundation had contributed to Harlem artists' careers. Savage spearheaded an effort to channel federal funds to artists during the Depression, opening a school and becoming director of the Harlem Community Art Center in the late 1930s. Savage's ongoing struggles to secure jobs for fellow artists of color, as well as make sales of her own work, surely inform *Lift Every Voice and Sing.* Savage knew this work would be seen widely, by a diverse audience, at the World's Fair. She also knew she had to balance competing goals—to acknowledge an emotional and painful path (both personal and historical), while meeting expectations of uplifting affirmation. The result is a work that was one of the most popular in the Fair, one with an enduring legacy that still touches people on a universal, cultural, and personal level. *That* is art.

*Langston Hughes, "The Negro Artist and the Racial Mountain," The Nation, 1926. Http://faculty.wiu. edu/M-Cole/ Racial-Mountain.pdf

VOCABULARY IN INTRODUCTION

composition	Visual elements and principles of design
left brain	The left hemisphere of the brain
medium, media (plural)	Materials and methods of making art
patron	The person who pays for art, sponsors the artist
principles of design	Organizing principles used in creating a work of art. Includes unity and variety; balance; rhythm and pattern/repetition; time and motion; emphasis and focal point; scale and proportion; and contrast
right brain	The right hemisphere of the brain
sculpture, sculptor	Three dimensional work of art (having height, width, and depth); creator of three-dimensional art
style	Visual quality of art, imparting a particular "look"
visual elements	Essential components of a work of art. Includes line (including shape), light (value or key), texture, space (including form), and color

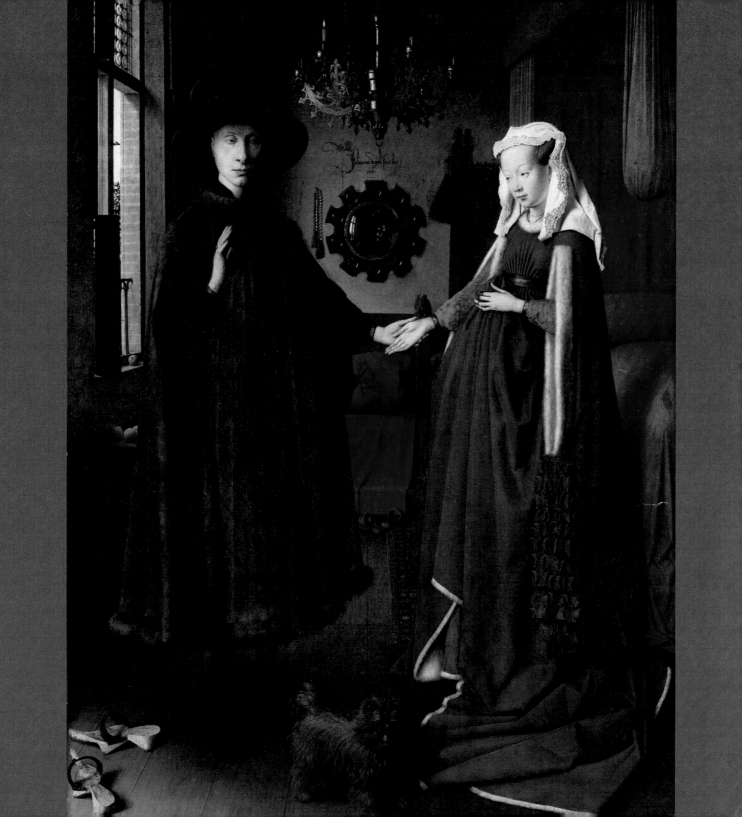

1
ART &
CULTURE

1: ART AND CULTURE

REALITY IS RELATIVE!
WESTERN ART HISTORY AND FIGURAL SCULPTURE

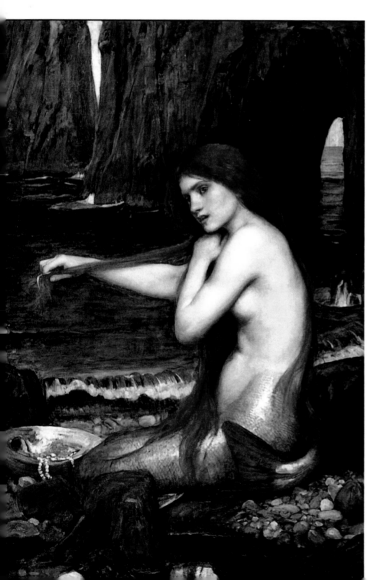

Our perception of "reality" depends on …
when we're from
where we're from
what we're used to
what we value
(what's important, according to us)

We often use the term "realistic" to describe images that look life-like—having the kind of detail, clarity and "realism" we associate with photographs.

However, the word "realistic" can be misleading. Your definition of reality might differ from mine, or from your next-door neighbor's. The woman in the painting here looks very "realistic"—her skin looks fleshy, her hair looks … hairy! But is she *really* realistic? Only if you believe that mermaids are "real." In fact, many sea-faring peoples of the past did consider mermaids to be real creatures. In ancient Greece, they were called sirens; with their haunting siren-songs, they were thought to lure men to their watery graves. In Germany, they were the Lorelai, beautiful terrors of the Rhine River. To people charting dangerous waters, these creatures were very real indeed.*

Rather than describe our mermaid here as "realistic," then, let us use the terms **illusionistic** or **naturalistic.** Fantasy or reality, this fish-woman looks like you could reach out and touch her—she presents a convincing illusion. Of course, a mermaid does not really exist in nature—but if she did, she would have the natural-looking, shiny fish scales and naturalistic, fine hair strands that this painting shows. We *know* she is not natural, but she *appears* natura*listic*.

*Some sailors of the Caribbean, unfamiliar with the local sea life, mistook swimming manatees for homely mermaids!

John William Waterhouse, *The Mermaid*, 1900.
Royal Academy of Art, London, England. 26.4 x 38.61 in.
Oil on canvas.

John Waterhouse was a member of a British group of artists, working in the mid-1800s, called the Pre-Raphaelites. While the Industrial Revolution was (literally) running full-steam ahead, the Pre-Raphaelites looked to romantic fantasy subjects of yester-year. The inviting, naturalistic details of their paintings were meant to sweep the viewer away into a "better" reality—a world of knights, maidens, and mystery.

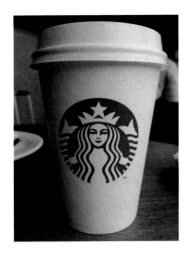

Illustrated below is a mermaid who is far less naturalistic than Waterhouse's watery lady. This mermaid appears to be much simpler and "streamlined," without all the surface details seen in the painting on the previous page. This mosaic design appears more like a logo. Indeed, a famous corporate logo, found on coffee cups all over the world today, appears to be modeled on the medieval mermaid type. Rather than **illusionistic** or **naturalistic**, these designs are best described as **abstract**. This means that the things represented here (mermaid in water) are shown with a minimum of details. The visual information that you would see in the *actual* object appears **abstracted**—reduced to a few, essential bits of symbolic (rather than literal) information.

Like a *haiku* poem, abstract art is challenging. Since so little information is given, the artist must be very selective, putting in those few elements that will say *exactly* the right thing. The "reader" is challenged, too—you must apply all of your (culturally-based) knowledge to understand and appreciate what you are "reading." Because of cultural distance, the abstract mermaid design at right may not hold much meaning for people today; however, the "Starbucks" logo must surely say more to today's viewers than simply "coffee"! (What do *you* associate with this logo?)

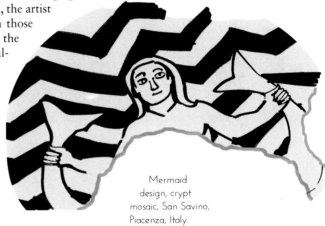

Mermaid design, crypt mosaic, San Savino, Piacenza, Italy.

The mermaid **mosaic** (made from small tiles) is about a thousand years old, which would place it in the European Middle Ages. It appears as part of a much larger floor design in the church of San Savino, in Piacenza, Italy. Installed on the floor of the crypt (the oldest, underground part of the church), the mosaic shows disc-shaped "islands" in a **stylized**,* zig-zag-patterned "sea." Each disc shows a sign of the zodiac (representing the month), accompanied by a "labor of the month"—a typical activity for the farmers of the region.

Labor of the month of July, with zodiac sign of Cancer. Crypt mosaic, San Savino, Picaneza, Italy.

*Stylized means having a style that follows set patterns or conventions that differ from how we naturalistically see things in the world. Stylized art may seem simpler than naturalistic art, but the meaning can often be more complex. Consider: Why do you think the artists chose a sharp, zig-zag pattern for the waters of the world, rather than a soft, wavy design? (Hint: how safe are these waters? How easy is our path in life?)

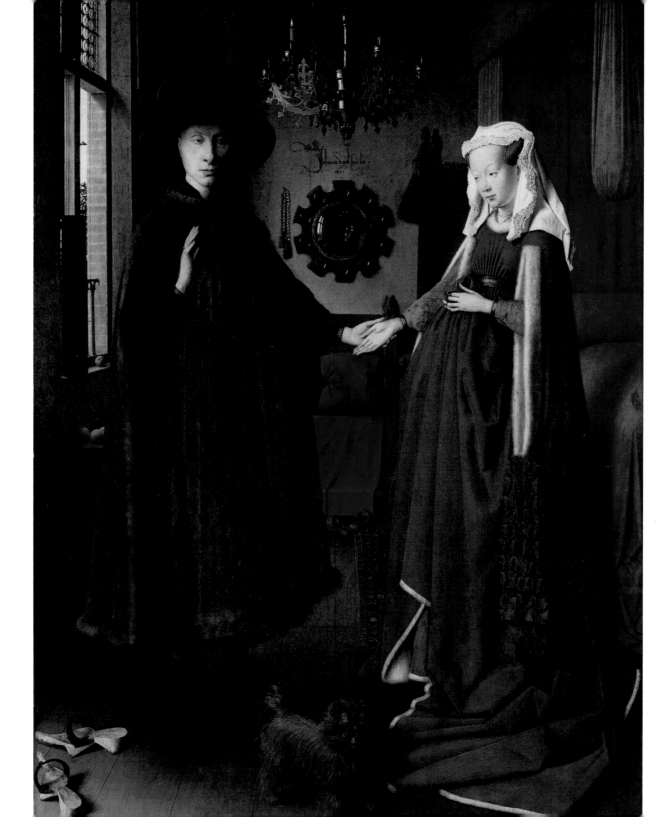

14

Worshippers would have understood this design as a sort of map of the world—charting their journey through life, in terms of both time (months and labors) and physical space. Looking down, the Christian believers would see the world at their feet, from the "familiar territory" of everyday routines, to the far, exotic corners of the earth, where two-finned mermaids lurk. The church would be designed as "heaven on earth," so that, looking to the light of the windows above, the worshipper could "escape" the boundaries of the earth (represented below), and aspire up, to heaven.

The artists of this mosaic assumed that the viewers shared their cultural point of view, their sense of "reality." This reality rests in a supernatural worldview, rather than a natural one. The artists did not want to capture the superficial surface appearance of their subjects; rather, they wanted to communicate complex, supernatural concepts through an **abstract** visual language.

The double-portrait on the preceding page was painted in 1434 by Jan Van Eyck, a well-known artist working in Flanders. Today Flanders is part of Belgium, in Northern Europe. The wedding portrait of Giovanni Arnolfini and his bride Giovanna Cenami looks rather naturalistic. Objects are not only recognizable, but look so detailed that you could reach out and touch them. Notice the shining polish on the candelabra, and the soft, tactile folds of Giovanna's gown. There is more here than meets the eye, however!

Symbolic Art and Iconography

Symbolic art presents the viewer with subject matter that can be "read" on more than one level. For example, in the *Arnolfini Portrait*, note the small, succulent fruit near the window. On the most literal level, they may be read as "peaches." However, these fruit also carry *symbolic* meaning, suggesting a fruitful marriage, with thriving offspring. Art historians apply their knowledge about a culture to such symbols, to find deeper meanings. We know that fresh fruit was an expensive rarity in 15th-century Europe; therefore, the presence of so many delicious peaches in this home also symbolizes the wealth of Mr. Arnolfini. Many of the symbols appearing in this work may still be easily "read" today. Fur is still considered a luxury item in today's society, so that the meaning of Giovanna's fur-trimmed cloak is clear to us. Dogs have long represented faithfulness, and the little dog in the **foreground** ("front" area) of the painting symbolizes the same. Note that the breed of dog (a "toy," clearly not meant for hunting or other practical labor) suggests luxury as well.

The meaning of a symbol—its **iconography**—is directly related to the culture's values and belief systems. In studying the iconography of a work of art, one must be careful not to confuse one's own cultural expectations with those of the original artist. Note that several symbols in this painting do *not* immediately translate to the modern viewer. Giovanna's pale skin, delicate hands, and shaved hairline might say "unhealthy"

Opposite: Jan Van Eyck, *Arnolfini Portrait* (Giovani Arnolfini and Giovanna Cenami), 1434. National Gallery, London, England. 32.4 x 23.6 inches. Oil on oak panel.

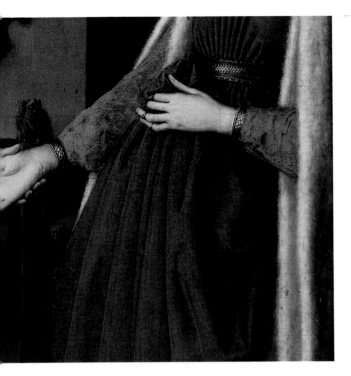

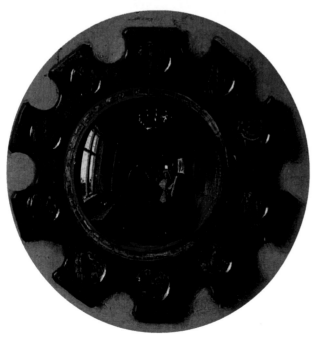

today—but in the Northern Renaissance, all three **attributes** (character-istics or accessories) suggested a well-to-do lady. Were Giovanna's hands really so small? Was she really so pale? Remember that the artist, Jan Van Eyck, wants to show you his *version* of reality—*his* culture's defini-tion of the perfect upper-class lady. According to Northern Renaissance culture, pale skin was the sign of a leisurely life; only working women (the lower class) labored outside under the tanning rays of the sun. The delicate hands would symbolize how other people would do the hard work for her. The shaved hairline was considered elegant and regal.

Most curious to modern viewers is the lady's apparent pregnant form. Look carefully; the lady has folded and bundled her robe in front of her abdomen, to give herself a pregnant silhouette. The lady is not yet preg-nant—but she is signaling her desire to produce children for Giovanni once they are wed. Her position by the bed reaffirms her traditional role in society; he stands, in contrast, by the window. He is a merchant, an international businessman; the message here is that her world is domes-tic—*his* is the much wider world.

The bulk of the symbolism in this painting is actually religious. The culture represented here is Christian; the floor is decorated with Old Testament scenes, and the convex mirror on the wall is surrounded by New Testament images of Christ. This culture viewed the marriage union as a sacred and binding religious contract—as well as a socially-approved business arrangement between her family and his. The single lit candle in the chandelier symbolizes the presence of God. Arnolfini's shoes (a rather spiffy pair of clogs, called pattens, in the left corner) have been removed, symbolizing respect for this sanctified space.

Finally, two figures (reflected in the mirror) seem to stand as wit-nesses, to make the union official. Jan Van Eyck's signature ("Jan Van Eyck was here") confirms more than just his status as the painter—it also seems to suggest his presence as witness to the event (perhaps he is one of the two "guests" in the mirror?)

By studying a culture, we can begin to read the symbols in that cul-ture's artwork. However, just because we can "read the signs" does not automatically mean that we "know the truth"! We must be careful not to confuse a naturalistic style with reality—no matter how "realistically" convincing the artwork might appear. Since historians do not know for certain in which year the two were wed, Jan Van Eyck may have already been dead for several years when these two "tied the knot"! This may

not be a wedding portrait at all, but rather a betrothal—a promise to marry in the future. Supporting this theory, scholar Edwin Hall points out Arnolfini's gestures; one hand is raised as though in blessing, and the other is taking Giovanna's into his own. Known wedding images of this time show couples shaking hands firmly; here Arnolfini's hands seem to be saying that he is accepting a promise, rather than joining a binding union.*

Regardless of its ultimate meaning, this painting was clearly intended to reflect the interest of its **patrons** (those who paid for it). It is *their* reality, as *they* wished to define it. Of course, things do not always turn out as we wish. In spite of the many references here to a fruitful marriage, document evidence suggests that either the two had no children, or had no surviving heirs. Alas, the symbol of fidelity (faithfulness) embodied by the little dog ultimately did not pan out either:

> We do have records of Giovanni having an extra-marital affair. In 1470, thus late in Giovanni's life, a woman took him to court to have returned to her jewelry he had given her. She also sought a pension and several houses that she had been promised.**

*See Edwin Hall's *The Arnolfini Betrothal: Medieval Marriage and the Enigma of Van Eyck's Double Portrait.* Berkeley: University of California Press, 1994. Http://www.escholarship.org/editions/view?docId=ft1d5nb0d9&brand=ucpress.

**See Dr. Alan Farber's instructive website for students of SUNY College at Oneonta, NY: http://employees.oneonta.edu/farberas/arth/arth214_folder/Van_Eyck/Arnolfini.html.

CULTURE AND ART: A CASE STUDY
(The Battle of Little Bighorn, 1876)

Now let us look at two very different views of the same event—one told by a person of European descent, and one recounted by a Native American.

Both describe aspects of combat in the 1800s, showing violence and death as enemies engage each other on foot and horseback; however, both are colored by the artists' differing values, beliefs, and backgrounds.

Traditionally, this battle has been called "Custer's Last Stand"—showing that those who did the "calling" were more concerned with Custer and his demise, than with the repercussions for the Native Americans. Indeed, after Sitting Bull and the Lakota Sioux warriors wiped out Custer's army, General Philip Sherman responded by ultimately capturing the Lakota and forcing their surrender. The following year, Nez Percé Chief Joseph would utter his famous words, "From where the sun now stands, I will fight no more forever."***

Rather than convey "reality," each work of art conveys the artist's own version of reality. For example, the European-American artist wanted to tell of the bravery of General Custer and his soldiers against overwhelming opposition. In the illustration above, notice the positioning of the ill-fated general in the center of the **composition.** The heroic officers defending a slumped companion in the **foreground** lead the viewer's eye to the most important figure, in the artist's estimation. Custer stands out in his dark jacket and hat, striking a dynamic pose like a ringmaster at the circus.

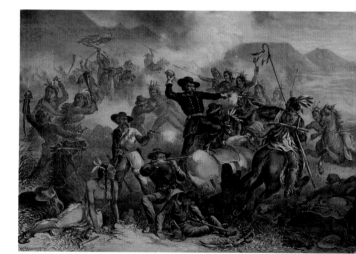

Henry Steinegger, *Battle of Little Bighorn*, c. 1878.

The style of this illustration is very illusionistic, and very literal—what you see is meant to come across like a photographic snapshot, a moment captured from the thick of battle—and "what you see is what you get." The blur of figures in the **background** suggests a vast number of combatants, and the dust kicked up by the horses, the play of light and shadow, as well as the hills in the distance, all aim to report the scene, as though by

***See the extensive PBS website "New Perspectives on the West," http://www.pbs.org/weta/thewest/program/.

a neutral observer. However, a naturalistic, "you-are-there!" style does not automatically mean a neutral report, or a more authoritative reality. You are seeing what the artist *wants* you to see and believe.

As you read the excerpted narrative, told by an Native American survivor of the battle, consider how this cultural perspective might influence a Native American artist's visual choices:

An Eyewitness Account by the Lakota Chief Red Horse, Recorded in Pictographs and Text at the Cheyenne River Reservation, 1881

Five springs ago I, with many Sioux Indians, took down and packed up our tipis and moved from Cheyenne river to the Rosebud river, where we camped a few days; then took down and packed up our lodges and moved to the Little Bighorn river and pitched our lodges with the large camp of Sioux.

The Sioux were camped on the Little Bighorn river as follows: The lodges of the Uncpapas were pitched highest up the river under a bluff. The Santee lodges were pitched next. The Oglala's lodges were pitched next. The Brule lodges were pitched next. The Minneconjou lodges were pitched next. The Sans Arcs' lodges were pitched next. The Blackfeet lodges were pitched next. The Cheyenne lodges were pitched next. A few Arikara Indians were among the Sioux (being without lodges of their own). Two-Kettles, among the other Sioux (without lodges).

I was a Sioux chief in the council lodge. My lodge was pitched in the center of the camp. The day of the attack I and four women were a short distance from the camp digging wild turnips. Suddenly one of the women attracted my attention to a cloud of dust rising a short distance from camp. I soon saw that the soldiers were charging the camp. To the camp I and the women ran. When I arrived a person told me to hurry to the council lodge. The soldiers charged so quickly we could not talk (council). We came out of the council lodge and talked in all directions. The Sioux mount horses, take guns, and go fight the soldiers. Women and children mount horses and go, meaning to get out of the way.

Among the soldiers was an officer who rode a horse with four white feet. [This officer was evidently Capt. French, Seventh Cavalry.] The Sioux have for a long time fought many brave men of different people, but the Sioux say this officer was the bravest man they had ever fought. I don't know whether this was Gen. Custer or not. Many of the Sioux men that I hear talking tell me it was. I saw this officer in the fight many times, but did not see his body. It has been told me that he was killed by a Santee Indian, who took his horse. This officer wore a large-brimmed hat and a deerskin coat. This officer saved the lives of many soldiers by turning his horse and covering the retreat. Sioux say this officer was the bravest man they ever fought. I saw two officers looking alike, both having long yellowish hair.

... The soldiers charged the Sioux camp about noon. The soldiers were divided, one party charging right into the camp. After driving these soldiers across the river, the Sioux charged the different soldiers [i.e., Custer's] below, and drive them in confusion; these soldiers became foolish, many throwing away their guns and raising their hands, saying, "Sioux, pity us; take us prisoners." The Sioux did not take a single soldier prisoner, but killed all of them; none were left alive for even a few minutes. These different soldiers discharged their guns but little. I took a gun and two belts off two dead soldiers; out of one belt two cartridges were gone, out of the other five. ...

One band of soldiers was in rear of the Sioux. When this band of soldiers charged, the Sioux fell back, and the Sioux and the soldiers stood facing each other. Then all the Sioux became brave and charged the soldiers. The Sioux went but a short distance before they separated and surrounded the soldiers. I could see the officers riding in front of the soldiers and hear them shooting. Now the Sioux had many killed. The soldiers killed 136 and wounded 160 Sioux. The Sioux killed all these different soldiers in the ravine. ...

—From the text by Garrick Mallery, *Picture Writing of the American Indians*, 10th Annual Report of the Bureau of American Ethnology (1893).*

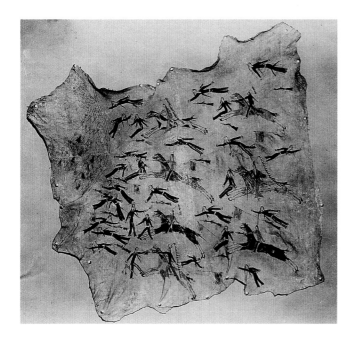

Two Moons (Cheyenne Indian), *The Battle of Little Big Horn*, drawn at the Lame Deer Agency, 1895.

This painting by Two Moons shows a rather different reality from the European-American illustration. First, it is painted on buffalo hide, a traditional material for warrior robes. Here, the Native Americans receive prominent recognition throughout the composition. Custer's army is remarkable only in the depiction of its destruction—uniformed bodies are everywhere and unquestionably dead (or soon to be dead).

Here we see the traditional Native American use of abstract, symbolic motifs. The number of dead shown is not meant to be taken literally, as a tally of casualties. Similarly, the teepees in the upper left corner form a symbolic, rather than literal indicator of the number of different Native American tribes that took part in the battle (recall, in Chief Red Horse's retelling, how prominently the tribal identity and placement of the lodges figured in his story.)

Although the teepees appear in the upper corner of the buffalo hide, they are not in the **background** (space appearing farther from the viewer, at the "back" of the scene). Indeed, the "flat" treatment of the space here is so different, compared with the European-American composition, that the spacial terms "foreground" and "background" do not apply. We will discuss the cultural impact on the depiction of space in the next chapter.

Note that Two Moons created this work many years after the actual battle, while living on the Lame Deer reservation. The photograph here was taken in Washington, DC, where he routinely advocated for Native American rights. This context calls into question the "reality" of Two Moons's artwork; it's possible that he left out details—such as the death of Custer himself—to avoid antagonizing or embarrassing any government officials who might see the work. Keep in mind that the study of art is the study of what artists *choose to tell you*. Art is, by its very definition, subjective. Reality is always relative, regardless of whether the style is naturalistic (as in the European-American illustration), or abstract (as in Two Moons's painting).

THEMES ACROSS CULTURES: CASE STUDIES IN LAND AND DEATH

Look again at the two different visual accounts of the Battle of Little Bighorn. Did you notice that the Native American painting gave no indication of the land—in contrast to the scenery of the European-American work? Should we conclude, then, that the Native Americans were not concerned with the land? Obviously, that would be a very inaccurate anthropological conclusion. The lesson here is that one should be careful not to leap to conclusions, when connecting artwork to the cultural attitudes

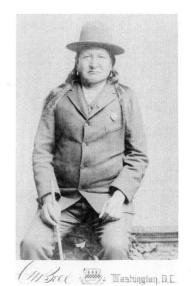

Two Moons, photographed by Charles Milton Bell.

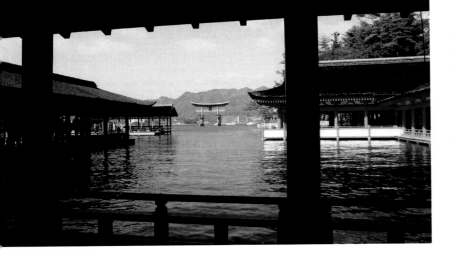

Itsukushima shrine, Japan, marked by a red torii, meaning "gateway."

and interests that drive its creation. Let us further explore how culture impacts art, by looking at the various visual approaches to land and death.

LAND

Who we are is powerfully linked to *where* we are—or where we *think* we are, or imagine ourselves to be. Our connection to place defines us, in many ways. Let us examine the how cultural values and concerns can shape the artistic depiction of land.

Traditional Japanese Painting

Shown here is a Shinto shrine. Shinto is an ancient belief system in Japan, thousands of years old. Practitioners believe that the spirits, or *kami*, inhabit the rocks, trees, water, and other elements in nature; shrines would be built to mark areas believed to be particularly blessed by *kami* presence.

Traditional Japanese art may reflect combined Shinto and Buddhist influence. Buddhism is the belief that one can end *samsara* (the cycle of reincarnation which brings one back, again and again, to earth) by following the "middle path" to a state of enlightenment. Originating 2,500 years ago in India, Buddhism moved eastward, and was introduced to Japan in the 6th century C.E.*

Known as **Chan Buddhism** in China and commonly known in the United States by its Japanese name, **Zen Buddhism** is a form of Buddhism that teaches practitioners to seek enlightenment by maintaining focus through the course of daily life. Rather than set aside a time for meditation, or speak specific prayers or mantras, the Zen Buddhist should try to make every action meaningful and purposeful.

*C.E. = "Common Era," known to Christians as A.D., which is an abbreviation of the Latin phrase *Anno Domini* (meaning "in the year of our Lord"). B.C.E. = "Before Common Era," also called B.C, "before Christ."

The work at the top of the next page is a Chinese hanging scroll, which would be kept in a box until hung for a viewer's study. Here you see a Chan Buddhist monk engaged in cutting a piece of bamboo—a mundane, everyday activity. The monks believed that, by keeping focused on the simplest, humblest tasks (the kinds that one is most tempted to do un-thinkingly), they could achieve enlightenment. The Chan monk was expected to maintain a constant state of personal awareness.

What is "Traditional"?

When speaking of traditional Japanese art, note that the term "traditional" can be a bit confusing. Some might call art "traditional" if it is based on indigenous customs, practices, and beliefs—not influenced by "outside" ways.

When speaking of Asian art (or African art, or art of the Americas), scholars have often used the term "traditional" to mean art that predates the heavy influence from Europe in the colonial era (1500s onward). Although a common (and convenient!) frame of reference, this narrow definition of "traditional" gives the impression that, before being "tainted" by the European touch, these cultures produced "pure" or "authentic" art, free of outside influence.

This view does not take into account that art, along with culture, is continually changing, continually influenced by "outside" influences. Is Japanese art "inauthentic" or not traditional if it has Chinese influence? Or influence from India? If these influences (which go back thousands of years) are taken into account, then how far back must we go to get real, true, "traditional" Japanese art? This framework is clearly problematic!

If we look at history as a complex web of intercultural exchange—rather than a simplistic "before/after" view—then we will have a greater appreciation for the art and the complexity and richness of its meaning. Let us use the term "traditional," then, to mean "long-standing practices that are closely bound to a culture's identity."

Notice that this work is created in brush-and-ink; this medium leaves no margin for error— there would be no chance for erasing here! The artist, like the monk shown, was expected to maintain a high level of mental discipline, applying to each and every stroke of the brush all of his accumulated knowledge and experience. The master artist Liang Kai must communicate, with just a few strokes, all the master monk's vigor and spiritual intensity, investing each mark with the utmost level of care and specificity.

In this painted screen, you will find reflections of both Shinto and Zen Buddhist thought. As the viewer walks past the screens from right to left, he or she is engaged by the energetic, inward sweep of the pine trees, and invited to feel the presence of the *kami* in each stroke of ink. The treeless **negative spaces** (spaces without objects) are far from "empty."

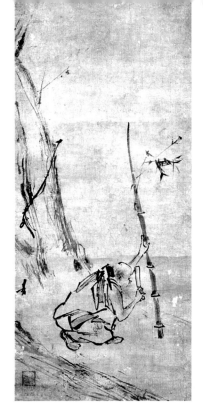

Liang Kai, *The Sixth Patriarch Cutting Bamboo*, Southern Song Dynasty, 1200s. Ink on paper.

Instead, the attentive viewer becomes aware of the quiet, and takes a metaphorical "inward breath." Quieted and focused by the negative space, the viewer is ready to greet the next stand of dark pines, which abruptly appear, vertical and forceful, like a sudden awakening: an invitation to the moment of enlightenment.

Like the hanging scroll and the screen, the **handscroll** is meant to be "journeyed through," both mentally and physically, rather than taken in, all at once. Like hanging scrolls, handscrolls would be kept in custom-made boxes, and taken out at special occasions, to be "read"—in many cases, quite *literally* read, as poetry or owners' commentary might accompany the imagery.

The handscroll by Sesshu Toyo, shown on the next page in detail, is almost 6 feet long—but other handscrolls by Sesshu range from 40 to 60 feet or more. There is no way

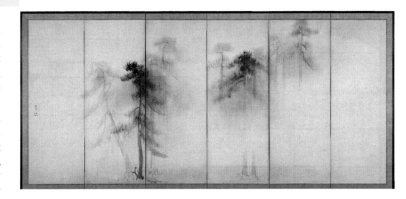

Hasegawa Tohaku, *Pine Forest*, late 1500s. Ink on paper screens, 5' tall. Tokyo National Museum.

the viewer could see the entire scroll at once, unless he or she had super-stretchy arms, like Mr. Fantastic from the Fantastic Four. Instead, the viewer would look at small sections at a time, rolling and unrolling as necessary. This would allow the viewer to examine the work closely, and pay attention to details that might escape the eye on first viewing. No part of the scroll is more important, or worthy of attention, than another. Like chopping bamboo, viewing the handscroll was meant to be an act of meditation, requiring focused attentiveness—not just an exercise in art appreciation.

Notice the minimal role of the human figure and human habitation in Sesshu's handscroll. From Sesshu's viewpoint, the figure is neither physically nor philosophically the center of this universe. The viewer of the handscroll is invited to "walk" through this landscape, as though they were the small figures appearing periodically in the work. The Buddhist message is clear: as a viewer, you should not be distracted by your own needs and desires; you should not think of yourself ahead of the world around you.

Sesshu Toyo (1420-1506), *View of Amano-Hashidate* (detail), 1501-1506, ink and light color on paper, 35.4 x 70.2 in, Kyoto National Museum.

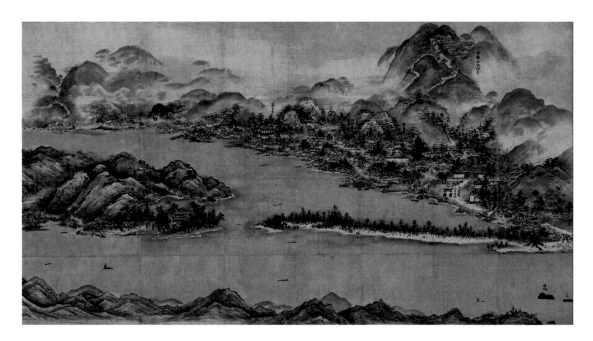

We will explore further the use of space in traditional Asian handscrolls in the next chapter. Now let us turn to a more illusionistic interpretation of landscape, which speaks to a different cultural reality.

Born in England in 1829, the painter Thomas Hill comes from a distinctly different cultural background than that of the Japanese and Chinese artists noted earlier. Hill was a member of the Hudson River School, a group of artists, many of them European, who found inspiration in the grandeur of the American West. Like the notable 19th-century painters Albert Bierstadt and Frederick Edwin Church, Hill found in Western scenery a sense of raw beauty and power. Remember that, at the time, Europe was undergoing a radical transformation

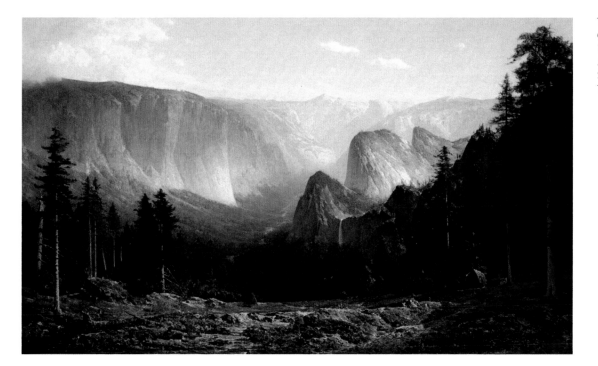

Thomas Hill, *Great Canyon of the Sierra, Yosemite*, 1871. Crocker Art Museum, Sacramento, CA. 72 x 120 in. Oil on canvas.

with the Industrial Revolution. As the last quarter of the century approached, some European artists grew disillusioned by what they saw in their own "back yard": an old, stuffy civilization, so bloated in history and tradition that it had lost its spark. In contrast, the United States seemed wild, young, and fresh—and the American West seemed positively primeval. "Untamed," and therefore "purer" than the Old World, the West stood in the romantic's imagination as one of the last, "untainted" places. For this reason, the people in Hill's work appear as a part of the landscape; visitors are dwarfed by the enormity of the space. Native Americans who appear in the work of Hill and others of the Hudson River School are included as symbols of this vast, untamed world, not yet touched by European influence.* This is not a faithful report of Yosemite, nor is it meant to be; from the clouds above to the picture-perfect rocks below and soft, misty light, this scene is orchestrated to maximize the "wow," and minimize any element that might detract from the clear, hopeful order of things.

The style of Hill's painting is much more naturalistic than the abstract marks in Hasegawa Tohaku's work; however, Hill's painting is no more—or less—"real" than *Pine Forest*. Both are selective views of the landscape, and both seek to impart a selective slice of reality. Hill presents us with a pristine, perfect world, rich in detail, hoping to convince the viewer of the sheer grandeur of the untouched West. The Japanese artists present an abstraction of the Japanese landscape, with the spiritual reality of the trees and mountains taking precedence over mere geographical accuracy.

*From this point of view, a land occupied by Native Americans was still considered "empty."

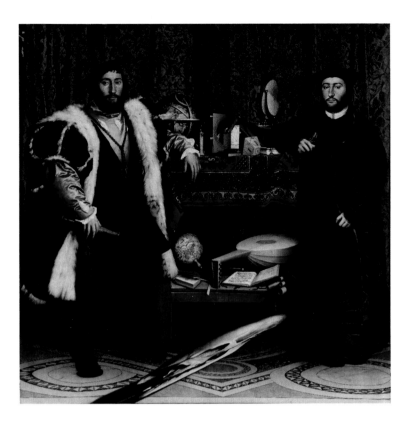

Above: Hans Holbein
the Younger, *French
Ambassadors (Jean de
Dinteville and Georges
de Selve)*, 1533.
National Gallery,
London, England.
81.5 x 82.5 inches.
Oil on oak.

Right: Anamorphosis of
Holbein's *Ambassadors*.

DEATH

The painting here reveals much about the values and concerns of the artist's culture. Born in Bavaria (today's Germany), Hans Holbein the Younger shows us 16th-century, Northern Renaissance beliefs in a nutshell. Here are two well-do-to fellows, in the prime of life. True Renaissance men, they are surrounded by symbolic objects that reflect their intellectual power as well as social status. Remember, though, that the Renaissance was preceded by the devastating Plague—the Black Death, which is thought to have eliminated a third of the European population. The lesson that "life is fleeting" is also tucked into this beautiful painting, a reminder that appeared in many luxurious paintings for well-to-do clients.

The Memento Mori

Literally, the Latin phrase ***memento mori*** means "reminder of death." Wealthy European patrons wanted their guests to see that they understood the dangers of vanity. Although they

*We will discuss the Baroque era in more detail in Chapter 6.

surrounded themselves with beauty, believing beauty would improve their moral outlook, they thought it vain to fixate on beautiful things. The *vanitas* (vanity) tradition is based on the Christian beliefs of the European Renaissance world, which held that—although wealth in this world is good, and shows heavenly blessings—it will not last forever; the soul must be prepared for the next world, and earn the true riches awaiting them there.

The reminder of death in Holbein's painting appears in the form of an optical illusion: the distorted shape on the floor. If viewed at a sharp angle, looking down from the upper right corner of the painting, you will see the form compress into a skull image. The unexpected, hidden presence of this skull points not only to the *memento mori* tradition, but also to the budding science of optics in the Renaissance era.

A hundred years later, Dutch Baroque* artist Willem van Aelst painted the still life here. The still life was a popular *memento mori* form in Holland in the 1600s. Dutch artists' paintings of sumptuous feasts, fruits and flowers show the Calvinist Christian belief that financial well-being comes from hard work and moral living. The lovely flowers cascading over the marble mantle are in full bloom—but they will not stay fresh forever! The watch (tied with a blue ribbon) reminds the viewer that time is fleeting. The blessings and pleasures of the world should be enjoyed while they last.

When you look at the rich details in Van Aelst's painting, consider the rhyme of 17th-century English poet Robert Herrick. The opening stanza of his poem, "To the Virgins, to Make Much of Time" captures the essence of the *memento mori*:

> Gather ye rosebuds while ye may,
> Old Time is still a-flying:
> And this same flower that smiles today
> Tomorrow will be dying.

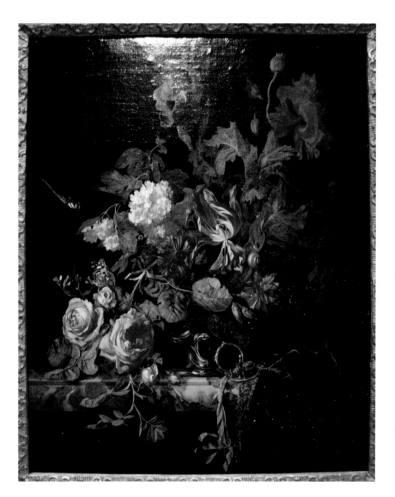

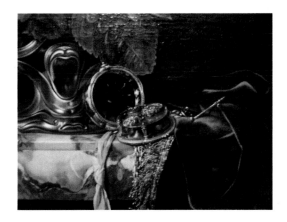

Willem van Aelst, *Flowers in a Silver Vase* (above, detail at left), 1663. Oil on canvas. Legion of Honor, San Francisco.

REMATE DE CALAVERAS ALEGRES

Y SANDUNGUERAS

Las que hoy son empolvadas GARBANCERAS, pararán en deformes calaveras.

Días de los Muertos/Days of the Dead

In the United States today, we generally prefer to keep death at arm's length, whenever possible. Rarely are wakes conducted in the presence of the corpse, in the deceased's own home (as was traditionally the custom). An entire funeral industry has emerged to make "dealing with the dead" a discreet and "unmessy" occasion for the living. Emphasis is placed on showing the dead the proper respect; to that end, caskets are elegant and tasteful, satin-lined and cushioned as though the dead were merely "sleeping comfortably" through eternity.

Funeral customs are purely cultural constructs. There are no universal aspects to dealing with the dead. Just as some cultures keep death as private and somber events, there are others that celebrate the deceased with boisterous, public displays, designed to honor (and appease) the dead, ushering them toward an afterlife of even greater joy and richness.

The Mexican *Días de los Muertos* tradition commemorates the deceased with elaborate altars (*ofrendas*) and festivities, bringing not only families but whole communities together with

Top: Jose Guadalupe Posada (1852-1913), La Catrina. An artist working in the years leading up to the Mexican Revolution, Jose Guadalupe Posada (1852-1913) was an illustrator whose prints of *calaveras* (skulls) addressed the inevitability of death—for rich and poor alike—with politically-charged humor.

Right: Mexican "Altar de muertos" detail: sugar skull, cempasúchitl flower and candle.
Sugar skulls are a popular decoration in Days of the Dead celebrations. The sugar skull shown here is accompanied by marigolds, flowers traditionally used to honor the dead.

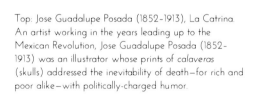

music, dancing, and feasting. This tradition reflects both indigenous Mesoamerican beliefs and the influence of Catholicism from Spain.* In Oakland, a yearly community celebration of the Days of the Dead is hosted by the Oakland Museum of California. In addition to mariachi music, food vendors, dancing, singing, and face-painting, the celebration coincides with the museum's exhibition of altars, ranging in form and theme from traditional to modern. The altars present an interactive site to commemorate the dead, as well as raise social and political concerns shared by the Oakland community.

Kane Kwei and the Ghana Funerary Tradition

The Days of the Dead tradition may be compared with funereal practices in Ghana. In this coastal, West African nation, the deceased are also sent into the afterlife with festive celebrations of feasting and dancing. Here the deceased may be buried in a custom-built art coffin. Both functional and symbolic, coffins are carved in wood and painted to look like a Mercedes Benz, a giant piece of fruit, a cell phone, a fish, a lion—objects or creatures that reflect the identity, interests, and hopes of its eternal occupant. With the cost of food and the customized coffin, the extravagant funerals are often profoundly expensive, but attendees are expected to bring contributions to honor the dead, and help foot the bill. The practice of sending the deceased off to the afterlife "in style" was popularized by Ghanaian artist Kane Kwei (1922–1992), whose innovative wooden creations gained widespread attention and prestige. Artists carry on the tradition today, updating the coffin designs for modern tastes.

Consider how the funeral practices in Ghana compare with Mexican-American Days of the Dead celebrations. In both cases, the artwork cannot be separated from the performances (dancing, feasting, congregating) surrounding them. The art is sacred—yet impermanent. Generally, altars are assembled from scratch, and dismantled after the Days are ended. Those costly coffins in Ghana are only briefly admired, before they are consigned to the ground.

Clearly, many cultures do not judge the value of a work of art by how long it lasts! We will see more examples of temporary, "fleeting" art in Chapter 4.

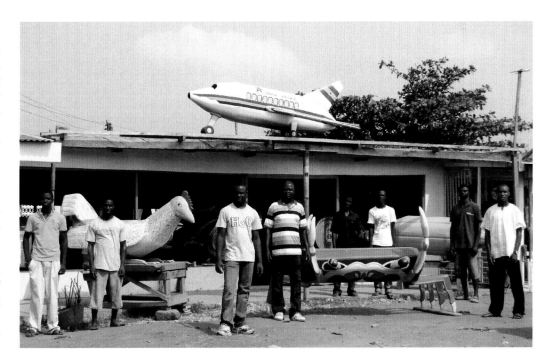

The Kane Kwei Carpentry Workshop, 2010.

*In Catholic Christianity, the Day of the Dead is "All Souls Day" (November 2 or 3), which follows "All Saints Day." The evening before All Saints Day is commonly known as Halloween. For more information about the artwork related to the Days of the Dead, see the PBS website http://www.pbs.org/independentlens/newamericans/culturalriches/art_altars.html.

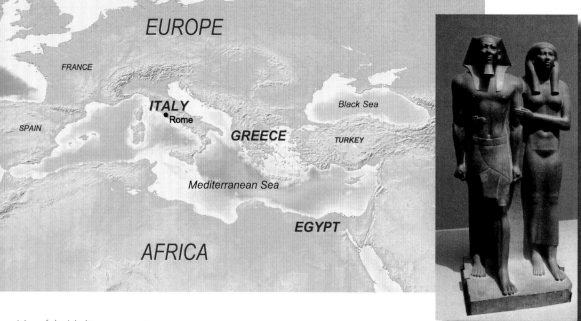

Map of the Mediterranean region.

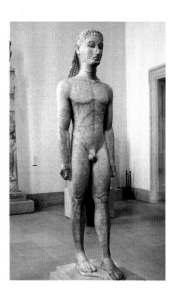

Menkaure and Queen, artist unknown, 4th Dynasty, Old Kingdom Egypt, 2548-2530 BCE. Museum of Fine Arts, Boston. 4 feet, 7 inches tall. Greywacke stone.

WESTERN ART HISTORY: ORIGINS, INFLUENCES, AND THE MYTH OF "PROGRESS"
Focus on Figural Sculpture

Egyptian and Early Greek Art

Let us examine the cultural traditions in Europe that have shaped attitudes toward abstract art in the United States. The European world has long looked to the art of Ancient Greece and Rome for inspiration.* The Greeks found their inspiration, in turn, from the arts of ancient Egypt. Notice the youth and beauty of the Ancient Egyptian king and queen. Menkaure appears buff, lean, and very dependable, much like the later Greek *kouros* (young male) figures, such as the one shown here.**

The reason for the Greek interest in Egyptian art is two-fold: first, note on the map above how close Greece and Egypt are, geographically; then, consider how legendary the power of Egypt has been for thousands of years. Borrowing the visual language of Egyptian "power figures" would have made a lot of sense to the budding Greek civilization.

Both the Egyptian sculpture and the Greek *Kouros* are sculpted **in the round**—they are **freestanding,** without the support of architecture, wall, or wall-mounted plaque. They both have some naturalistic features (recognizable muscles, facial expressions, etc.); however, both sculptures have abstract elements as well. In each, note the squared-off shape of the knees, and the crisp line to indicate the shin bone. Though all three figures appear to stride

*The city of Rome, Italy was the political and economic heart of the Roman Empire, which (at its height, about 2,000 years ago) included much of Europe, North Africa, and the Middle East. We will take an in-depth look at Greek and Roman art in Chapter 8.

**We will also discuss the nudity of Greek sculptures like the *Kouros* figure in Chapter 8!

Kouros, (male youth), c. 590-580 BCE, Archaic Greek. Metropolitan Museum of Art, New York. 6.3 feet tall. Naxian marble.

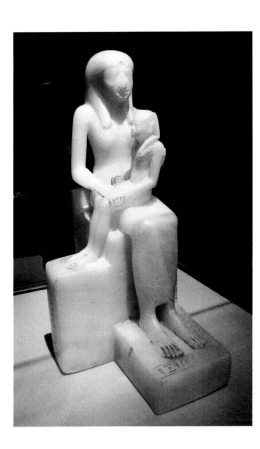

Pair statue of Queen Ankh-nes-meryre II and her son Pepi II seated. Egyptian, Sixth Dynasty, reign of Pepi II. Alabaster, Height: 15 1/4 in; Brooklyn Museum of Art. Wikimedia Commons.

purposefully forward, their hips remain level, as though they were standing at attention.

The **sculptor*** of the Egyptian statue of Menkaure and his queen purposefully preferred geometric simplification to naturalistic details. The resulting stiffness of the figures keeps them from appearing too casual, soft, and approachable. This stylistic choice makes sense, when you consider the cultural meaning of this work. This statue was likely a **ka statue**, placed in the king's tomb to house the spirit (*ka*) of the king. The ancient Egyptians believed that the king was a living god, and that in death, part of his soul would join the gods in the sky. This is why Menkaure must not appear as a casual, everyday man. Similarly, the sculpture of the Greek hero acts as a grave marker, presenting the warrior/athlete as he enters an eternal afterlife.

The small Egyptian sculpture here, featuring the young king Pepi II and his mother, differs from the Menkaure ka statue. First, the artist here chose alabaster, which is a softer medium than Menkaure's greywacke stone. This is a more suitable choice for the more tender mother-and-child subject. Second, the **scale** (overall size of the sculpture, when compared with the viewer) is much more personal.

However, you will find the same visual rule-bending in the Pepi sculpture, as in Menkaure's statue. The choices of the artist must, first and foremost, conform to the demands of his or her culture. Note the formality of the poses, and the exquisite use of right angles throughout the piece. The ancient Egyptians did not want to see the young king—considered a living god upon earth—as a cute, wiggling little boy on his mother's lap. To depict Pepi as a regular kid would have been entirely inappropriate and unthinkable. As a compromise, the artist presents young Pepi as a miniaturized king, sitting regally but firmly in his mother's grasp.

The art and architecture of ancient Egypt had a significant influence in the Classical (Greek and Roman) world, as evidenced in the *kouros* figures. However, as the power of the Greek city-states grew, the art became increasingly naturalistic, moving away from the abstractions discussed above. Many cultural reasons directed this move toward naturalism—one being a rising **humanistic** philosophy that put kings on a human (rather than near-godly) level, and allowed land-owning men to enjoy greater status and autonomy.**

Generally-speaking, if a culture wishes to emphasize the common man's inferiority to an infallible, ruling elite, the artwork will show leaders as abstracted, untouchable and godly. Conversely, if a culture wishes to celebrate the powerful potential of the common man, then the artwork will likely celebrate the naturalistic, human figure.

*A sculptor is one who sculpts. A sculpture is an object, sculpted by a sculptor!

**Unfortunately, the ancient Greeks did not think too highly of the common woman. Also, slaves and non-land-owning men weren't highly thought-of, either!

Classical Art (Ancient Greek and Roman)

The Greek sculpture at right has much less in common with the Menkaure figure. The figure stands in a naturalistic stance, his hips shifted so that his body weight rests on one leg more than the other. Although the figure is beautiful and fit, he is not stiff, geometric and remote like the Egyptian god-kings or the earlier Greek *kouros* figures. His pose is called *contrapposto*, an Italian term literally meaning "counter-poise." Note that the engaged leg (the leg that takes the bulk of the weight) is across from (counter to) the arm that was once likely holding palm branches. The relaxed leg is opposite to the relaxed arm, which casually rests a wreath of victory (now lost) on his head. This is a very natural way to stand—relaxed, balanced, but ready to act. Try it!

*We will return to Augustus and his choice of positive visual vocabulary in Chapter 8.

The statue of the Roman emperor Augustus Caesar shares a similar contrapposto pose. Now the relaxed arm gestures as though Augustus were speaking to a group of senators, while the engaged arm holds senatorial robes. Augustus still wears a chest plate to signify his warrior credentials, but the images on the battle armor suggest that all the barbarian enemies have surrendered, and peace and prosperity now reign in Rome, and its vast territories.

Although Augustus rules a wide swath of the known world, he still appears here as a touchable mortal—he reaches out to you, as you might reach out to him. The cupid figure riding the dolphin at his feet is a subtle reference to his supposed connections to the goddess Venus, who emerged from the sea. However, the sculpture's naturalistic appearance ultimately emphasizes Augustus's humanity, rather than his divine "elbow-rubbing."*

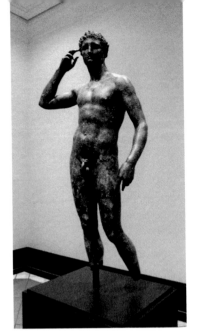

Victorious Youth, 300-100 BCE. Bronze. Getty Villa, Los Angeles. Life-sized. Photo by the author.

This figure above, like many made in the Classical era, was sculpted in bronze—but few have survived. Bronze is a strong and lasting metal—but it is costly, and may be melted down for multiple reuses. In contrast, marble can be chipped and broken—but not conveniently remade into anything else (except whittled down to a smaller marble sculpture).

Medieval Art

The sculptures on the next page are medieval (*medi* = middle, *ævum* = ages). The European Middle Ages followed the end of the Roman Empire, and dates from approximately 350 to 1400 C.E. This is a long period, to be called the "middle"! The term shows a cultural preference for the art that came before (Greek and Roman) and the art that came after (Renaissance). Generally-speaking, the art of the Middle Ages was more abstract than the art of the Greco-Roman period. This move away from naturalism can be traced to a cultural shift. Art no longer reflected the humanistic interests of the Classical world, but instead communicated the concerns of the Catholic Church, which sought to encapsulate its teachings in a compressed, emotionally-persuasive form.

This **relief sculpture** (sculpture that emerges from a wall or vertical surface) shows the Judeo-Christian parable of the first humans. A complex story has been packed into this

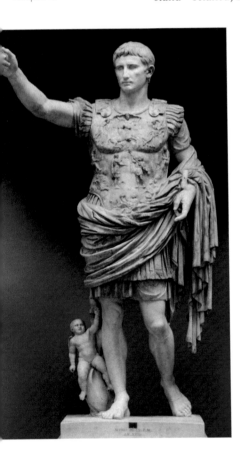

Augustus of Primaporta, early 1st century, CE. Marble, originally painted. Possibly a copy of earlier bronze original. 6' 8" in height. Musei Vaticani, Rome, Italy.

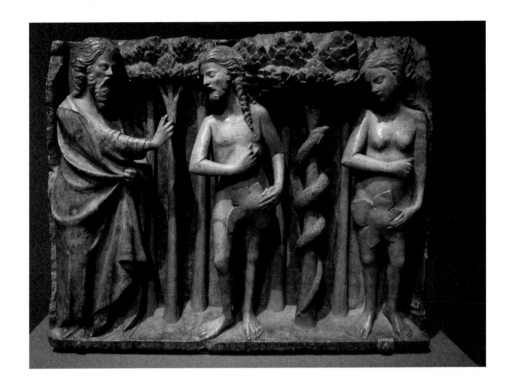

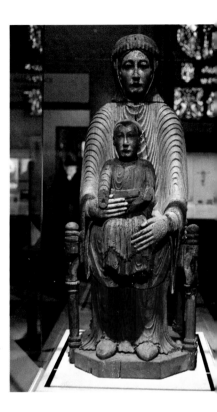

Bartolomeu Rubio (Spanish, active 13th–14th century), The Lord Reprimanding Adam and Eve, late 14th century. Alabaster with traces of polychrome [color paint], 20¼ x 25¾ x 4¾.

small space: representing Satan, the snake has tempted Eve to eat from the Tree of Knowledge; Adam and Eve become conscious of their nakedness, are confronted by God, and are expelled from Paradise. Rather than show the beauty and strength of the human figure, here the artist emphasizes the awkward postures of Adam and Eve, to highlight their guilt in the face of godly wrath. The faces would have been more expressive with the sculpture's original paint; you can still see a bit of the painted stars on God's robes.

This medieval **freestanding** sculpture has a lot in common with the ancient Egyptian sculpture of Pepy II. This work clearly emphasizes the supernatural, rather than the merely natural—specifically, the Christian belief that the son of God was born to a virginal woman. Like Pepy II, Christ appears as a small adult (complete with an adult male hairline). Also like the Egyptian sculpture, this medieval piece emphasizes rigid, geometric forms; note the energetic pattern of concentric swirls in the Virgin's robe.

This sculpture may not appeal to today's Christian viewers, who generally prefer a more approachable, human image of Christ in their worship. In contrast, medieval viewers would be deeply dismayed by an image of Christ as a sweetly-dimpled baby. The medieval Christian worshipper would have seen the remote, "adultish" child-Christ as the proper appearance of a god in human form. The broken hand of Christ would have been raised in a blessing gesture, reassuring the viewer of his power to save, at any age and through all time.

Virgin and Child in Majesty, 1150–1200. French; Made in Auvergne; Oak, polychromy, gesso, linen; H. 31 in. Metropolitan Museum of Art, NY.

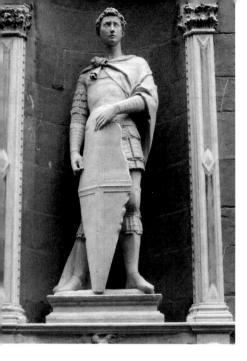

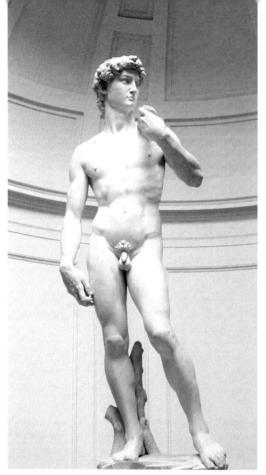

Top: Donatello, St. George, c. 1415–1419. Copy of marble original (moved indoors). Florence, Italy.

Right: Michelangelo, David, 1501–1504. Marble. Galleria dell'Accademia, Florence, Italy.

*The word *renaissance* means "rebirth" in French; it is called *rinascimento* in Italian.

Italian Renaissance

Like artists throughout Europe, the Italian artists of the Middle Ages often leaned toward more symbolic, less naturalistic depictions of sacred subject matter. However, the culture began to change by 1400. A thousand years after the Roman Empire, Italian artists began to look back at ancient Greek and Roman art with increased interest.* What prompted these changing interests? As with any cultural shift, there are many factors; one of the main catalysts was the rise of a new class of merchants, whose power lay in newfound economic status, as well as family ties to kings and popes. This merchant class profited from the ever-expanding trade of precious goods and "commodities" (silks, spices, slave labor)—which began to take on global proportions with advancements in naval technology, weaponry, and cartography.

The old medieval guilds also gained status and influence in the Renaissance. This sculpture of the dragon-slaying saint, George, was commissioned by the Armorer's Guild, and sculpted by the famed Renaissance sculptor, Donatello.

These new **patrons** of the arts were less inclined to embrace the Medieval view of humanity as frail, flawed, and puny in the face of the Almighty. Rather, they were more interested in a form of **religious humanism** which will be discussed in greater detail in the next chapter. Humanists are concerned about improving the well-being and moral and mental strength of humankind; religious humanism suggests that such improvement is humanity's holy duty. This philosophy is reflected in Michelangelo's sculpture of David, which we will meet again in Chapter 6.

During the Middle Ages, Italian artists did not "forget" about Roman art (how could they, when it was semi-buried all around them?). Their rejection of the naturalistic Roman style was a cultural choice. Conversely, Renaissance cultural values prompted a resurgent desire to embrace Greek and Roman philosophies. Compare the two Italian Renaissance sculptures here with the Greek and Roman statues shown earlier. Note the similarities in pose, attitude, and naturalistic style. The Classical and Italian Renaissance works equally emphasize youth, strength, concentration, and composure—physical perfection as a metaphorical model for moral strength.

Cultural Bias and the Preference for Naturalism

In the 20th century, art historians from Europe started to look more seriously at the art produced by tribal cultures. Many works of African tribal art look abstract and not naturalistic—like the mask dramatically lit, and shown in profile, on the left side of this old *Horizon* magazine spread. For centuries, Europeans equated naturalistic-styled art with advanced, civilized cultures (like the ancient Greeks). By that reasoning, however, abstract art became a signal of a "backward, uncivilized" culture. The caption (in white, running across the bottom of both pages) reads: "Its primitive and savage profile, modern scholars are discovering, has obscured a rich and cultivated history." The "primitive and savage profile" presumably belongs to the dramatically-lit, abstract mask to the left. This phrase seems to betray an assumption that "abstract" equals "savage."

*We will return to traditional African art, and Picasso's use of African art, in Chapter 3.

For centuries, African art was displayed in such a way as to highlight its "savage" character. Collectors were un-interested in African artworks' complex roles in society—how the works reinforce social rules, address spiritual concerns, and celebrate important events. Transplanted to natural history museums in Europe, works such as this mask were divorced from their contexts. Masks danced with costumes to the sounds of festive music under bright African skies were placed in deathly-quiet semi-darkness. Looming from their cases, they looked ominous rather than celebratory. Indeed, early **modernists** like Pablo Picasso were excited by African art, because to their eyes the art looked wild, scary, and dangerous. The modernists wanted to shake up the art establishment, and break traditional, naturalistic rules of art-making. African art provided them with a ground-breaking visual vocabulary to make their statements. Ironically, the art they used to speak of rule-breaking was originally created to confirm and strengthen social norms.*

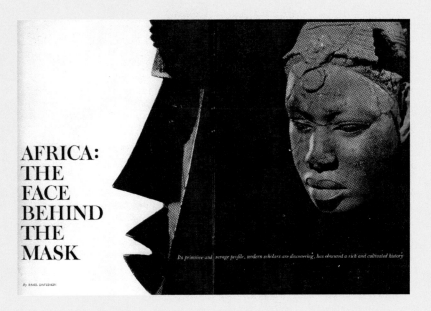

AFRICA:
THE
FACE
BEHIND
THE
MASK

By BASIL DAVIDSON

Its primitive and savage profile, modern scholars are discovering, has obscured a rich and cultivated history

When European archaeologists discovered the naturalistic artwork of the Ife kingdom (Nigeria), some assumed (wrongly) that the Greeks had visited Africa, and made sculptures like the one shown on the right side of the *Horizon* spread. Scholars had a hard time picturing "primitive" Africans making "advanced-looking" naturalistic work. The *Horizon* caption essentially blames African artists for the scholars' mistake. The author says here, in essence, that the frequent choice of abstraction in African art has "obscured a rich and cultivated history." In other words, "if Africans had made naturalistic art all along, we wouldn't have dismissed their history as primitive and uncultured. Now that we have noticed their naturalistic art, we can start taking a serious look at their cultural history."

This old magazine article reveals biases that are very deep-seeded, and have impacted cultural views in Europe and the United States for many years. The Western preference for naturalistic art has its roots in Italian Renaissance thinking. Giorgio Vasari (1511-1574), an Italian Renaissance biographer of artists, sums up this viewpoint in his *Lives of the Artists* (Penguin Classics):

> ... The first men [the early Greeks] were more perfect and endowed with more intelligence, seeing that they lived nearer the time of the Creation; and they had nature for their guide, the purest intellects for their teachers, and the world as their beautiful model. So is there not every reason for believing that they originated these noble arts and that from modest beginnings, improving them little by little, they finally perfected them? (p. 31).

> In the end [in the Middle Ages, after the Roman Empire] there was left not the slightest trace of good art. The next generation of artists was awkward and crude, especially when it came to painting and sculpture ... The work produced could not have been more awkward or more lacking in the qualities of design. (p. 38)

> For from the smallest beginnings art attained the greatest heights, only to decline from its noble position to the most degraded status. Seeing this, artists can also realize the nature of the arts we have been discussing. ... [L]ike human beings themselves, [the arts] are born, grow up, become old, and die. And they will be able to understand more readily the process by which art has been reborn and reached perfection in our own times [the Italian Renaissance]. (pp. 46-47)

From Vasari's perspective, naturalistic art is modeled on nature; nature is a product of God; God is perfect; therefore, art that aims toward perfect naturalism is superior to abstract art (which, to Vasari's eyes, was art that had "died").

Five hundred years later, this cultural attitude still lingers. Even as we celebrate cultural diversity, it is difficult to remove the "tinted specs" of our own culture, which will inevitably color how we see art of other cultures. The key to art appreciation is to develop an awareness of our own cultural filters, which might drive our preference for one style of art over another. As you proceed, keep in mind that art does not "get better" from one century to the next, or from one culture to the next. The definition of "good art" depends very much on who is doing the defining!

Works related to **style** are in boldface.

abstract, abstracted, abstraction	Style in which details are eliminated or distorted from the object on which the image is based
attribute	Accessory, object or motif associated with a person
background	Space that appears farthest from the viewer, in the "back" of the picture
Classical	Related to the Ancient Greek and Roman eras
Days of the Dead/*Días de los Muertos*	Celebration of the dead of Mexican origin
freestanding sculpture	Sculpture that stands clear of a wall or other vertical support
hanging scroll	Scroll that is hung on a wall or other vertical support
humanist, humanistic	Related to human beings; human-centered philosophy
iconography	Study of signs and symbols and their meaning
illusionistic	Style giving the illusion of a three-dimensional reality, as seen in the natural world
Italian Renaissance	Period in 1400s–1500s Italy following the Middle Ages
ka statue	Sculpture made in the image of an Egyptian king, to hold a part of his spirit in the afterlife
Medieval	Related to the Middle Ages
memento mori	Reminder of death
modernist, modernists	Related to art movements rejecting traditional Western style
mosaic	Medium in which small tiles are used to create an image
naturalistic	Style giving the illusion of the natural world
negative space	Space not occupied by objects
relief sculpture	Sculpture that is attached to a wall or other vertical support
Renaissance	Period of 1400s–1500s Europe following the Middle Ages
scale	Principle of design addressing the relative size of an object, compared with other objects
stylized	Style featuring simplified forms; abstract
Zen Buddhism	Buddhist philosophy emphasizing individual pursuit of Enlightenment

2 CULTURE & THE VOCABULARY OF SPACE IN TWO DIMENSIONS

2: CULTURE AND THE VOCABULARY OF SPACE IN TWO DIMENSIONS

Pietro Perugino, *Delivery of the Keys to St. Peter*, 1481-2. Fresco. Sistine Chapel, the Vatican, Rome, Italy.

TRADITIONAL WESTERN SPACE

In America today, our view of what makes a "good" or "correct" depiction of space depends a great deal on 500-year-old art. In the Italian Renaissance, artists set the cultural standard that we still rely upon today, even as we have become more aware and appreciative of other cultural attitudes towards space. First, let us examine the Italian Renaissance model, epitomized by Perugino's painting in the Vatican's Sistine Chapel.

When you look at this painting, you are seeing a work of art in two dimensions: **height** and **width.** However, Perugino has created an illusion of **three-dimensional space,** the illusion that there is **depth** as well. There is the illusion of a very deep space, in fact—the viewer can see figures in the **foreground,** more people scurrying in front of buildings in the **middle ground,** as well as trees and hills in the **background.** Notice that the closer hills look darker and greener. The farther away the hills, the bluer and lighter they appear. This illusion is known as **atmospheric perspective.** Perspective is a way of seeing space; atmospheric perspective is a way of seeing distant objects through the atmosphere—the scattering of light through the haze of air (including dust and other particles) between the viewer and the hills. Naturalistic art can use more than just atmospheric perspective, however, to create the illusion of distance. In addition to making far-away things smaller, overlapping objects, and putting "nearer" things closer to the bottom of the painting, artists like Perugino use **linear perspective.**

Note how the ground on which everyone is standing has a square design; yet, the squares don't look square. Their lines are running diagonally, and appear to converge (come together) at the center building. You will find the same illusion happen when you look down a long hallway; the walls appear to come closer together at the end of the hall. You know that the walls are really parallel, the entire length of the hallway, but your eyes trick you into seeing **linear perspective**.

Let us look at how linear perspective works. First, there is the **horizon line.** This is the line that marks the edge of the world (the horizon). Because the earth is round, this line is actually a bit curved, but the earth is big enough to make that curve very slight. Viewed in small snippets, the horizon line looks straight to your eye. Note that in some contexts, particularly where there are a lot of buildings or other visual obstructions in the way, it can be hard to see the horizon.

In **one-point linear perspective,** the **vanishing point** is the point where the walls (in our theoretical hallway) would eventually meet, if the hallway was long enough to extend all the way to the horizon. Obviously, no hallway is that long. The **orthogonal lines** are those imaginary lines that "keep going," following the path that the *existing* lines of the wall suggest, leading to (and converging at) the vanishing point.* If you have difficulty finding the horizon line in a two-dimensional work of art that is using **one-point perspective,** just follow the **orthogonals.** Wherever they converge, that will be your vanishing point—and the vanishing point *must* be on the horizon line.

In this diagram of Perugino's painting, you will see the orthogonal

*Orthogonals are easy to find and track on constructed objects (built structures, boxes, etc.). The shapes of people, hills, trees, and other things with organic, fluid dimensions will guide your eye through the artwork—but not necessarily to a vanishing point!

Pietro Perugino, *Delivery of the Keys to St. Peter,* 1481-2. Diagram by the author.

lines on the ground, as well as the orthogonals indicated by the sides of the two buildings, which are flanking the central domed structure. Notice that all the orthogonals (indicated by solid and dashed orange lines) meet at the vanishing point (the yellow dot), which is at the doorway of the domed building. The horizon line (in blue) runs horizontally through that point.

The vanishing point does not have to be at the center of a composition, but the fact that Perugino deliberately wanted the point there, rather than at the edge of the painting (or beyond its borders), tells us about the interests of the Italian Renaissance culture. Contrast the positioning of Perugino's vanishing point, in the center, with a late-Renaissance work by Tintoretto below. By the mid-1500s, Italian Renaissance tastes were already shifting toward the **Baroque** era (c. 1600). But in Perugino's painting, we are in the **Renaissance** (c. 1500), the era of Michelangelo, Raphael, and Leonardo. These great thinkers of the Renaissance embraced the idea of

Tintoretto, *Vulcan Surprises Venus and Mars*, c. 1551. Oil Painting. Die Alte Pinakothek, Munich, Germany.

Follow the orthogonal lines on the floor to find the vanishing point. Notice how much more invigorating this placement is! The use of a dynamic one-point perspective here mirrors the active subject matter—the great Roman god of war has ducked under the table, as the jealous husband Vulcan (god of the forge) surprises his cheating wife, Venus. The dog is seconds away from giving away the hidden lover. This painting is newer than Perugino's, and is showing the tastes of the next generation of artists, who were less interested in logic and order (and much more interested in drama and suspense).

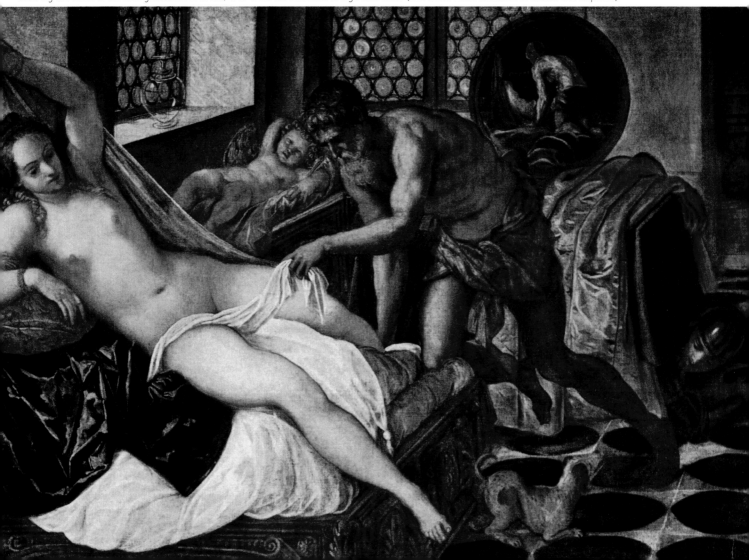

human betterment through beauty—the idea that people could see, in the beautiful perfection of art, the possibility of their own spiritual improvement. They viewed God as the ultimate form of perfection—and reasoned that, if God has the perfect mind, then his ideas wrought perfect creation. From this perspective, the "original sin" of Adam and Eve introduced imperfection to humanity, so humans should use their own god-given minds to redeem themselves, and get back closer to him.

The "movers and shakers" of the Renaissance believed that moral improvement would come through studying and emulating the natural world, at its best. If God made the world to be rational, orderly, and perfect—and if linear perspective is the most logical, orderly, and natural way of seeing the world—then *that* was the way Renaissance artists were going to depict the world. It should come as no surprise that in Renaissance paintings, the vanishing point is routinely placed right in the middle—the most perfectly logical place for it to be.

This philosophy permeates Perugino's painting. The artist here shows the Catholic Christian idea* that Christ gave the authority to lead the church (symbolized by the key) to one of his followers, Peter (kneeling). Peter is therefore honored by Catholics as the first pope, who confers his authority to all popes who follow. Perugino puts the most important figures front-and-center, which is very logical—especially considering the painting's placement in the Sistine chapel, the pope's "spiritual house." The two side-stories shown in the middle ground (a scene where Christ allows his followers to give tribute money to Caesar, and a scene showing an attempt to stone Christ to death) are placed at a "safe distance," so that the viewer will not be distracted or emotionally carried-away. The intended viewer (especially the Pope himself) is invited to observe this model of perfection, mentally appreciate its logical use of space, and then aspire to be worthy of the powerful gift of authority that it shows. Note that Michelangelo's ceiling in the same chapel (particularly his famous *Creation of Adam* scene) reiterates this message. Added about twenty years after Perugino's work, Michelangelo's ceiling shows the same Renaissance interest in clarity, order, and the naturalistic view of things as they appear to the human eye (albeit in a more "perfected" form).

Let us take a look at the Sistine Chapel, the site of both Perugino's and Michelangelo's paintings. Notice how all the decoration is laid out before you, like a storybook where all the pictures are revealed at once. Each piece can be seen as part of the whole. Each scene is like a window; each space seems carved out of the wall (even though much of the architectural details are painted illusions, rather than "real" columns and niches).

The way the viewer is meant to "use" the art here** corresponds perfectly to the artists' illusionistic use of space. Viewers can look up, and take it all in—becoming themselves part of the "perfect whole."

Fra Carnevale, *The Annunciation*, c. 1445/1450. Tempera on panel. National Gallery of Art, Washington, DC. Find the vanishing point in the Italian Renaissance painting, left. Consider: how is the use of space consistent with Renaissance values?

*When this painting was made, there were only two main branches of Christianity—the Catholic Church, and the Eastern (Greek) Orthodox Church. The Protestant Reformation (which split the Catholic Church in the 1500s) hadn't happened yet ... but certainly the Pope was already sensing discontent in the air. The statement here is a political one, as much as a spiritual one: the Pope is saying, "I am in charge, because Christ put my predecessor Peter in charge. So you better follow me!"

**Even though the art is not "used" here in the traditional sense (it's not a plate for food, or a vase for flowers), it is still *has a use or function*. In other words, it is not purely decorative; the art is doing a job—primarily, reinforcing the beliefs of the pope, in the mind of the viewer.

In the *Creation of Adam* scene, at the center of the ceiling, you can see the Renaissance philosophies in action. Here Michelangelo depicts perfection in human form. God himself is buff and wholly naturalistic-looking. In earlier, Medieval times, such a depiction would have been thought completely inappropriate; God was shown only as a hand descending from the heavens, or as an enthroned being, wearing a majestic tiered crown, sitting remote and inhuman (much like the medieval figure of Mary and Jesus shown in the previous chapter).

In this scene, Adam has not yet received the spark of life, the "soul" that will make him not just physically present, but mentally alive and aware. This emphasis on the mind is reiterated by the billowing shape of God's cloak. This shape looks very much like a brain! In essence, Michelangelo is showing you (in a very veiled way) the mind of God—the model for the human mind, according to Italian Renaissance philosophers.*

*Consider: how did Michelangelo know what a human brain looked like? Would this have been common knowledge?

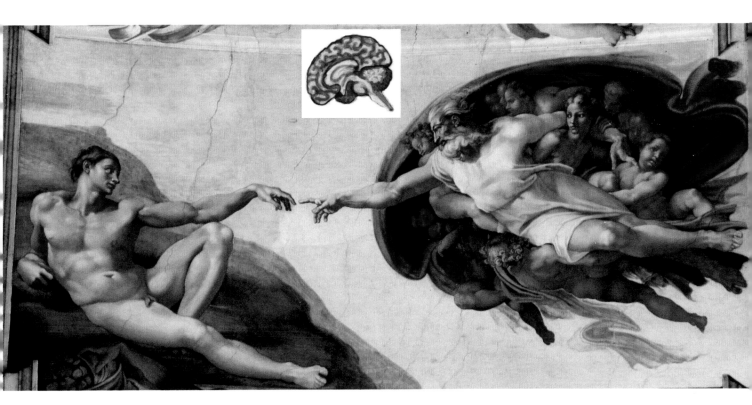

Main page: Sistine ceiling by Michelangelo, 1508-1512.

Inset: The Sistine Chapel, Rome, Italy—looking West, with our backs to the altar. Perugino's painting is on the left wall, second from the end.

The Creation of Adam scene is found near the middle of the Sistine ceiling.

LINEAR PERSPECTIVE IN A NUTSHELL

One-point perspective

The diagram of a box sitting on railroad tracks, shown on the opposite page, is an example of one-point perspective, with the viewer looking at an object head-on. Note how the top of the box is angled toward the vanishing point. The vanishing point is located on the horizon line, the **horizontal** line running from left to right.

The placement of the vanishing point at the center of the diagram is typical in Italian Renaissance paintings. However, note that the vanishing point does not have to appear within the frame of a picture. The drawing of the bedroom at right is loosely based on the Tintoretto painting, *Vulcan Surprises Venus and Mars*, shown earlier. Here, the vanishing point is located outside of the frame of the artwork. This creates a more dynamic sense of space.*

Two-point perspective

In this chapter we are focusing on the use of one-point linear perspective. Note that there is more than one kind of linear perspective. As the name suggests, two-point perspective features two vanishing points, instead of one. Viewed at an angle (rather than head-on), the sides of geometric objects appear to recede toward two different points on the horizon line. When you look at a building on a street corner, chances are you will see the building in two-point perspective, as in the snapshot of a San Francisco parade below.

Three-point perspective

Three-point perspective is used to look at objects at an extreme, dramatic angle, from above or below.

*We are looking at this bedroom head-on, so technically this is still considered one-point perspective. The scene has simply been cropped, so that we are looking at the bottom left corner of our entire field of view.

2: CULTURE AND THE VOCABULARY OF SPACE IN TWO DIMENSIONS

One-point perspective.

Dynamic use of linear perspective: horizon line and vanishing point beyond the picture frame.

Two-point perspective.

Three-point perspective.

Sesshu Toyo (1420-1506), *View of Amano-Hashidate* (detail), 1501-1506, ink and light color on paper, 35.4 x 70.2 in, Kyoto National Museum.

TRADITIONAL EASTERN SPACE

The use of space in Sesshu's landscape is remarkably different from the space in Perugino's painting. Remember, though, that the Japanese handscroll is used by the viewer in a very different way from the viewer's "use" of the art in the Sistine Chapel. The length of the scroll, at almost 6 feet, prevents the viewer from standing back and seeing it all. In the previous chapter, we discussed the way in which Japanese viewers were expected to journey through the art, making discoveries in the work while also opening themselves up to spiritual discovery. Notice how the *Creation of Adam* scene in the Sistine Chapel is presented as the culmination of the story—the literal and symbolic center of the room, representing the heart of its purpose and meaning. This moment is powerful and unchanging; the viewer is meant to look up and see an image of perfection, aspire to be worthy of that perfection, and hope for a return to that perfection in heaven. In contrast, *View of Ama-no-Hashidate* deliberately avoids creating a single, climactic moment for the viewer. Each part of the landscape is important, beautiful, and worthy of meditation, in its own right. The art of the handscroll may not literally change, but the viewer does—his or her perceptions, experiences, and observations will continually change and grow each time he or she returns to study the art. With each viewing the composition will also change, depending what area the viewer chooses to reveal at each moment, at each sitting.

The richness of this Chinese handscroll at right is evident throughout the piece—from the likely identity of the artist (Emperor Huizong himself), to the subject matter (the cleaning, dyeing, sewing, and folding of fine silk), to the medium (ink and gold, painted on the kind of silk that the ladies are shown preparing). This is a work that is meant to be prized in a collection, revealed for special guests, handled reverently, and examined scrupulously—treated with the same kind of care that the ladies themselves would apply to the handling of precious silk.

Like Sesshu Toyo's handscroll, the Chinese handscroll would also be viewed in segments. As we "read" from right to left, notice how each unrolled segment would present a different composition, and different points of interest.

Again, the form of the handscroll mirrors the cultural message. Each part of the silk preparation process is equal in importance. The point of the scroll is not just to reach the end—just as the value of the silk lies not just in the final product, but rather in every step of the process. This may be read as a metaphor for life itself, and how one should conduct oneself in the journey of life. We should not be judged by our final accomplishments but rather by the quality of our everyday conduct, and our fulfillment of everyday duties. This belief may be linked to **Confucianism,** a Chinese belief system with its origins in the teachings of philosopher **K'ung Fu-Tzu** (551–479 BCE). He proposed that one's position in both family and society holds certain moral responsibilities. Just as the ladies of the court have their duty to the Emperor, so the daughter has duties to her mother (and mother-in-law, when she marries); so too, the son has a duty to his father. Students of **Confucius** extended this philosophy to include the duties of the Emperor to look after his subjects; in other words, the river of responsibility flows both upstream and down.

Let us compare the use of perspective in Emperor Huizong's handscroll to the one-point linear perspective in Perugino's Renaissance painting.

As you recall, the orthogonal lines in one-point perspective all appear to converge, or come together, at a single point in the distance (on the horizon). These orthogonal lines can be found on the ground, in the square pattern of the plaza. This plaza is composed of large, white squares, arranged in a grid; through the illusion of

Emperor Huizong, *Court Ladies Preparing Newly-Woven Silk,* Chinese, Northern Song Dynasty, 12th century. Approximately 14.5" high x 57" long. Ink, color, and gold on silk. Museum of Fine Arts, Boston.

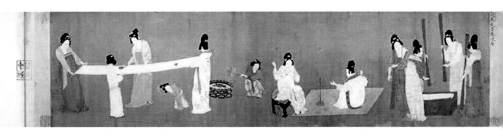

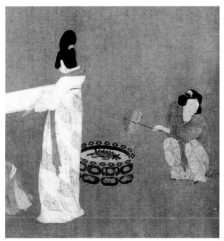
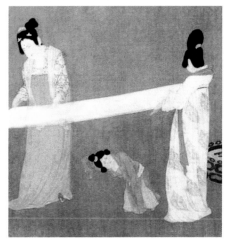
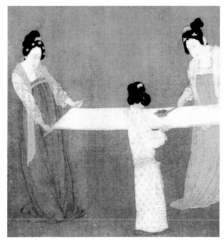

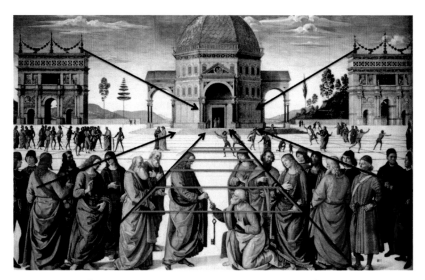

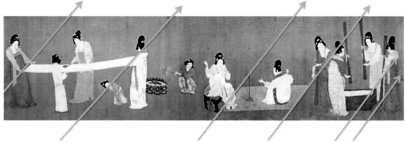

Perugino's illusionistic space (featuring one-point linear perspective) and Emperor Huizong's abstract space (featuring oblique projection).

one-point perspective, Perugino creates the impression that the squares are receding in space. This enhances the viewers' sense that they could walk into that space, and make their way back toward the buildings and hills in the background.

In contrast, Emperor Huizong's handscroll provides no such illusion of depth. Instead of orthogonal lines that converge on a single point, here we find **oblique projection**. The edges of geometric shapes—such as the wash basin and the mat on which the women are sitting—are all aimed at the same oblique (non-right) angle. The direction of the edges (indicated by the arrows in the illustration above) give the impression that the objects are *projecting,* or moving farther back, in space. This gives the viewer the idea of three-dimensional space; however, it does not give the *illusion* of space—the illusion that you could physically step into the world depicted.

There are specific reasons why the emperor chose to depict the ladies in oblique projection, rather than linear perspective. The first reason lies in the flexible use of the handscroll. In linear perspective, the artist demands that you stand at a certain place for the illusion to work. The artwork is viewed, from one spot, all at once. In contrast, oblique projection creates an ordered sense of space, *without dictating the viewer's actions.* In the handscroll, the viewer is free to concentrate on whatever area he or she likes, at any time, from any vantage point.

There are many video games that feature oblique projection. In these games, the viewer (the player) is the one who directs the movement of game-play, looking "down" upon the space and ordering the characters "from above." Like Emperor Huizong, the programmer has designed the space so that players can move freely, and focus their attention on whatever area they wish.

Screenshot, "Civilization V."

The essential reason for choosing oblique projection over linear perspective—or vice versa—is cultural. Inspired by the idea that God created the world as perfect, the Italian Renaissance artists wanted to emulate the natural world, and wanted to follow the natural laws (such as perspective) that govern it. Essentially, they wanted to paint as the eye would see, in a perfect world. Linear perspective would be the ultimate way to reflect that set of values.

However, Song Dynasty artists such as Emperor Huizong would have found that approach unacceptable. To medieval Chinese culture, the artist's ability to synthesize the complexities of the natural world into its essential components was the ultimate expression of skill. Everyone knows what the natural world looks like; what purpose would it serve to slavishly reproduce it? The true value and essence of the natural world lies not in its superficial visual qualities, but rather in what lies beneath. According to this point of view, objects should be arranged in space according to their symbolic importance. Viewers are given the freedom—and the responsibility—to make connections between the selective images in the artwork and their own visual, physical, and spiritual experiences in the world.

We have seen that, in the traditional Western world, artists have strived to create the illusion of three-dimensional space within the limits of two dimensional art. In many traditional Eastern cultures, however, artists have simply implied the existence of three-dimensional space. This may be accomplished by the use of oblique projection, combined with more basic signals of depth (such as overlapping figures, and placing "closer" objects lower on the page).

When artists reject the use of illusionistic space, they usually employ other **devices** or emphasize other visual aspects to engage the viewer's attention, and create a dynamic composition. We will examine two visual elements that are often featured to great effect in traditional Eastern art.

THE SHAPES OF NEGATIVE SPACE

Positive space is the usual attention-getter; this is the space occupied by all the objects in a work of art. As noted in the Introduction, the left brain is primarily responsible for the language skills that provide names for objects. As we look at a work of art, our left brain focuses on the things it can recognize and name. In the case of the *Court Ladies*, we focus on the women, the baskets, the stool, etc.

However, the right brain has no interest in the names of things. The right brain gives equal attention to every element in the composition—including the **shapes** of the areas around the things.* This is the **negative space**. A good composition must have good negative space; the artist must create invigorating, interesting shapes around the positive imagery. Notice the variety of black shapes in the diagrams here. When the viewer rolls or unrolls a portion of the handscroll, the shapes of the negative space will change. Compare the negative space in the following three details of the scroll. Emperor Huizong could not know exactly where his composition would be "cut" vertically, as the viewer rolled and unrolled his scroll. Therefore, he had to be sure that the negative space was dynamic *throughout* the composition. Artists with extensive practice and training often create effective negative space subconsciously. Subsequently, the viewer can train his or her right brain to see (and appreciate) the negative space in a work of art. This is part of the mental concentration and discipline that traditional Eastern art would demand of its viewers.

**Shape is the visual element addressing an area in a two-dimensional work of art. Form is the visual element that addresses an area in a three-dimensional work.*

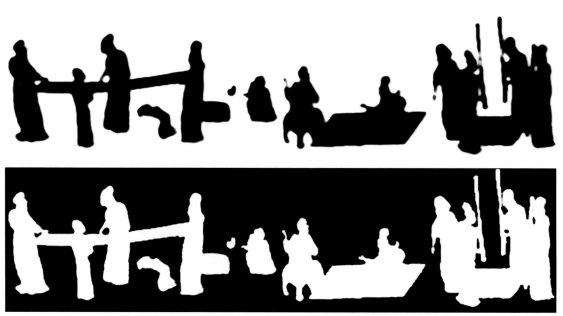

Left: Cropped sections of *Court Ladies* showing negative space in black.
Top: Longer section of *Court Ladies* showing positive space in black.
Bottom: Same section, negative space in black.
Illustrations by the author.

Pattern and the Play of Space

Here is an excellent example of Eastern-styled space. This page is called a **Persian miniature**—a miniature (very small) painting created for Persian royalty. When the Mongols invaded Persia (an ancient Middle Eastern land that includes modern-day Iran) in the 13th century, the new rulers brought their Chinese artistic traditions with them.

Following is a description of this piece from the Metropolitan Museum of Art:

> The fourth of the late twelfth-century Persian poet Nizami's five epic poems, later combined to form the famous *Khamsa* (Quintet), was the *Haft Paikar*, or *Seven Portraits*, so named from one incident in the story.
>
> It recounts the legendary history of the Sasanian king Bahram Gur, who is idealized as a great lover and hunter. The story is known also as the *Seven Princesses* because Bahram Gur, so the story goes, married seven beautiful princesses from the seven regions of the world, and visited each in her own pavilion on successive nights of the week.
>
> In this highly sensual but moralistic work, each princess tells a story and there are additional stories within these. ...
> —http://www.metmuseum.org/toah/ho/08/nc/ho_13.228.7.10.htm

Bahram Gur in the Turquoise Pavilion: Page from a manuscript of the Khamsa (Quintet) of Nizami, dated 1524–25; Safavid period. Afghanistan (Herat). Colors, gold, and silver on paper; H. 12 5/8 in. (32.1 cm), W. 8 3/4 in. (22.2 cm). Metropolitan Museum of Art, New York.

In this miniature painting, Bahram Gur is paying a Sunday visit to the Byzantine Princess Humy, in the Yellow Pavilion. Both are dressed in sunny yellow, as the princess tells the king a story of love and honesty. They are placed literally and figuratively above the attendants in the foreground. Although we understand the pair to be "farther back" in space, they are no smaller than the foreground figures. This defies the laws of illusionistic space—but it is a fitting use of symbolic space. The prince and princess are more important than everyone else—they may be seated farther from the viewer, but they are not allowed to be smaller.

The depiction of the pavilion also defies naturalistic space. We see both "inside" and "outside" at once, as the interior of the pavilion is revealed, doll house-like, for the viewer to peer within. We will discuss in Chapter 6 the use of shading to suggest depth; such shading is wholly absent here. Instead, within the "flatness" of the space, there is a delightful play of shapes, objects, and colors. The play of space creates an engaging dance of backward-forward, inside-out, push and pull for the viewer's eye that is characteristic of the best traditional Eastern compositions.

One of the most effective ways that the artist plays with space is with the use of **pattern.** There is just enough patterning to engage the viewer, but not so much as to lose visual sense; the viewer's eye bounds effortlessly from pattern to solid and back again. The gold which threads throughout the sumptuous designs speaks of the richness of the Prince, but also speaks to the wealth of the artwork's owner. The rich patterns of the painting speak of the vitality of the royal Persian court, as well as the complexity of the princess's story-telling.

The floral and geometric shapes used throughout the composition are likely based on the rich patterns found in Persian **textiles**, such as the antique rug shown on the following page. The writing (a form of **calligraphy**) becomes part of the intricate design.

Left: Antique Tabriz Persian rug.
Right: Detail of Cassatt's *Little
Girl in a Blue Armchair.*

TRADING SPACES

So far we have been looking at the use of space in traditional Western art (Italian Renaissance, specifically) and traditional Eastern space (Japanese, Chinese, and Near Eastern). The Italian Renaissance emphasis on illusionistic space continued to influence European art and the art of the United States throughout the 1800s. This style of art is now called "academic," because it follows the traditional rules affirmed by the official art academies of England and France. However, by the 1860s, a small group of radical French artists had begun to reject the old rules of space and turn to Eastern art for inspiration.

One such radical group working in France in the late 1800s was the **Impressionists.** Their work was refused from the official **salons,** the gathering spaces for art shows. Instead, the Impressionists exhibited their work in a show dubbed the *Salon des Refusés*, or "rejects' show."

The art academy had rejected Impressionist work because it looked "flat" and sketchy. Working in France, the American-born Impressionist Mary Cassatt embraced this loose and non-traditional way of painting. Her compositions reflect the Impressionist interest in Japanese art (an interest known in France as *Japonisme*). Notice the engaging use of negative space in Cassatt's painting of a girl lazing with her dog, and the play of pattern against solid color that delights the eye throughout the composition.

Several European artists followed in the footsteps of the Impressionists with their radical spatial experiments. Like the Impressionists, French artists Pierre Bonnard and Henri Matisse were influenced by the use of pattern and "flattened" space in Eastern art. In the two paintings on the next page, the space appears two-dimensional; shading is minimal; pattern abounds; and linear perspective is absent, or deliberately distorted. This play of space may be found in many works of modern art.

Mary Cassatt, *Little Girl in a Blue Armchair*, 1878. Oil on canvas. National Gallery of Art, Washington, DC.

Pierre Bonnard, *Interior at Le Cannet*, 1938. Oil on canvas. Yale University Art Gallery.

Henri Matisse, *Woman Seated in an Arm-chair*, 1940, National Gallery of Art, Washington, DC.

Take a moment to examine the repetition of pattern in Bonnard's *Interior at Le Cannet*. The mirror reflects the patterned floor, which subtly mimics the pattern on the chair in the foreground. The darker, turquoise colors in the back room give some indication of depth, yet the overall picture plane appears tipped towards the viewer, as if all parts of the picture were playing pieces on the same game board.

Henri Matisse's portrait of a woman in a patterned, sheer blouse is far more abstract than Cassatt's little girl relaxing in an armchair. The patterns of the woman's shirt pop vividly, echoing the dollops of blue in the woman's eyes, and the intense red of her bud-shaped lips. Note the active brushwork in blue around the woman's head. Like the floor that surrounds the furniture, flowing like a river through the center of Cassatt's room, this solid blue provides a place for the viewer's eye to rest; at the same time, the blue background's prominence pulls the negative space forward, playing off the blouse's blue flowers and neckline stitching. Like Cassatt and Bonnard, Matisse clearly owes his treatment of space to traditional Asian art.

New Vocabulary in Chapter 2

Vocabulary dealing with **space** is in boldface.

atmospheric perspective	The perception that objects in the far distance appear hazy and blue-ish
background	The space toward the "back" of a picture
calligraphy	A fluid form of writing
Confucius, Confucianism	Chinese philosopher, his philosophy
foreground	The space toward the "front" of a picture
form	Visual element in two-dimensional art that refers to an area bound by real or implied lines
High Renaissance	Period in Italy, c. 1490-1520
horizon line	Horizontal line marking the edge of the earth (horizon)
Impressionist, impressionistic, Impressionism	Related to a French style of art, c. 1870; gives fleeting impression of a scene, rather than fixed details
linear perspective	Naturalistic system of defining three-dimensional space in a two-dimensional work of art
middle ground	The middle space (between far back, and up close)
negative space	Space defining areas around foreground objects
oblique projection	Abstract, symbolic system of suggesting three-dimensional space in a two-dimensional work of art
one-point perspective	A type of linear perspective using one vanishing point (looking at an object head-on, not from an angle)
orthogonals, orthogonal lines	Lines that continue from an object and appear to converge (come together) at a vanishing point
pattern	Principle of design in which shapes, colors, and other elements are repeated
Persian miniature	Small, ornate painting from Iran (Persia)
positive space	Space occupied by objects (usually in the foreground)
shape	Visual element in two-dimensional art that refers to an area bound by real or implied line
vanishing point	The point at which orthogonals converge

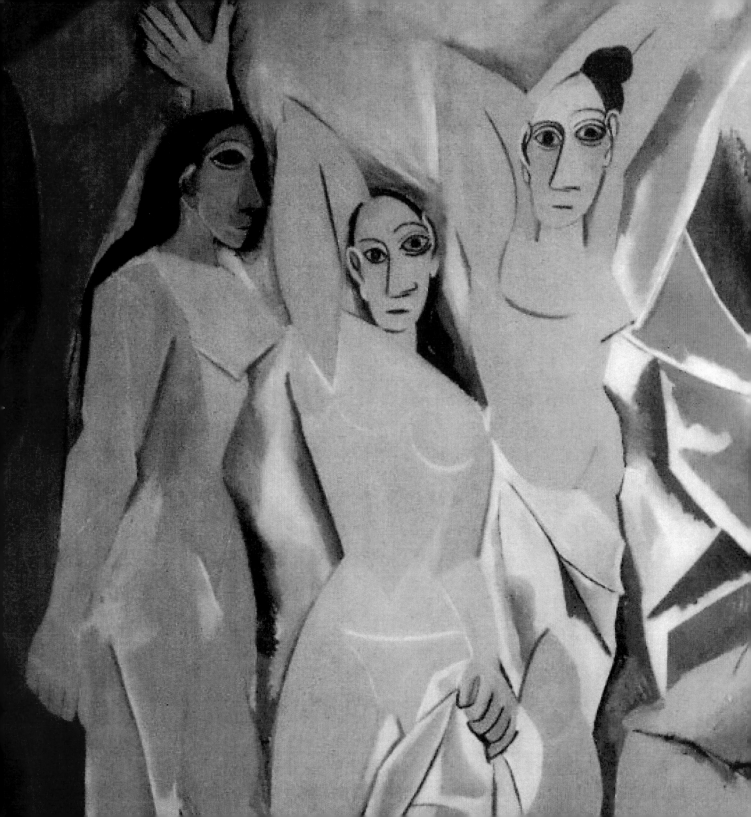

3
APPROACHES TO ABSTRACTION

3: APPROACHES TO ABSTRACTION

STYLE—ABSTRACTION
COLLAGE
UNITY/VARIETY

In the first two chapters we looked at the impact of culture on the style of artwork. While the naturalistic style has been traditionally favored in the Western world, **abstraction** has served the cultural needs of many non-Western cultures. Over the past hundred and fifty years, a dialogue among artists of different cultures, throughout the globe, has produced a variety of styles in modern art—from photo-realistic naturalism to total abstraction.

"Writing an Abstract"

In some fields, it is necessary to write an **abstract** for a thesis, an article that will be published in a journal, or other long, official document. An abstract is a brief, less-than-one-page summary of the work. Writing an in-depth, researched paper is difficult; you must be sure of every detail, and develop your argument fully and clearly. Even though it is significantly shorter than the completed work, the abstract can also be quite difficult to write. The challenge is not one of quantity or detail—quite the opposite! The difficulty lies in figuring out how to compress all the intricate information, all the detail and nuance, of the entire project into a succinct and persuasive synopsis. You must decide, what is *really* essential? What needs emphasis? What is distracting to the main points, and should be omitted? Does it still make sense, in this shortened form? Making abstract art presents similar difficulties.

Approaches to Abstraction

There are many different approaches to making abstract art. Each approach can convey a different idea, or produce a different feeling in the viewer. Artists may choose an abstract approach for different reasons. These reasons need not be mutually exclusive—artists may combine different approaches, for multiple reasons. Let us examine them one by one.

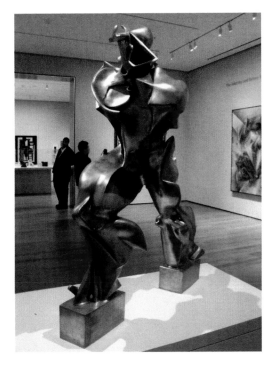
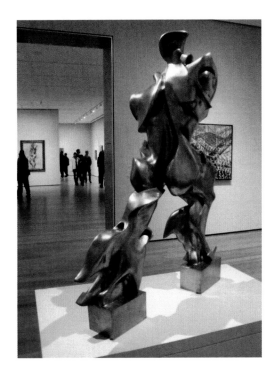

Umberto Boccioni, *Unique Forms of Continuity in Space*, 1913. Bronze. 44" tall. Museum of Modern Art (MoMA), New York.

1. ABSTRACTION TO COMMUNICATE A BIG IDEA

—AN ABSTRACT, COMPLEX, GRAND CONCEPT (SUCH AS POWER, VISION, ETC.)

Take the concept of "power." An artist could choose to sculpt the figure of someone muscular, poised for combat (such as the victorious ancient Greek youth, shown in Chapter 1). Or, an artist might paint the portrait of a well-dressed figure, surrounded by detailed symbols of wealth and knowledge (like Holbein's *French Ambassadors*, also shown in Chapter 1). These are literal depictions of power. The left brain sees muscles, and thinks: "muscles are powerful, therefore this shows power." The left brain sees the accessories of powers, and thinks: "these must be powerful people, to have such nice things." But how can the artist communicate "power" without going the "slow" route, running through the logical—but not particularly intuitive—left brain? How do you visually "cut to the chase," and deliver all the meaning of these naturalistic pieces, in one knockout punch?

You want power? Here is power, delivered directly into the right brain:
FLASH! The shiny bronze appears liquid-fast and wicked sharp.
SLICE! Pointy and streamlined, all daggers and darts.
SNIKT! Piercing and cutting, sawing and slashing.
Are those flames? Ouch!
Is that a horn? Yow!

Decades before Wolverine or the Terminator, you have the essence of the relentless mechano-man-fighting-machine, who will stop at nothing, and won't be slowed down by sentiment or soft-heartedness.

Left: Ana Mendieta, *Tree of Life*, 1976. Photo-documentation of an earth-body work in mixed media Museum of Fine Arts, Boston.

*Fascist beliefs vary, but they all generally center on an all-powerful government that operates like a stern father-figure—knowing what's best, and not open to debate. Fascists are often strongly nationalist, swearing faithfulness to their own nation and its official policies without question; indeed, dissent or diversity is seen as a threat to unity, which is thought to hamper, dilute, or corrupt the integrity of the state.

The artist of this work, Umberto Boccioni, was a member of the radical, pro-fascist* art group called the **Futurists,** working in Italy in anticipation of Mussolini's rise to power. As you read excerpts of Futurist thinker F.T. Marinetti's manifesto, consider how these attitudes are reflected in Boccioni's sculpture:

> We intend to exalt aggressive action, a feverish insomnia, the racer's stride, the mortal leap, the punch and the slap. ...

> Except in struggle, there is no more beauty. No work without an aggressive character can be a masterpiece. Poetry must be conceived as a violent attack on unknown forces, to reduce and prostrate them before man ...

> We will glorify war—the world's only hygiene [cleansing agent]—militarism, patriotism, the destructive gesture of freedom-bringers, beautiful ideas worth dying for, and scorn for woman. ...

> We intend to sing the love of danger, the habit of energy and fearlessness. ...

We will return to the Futurists later in this chapter; for now, let us look at another example of abstraction used to communicate, directly, a complex and powerful idea. Consider the work of Cuban-born artist Ana Mendieta (1948–1985).

Ana Mendieta, *Isla*, 1981.
Estate of Ana Mendieta
Collection and Whitney
Museum of American Art.

Mendieta's parents sent Ana and her sister away from Cuba after the revolution brought Fidel Castro to power. A thirteen-year old girl at the time, Ana found herself supplanted from her native land, and rather abruptly relocated in Iowa. Her ensuing feelings of displacement, both physical and social, became the foundation for her artwork.

The concept of displacement is both personal and global. We each have experienced the sense of being "out of place," unpleasantly divorced from the comfort and security of home. The displacement of whole villages and populations, resulting from natural disaster, war or political turmoil, is also felt throughout the world. Mendieta successfully encompasses these vast and profound experiences through the language of abstraction. Rather than show, in detail, one particular story (to which the viewer may or may not relate), Mendieta's works are more essential—quite literally, more *elemental*.

Mendieta used, as her materials, her own body as well as the natural world around her. In *The Tree of Life*, 1976, you see her body appearing as part of the tree; she is like a living sculpture, at once alive but also frozen, like petrified wood. She also appears like an ancient nature-goddess figure, in a pose that echoes the earliest female sculptures. The artwork here is the performance itself; the photo is simply a way of documenting the action. Like elements of nature, the art of performance is also changing and impermanent.

Mendieta's *Isla*, or "island," is haunting and poignant. The viewer immediately feels the fragility of the moment. One sees the earth-body is surrounded on all sides, and senses that it is sure to submerge before long (or has it just now risen to the surface, after having been long-buried?). The rough textures suggest the craggy contours of a real island, while still evoking the shape of a woman (Mendieta in symbolic form, or an ancient idol, a goddess figure). The island to which she refers in the title is both literal and figural. Here she speaks of the isolation of a Latina growing up in 1960s middle-America; she also speaks of the island she once knew, Cuba, which is itself isolated economically and politically. The viewer is immediately touched by a sense of both resilience and decay, stillness and change. The enormity of Mendieta's message contrasts with the deceptive simplicity of the work's abstract style.

Style: From Naturalism to Abstraction

All art is, to some extent, abstract. There is no way to reproduce every detail of the natural world in a work of art. Even artists who are trying to create ultra-naturalistic work from a real-life model must choose to omit some aspects of what they see. Artists who work in two dimensions must decide where to "cut" the scene—where the edges of their work will be. Sculptors must decide whether or not to include background imagery, or whether the objects they sculpt will stand alone. Either way, they must leave something out!

Consider the four images below. The photograph at the far left is the most naturalistic, because it most closely reflects the observable, natural world. However, the photo is certainly not the same as reality. It is two dimensional; unlike your vision, it is cut off at the top, bottom, left, and right sides, at right angles; it has no sense of air, wind, heat, sound, etc. The photographer chose to make the tree in the foreground a **focal point,** just off-center, to hold the viewer's attention. The telephone pole in the distance has been included, and not cropped out, so that the viewer's eye can jump from one dark, vertical shape to another.

The second picture has been further abstracted to make all the shapes more regular and predictable in appearance. The direction of the phone lines in the background has been "cheated," so that the new diagonal line might play with the other lines of the composition in a more interesting way.

The third picture is very abstract. The shapes have been further regulated, with an emphasis on sharp, geometric lines that contrast with the softness of the subject-matter. Colors have been further simplified, and color substitutions have been made, so that the eye now jumps from the "river" of white in the foreground to the white sky in back. Although the viewer might still recognize the objects (tree, lawn, hills in the background, perhaps?), we have moved quite a bit away from what the eye naturally sees.

The **non-objective** image at far right no longer shows recognizable objects—just colors and shapes that cannot be identified by name (tree, roof, etc.). A viewer might see an object here, the way that you might see a "picture" in the clouds, but it would require a stretch of the viewer's imagination—and the viewer might just as easily envision a person here, as a tree. The art is not trying to suggest anything in nature; it is not in any way naturalistic.

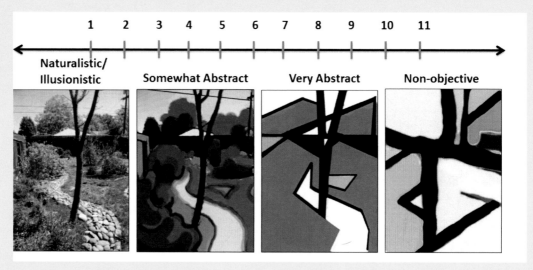

BIG EYES, VAST VISION

Abstract distortions, including using non-natural **proportions** in the human figure, suggest supernatural capabilities. This use of abstraction is often found in depictions of religious figures and political leaders claiming divine influence. Note the use of larger-than-life eyes, compared with the rest of the face, in the works of art shown here and on the next page. Although they were created at different times, by different cultures, the use of proportionally-oversized eyes is remarkably similar. This use of disproportion hints at a vision beyond the natural—the ability to see more deeply than others, or communicate with the supernatural (with gods, the dead, and so forth).

Sumerian votive statue (detail), from Eshnunna (Tell As-mar, Iraq), c. 2700 BCE. Metropolitan Museum, NY. About 8" high.
The statue (left) would have been placed in the temple at the top of a ziggurat (a mountain-like tower for worship, found in the ancient Near East). Sumerians believed that the votive was invested with the power to "transmit" prayers to the gods on behalf of worshippers.

BIG HEAD = POWER BEYOND THE PHYSICAL

Not only are the eyes of the *oba* (king) oversized in this Benin plaque from Nigeria—his head is also abstractly oversized, compared with the rest of his body.

This abstracted use of proportion suggests that the *oba*'s power extends beyond the mere physical. He is not just a great warrior; he is the spiritual commander-in-chief, whose authority comes from his divine lineage rather than his muscles. The Benin people believed that their rulers were descendants of the first man Odudua, the son of the sky god Olorun.* Because of the oba's importance, he is also presented in a larger **scale** than the lesser figures around him.

*The belief of Benin are continued by the Yoruba peoples today. The Yoruba believe that one's soul—invested with the spirits of powerful ancestors—enters and exits through the head. This belief also explains the disproportionate emphasis on the obas's head.

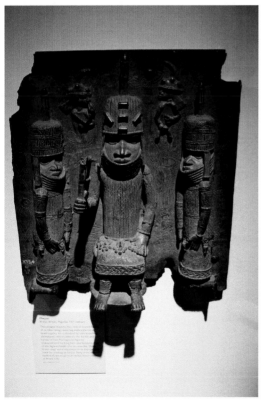

Plaque with Oba and Attendants, brass, 16th century, Benin culture. British Museum.
This plaque is one of many stolen from the royal family when the British attacked and burned the oba's palace in 1897. Notice in whose museum collection it rests today!—a point of considerable controversy.

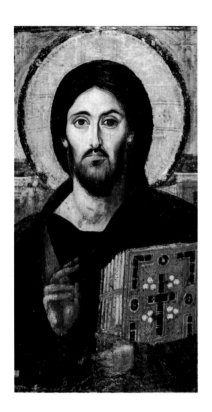

2. ABSTRACTION TO PLACE MIND OVER MATTER— EMPHASIZING GEOMETRIC SHAPES TO SUGGEST CLARITY, PURITY, RATIONALISM

Geometry is linked to mathematical precision, measurability, and predictability. When artists reduce the world around them into clean geometric shapes, the result often feels as precise and predictable as the geometric vocabulary used to create it. This approach to abstraction works well for artists who wish to convey a sense of order and clarity. We usually associate those characteristics with clear thinking—the exact opposite of raw emotion and gut reaction. We will look again at the vocabulary of geometric lines in Chapter 5.

Note the use of precise geometry in the sculpture below: the repeated circular shapes, right angles, parallel lines, squares and rectangles, and **symmetrical balance**. Altogether this emphasis on geometric forms* suggests perfect beauty and the assurance of overall well-being (physical, psychological, and social).

This is an *aku'aba,* a sculpted female figure meant to be carried by pregnant women—or those hoping to become pregnant—in the Akan culture of Ghana, to ensure a healthy and beautiful child. The following excerpt from the Metropolitan Museum in New York shows how the abstract features of the *aku'aba* are both practical and symbolic:

> The flat, disklike head is a strongly exaggerated convention of the Akan ideal of beauty: a high, oval forehead, slightly flattened in actual practice by gentle modeling of an infant's soft cranial bones. The flattened shape of the sculpture also serves a practical purpose, since women carry the figures against their backs wrapped in their skirt, evoking the manner that infants are carried. The rings on the figure's neck are a standard convention for rolls of fat, a sign of beauty, health, and prosperity in Akan culture.

> —https://metropolitanmuseum.org/toah/ho/11/sfg/ho_1979.206.75.htm

The Akan culture is matrilineal—Akan people trace their lineage through their mothers. For this reason, the *aku'aba* is female, rather than male, as prospective mothers hope for a baby girl to continue their family line. Through its abstraction, the *aku'aba* figure suggests more than a

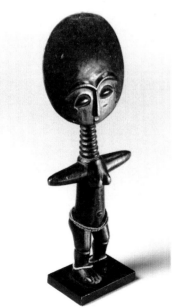

Top: Byzantine icon, Christ Pantocrator (Christ as Judge), Monastery of St. Catherine, Sinai, Egypt. 500s CE. Encaustic.

The eyes here feature a trait shared by other Medieval works of art. Notice that one eye looks at the viewer, while the other looks beyond. This visual device would have reinforced the Byzantine belief that Christ would act as intercessor between the worshiper and Christ's father/God.

Aku'aba figure, Akan culture, 20th c. Wood, glass beads. 10 3/4" high. Brooklyn Museum.

*As noted in Chapter 2, **shapes** refer to the dimensions of a two-dimensional thing (such as a triangle). **Forms** refer to the dimensions (including volume) of a three-dimensional thing (such as a pyramid).

hoped-for child—it represents the woman the girl will grow up to become, who will ideally have healthy, beautiful children of her own.

Malevich's *Woodcutter* exemplifies the use of geometric abstraction to communicate the idea of order, purity, and dependability. The Russian artist believed in the strength and moral clarity of the peasant worker, and was a supporter of the Bolshevik Revolution (the 1917 revolution in Russia that ushered in the Soviet era).

In the early 1900s, there were movements in industrialized nations (from the United States to Nazi Germany and the Soviet Union) to champion the laborer—both in the factory and in the field. Social movements were aimed at improving factory working conditions to provide not only a healthy physical environment, but also a stimulating mental environment for blue-collar workers. The worker was heralded as the backbone of the country; therefore, maintaining worker cleanliness—of both mind and body—was a recurring theme.

In Malevich's Russia, rural laborers were especially lauded because they were considered to be closer to the land, simpler and purer of heart, and less susceptible to the corrupting influences of the materialistic city. In Communist Russia, the proletariat was celebrated as the rightful inheritors of the authority once held by the aristocracy (of which the executed tsar and his family were members). This point of view is reflected in Malevich's painting. The woodcutter gives no impression of being gritty, grizzly, or otherwise "backwoodsy." Clarity of purpose is evident in the clarity of geometry; the morality of his motives is inscribed in the clean, cylindrical forms that make the worker and his environment one, unified entity. The woodcutter does not appear as an individual man, but rather as a symbol of a pristine idea, evoked by the geometric form. Labor itself is the real subject here—and through geometric abstraction, Malevich presents labor as an essential, unassailable good.*

*Malevich's abstract style did not become the official art form of the Soviet Union, however. Abstraction is *not* the style of art to use, if you want to *tell* people what to think. By its very nature, abstraction allows the viewer the freedom to bring his or her own thoughts and interpretations to the artwork. This kind of flexible, open-ended communication is generally not favored by authoritarian governments! For this reason, the Soviet government preferred the kind of naturalistic, didactic art that Hitler also favored. We will look at this art in detail in Ch. 8.

Kasimir Malevich, *The Woodcutter*, 1912, oil on canvas, 37 x 28 1/8 in. (94 x 71.5 cm), Stedelijk Museum, Amsterdam.

3. ABSTRACTION TO CREATE EMOTIONAL IMPACT

Often the nature of abstraction leaves aspects of a work of art open to interpretation, inviting (or demanding) that the viewer "complete" the image. By engaging the viewer in this way, abstraction can often carry a deeper emotional impact than the naturalistic alternative, in which the viewer would be given a maximum amount of detail, and so get all the answers, right away. The viewer's imagination is a powerful tool, which is automatically engaged when an artist suggests or alludes to a visual impression, rather than *tell* the viewer explicitly what he or she is supposed to see. Abstraction can signal anxiety, despair, ecstasy or exhilaration—through the use of rough, expressive mark-making, and/or the use of symbolically-distorted forms.

One of the most famous abstract paintings to engage viewers' emotions is Norwegian artist Edvard Munch's *The Scream*, a work which features both expressive, gestural marks and symbolic distortion. Following is a description from the Smithsonian Magazine article, "Edvard Munch: Beyond *The Scream*" (March 2006):

> … Munch defined how we see our own age—wracked with anxiety and uncertainty. His painting of a sexless, twisted, fetal-faced creature, with mouth and eyes open wide in a shriek of horror, re-created a vision that had seized him as he walked one evening in his youth with two friends at sunset. As he later described it, the "air turned to blood" and the "faces of my comrades became a garish yellow-white." [Art historians have speculated that Munch was witnessing the light effects of the 1883 Krakatoa volcano.*] Vibrating in his ears he heard "a huge endless scream course through nature." He made two oil paintings, two pastels and numerous prints of the image; the two paintings belong to Oslo's National Gallery and to the Munch Museum, also in Oslo.

> —Arthur Lubow, Smithsonian Magazine, http://www.smithsonianmag.com/arts-culture/munch.html

The loose, sketchy brushwork gives viewers just an impression of sky and seascape; the two heave together toward the disconsolate person in the foreground. In this wraithlike figure, we see again an emphasis on the eyes, out of proportion to the rest of the head—as well as a head disproportionate to the rest of the body. As noted earlier, these distortions suggest an uncanny or supernatural vision. The whispery suggestion of the figures behind are ambiguous—their lack of detail triggers in the viewer a sense of unease and uncertainty (are they coming or going? Are they oblivious to the suffering of the foreground figure? Are they even real?).

The simplified features of the horrified face suggest a petrified mummy, corpse, or mask—symbols that may trigger different memories and emotional responses, depending on what experiences the viewer brings to the table. (Note that the Smithsonian reviewer Arthur Lubow perceived the face to be fetus-like, a perception that triggers thoughts of the womb, fragility or vulnerability, childbirth, etc.). The flipper-like hands framing the face draw out the scream, amplifying the reverberation that resonates through the body. The abstraction does not permit the viewer any safe or comfortable distance; we are forced to "fill in the blanks" ourselves, and thus are drawn into this drama. We are not merely witnessing a screaming person; rather, we are empathetically experiencing a psychological scream—an outpouring of panicked emotion communicated directly to our gut instincts, via the abstract form.

Munch belonged to a European artistic movement of the late 1800s known as **Symbolism.** Symbolists were responding, in part, to the uncertainty of their time; the new century was coming, and some feared that the modern, industrial world (already well underway) was taking civilization terribly off-course. Society seemed more "advanced," but was that just an illusion? Sigmund Freud had introduced the new field of psychoanalysis, which suggested that there were dark and unknown places in the human mind that even Edison's electric light could not illuminate! Symbolist art aimed at shining a light where "realistic" art could not peer, using symbolic rather than literal imagery to unveil a deeper, psychological reality.

*See "Stratospheric echo locates Munch's Scream" by Tim Radford, the Guardian (UK), 12/10/03 (http://www.guardian.co.uk/world/2003/dec/10/science.highereducation).

Opposite page: Edvard Munch, *The Scream*, 1893. Oil, tempera, and pastel on cardboard. 91 x 73.5 cm. National Gallery, Oslo.

German Expressionism

The Symbolists of the late 1800s had considerable impact on the German **Expressionists,** the next generation of European artists looking to the "inner world," the subconscious, for inspiration and understanding. German artist Franz Marc exemplifies the Expressionist movement. His painting *The Yellow Cow* celebrates the joy and freedom of the countryside. As in the Symbolist work of the previous century, symbolic imagery appears here; Marc often painted animals—horses, cats, deer—in their natural state, symbolizing innocence and the purity of nature. The bright yellow of the cow signals exuberance and energy, as it leaps and stretches in a swooping arc. Black tree trunks emerge from the background like great exclamation marks. The viewer can't help but feel more alive and liberated, when looking at this painting. Marc never intended the work as a literal depiction of a cow on a hillside; rather, the work is an expression of unadulterated, unfettered emotion, evoked through exuberant colors and exaggerated forms.

Marc's optimism about the world's prospects dimmed as the start of World War I approached. The darker work on the following page reflects his grim concern about humanity's defectiveness—that the world was so corrupted, that even animals are now capable of savage cruelty. The space is shattered in shards of color; the

Franz Marc, *The Yellow Cow*, 1911. Oil on Canvas. Guggenheim Museum, NY.

animals rear up, attacking each other and howling in dismay. The trajectory of Marc's Expressionism—from expressions of innocence to expressions of horror—mirrors that of many German Expressionists who enlisted in WWI. In *The Fate of Animals*, Marc created a powerful prologue for a future that the artist himself never lived to see. Marc was killed in action in 1916.

Franz Marc, *The Fate of Animals*, 1913. Oil on canvas, Kunstmuseum, Basil. The right side of the painting shows fire damage, which occurred when the painting was in wartime storage.

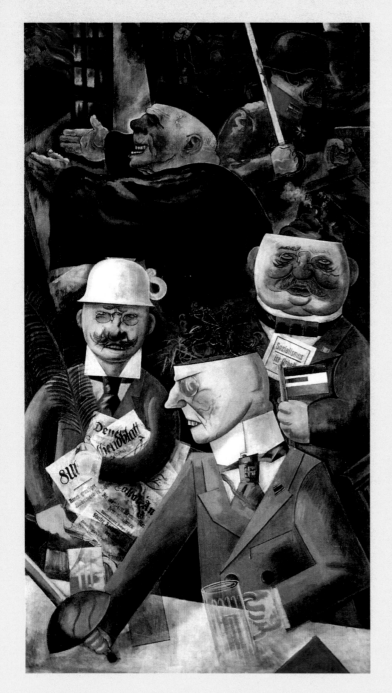

Spotlight: George Grosz

Wartime experiences can often inspire emotional, abstract art. German artists, reeling from horrors experienced first-hand in World War I, used abstraction to convey the intensity of their nightmarish recollections, and their adamant anti-war sentiment. George Grosz, born in 1893, was one of the many German artists of his generation to enthusiastically join the military at the start of the war. In his post-war paintings, Grosz's traumatic experiences and subsequent disillusionment with German society took powerful abstract form.

In *Pillars of Society*, Grosz depicts the supposedly upstanding members of "decent" society as charlatans, hypocrites, know-nothings and hate mongers. At the top of the scene, a building burns as soldiers storm through a city; a priest appears to bless the flames. At his shoulder, a frumpy, flag-waving patriot has a head filled with steaming excrement; next to him, a newspaper publisher wears a teacup on his head, and carries an armful of hollow propaganda. In the foreground, a scowling, sword-wielding Nazi official carries schemes of conquest in his gaping head. Note that Grosz created this abstract, monstrous montage in the 1920s, before the Nazis had seized power. However, Grosz was a keen observer of German society, and correctly predicted that civic leaders and "upstanding citizens" would ultimately fall in line with totalitarianism, like lemmings off a cliff. Grosz left Germany for good in 1933, the year its "pillars of society" elected Hitler as chancellor.

George Grosz, *Pillars of Society*, 1926. Oil on canvas, 200 x 108 cm. Staatliche Mu-seen zu Berlin - Preussischer Kulturbesitz, Nationalgalerie, Berlin, Germany.

Although not a soldier, German Expressionist Käthe Kollwitz experienced first-hand the cost of war. Her son was killed in WWI; her grandson was killed in WWII, fighting at the Russian front. Rather than focus on the toll of war on the battlefield, however, Kollwitz turned her artistic attention to the suffering of mothers and children back home. Kollwitz witnessed how poor women and their children seemed to bear the brunt of social crises, from the global economic Depression to the wars that wracked Europe between 1914 and 1945 (see timeline). Bereft of financial and emotional support, these women (many of them widows from one war or another) sought desperately to provide for their children, and feared the specter of homelessness and starvation.

These fears take visual form in a number of works by Kollwitz. In a 1934 series which she called, simply, "Death," the skeletal figure of Death wrestles with a mother figure, threatening to take her, or her child, away. In this earlier work, Kollwitz documents the aching loss of a child in potent, simple abstraction. The mother's powerful arms grasp the dead child tightly, her large hand emphasized around the child's shoulder. The stark, blue background isolates the scene, freezing the moment into a timeless *memento mori*. Kollwitz's abstraction here pulls no punches; it is a gripping device to confront the viewer with society's hidden casualties.

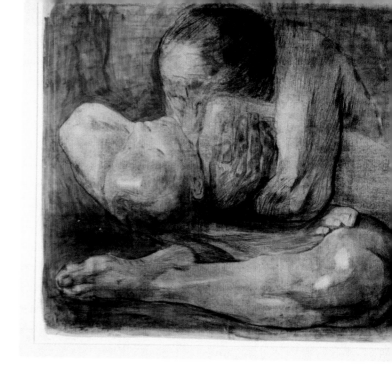

Käthe Kollwitz (German, 1867-1945), *Mother and Dead Child*, 1903. Yale University Art Gallery.

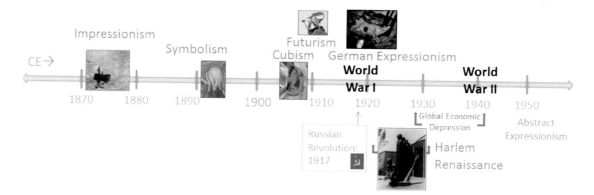

Timeline of modern abstraction, 1870-1950. Artistic movements originating in Europe are noted above the line, in orange; American art movements are noted below the line. Note that this timeline is not comprehensive; it is simply for your reference, as you read the chapter.

EMOTION, ABSTRACTION, AND PICASSO'S USE OF AFRICAN ART

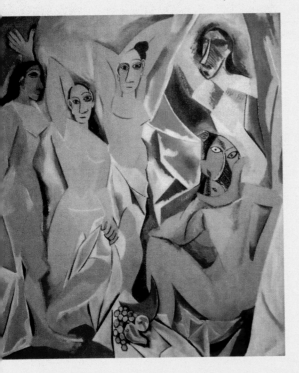

We discussed the traditional Western view of African art at the end of Chapter 1. Since we are presently considering the use of abstraction to communicate emotion, we should set aside a moment to look at one of the most pivotal works of Western abstraction, and examine its "borrowings" from African art.

Picasso finished painting *Ladies of Avignon* in 1907. His earlier studies for the painting suggest that he made a radical revision of the composition after having visited the display of African art at the Ethnographic Museum at the Trocadero in Paris. The painting originally showed two "Johns" visiting a group of prostitutes in a brothel (Avignon had a notorious red-light district). In the final version, shown here, the men are gone; the women now turn towards the viewer. Rather than appearing seductive and approachable, however, the women are rather scary, rendered in a **Cubist** style. Their body parts are flat and sharp, rather than soft and rounded. Here geometry is not clean and simplified, to suggest purity and strength. On the contrary, the ladies' geometry is rough, jagged, and irregular. Their gazes are cold. In a stand-off with these almost monstrous sexual creatures, the viewer is forced to confront a danger that is uncontrollable and forbidden.*

Picasso chose to give these women mask-like faces, borrowing from the kind of abstract forms he saw in African art at the museum. Misunderstanding the meaning of these works to their respective cultures, Picasso saw them as weird, scary, exciting and "primitive"— perfect for his psychologically-troubling prostitutes.

Pablo Picasso, *Les Demoiselles d'Avignon* (*The Ladies of Avignon*), 1907. Oil on canvas, 8' x 7' 8, Museum of Modern Art, New York.

*Keep in mind that Picasso is talking to a predominately male audience, 100 years ago. He is not thinking about the female viewer of today, who might justly ask "Are women really as scary as all that?" Critic Carol Duncan examined these questions in her famous 1989 essay, "The MoMA's [Museum of Modern Art's] Hot Mamas"

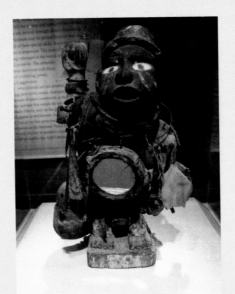

Power Figure (Nkisi), 19th-20th century, Kongo peoples; Democratic Republic of Congo. Wood, glass, iron, pigment, cloth, plant fiber, horn, nails. Smithsonian Museum of African Art, Washington, DC. Photo by the author.

We will return to the nkisi figure at the end of the next chapter.

In the following quote, Picasso expresses the emotion he felt upon seeing the African art in Paris. He projects his own fears onto the masks, and assumes (wrongly) that the artwork was created to face down and ultimately triumph over evil, supernatural forces. The feeling of having vanquished the "dark side" is the very emotion he wishes to impart to the viewer, with his intense *Ladies*:

> When I went to the Trocadero it was disgusting ... The smell. I was all alone. I wanted to get away. But I didn't leave. I stayed. I stayed. The masks ... were magical things. ... The Negroes' sculptures were intercessors... [a]gainst everything; against unknown, threatening spirits. I kept looking at the fetishes. I understood: I too am against everything. I too think that everything is unknown, is the enemy!. ... [A]ll the fetishes were used for the same thing. They were weapons. To help people stop being dominated by spirits, to become independent. ... If we give form to the spirits, we become independent of them. ... All alone in that awful museum ... *Les Demoiselles D'Avignon* must have come to me that day, but not at all because of the forms: but because it was my first canvas of exorcism—yes, absolutely!*

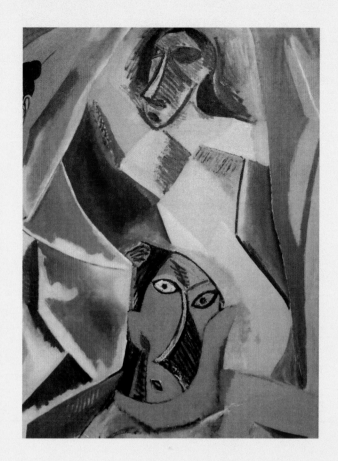

Contrary to Picasso's beliefs, African artists traditionally create work to ensure a strong connection between the natural and supernatural worlds. For example, the *Nkisi* figure on the previous page was created to call upon the spirits to act as witnesses, when members of a Kongo village made an agreement. These spirits were believed to ensure that the agreement was honorably kept. This work, like the *Aku'aba* figure discussed earlier in this chapter, is abstract in order to communicate "big ideas" which are generally positive, such as protection, responsibility, beauty, and strength. Yet, to Picasso and other European modernists, these same works spoke of dark, unpredictable forces and feelings.

Beyond their abstraction, the manner in which these African works were displayed certainly heightened Picasso's emotional reaction. Stuffed randomly together in dark rooms with no regard to culture of origin, and wholly divorced from their original mode of display (worn as part of a costume, carried, etc.), they would have appeared oppressive and mysterious indeed—curious trophies from a far-away land.

*Jack Flam, *Matisse and Picasso: The Story of Their Rivalry and Friendship*, 2003, p. 34.

African Abstract Art, in Context: The *Chi Wara*

The **Chi wara** headdress reflects the role of abstract art in many traditional African cultures. In the following excerpt, note how the artwork is intertwined with the environment, dance, and music, to address community concerns. In stark contrast to Picasso's view of African sculpture, this art plays a positive spiritual role in Bamana society:

> Chi wara is a mythical being that taught the Bamana people of south-central Mali [in West Africa] how to farm. Bamana people represent Chi wara with a headdress of intricately carved wood that combines the horns of a large antelope, the body of an aardvark and the textured skin of the pangolin—all animals that dig up the earth. In performances held in the fields, dancers wearing the headdress and long raffia costumes imitate the movements of the antelope, tossing their heads and scratching at the earth with a stick in each hand. ...
>
> The *chi wara* historically recognizes the importance of both men's and women's contributions to farming. It praises the virtues of hard working farmers and promotes the productivity of their land and labor. Though performed by men, *chi wara* can take both male and female forms and are danced in pairs, demonstrating the importance of co-operation and harmony between women and men in farming, as well as to produce a new generation.
>
> —http://www.agra-alliance.org/section/people/farming_culture

Pictured here is a male *chi wara* figure, which would be worn on the head of the Bamana performer and danced with an accompanying female figure (note the baby *chi wara* behind the mother in the illustration). This dance presents the joining of men and women as a metaphor for the productivity of the earth, and the nurturing of healthy crops. The performance also speaks of the roles and responsibilities of men and women in the community—roles that continue to change in the modern era.

Male Chi wara figure, Bamana culture, Mali. Carved wood with nailed metal and thread decoration. 16 3/4 × 7 in. Collection of the author.

4. Abstraction to create a SENSE of MOTION

This painting was created by Umberto Boccioni, a member of the Italian **Futurist** group, which we have already met. The Futurist interest in speed is reflected here in the use of abstraction: the repetition of shapes creates a sense of **motion blur.** This effect is shown in a photo of kittens, who are notorious for not sitting still.

The blurring and repetition visible in the photo is caused by the camera shutter speed. The naked eye also observes this phenomenon—for example, when one looks at a quickly-turning fan blade. In Boccioni's painting, the "stuttering" of shapes similarly suggests energy and movement. The breaking of space into geometric shards, as well as the use of collaged newspaper, is borrowed from Picasso's Cubist innovations. Unlike the irregular Cubistic shapes in Picasso's *Ladies of Avignon*, however, Boccioni chose to repeat his lines and curves with an emphatic, staccato rhythm. Remember that the Futurists despised sentimentality, nostalgia, and the softer emotions. The repetition of geometric shapes not only speaks of incessant movement, but also machine-like *precision* in motion. The lancers—men on horseback wielding the lance, a weapon of war—run like pistons in an engine, unstoppably relentless, an inevitably-victorious force.

On the other side of the political spectrum, Russian artist Natalia Goncharova used a Cubistic style in her painting to show the industriousness of the worker on his way to the factory. Painting in the years leading up the Russian Revolution, Goncharova presents a bicyclist passing shop windows, advertising luxury items that the man himself might make at his factory—but that he may not be able to afford to buy for himself. Like her countryman, Kasemir Malevich, Goncharova is celebrating through abstraction the humble labor of the common man—yet in a more dynamic, energized form.

Top: Umberto Boccioni, *The Lancers*, c. 1913. Tempera and collage on paste-board, 32 x 50 cm, Ricardo and Magda Jucker Collection, Milan.

Middle right: Natalia Goncharova, *The Cyclist*, 1913. Oil on Canvas. The Russian Museum, St. Petersburg.

Bottom: Two kittens, one in motion (showing motion blur). Photo by the author.

Claude Monet, Impression:
Sunrise, 1873. Oil on canvas.
Musée Marmottan, Paris.

5. Abstraction to create a SENSE of ATMOSPHERE

Left: Venice, Italy, in November, 1992. Photo by the author.

Right: Claude Monet, *Palazzo da Mula, Venice*, 1908. Oil on canvas. National Gallery of Art, Washington, DC.

The city of Venice shimmers with light—reflecting off the myriad canals, and splintering through the warm, misty air. In winter, the mist rising off the waterways creates an ethereal effect; sound bounces unpredictably through the fog, and water and air share hues of silvery grey. Although one could take a color photo of Venice to capture the visual facts of the environment, it will not fully impart a sense of atmosphere—the physical sensations of air, and the fluctuations of temperature, light and water. This is where abstraction can be especially effective. By using little touches of color, the French artist Monet activates the entire surface of *Palazzo da Mula*, creating a sense of pulsating light and shimmering water. Contrast the thousands of flitting brushstrokes in Monet's painting with the crisp details of the photo. Although the photo clearly shows fog over a Venice canal, the viewer must infer the quality of air, and the reverberations of sound and light. There is a trade-off: the photo provides literal, specific visual information, but the moment is frozen in time. The painting sacrifices some specific details for an overall impression of atmosphere: light, air and water that is alive, in constant motion.

The style of Monet's painting is called Impressionism, which we first encountered with Cassatt's painting of the little girl in the previous chapter. By 1908, when this *Palazzo da Mula* was painted, Impressionism had become a more-accepted stylistic movement. In contrast, when Monet painted *Impression: Sunrise* in 1873, the reception in France was very negative. Critics took the lack of detail as an insult—as though Monet was trying to pass off a mere sketch as a "finished" work. Indeed, the work appears very "sketchy," lacking the layered details of a traditional oil painting. However, a painting that appears "finished" also tends to look "locked in;" it may not have the living presence, the sense of movement and unpredictability, as well as the sense of air and light, that a loosely-painted work can convey.

Jacob Lawrence, *Migration
of the Negro Series*, Panel 1,
"During World War I, there
was a great migration
North by Southern African
Americans," 1940. Casein
tempera on hard-board,
12 x 18 in.
The Phillips Collection,
Washington, DC.

3: APPROACHES TO ABSTRACTION

6. ABSTRACTION TO CREATE A VISUAL PATTERN AND BEAT

The human brain is an incredibly sophisticated instrument. Your eye can discern the most subtle of visual differences. It is a talent you probably take for granted, but in the early days of humanity, the ability to differentiate minute visual cues was a matter of life and death. Imagine if the plant with the yellow flowers and five petals was delicious and nourishing, but the plant with the golden flowers and four petals was deadly. Humans without the ability to discern the difference would be more likely to die young; humans possessing that ability would be more likely to survive and reproduce offspring, who would be more likely in turn inherit that same aptitude.

Today, our discerning eyes are sensitive to variations of pattern, just like our earliest ancestors. As children, we play games that reward our ability to group objects according to shape and color, connect the dots, find Waldo, etc. As adults we tend to set those games aside, but the right brain still wants to play! It is this talent, after all, that got us humans where we are today. The right brain delights in pattern as well as exercises of pattern recognition. We enjoy artwork in part because it satisfies this desire. All artwork, whether naturalistic or abstract, relies on pattern to some extent to engage the viewer. As we observed in the previous chapter, when abstraction is used to emphasize pattern, the result can be especially engaging, and visually satisfying, for the viewer.

The "Migration of the Negro" series by **Harlem Renaissance** artist Jacob Lawrence shows the **Great Migration,** the movement of African-Americans from the rural, post-Civil War South to the industrial North, and the opportunities, obstacles, and discrimination they encountered. In *Panel 1*, note the repetition of shapes and colors that leads the eye on a pulsating journey around the painting. Lawrence reduces the color **palette** here to variations on the three primary colors—red, blue, and yellow. The abstraction focuses the viewer's attention, and guarantees the maximum impact of the visual "beat" created by alternating pattern. This patterned beat reflects the subject of the work, as the figures move as a bustling, rhythmic tide toward the train platforms, headed for jobs and educational opportunities in northern cities like Chicago, New York, and St. Louis.

COLLAGE AND ABSTRACTION

Early in the 1900s, artists began to make **collages,** mixing pictures from magazines and other commercial media (newspapers, wallpaper, etc.); pieces of photo; and text. We are used to seeing collages everywhere today, but a hundred years ago, they were a new and radical way to put together visual symbols from various sources, creating new and unexpected meanings through the juxtapositions.

Hannah Hoch, an experimental artist in early twentieth-century Germany, created many collages as a member of the **Dada** group—linked to the Expressionists because of their shared interest in the irrational and the subconscious. The Dada artists were also politically and philosophically opposed to the Futurist point of view. They cautioned that machines might not be the instruments of convenience and positive change that they appear to be. The Dada artists abhorred the First World War and the random destruction it brought; they argued that if reasonable people could bring about such chaos, then the only logical path would be to embrace the illogical, fantastical, and absurd.

In the abstract world Hoch collaged here, consider how the seemingly disconnected images create an intriguing puzzle—just what makes a "beautiful girl"? The refinement of a BMW, the eyes of a doll? A pretty head of hair? Which is the real "brain" of the woman, the comic book clipping (maybe suggesting the expectations of popular culture) or the light bulb (suggesting original thoughts and ideas)? Is she strong or fragile? Does she take her time—or is her time running out? The abstraction of this collage opens the doors to various interpretations. The repetition of symbolic images creates a vivid pattern that intrigues the eye as well as the imagination. This repetition of conceptually-linked motifs—images that relate to the same idea or concept—also helps to create **unity** out of a seemingly jumbled, abstract space. We will discuss the ways that artists can create "order out of chaos" in the next section of this chapter.

COLLAGE, UNITY AND VARIETY

The Parallel of Poetry

Consider the structure of language. The rules of grammar act as the steel construction girders of language—they create the framework, unifying the language into comprehensible sentences. The following sentence follows faithfully the rules of language construction:

> *I walked down the road on a hot day, and looked up at a big, blue sky.*

Although structurally correct and sensible, the sentence is not poetic. In other words, it is not art. To create art with words, one needs to add **variety**—to disrupt the structure in unexpected ways, and take the reader beyond the mere facts of the sentence. The difference between a factual sentence and a line of poetry is that poetry opens a doorway for the imagination; poetry creates an opportunity to move the reader beyond his or her immediate concerns and experiences. Art, at its best, is transformative—it takes us beyond the obvious.

Hannah Hoch, *The Beautiful Girl*, 1919-20, Photomontage, 13 3/4 × 11 1/2 in, private collection.

*Neruda, Pablo, *Selected Odes of Pablo Neruda*, trans. Margaret Sayers Peden, Berkeley: University of California Press, 282-286.

Iba
por el camino
crepitante
el sol se desgranaba
como maíz ardiendo
y era
la tierra
calurosa
un infinito círculo
con cielo arriba
azul, deshabitado.

I was walking
down
a sizzling road:
the sun popped like
a field of blazing maize,
the
earth
was hot,
an infinite circle
with an empty
blue sky overhead.

—from "Ode to Bicycles" by Pablo Neruda*

Frederic Chopin, opening from an etude, Op. 25 no. 5.

Jazz musician Wynton Marsalis at the Oskar Schindler Performing Arts Center (OSPAC) Seventh Annual Jazz Festival in West Orange, NJ. Photo by Eric Delmar.

Notice how Neruda takes the reader beyond the literal image of a person walking on a hot road, to imagine the potency of the sun, and the potential magnitude of this small moment. This is achieved by playing within a structure: creating pauses in unexpected places (breaking up sentences by putting each word or phrase on a separate line); introducing unexpected imagery (*maíz ardiendo*, *un infinito círculo*); and adding alliteration and other forms of sound-repetition (*y era/la tierra*). Altogether, these devices impart both a **unity** that is structurally-sound, and a **variety** that is intriguingly dynamic.

The Parallel of Music

Music is often compared with the visual arts, because of the parallel challenges of musical and visual composition. Just as musicians must decide how to arrange notes in a musical score, so visual artists must arrange line, color, light, etc. in a work of art.

Musicians must also balance unity and variety. In music, the **structure** (including time and key) provides unity. For example, in this piece by Chopin, the 3/4 time ensures a structured, predictable beat. Playing a song in a particular key (such as Chopin's choice of E minor) also ensures a harmonious, unified sound throughout the piece.

Playing the scales is not the same as "making music." To make music, the musician must introduce variety. When a musician creates variety within the structure of the music, he or she is **improvising.** Music, then, occurs in the give-and-take between **structure** and **improvisation** (or "improv").

Jazz musicians are masters at improvisation. Expert jazz players like Wynton Marsalis push the limits of structure, maintaining just enough unity to ensure a coherent piece of music, while introducing a variety of notes with varied instrumental sounds, rhythms, and textures.

The best artists in *every* creative field walk the wavering tightrope between structure and improv, between unity and variety. From chefs and hairstylists to fashion designers and theater-set makers, from automakers to aeronautical engineers, every creative person tries to find the perfect alchemy of control and daring, order and chaos.

As a newer form of music, DJing (including mixing and scratching) has shared with collage the status of a once-marginalized, "outsider" art form. Also like the collage artist, the DJ can choose from an almost unlimited supply of materials, sampling pieces of music from just about any record ever pressed.

In these collaged forms (both visual and musical), variety comes standard. That is, the vast range of materials available to the artist guarantees a relatively high level of variety, even before the work is begun. For these artists and musicians, the challenge lies less in finding variety, and more in maintaining a sense of structure which will hold together the many variables of the piece. In scratching, unity/structure is provided by the beats of the sampled music, the timing of the breaks, and the timing of the scratching sound itself (created by quickly reversing the direction of the record, spinning on the turntable, by hand). DJs also rely on repetition to help create a sense of unifying pattern. In the next section, we will look at the how this balance of unity and variety is achieved in collage.

ROMARE BEARDEN: UNITY AND VARIETY IN COLLAGE

Collage as a Metaphor for Memory

To examine how unity is created in a work of visual art, we will look at the collage work of Romare Bearden. Born in Charlotte, North Carolina in 1911, Bearden and his family joined the Great Migration that brought many Southern-born African-Americans to the North. Bearden's family moved to Harlem, New York, where Romare found himself in the middle of a surging **Harlem Renaissance**—a burgeoning scene of art, music, literature and philosophy in the early 20th century.

Bearden's *Early Morning* features a varied, complex composition. This goes hand-in-hand with the varied nature of collage, with its use of different materials and textures. The choice of collage in turn mirrors the

conceptual complexity of Bearden's work. Just as the collage medium demands that the artist piece together disparate materials, so Bearden conceptually pieces together complexly-interconnected issues related to the African-American experience. Indeed, collage is the perfect medium to convey Bearden's ideas: it represents the drive to create order out of chaos; to piece together a scattered past; and to bring together a displaced community.

For his collages, Bearden cut out photos reproduced in popular magazines, such as "Life" and "Ebony," reflecting modern American life in general, and also interests specifically related to African-American popular culture. He also used pictures of masks from different African regions and cultures, piecing together bits of these different masks with African-American faces. This mixing of different African and African-American visual sources suggests the mixing of African peoples when they were brought as slaves to the New World, as well as the continued mixing and displacement of African-American people, from the Civil War through the Great Migration. The different materials—fabric, wallpaper, construction paper, magazines, newsprint, etc.— also reflect the varied social and economic backgrounds of Bearden and members of his Harlem community.

To convey these far-reaching and complex ideas, Bearden employs the abstract style. Abstraction and collage are natural allies; piecing together materials often invites the kind of simplification and exaggeration which—as we have discussed earlier in this chapter—may amplify the conveyance of abstract ideas, geometric purity, or emotional impact.

Collage is especially powerful in conveying the concept of memory. Thinking back to his childhood in the South, Bearden used the splintered pieces of collage to symbolize the nature of memory—which is always incomplete, being pieced together from various sources (inevitably varying in reliability). Memory is also disproportioned—we sometimes remember very small things as being huge; some people loom larger than others in our minds, their "size" out of scale to our memory of others. Memory can put two distant places close together, or make things seem farther apart than they actually were. Memory is an abstract thing; it is never clearly laid before us, and never arranged in order, like a storybook with one chapter neatly following the next. Memory, like the abstract treatment of collaged forms, is filled with jump-cuts. For the viewer, these juxtapositions trigger the imagination—transporting us to the world of imagination and abstract thinking, beyond the literal. Collage is neither a scrapbook nor a storyboard; it is a rich web of visual signs that leads the viewer into a new and unexpected experience of what was, is, and might have been.

Romare Bearden, *Early Morning*, 1964. Collage on board. New Britain Museum of American Art, Connecticut.

Creating Unity with Implied Line

In the previous chapter, we examined a very specific kind of line, the orthogonal line found in linear perspective, leading the eye to a vanishing point. Here, we will explore the much broader usefulness of line, both real and implied, to create unity. A *real* line is literally a line you can see in a work of art, often appearing as an edge between shapes. Lines can be thin or thick, wavy or straight, moving through a work of art, and directing a viewer's eye as they go. An **implied line** is suggested but is not solid; the viewer's eye must "connect the dots" to complete it. As mentioned earlier, the human brain is a sophisticated pattern-recognition machine; for that reason, the eye can pick up very subtle visual cues that point to an implied line. Subconsciously, as we look around our world, we are connecting the dots all the time!

In the left diagram of Bearden's *Early Morning*, the short dashed lines emerging from the eye of the female figure in the background indicate the implied line of gaze. The longer dashed lines are implied lines of gesture. We are drawn, almost by instinct, to follow the gaze of someone in a picture: where she looks, we look. In this collage, the woman's gaze directs our attention back toward the foreground figure, ensuring that our attention does not wander too far. This helps maintain unity. Similarly, the raised cup and the angle of the fork are gestures that aim the viewer's eye back to the young man's head. Gazing out at the viewer, the young man becomes the **focal point**; we cannot help but return his gaze. Coupled with the use of gaze and gesture around him, *his* gaze helps to refocus the viewer's attention back to the center, again and again, even as the eye bounces around the varied patterns and textures of the whole composition.

Keep in mind that the viewer's eye does not scan a subject from top to bottom like a flatbed scanner. Rather, our eyes are constantly darting back and forth, up and down, and all over whenever we "take in" a scene. This is how our eyes pick up patterns. An artist can take advantage of how the viewer's eye works by using implied lines to "tie up" the composition into a single, unified whole. In addition to gaze and gesture, the artist can direct implied lines into an overall, unifying shape, such as a circle or triangle. The right diagram of *Early Morning* shows in dashed lines the use of concentric circles, which spiral outward from the central figure. This unifying shape acts almost like a washing machine on the spin cycle, creating a sort of visual centripetal force to keep the viewer's eye from scattering.

Interestingly, Romare Bearden helped found an artist's group called "Spiral," to suggest the members' desire to "move up and outward from a common goal."* His use of the spiral here might have been a coincidence—a product of a finely-tuned right brain, working subconsciously—or it might have been intentional.

For more on Bearden's life and art, be sure to visit the official Bearden Foundation web page at http://www.beardenfoundation.org/index2.shtml.

Even before the kitty's dots are able to draw those lines in your head. Your right brain lets you visualize the implied lines.

Left: Implied lines indicate direction of gaze and gesture.

Right: Implied lines creating unity with concentric circles.

*See the documentary film, "The Art of Romare Bearden," 2003, directed by Carroll Moore, and narrated by Danny Glover and Morgan Freeman.

iginal caption, Office for Emergency Management, Office of War Information. mestic Operations Branch. News Bureau. (06/13/1942-09/15/1945): Sgt. Romare arden, noted young Negro artist whose paintings have been exhibited in galleries and useums in several metropolitan centers ... is shown (right) discussing one of his intings, 'Cotton Workers,' with Pvt. Charles H. Alston, his first art teacher and cousin ... th Bearden and Alston are members of the 372nd Infantry Regiment stationed in ew York City.", c. 02/1944.

peated circular lines to create unity.

BEARDEN AND IDENTITY

In the Introduction, we examined a sculpture created by Augusta Savage for the New York World's Fair. Savage was an instrumental part of the Harlem Renaissance, and taught one of Bearden's contemporaries, Jacob Lawrence. Although almost 20 years younger than Savage, Bearden encountered many of the same social and economic pressures as she, including the inequities of racism and segregation. Note the original caption to this war-time publicity photo, identifying Bearden as a "noted young Negro artist." Bearden's African-American identity would be a factor in his artwork, regardless of whether Bearden himself wanted that identity to take precedence. As with all things related to culture, the perception of Bearden's identity shifted over time. In the 1960s, at the dawn of the new Civil Rights era, Bearden's collaged memories of the rural South and Harlem resonated with a new generation of viewers, seeking affirmation of their identity, history, and struggles.

Because of identity, there is often a double-standard that arises in discussing abstract art. Many speak of the rhythm in Bearden's work—and Bearden was certainly influenced by jazz and its rhythms. Yet few speak in the same terms about Picasso's rhythm, or Hannah Hoch's rhythm. These European artists were also influenced by jazz music. Indeed, all art possesses some kind of visual rhythm—it's a universal strategy to unify a composition. Yet African-American artists are more routinely praised for their "natural rhythm," which sours the compliment with a tired ethnic stereotype.

Let us take a moment to return to Hannah Hoch's *Beautiful Girl*. As we have already noted, Hoch unifies the composition *conceptually* by selecting images that are thematically related. The viewer is invited to try to figure out how all these items (BMW logos, light bulb, woman in a bathing suit, etc.) relate to the concept of the "beautiful girl." Note that this composition is also *visually* unified through a rhythmic repetition of circular shapes throughout. Some of the circles are readily apparent, such as the shape of the BMW sign. However, other circles are more subtle, created through implied line.

This extra layer of unity is necessary for such a complicated and abstract use of space. **Unity through repeated shape** ensures that the viewer stays engaged in the artwork. Essentially, the artist's job is to keep the viewer "in the action"—to make him or her *care enough to stick around and pay attention*. Artists may do this by appealing to the left brain—offering a naturalistic scene that "makes sense" on a literal level. However, the artwork must also be compelling on the compositional level, balancing unity and variety to engage the right brain. Let us examine another of Bearden's works to see this balance in action.

Bearden's *The Dove* reveals a sophisticated system of implied lines. At first glance the collage may appear as a convoluted and confusing composition. However, with extended study one finds a firm and persuasive underlying structure that effectively unifies this highly-varied image.

First, let us examine the grid of implied vertical and horizontal lines which run, like the girders of a building, beneath the surface of the image.

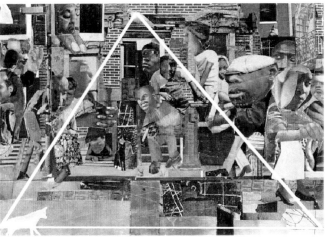

Note all the implied vertical lines. Keep in mind that the left and right edges of the work "count" as vertical lines; the edges are always part of a composition. Next, notice all the horizontal beams that further stabilize this grid. Though the street itself forms a strong horizontal, many implied horizontal lines run through the entire composition.

This grid of horizontal and vertical lines supplies the backbone of the composition, ensuring that the surface does not completely dissolve into chaos. On the contrary, this composition enjoys a rigorous sense of consistency throughout. You will find a grid running through many successful compositions—particularly those with great variety.

Finally, consider Bearden's use of the unifying, implied triangle. The underlying sketch in the bottom right-hand corner (see detail, below), left deliberately "unfinished," suggests the framework for this shape—as though Bearden had left a scrap of his "structural blueprints" behind.*

This triangle does more than just unify the collage visually; it also provides an important conceptual link, which is perhaps why Bearden left the "hint" in the corner. The other two corners of the triangle are occupied by a cat and a dove. The dove, symbol of peace and love, provides the title for this collage; its placement at the pinnacle of the composition, the culmination of the unifying triangle, suggests that—despite the hustle and bustle of this busy street—there is harmony here, above all.

Above: Implied vertical and horizontal lines creating unifying grid.

Left: Implied lines create a unifying triangle.

Romare Bearden, *The Dove*, 1964. Cut-and-pasted printed papers, gouache, pencil, and colored pencil on board, 13 3/8 × 18 3/4" (33.8 × 47.5 cm). Museum of Modern Art, New York.

*Having examined this work by Bearden, now go back once again to Hannah Hoch's *Beautiful Girl*. Can you find the overarching triangle shape, which subtly holds the entire composition together?

ROMARE BEARDEN AND ABSTRACT INFLUENCES

*We have already looked at the Benin palace plaques. Sculpted heads were placed on an altar to honor a deceased ruling ancestor, and to lend legitimacy to the current oba. There is usually a round hole at the top of the sculpture, into which would be inserted an elephant tusk, carved with scenes of valor from the king's rule.

In his development as a professional artist, Bearden studied a wide variety of artistic traditions. His influences included the traditional European art taught in American art academies, as well as traditional African art which had not yet received serious attention by Western art historians. Working with George Grosz, the German artist who fled to the United States in 1933, Bearden examined the work of European modernists such as Pablo Picasso (who was, as we have seen, himself influenced by African art).

In the only known self-portrait by Beardon, the artist stands next to his easel, as a model poses nearby. The collage was created late in the artist's life, as a reflection on his early painting career, and reveals the disparate artistic threads woven through the artist's practice. As we will see in Chapter 5, the nude model is a standard "fixture" in traditional artist studios; from the model, the artist makes sketches (seen in the foreground) that become the basis for his figural paintings. Next to the model drawings, on the same sheet of paper, we see a sketch of a Benin sculpture, such as this brass *oba* head.* The sculpture's abstract, geometric forms and patterned textures are reflected in Bearden's own use of geometry and pattern, found throughout this collage.

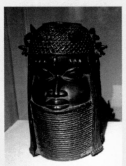

Above: Commemorative oba head, 18th century. Benin kingdom, Nigeria. Copper alloy with iron inlay. National Museum of African Art, Washington, DC. Photo by the author.

Right: Romare Bearden, *Profile Part II, The Thirties: Artist with Painting and Model*, 1981. Collage. Romare Bearden Foundation.

At Bearden's elbow appears a small reproduction of a painting by the Italian painter Duccio. Working just before the dawn of the Italian Renaissance, Duccio's art still features the dramatic abstractions of Medieval art. Although just a corner of the picture is visible, it is identifiable as *The Road to Emmaus*. Though representing an entirely different culture than the Benin head, Duccio's work here shares the same reliance on bold, geometric shapes. Note here the large-scale figures, a kind of perspective not unlike oblique projection, and flat, patterned space (which, incidentally, we have also seen in traditional Asian painting). Again, we find this abstract use of space in Bearden's collages.

Duccio di Buoninsegna, *The Road to Emmaus*, 1308-11. Back of Maesta alterpiece. Tempera on wood panel, 22.44 × 20.08 inches. Museo dell'Opera del Duomo, Siena, Italy.

Romare Bearden, *Now the Dove and the Leopard Wrestle*, 1946. Oil on canvas, Clements Library, University of Michigan.

Its imagery based on a Spanish poem, Bearden's *Now the Dove and the Leopard Wrestle* borrows its splintered, overlapping animal forms from *Guernica*—Picasso's gripping ode to war-torn Spain. The straining, arched head of Bearden's rearing horse is a clear homage to the braying horse at the center of Picasso's famous composition.

Bearden's fractured collage forms are often linked to Picasso's **Cubist** work. Although Bearden ultimately moved away from the purely Cubist style seen in *Now the Dove and Leopard Wrestle*, his work continued to include sharply-cut, overlapping geometric shapes, which reflect the spatial tension of interpenetrating planes found in Picasso's Cubist work.

We can understand *Guernica*'s appeal to Bearden, whose work is typically rich in energy and emotion. In *Guernica*, Picasso married Cubism's shattered geometric planes with raw Expressionism to produce a visceral tableau of despair and outrage—which a former student of George Grosz would readily appreciate. We will return to *Guernica* in Chapter 7, to examine this seminal work in detail.

Pablo Picasso (1881-1973),
Guernica, 1937. Oil on
canvas, 137.4" × 305.5."
Museo Reina Sofia, Madrid.

New Vocabulary in Chapter 3

Aku'aba figure	Female sculpture from Akan culture, Ghana, Africa
Chi-wara figure	Animal headdress sculpture from Bamana culture, Mali, Africa
collage	A mixture of media assembled into a two-dimensional work of art
Cubist, cubistic, Cubism	Relating to Cubism, an art movement, begun in Europe, early 1900s, emphasizing fractured geometric shapes
Dada	Art movement, early 1900s Europe, calling out absurd contradictions in society, and calling for a playful, intuitive approach to art-making
Expressionists, Expressionism	Art movement, early 1900s Europe, reacting to horrors of WWI with emotionally-expressive art, reflecting both psychological turmoil and social concerns
focal point	Area in a work of art that draws the viewer's attention, creating emphasis (a principle of design)
Futurist, Futurism	Art movement, early 1900s Italy, expressing hatred for the past, and belief that progress comes through action, force, and war
Great Migration	The movement of African-Americans from rural South to industries and opportunities in the North
Harlem Renaissance	African-American movement of art, dance, music, and literature, early 1900s, centered in Harlem, NYC
implied line	Lines that are suggested to the eye, not physically present
improvisation, "improv"	Technique used in Jazz music and other art forms, allowing extensive variation within a structure
motion blur	The blurring that occurs in photos of things in motion
non-objective	Style without recognizable or nameable objects, sometimes called "pure abstraction"
palette	A selection of colors used in a work of art (also refers to the surface on which colors are mixed)
proportion	The relationship, in size, among features within an object
scale	The relationship, in size, among various objects
structure	Organizing a piece of music through time, key, etc.
Symbolism, Symbolists	Art movement, late 1800s Europe, using symbols to represent subconscious desires and fears
symmetrical balance	Principle of design featuring even visual weight on both sides of a work (see Chapter 9)
unity	Principle of design addressing structure, order within a work of art
variety	Principle of design addressing unexpected changes in/deviations from a given structure

4 BEYOND PICTURES

4: BEYOND PICTURES

STYLE—NON-OBJECTIVE
"CRAFTS" AND THE MEANING OF MATERIALS

"The subject of art is a non-thing ... we're talking about feelings."
—Robert Irwin

Irwin's comment sheds light on the power of art to engage the viewer in a transcendent experience. As Wynton Marsalis has said, art "expands your conception of the possible."* The job of art is not to show us something we haven't seen before—rather, it is to reawaken viewers to the world around them, to help viewers see their everyday world with fresh eyes. In this chapter, we will begin to look at the ways that art can encourage the viewer to see beyond the "picture." We will examine how meaning may be found in the materials themselves, as well as in the use of space, the manipulation of light, and choices of line, texture and color.

NON-OBJECTIVE ART

*Wyton Marsalis, narrator,
"Romare Bearden, Visual Jazz,"
created and produced by
Linda Freeman, 1995.

Robert Irwin, *Nine Spaces,
Nine Trees*, 2007. University
of Washington, Seattle.

Art lies in making connections with the right brain, and communicating those connections to the viewer, so that he or she can enjoy the same creative process. Artwork that is devoid of recognizable subject matter (called **non-objective art** or **non-representational art**) can sometimes be more effective than representational art in opening the doors of viewer experience, because there are no "things" to "get in the way."

Robert Irwin's work here is linked to the **Minimalist** art movement that began in the 1960s. The Minimalists were disaffected by the pop-culture emphasis of 60s Pop art, which they thought encouraged viewers to lose touch with the most essential aspects of real human experience. Life is not flashy images and surface impressions; life is 360 degrees of sight, smell, touch, sound—all the sensations we are capable of feeling. In *Nine Spaces, Nine Trees*, Irwin created a communal space on the University of Washington campus, in which to converse, congregate, and contemplate. Irwin argues that our world doesn't come with "frames;" it is a continuous stream of sensory information. Art should honor and support that experience, rather than compete with it. Minimalist art rewards the viewer for being physically present. Here, Irwin creates a moving composition, which changes as the viewer walks through the space. Geometric shapes

shift with each step, as the purple chain link fences overlap to make deeper purple planes of color. The shadows of the fences unify the pattern of the walls with the pattern of the ground. As we follow the vertical line of the trees, we see the soft shapes of the leaves play against the geometry of the nearby buildings. Each piece of the work connects to its surroundings, just as each visitor is connected to one another, and to the wider world.*

YOU ARE NOT HERE!

... But imagine that you were here, in the Museum of Modern Art in San Francisco. Hopefully the photographs of these large-scale, non-objective works (shown on this page and the next) will give you a small sense of what it feels like to actually stand in front of them.

Notice the scale, the textures, and the play of light in each piece. Although neither provides a "picture" for you to "read," they still communicate meaning. What ideas, places, or events does each remind you of? What feelings do you get from each? What feelings do you clearly not get? What insight do the titles and materials provide?

Which of the two reflects your personality more?

Is it obtrusive, at odds with its environment—or is it acclimated to its space? What about you?

Jay DeFeo, Incision, 1958-61. Oil paint and string on canvas mounted on board. San Francisco Museum of Modern Art.
This is decidedly *not* Minimalist art, even though it offers little in the way of color, and nothing in the way of "picture." Like Minimalist art, this work engages the viewer on a physical as well as optical level. The painting rests on the floor, sculpture-like, and the paint itself seems ready to slough onto the floor—if not reach out and grab a passerby.

The Minimalists preferred the universal neutrality of geometric shapes, which reoccur throughout our world. Jay DeFeo wasn't exclusively interested in such pure, rational shapes—she preferred the unexpected shapes created through the visceral power of paint. In every way, DeFeo defies the traditional use of oil paint. She does not erase the brushstrokes to create an illusionistic world. Rather, the weight and motion of the paint has become the essence of the work itself.

*While I was walking with a friend through *Nine Spaces, Nine Trees*, my friend ran into an old acquaintance, whom she hadn't seen in many years. We sat on the bench around one of the nine tree and talked. Such chance encounters are an integral part of life, as is our relationship with friends, acquaintances, and passing strangers. Irwin's work not only enabled that connection—it also ensured that the memory lasted in my mind, long after the specifics of our conversation have been forgotten.

Sol LeWitt, *Steel Structure*, 1975-76. Aluminum and enamel. San Francisco Museum of Modern Art.

This is Minimalist art, to be sure. At first glance, one might dismiss the sculpture as nothing more than that—a minimal effort, with minimal stuff to look at. Look further ... note that this "minimal" work is huge. As in Irwin's work, the piece is more than just the object itself; your experience, as a visitor, includes your perception of the size of the piece, relative to your height; the shadows of the piece, and the interaction of those shadows with the walls of the museum (and your shadows, as you walk by); and the shape of the piece, as it echoes the shape of the room you are walking through. Yet, the color of the work is white, like the walls.

CHRISTO AND JEANNE-CLAUDE

The work of the husband-and-wife team Christo and Jeanne-Claude reflects the ability of non-objective art to connect viewers to their environment. Their site http://www.christojeanneclaude.net shows the couple's long history of making non-representational public art. Sadly, Jeanne-Claude passed away in 2009.

One of their most ambitious projects is *Running Fence*, an **earthwork**—a site-specific work of art connected with (or built into) a landscape. Eighteen feet high, composed of 2,050 panels of white fabric, and standing for just two weeks after its September 10, 1976 completion date, this "fence" ran as billowing ribbon of white over 24 miles of Northern California hillside, "on the private properties of fifty-nine ranchers."

Note how the white of the "fence" draws the viewer's eye to the strips of white cloud in the sky above. The cadences of the fabric's edge echo the contours of the rolling hills. These visual elements encourage the viewer

Christo and Jeanne-Claude, *Running Fence*, Sonoma and Marin Counties, CA, 1972-6.

to make connections among the natural and artificial pieces of the composition. Essentially, the entire world becomes the art, and the viewer engages in the creative process, finding the **unity** within the varied visual stimuli:

> The art project consisted of: forty-two months of collaborative efforts, the ranchers' participation, eighteen public hearings, three sessions at the Superior Courts of California, the drafting of a four-hundred and fifty page Environmental Impact Report *and the temporary use of hills, the sky and the Ocean.* [Emphasis added.]

> All expenses for the temporary work of art were paid by Christo and Jeanne-Claude through the sale of studies, preparatory drawings and collages, scale models and original lithographs …

> … As it had been agreed with the ranchers and with the County, State and Federal Agencies, the removal of *Running Fence* started fourteen days after its completion and all materials were given to the ranchers.

> *Running Fence* crossed fourteen roads and the town of Valley Ford, leaving passage for cars, cattle and wildlife, and was designed to be viewed by following 65 kilometers (forty miles) of public roads, in Sonoma and Marin Counties.
>
> —http://www.christojeanneclaude.net/rf.shtml

Although *Running Fence* lacked any recognizable objects—the fence was not laid out in a "smiley-face," for instance—it was far from meaningless. Much of its meaning rests, ironically, in aspects of the art project *surrounding* the fence, rather than its physical presence alone. To look at *Running Fence*, for the two weeks it was in existence, was to see more than just the fabric, steel cables and poles, guy wires and anchors. We may speak of *Running Fence* in the present tense because its presence transcends the physical. Those who never saw the fence in person may view the photo-documentation; however, the "real artwork" exists in the minds of those who personally experienced the work in mid-September, 1976.

Consider the human effort involved in the creation of *Running Fence*. Christo and Jeanne-Claude had to orchestrate a massive collaboration of public and private parties, and convince hundreds of people to invest time, energy, money and faith in the project. This collaboration is part of the artwork itself, just as surely as the "hills, the sky, and the Ocean" referenced in the artists' essay. Those who took active part in its creation, as well as those who drove or walked by it, are all part of the work. The memory of their varied experiences have meaning, for them. We can imagine such experiences from looking at the photos and reading about the work—this imagining is also part of the work.

Keep in mind that the hills of coastal California, at this time of year (before the Winter rains set in), are brown and sun-burnt. The grass has not seen rain for almost five months; by most Californians' standards, the hills are neither lovely nor scenic. To an artist like Christo, however, the hills are starkly beautiful, their gentle rise and fall suggesting a rhythm like the movement of the ocean itself. Indeed, Christo and Jeanne-Claude's work unites the land and the ocean, as the fence emerges from the Pacific Ocean at Bodega Bay. The connection here is both literal and symbolic, as the fence joins the water to the land, as well as the land to the sky. The art cannot be separated from everything—and everyone—around it: the waves of the water at the coast; the rolling of the hills that appear, alternately, to swallow and hold aloft the ribbons of fencing; the billowing of the fabric in the breeze; the undulating shadows, thrown by people, trees and clouds, that move along the fabric's surface; the shifting color of the fence over the course of the day; the clouds themselves, rolling along, also reflecting the sun's rays. Together, these elements create a subtle "musical" arrangement of light and space for the viewer's eye and mind alike.

In many ways, Christo and Jeanne-Claude's works defy traditional Western attitudes toward art. Unlike the great monuments prized in Europe—made of polished stone and built as lasting tributes to conquerors, kings, and lofty aspirations—*Running Fence* is made of lowly materials, lasts only two weeks, and celebrates

everyone and everything around it, without preference or privilege. The two-week duration of Christo and Jeanne-Claude's work is vital to its understanding; a permanent work would not only scar the landscape; it would become yet another visual thing for the viewer's eye to eventually "tune out." "Great walls" throughout human history have spoken of power and control (from the Great Wall of China to Hadrian's Wall, from the now-demolished Berlin Wall to the innumerable walls that still divide peoples and nations)—yet in one important respect, the power of *Running Fence* eclipses all of these. Rather than restrict access, *Running Fence* opens up possibilities. Further, it seeks not to "pretty up" an otherwise drab landscape, but rather empowers the viewer to find beauty already present in the world. It is costs nothing to view, but offers open-minded viewers *a new way to see*—a gift that is truly invaluable, and a power that is longer-lasting than any wall ever built.

Works such as *Running Fence* are called **site-specific**, because their visual impact is directly linked to the site where they are erected. In other words, the fence could not be built "just anywhere," and keep its intended meaning. Similarly, Christo and Jeanne Claude created *The Gates* specifically for New York's Central Park.

In *The Gates*, the artists selected the dead of winter, a time when few people in New York would find beauty and life in Central Park. The strong orange color creates a startling contrast against the stark white of the snow, and the black of the tree trunks. The cool blue shadows, along with the blue haze of the buildings of downtown NY, both complement in vivid contrast the orange color of the gates. The geometric shape of the gates' frames echoes the geometry of the buildings, while the soft flow of the fabric in the air mirrors the flowing, organic lines of the park's pathways and the movement of the people walking there. The work creates an open-invitation opportunity for viewers to have a complete and interactive encounter with their environment—again, helping viewers see beauty in the subtle, rhythmic interplay of visual elements, and

Above left: Christo and Jeanne Claude, *The Gates*, Central Park, NY, February 12–28, 2005.

Above right: View of the gates with downtown New York City in the background.

Below: Aerial view.

become part of that aesthetic experience. Ideally, this experience remains active in the minds of those who have visited the site. After the work is "gone," visitors who return to the park may still take pleasure in the gentle shifts of line, shape, color, and texture that remain to gratify the right brain.

In the two weeks *The Gates* were up, they received over four million visitors. Given the magnitude of the event for New York City, the Times created a site with extensive information and reviews: http://www.nytimes.com/ref/arts/design/GATES-REF.html. As you peruse the site, note in particular the review by Michael Kimmelman ("'The Gates,' An Appraisal"). In this review, Kimmelman offers begrudging praise, highlighting the participatory power of the *The Gates* to create a kind of ceremonial space which endows the viewer with "democratic dignity."

SEEING OBJECTS NON-OBJECTIVELY

In children's bedrooms, it seems almost every object has a picture on it. The clock is shaped like Mickey Mouse; there are sailboats painted on the dresser; Snow White is on the drapes—or maybe a pattern of footballs and baseballs. Toothbrushes are shaped like seahorses. I still have a "Peanuts" pillowcase I can't bear to throw away, tucked in the back of the linen closet. From sippy-cups to breakfast bowls, chairs to pajamas, there are pictures on nearly everything a child sees, touches, uses, and adores.

However, most objects that an adult sees, touches, and uses on a day-to-day basis are not decorated with representational imagery. They are objects, yes, but their design is essentially non-objective. Like any non-objective work of art, your toothbrush has shape, texture, and color, but no identifiable imagery. It is a three-dimensional object whose design is determined by its use—it is not designed to reference any other object in the world, unlike the seahorse-shaped toothbrushes illustrated here. So, is your toothbrush a non-objective work of art? Strange as it may seem, the answer is … maybe. Does your toothbrush "expand your conception of the possible"? Does seeing its shape, feeling its contours, and looking at its color and rhythmic patterns open your mind to new ideas, or give you a fresh perspective on the world? If the (unlikely) answer is yes, then it is art (at least, it's art, to you).

Many people are baffled and offended by modern art because it seems, by its very presence in an art museum, to make outlandish claims about "what qualifies as art." After all, we are only in the fourth chapter of this book, and the author has already proclaimed your toothbrush to be a possible work of art! Surely, one would conclude, this whole "art thing" is a con, a joke—or just completely relative, a matter of personal taste.

Almost a hundred years ago, artist Marcel Duchamp tackled these concerns with his "readymades." He submitted *Fountain* for exhibition in a show organized by the Society for Independent Artists—a group formed in New York City to push the conventional boundaries of art. Apparently, Duchamp's prefabricated "fountain" (a factory-made urinal placed on its back, signed, and dated) was too unconventional for the unconventional Society, and they rejected the piece from the exhibition.

On one hand, it might seem that Duchamp's artwork had failed the Society's test for "what art is;" however, from Duchamp's perspective, it was the so-called independent art world that had failed *his* test. Anonymously signing the piece "R. Mutt," Duchamp ensured that the Society members would not be biased one way or another by their familiarity with Duchamp. As far as they knew, they were critiquing a stranger's work—and, as a "disinterested" third party, Duchamp was free to advocate for his fictitious Richard Mutt:

> They say any artist paying six dollars may exhibit.

> Mr Richard Mutt sent in a fountain. Without discussion this article disappeared and never was exhibited.

Above: Given seahorse handles, these toothbrushes become representational.

Below: A non-representational, adult toothbrush.

What were the grounds for refusing Mr Mutt's fountain:—

1. Some contended it was immoral, vulgar.

2. Others, it was plagiarism, a plain piece of plumbing.

Now Mr Mutt's fountain is not immoral, that is absurd, no more than a bathtub is immoral. It is a fixture that you see every day in plumbers' show windows.

Whether Mr Mutt with his own hands made the fountain or not has no importance. He CHOSE it. He took an ordinary article of life, placed it so that its useful significance disappeared under the new title and point of view—created a new thought for that object. ...*

It is highly unlikely that Duchamp ever expected *Fountain* to be accepted. His plan all along was to force the issue (what makes something art?) into the open. Ultimately, *Fountain* throws back in viewers' faces all the expectations that the Western world has placed upon art. Fountains traditionally take their place at the center of formal gardens; they speak of taste and elegance. Urinals, on the other hand, suggest the lowly, common, degraded, and crass. Must art be tasteful, elegant, "high-brow," in order to qualify? Who decides? Duchamp's choice of title questions the hallowed station of "high art." Clearly, this urinal is *not* a marble garden fountain ringed with cupids and garlands. However, by placing the piece on its back, and taking it out of its expected milieu (that is, removing it from the context of a men's restroom), the piece does indeed look different. It is not immediately recognizable; it takes the viewer a moment to figure out that it's no fountain—and that it has been arranged so that it is no longer in the "correct," operational position. As Duchamp claims, "its useful significance [has] disappeared."

What "new thought," then, does *Fountain* create in the mind of the viewer? It is not a fountain. But its title says "fountain." We could throw up our hands right here, and say that Duchamp was a very silly man with too much time on his hands. Yet, let us hold onto Duchamp's argument, just for a moment longer. Let us ask the question that Duchamp himself poses: **why is it automatically *not* art?** Do you *not* find the shape interesting? Is there not an engaging circular pattern repeated throughout the composition? Does the apparent contradiction between the title and the artwork not invite discussion? Does it not test your assumptions in some way? Duchamp did not expect the viewer to automatically bow down and coronate *Fountain* as art; he just wanted viewers to question what they see, and what they expect to see. In other words, he wanted to expand their "conception of the possible." For Duchamp—and for many modern artists today—art occurs in the

Marcel Duchamp, Fountain, 1917.

*Marcel Duchamp (1887-1968), 'The Richard Mutt Case,' in *Art in Theory, 1900-2000*, edited by Charles Harrison and Paul Wood (Blackwell, 2004), p. 252.

exchange between the artist's mind and the viewer's mind. The work of art becomes the doorway through which communication of ideas occurs.

Viewing Duchamp's work, only the most stubborn would insist that all they see, all they ever will see, and all they want to see is an old urinal on its back. To these same viewers, Christo's *Running Fence* is just a long white curtain. When the mind is *open to seeing beyond the object*, however, art becomes a lot more interesting and rewarding, both intellectually and emotionally.

The Japanese Zen Garden and Tea Ceremony

In Chapter 1, we discussed the role of Zen Buddhist philosophy in the design of Japanese handscrolls. The traditional rock garden was also designed to create a philosophical space for the viewer. Although many today enjoy these gardens for relaxation, Samurai warriors would use the rock garden as a space for mental exercise. Like the handscrolls, the traditional rock garden offers a spare, reduced range of visual stimuli. As with Christo and Jeanne Claude's *The Gates*, there is little lush greenery or floral color to be the "star of the show." Rather, the reduced vocabulary of the rocks allows the viewer to make associations with the arrangement of materials. With the viewer's imagination activated, the large rock in the garden below can become a mountain or waterfall; the pebbles appear to flow like a river. The horizontal stone becomes a bridge, over which the viewer can mentally traverse.*

Like the garden, the Japanese tea ceremony also presents the opportunity to make philosophical and aesthetic connections through non-objective art. The tea house provides a quiet, simple environment, separate from the environment outside. The participant is expected to enter the tea room with sensitivity both to the world outside, and the one within. Bowls used in the tea ceremony often feature non-representational textures and markings that leave the properly-attuned viewer free to make his or her own associations between the inner and outer spaces (both physical and psychological).

*For more images of Japanese gardens, see the Bowdoin University site: http://learn.bowdoin.edu/japanesegardens/ .

Daisenin Monastery Garden, Daitoku-ji, Kyoto, Japan.

Osamu Sato (architect), view of tokonoma (niche for hanging scroll), reproduction of a traditional Japanese tearoom, Asian Art Museum, San Francisco.

Held in the viewer's hands, these bowls reveal to the attentive viewer their subtle variations. Shifts in color and texture, line and shape suggest to the meditative mind the shapes and textures of the natural world outside. In this tea bowl, the undulations of the lip might evoke the movement of waves or the contours of a hillside. The depressions of fingermarks in the clay, covered in a shiny, blue-green glaze, welcome the tea-drinker's own fingers, while suggesting the texture of grass.

The opening scene of the film "Rikyu"* dramatizes a tea ceremony conducted by Japanese Zen master Sen No Rikyu (1522–1591). Rikyu popularized the "way of tea" in Japan, emphasizing its importance as an aide to meditative focus, and opening the practice to everyone, regardless of social status.

In the scene, Rikyu prepares his monastery for the emperor's visit. Lord Toyotomi is studying the way of tea—something an emperor is expected to know and adequately perform—and is coming (with his entourage) for a lesson. Ultimately the relationship between the Zen Buddhist master and the emperor will prove fatal to Rikyu, when he refuses to allow the emperor to marry his daughter. The root of the impending conflict is suggested at the very start of the film, as Lord Toyotomi impatiently barges into the monastic compound; it is clear he is an insensitive and violent man, demanding and undisciplined. To him, the tea ceremony is simply a series of steps to get through. Even as he intently watches Rikyu to mimic the monk's actions, he fails to grasp the "way of tea"—his actions are mindless, without focus or meaning. In contrast, Rikyu's performance is purposeful. Each moment has value, as he stirs the tea, takes a sip, and examines the bowl in his hand. He is attentive to every facet of the performance: to the intervals of time between action and stillness, sound and quiet; to the experience of the senses, such as texture, taste, color, shape, volume; and of course, to the experience of the guest who shares the performance.

As we have found in other non-objective forms of art, the tea ceremony is effectively performed as "art" when it expands the thoughts and feelings of the participant/viewer. This expansive potential is suggested in Rikyu's poetry:

Hon'ami Koetsu (1558-1637), Raku Teabowl 'Mount Fuji' c. 1600.

* "Rikyu," 1989, directed by Hiroshi Teshigahara.

> Many though there be
> Who with words or even hands
> Know the Way of Tea.
> Few there are or none at all,
> Who can serve it from the heart. …
>
> Though you wipe your hands
> And brush off the dust and dirt
> From the tea vessels.
> What's the use of all this fuss
> If the heart is still impure?
>
> When you take a sip
> From the bowl of powder tea
> There within it lies
> Clear reflected in its depths
> Blue of sky and gray of sea. …

—http://www.english.iup.edu/eaware/selected_verses_about_tea_by_rik.htm
Quoted by Elaine Ware, Associate Professor of English, Indiana University of Pennsylvania

The Issue of "Crafts": "High Art" Versus "Low Art"

As we have discussed in Chapter 1, the Western world has traditionally preferred naturalistic, representational art, which references a recognizable subject or story. In contrast, the works we have discussed in this chapter present the opposite aesthetic experience. As non-objective art, they present no nameable, recognizable objects to suggest a particular subject or tell a specific story; the viewer is challenged to make his or her own connections to the work, and find meaning in the visual elements provided.

Traditionally, art in Europe and the United States was valued for appearing timeless; the most celebrated works were grand and permanent monuments made of the finest, rarest, and most elegant materials. However, rather than stand back and observe the work as a precious object, the viewer of the *Gates* is encouraged to both participate and to touch. In the case of the Japanese tea bowl, participation and touching is in fact necessary to experience the artwork fully. Many of the works shown in this chapter are also made of ephemeral and common materials, such as the fabric of *Running Fence* and *The Gates*. These materials—textiles, twigs, tiles, etc. —are often associated with "crafts."

Power Figure (Nkisi), 19th–20th century, Kongo peoples; Democratic Republic of Congo. Wood, paint, nails, cloth, beads, shells, arrows, leather, nuts, twine; H. 23 5/32 in. (58.7 cm) Metropolitan Museum of Art, NY.

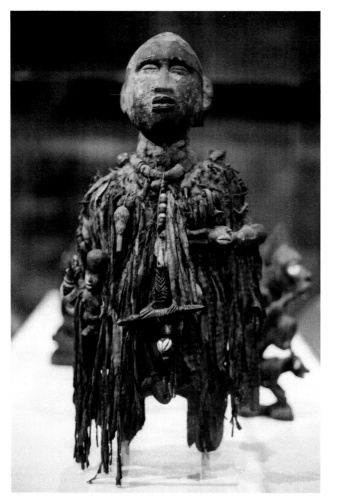

"Crafts" and the Issues of Gender and Culture Bias

The term **crafts** suggests functional and/or informal objects that are decorated with earthy, inexpensive, or easy-to-obtain materials. To some, crafts have the reputation as "non-serious" art; the term brings to mind scrapbooking, beadwork, stamping, and other common or untrained hobbies. In the traditional Western world, "crafts" were considered a "low art," made by people presumed (because of Western biases) to have "simple intellects," such as women (who were thought to be more emotional than intellectual) and tribal, non-Western people (who were thought to be wild, obsessive, and child-like). "High Art" included paintings and sculptures of historical, religious, or mythical subjects, which were thought to demand the "higher intellectual power" of Western men to make well.

Until the past decade, tribal ritual objects made of wood, fiber, shells, and other "low" materials were called "fetishes"—a term that brings to mind irrational devotion, fixation, and idolatry. This *nkisi* sculpture would have once been called a "fetish." From the traditional Western perspective, all the different materials added to the sculpture serve to *decrease* its value and qualifications as a "serious art form." In contrast, from the perspective of the Kongo peoples, the *nkisi* is a vital and valuable device, engineered to open a doorway to the supernatural world. Spiritual specialists (called *nganga*) work with the sculptor to create an *nkisi* for a community in distress. The intricately wrapped materials, noted in the caption above, ensure that the power of helpful ancestor spirits will be bound to the task at hand—to solve the community's problem. Each time the *nkisi* is used, it gains material—and spiritual power.

Embracing "Crafts:" The Arts and Crafts Movement

Just over a hundred years ago, the **Arts and Crafts movement** was launched in Europe and the United States in response to their quickly-industrializing societies.* As the new 20th century loomed, these artists embraced a "back to basics" approach, in which "fine art" would go side-by-side with hand-made furniture and decoration made from earthy materials. Old-fashioned, skilled labor would be valued alongside "high art" painting and sculpting. In this painting by Lucia Matthews, the carved and painted frame is as an equal partner to the painting within. The peaches of the frame complement the ripening peaches behind the red-haired girl. Reflecting the back-to-nature interests of the Arts and Crafts movement, this hand-made lamp looks like something that might grow on a desk, of its own accord—more like a mushroom than a household appliance! Though a functional thing, the lamp is considered to be no less of an art-form than *Portrait of a Red Haired Girl*.

*This movement became international, with adherents from Japan and Russia to California and New England. This movement might remind you of the Symbolists of the same time period (see Chapter 3), who shared similar concerns about the loss of the "human touch" in an increasingly mechanized world.

**The German Bauhaus (literally, "house of building") shared with the Arts and Crafts movement the ideals of social equity (in both the art world, and the wider society). Bauhaus painters studied side-by-side with craftspeople until 1933, when Hitler forced the studio's closure. We will look at Bauhaus architecture in Chapter 12.

Lucia K. Matthews, *Portrait of a Red Haired Girl*, 1910. Watercolor on paper with furniture shop frame. Oakland Museum of California. Photo by the author.

Dirk van Erp, lamp with mica shade, c. 1912–15, Metropolitan Museum.

Craftsman today: a mass-produced TV stand, made in the Craftsman style, but without the Arts and Crafts philosophy behind it. Indeed, Arts and Crafts artists would be appalled at how the term "Craftsman" is used today by corporations selling furniture that only superficially resemble their namesakes—furniture made from synthetic and shoddy materials, assembled by underpaid and undervalued factory workers. Photo by the author.

Craftsman house, Berkeley, CA.

The "Craftsman" house—still to be found throughout California—was built as a living extension of the artwork within it. Popularized by architect Frank Lloyd Wright, the Craftsman home was designed as a warm and enveloping composition, offering the homeowner a relief from the grinding mechanics of modern living, a unified experience closer to the earth and nature.

Although the Arts and Crafts movement was ultimately usurped by a sleeker and more modern-looking aesthetic, the idea of giving craft design the same respect as painting, architecture, and sculpture continued in art movements of the 20s and 30s.** Later, the push for social equality and a "back to nature" way of life found new voice in the late 1960s and early 70s, a time of revolutionary social change and upheaval. As

in the Arts and Crafts movement, some artists elected to work together in art communities and collectives to help foster a more egalitarian society. All these movements share a common theme: the use of tactile, functional art to connect people to their environment, and to each other as social equals.

COLLAGE, CRAFT, AND THE COMMERCIAL WORLD

Like artists today, early 20th-century artists looked on the commercial world of "Sell, sell, sell! Buy, buy, buy!" with mixed feelings. As the new century dawned, some artists questioned why they should paint in fine oils on canvas, when we had become a world of magazines, comic books, ticket stubs, and sales receipts. They began to use the detritus, the cast-off junk, of the modern consumer as their medium. The subject of their work was the throw-away culture itself—the fragmentation of society into the cheap and disposable bits that document everyday life.

Picasso had experimented with collage in the 19-teens, finding in common, everyday materials (such as newspaper, wallpaper, and construction paper) a refreshing new vocabulary to talk about the modern experience. At the same time in Germany, the **Dada** artists like Hannah Hoch were cutting up bits of text and imagery from common commercial sources. Dada artist Kurt Schwitters created a series of collages he called "Merz," from the term "commerce" (buying and selling). Schwitters realized that most of the things he touched, used, and discarded on a daily basis were mass-produced for commercial purposes. There is no boundary between who you are, and what you buy, use, and throw away. After making hundreds of Merz collages and **assemblages** (three-dimensional, mixed-media constructions), Schwitters started to call himself MERZ as well.

Schwitters's ironic use of the term MERZ for everything—including himself—echoes the irony of *Fountain* by fellow Dada artist Marcel Duchamp. Like Duchamp, Schwitters calls into question what is "high art" and what is "low." In this new world where everything (and everyone) seems to be for sale, are we are all just commodities—just a collection of MERZ? How can we distinguish between "low" and "high," when we are all products of the same consumer system?*

As discussed in the previous chapter, Western artists began to look to tribal art forms for inspiration toward the end of the 19th century. Coming from industrialized societies, artists such as Picasso were fascinated by what they thought to be frightening and "primitive" objects, whose style seemed to break all the stodgy aesthetic rules of "civilized society." These artists sought to inject a taste of what they thought to be otherworldly and "savage" into their own world—one that they saw as tired, sterile, and stuck in a literalist,

Kurt Schwitters, *Merz 19*, 1920. Collage on paper, 7 5/16 x 5 7/8 in. Yale University Art Gallery.

The *Merz* collage shown here appears to be a random collection of junk—old envelopes, blank forms, and tickets. Yet, note the unity of visual elements: white, black, browns and blues are arranged in a vertical/horizontal grid, creating a sense of order in an otherwise chaotic world.

naturalistic rut. The use of hodge-podge collage materials by so many of the early modernists (like Picasso and Schwitters) may be credited, in part, to the varied use of materials in the African art that inspired them. Further, modern artists' embrace of non-objective art can be traced to the kinds of designs found in "low art" forms.

Let us look, finally, at a case study, to see how the complex issues of culture, "craft," non-objective art and modernism intertwine.

*This rhetorical question was brought to you by caffeine-free Diet Pepsi!

THE QUILTS OF GEE'S BEND: A CASE STUDY

Many of the materials and products we associate with "crafts" have been traditionally used by women. Textile or fabric arts, in particular, have been associated with "women's work." Quilting, needlepoint, and weaving are all examples of textile art. As noted earlier, these art forms were dismissed in the past as "low art" in part because they often served as functional items with a limited lifespan. Such art has long been recognized for its technical difficulty and painstaking, laborious piecework;** on the other hand, it has also long been perceived as being not intellectually difficult, and consequently disqualified as "high art."

The quilts made by African-American women in the former slave community of Gee's Bend, Alabama, reflect many of the issues and ideas we have touched upon in this chapter. Ignored by the art world until their recent "discovery," quilts produced by Gee's Bend locals, such Jorena Pettway and her family, became an overnight sensation with a national, multi-museum tour in 2006. In the following excerpt from the De Young Museum's site, note how the museum presents the quilts as meaningful works of art, above "mere craft":

> Described by one reviewer as "eye-poppingly gorgeous," the quilts were pieced from scraps of fabric often salvaged from worn-out clothes combined in extraordinary combinations of color, pattern, and texture. … Bold geometric shapes, dramatic shifts in scale, and an improvisational approach to the way the fabrics are assembled produce abstract compositions more akin to the rhythms of jazz and African art than to the order and repetitiousness of many traditional American quilts.

—http://www.famsf.org/deyoung/exhibitions/exhibition.asp?exhibitionkey=549.

What makes these quilts works of art, and not just interesting designs? In other words, what is it about these quilts that expands the viewer's experience, leading him or her to deeper feelings, new ideas, or a keener awareness of the world? Let us examine the elements of the Gee's Bend quilts, piece by piece (so to speak), and see in what way the pieces may fit together.

First, note that the material itself has meaning. This is not just fabric bought from the local fabric store; the denim and corduroy in the quilts came from clothes that had been worn until worn-out. They speak of need and necessity. Both through their materials, and through the identities of the women who made them, these quilts represent a powerful history. Although non-objective, they are loaded with meaning for those who are aware of this history—telling personal stories of families struggling to survive in the deep South, and the broader legacy of slavery in American history.

**In some parts of the world today, women are still seen as "better equipped by nature" to perform tedious, monotonous, and delicate work—forced to work in factories for long shifts making everything from iPads to purses.

Jennie Pettway and another girl with the quilter Jorena Pettway, 1937. Farm Security Administration, Office of War Information Photograph Collection, Library of Congress.

The historical importance of the materials raises an interesting question, however. In the 21st century, Gee's Bend enjoys more prosperity than in the past. Now women of the community can buy fabric for their quilts, rather than rely on scraps of old clothes. Also, a younger generation of Gee's Bend women—who share the heritage, but not the personal histories of their mothers and grandmothers—are making quilts. Are these new quilts as meaningful as the older quilts? Do they "count" as fine art, at the same level as the works created by a previous generation?

While some might argue that the history of the quilts is an essential factor to their artistic value, others might place a greater emphasis on their modern-looking, non-objective designs. On this issue, the synopsis from the De Young Museum website is quite revealing. The quilts' "bold geometric shapes, dramatic shifts in scale, and … improvisational approach" are connected both to African art, and to Jazz music. As we have found, these qualities resonated with European modernists, and are now highly-prized by the art world. The quilters of Gee's Bend were creating improvisational, "visual jazz" before Picasso ever visited the Trocadero in Paris. However, the world of art can be unjust; it took almost a full century for museums to recognize the Gee's Bend brand of "jazz." Right or wrong, the Gee's Bend quilts may forever be compared with famous works of the European modernists, in order to verify their "authenticity" as fine artwork:

Women from Gee's Bend, Alabama, working on a quilt, 2005. ONB Magic City Art Connection, Linn Park, Birmingham, Alabama. Photo by Andre Natta.

Opposite page: Catherine "Caty" Selleck (b. 1783), pieced quilt, 1806, Darien, Connecticut. 90 x 87 3/4 in. Yale University Art Gallery.

"These art pieces are on par with Mondrian and Picasso …"

—Esau Kessler, Boise Contemporary Art Examiner

"The bold, abstract bed coverings made to keep the quilters' families warm tower over the gallery spaces like sensual and wild interpretations of abstract paintings by Piet Mondrian and Joseph Albers."

—Roberta Fallon, The Art Blog

Ironically, the now-famous works of the European modernists—based on African art they little understood—will never have their legitimacy or authenticity questioned. Picasso will never be described as making "wild interpretations" of African art that are "on par" with African-American quilts.

The De Young museum's quote raises a final question, with which we will conclude this chapter. The museum states that the Gee's Bend quilts have invigorating and unusual rhythms, which differ from the "order and repetitiousness of many traditional American quilts." Does "order and repetitiousness" negate the artistry of these other traditional, "undiscovered" quilts?

Consider this typical, early-American quilt shown on the previous page. The design is less spontaneous-looking than a modern European collage. Is it non-objective art, on par with a Gee's Bend quilt—or is it just a well-executed piece of handiwork?

In many ways, all of these quilts bring us back to the questions raised by Marcel Duchamp with his *Fountain*:

· Does art have to be original? What does it mean, to be original? (is an original idea enough?)

· Does art have to be hand-made? Can art be machine-made? Can it be "readymade"?

· Does an object become more of a work of art, or less a work of art, when it is used? What does it mean, to use a work of art?

· Does an object become more of a work of art, or less of a work of art, with the passage of time? Does art need historical weight or significance to be worthy as "fine art"?

Throughout this chapter, we have postulated that a key factor in determining the "artness" of a thing is whether it provides the viewer with an intellectual or emotional experience *beyond the object*. The subject of art, as Robert Irwin has said, "is a non-thing; we're talking about feelings." From this perspective, the questions above are important, but not *essential* to the meaning of art. Their answers are also, without doubt, culturally-relative. If we could gather in a room all these artists— the Pettways of Gee's Bend, the sculptor of the *nkisi*, Christo, and Kurt Schwitters—and put these questions to each of them—one would have a very lively discussion, indeed.

We have discussed at length the importance of materials in creating meaning in a work. In the next chapter, we will begin to examine in depth how composition—the visual elements and principles of design—impart meaning as well. These elements and principles speak in representational art, in conjunction with the "picture," to influence the viewer's perception of the work. In non-objective art, they must do the "heavy lifting"—suggesting ideas and feelings to the viewer in the absence of recognizable imagery. They are powerful tools that *every* artist uses to be effective. Without them—or at least, the *idea* of them—there is no art.

New Vocabulary in Chapter 4

Arts and Crafts movement	Art movement of the late 1800s, calling for a return to hand-crafted work and communal art-making
assemblage	Three-dimensional collage
crafts	Art media consisting of common, inexpensive materials, often serving a practical purpose
earthwork	Site-specific landscape-based artwork, made from, in, or on the earth
Gee's Bend	Location in Alabama, site of a former slave plantation
Minimalist, Minimalism	Art movement beginning in the 1960s, featuring non-objective work with simple geometric forms and spatial characteristics
Nkisi	Sacred figure, Kongo culture
non-objective	Style of art, featuring no recognizable, nameable objects
non-representational	Style of art in which no things/objects are represented; non-objective
site-specific	Artwork that gains meaning from its site (placement)
Zen garden	Common name for Japanese rock garden, designed to enable Zen meditation

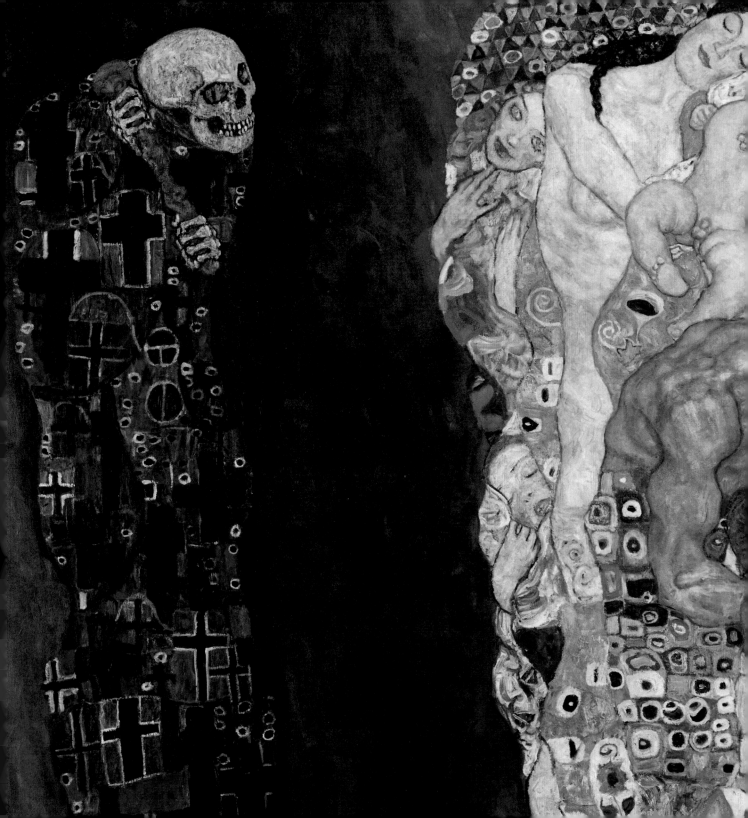

5

5 BETWEEN
THE
LINES

5: BETWEEN THE LINES

THE VOCABULARY OF LINE AND TEXTURE
DRAWING MEDIA AND TECHNIQUES

Line is one of the most basic tools of communication known to humankind. The ability to "read" lines effectively was a factor in early human evolution. Of course, our ability to develop written languages stems from our facility with line-making and line-reading. On a more basic level, however, a human who could easily perceive the diagonal lean of an uprooted tree would have had a distinct advantage over someone who failed to notice the subtleties of line—and who would be more likely to be crushed when the tree fell over. Conversely, the human who could accurately read the sleeping, horizontal position of the woolly rhinoceros would be more likely to sneak safely past it. We humans have developed an incredibly sensitive ability to perceive the most subtle visual differences. This ability was fine-tuned through millennia, as our ancestors learned how to differentiate an angry posture from a welcoming one—a key ability in forging community ties (not to mention hooking up with that handsome *Homo sapien* next door!).

Line Direction

The first element of line vocabulary we will examine is ***line direction.*** Notice that the more welcoming posture is also the more **vertical** one. A vertical line suggests alertness, stability, and predictability—sudden movement is not likely, at least not in the immediate future. The vertical line gives the viewer confidence; it is safe to approach.

In contrast, the **diagonal** posture of the gloomy figure on the left suggests instability; movement is imminent. We should be wary in our approach, and perhaps we should ready ourselves, to move out of his way.

Keep in mind that, with any vocabulary, context is important. The human mind processes hundreds of visual cues per second, weighing the different vocabulary signals and their potential meanings, while sorting through sometimes-contradictory visual information. Throughout this chapter, we will examine how different line vocabularies work together to create more emphatic or more nuanced meaning.

On the next page we have a picture of two figures in a running pose. Clearly the one on the left "feels" more in motion, since his body is

Diagonal lines (left) indicate action; vertical lines (right) indicate stability. Illustration by the author.

forming a strong diagonal line. Although we can see that the figure on the far right is moving his arms and legs, the strong vertical and horizontal pull of those implied lines brings him to a standstill.

Because the human eye is such a sensitive instrument—and the human brain is very willing and quick to pick up patterns—the mere presence of diagonal lines alone will not fool the eye into thinking "movement!" In this diagram, you see two boxes, filled with nothing *but* diagonal lines—and yet, the overall vertical shape of the first box, together with the overall vertical pattern of the marks, shouts "vertical!" to your eye. Similarly, in the second box, the implied horizontal band creates a stabilizing effect that overrides the moving diagonals within.

This effect is most pronounced in the case of the triangle—a shape that is made from two diagonal lines, and yet is the most stable shape in the human vocabulary. Here the diagonals, so even in size and force, cancel each other out—forming one big vertical line for the eye to follow. Note that an "X" shape gives the same effect, the two diagonals forming an overall rectangular shape.

Remember Kasimir Malevich's *Woodcutter* (1913) from Chapter 3? Here the artist wished to convey the noble strength (both physical and moral) of the humble worker. Although the man is clearly in motion (his arms, back, and legs form definite diagonals), the overall line vocabulary is strongly triangular, which creates a stabilizing effect.

Not long after creating this work, Malevich began to abandon representational imagery, embracing instead the pure and "uncorrupted" vocabulary of geometric shapes. He called this non-objective approach "**Suprematism**," believing that only non-representational art could capture the very essence of feeling, and offer the most sublime, supreme viewing experience. In the following excerpt, Malevich explains his Suprematist approach:

> When, in the year 1913, in my desperate attempt to free art from the ballast of objectivity, I took refuge in the square form and exhibited a picture which consisted of nothing more than a black square on a white field, the critics and, along with them, the public sighed, "Everything which we loved is lost. We are in a desert … Before us is nothing but a black square on a white background!" … Even I was gripped by a kind of timidity bordering on fear when it came to

Kasimir Malevich, *Woodcutter*, 1913, with diagram of line direction.

*Kasimir Malevich, quoted in Herschel B. Chipp's *Theories of Modern Art: A Source Book by Artists and Critics.* Berkeley, Los Angeles and London: University of California Press, 1968, 341 ff.

leaving "the world of will and idea," in which I had lived and worked and in the reality of which I had believed. But a blissful sense of liberating nonobjectivity drew me forth into the "desert," where nothing is real except feeling … and so feeling became the substance of my life. This was no "empty square" which I had exhibited but rather the feeling of nonobjectivity. … Suprematism is the rediscovery of pure art that, in the course of time, had become obscured by the accumulation of "things". … The black square on the white field was the first form in which nonobjective feeling came to be expressed. The square = feeling, the white field = the void beyond this feeling. Yet the general public saw in the nonobjectivity of the representation the demise of art and failed to grasp the evident fact that feeling had here assumed external form.*

Malevich speaks of "non-objective feeling." Let us now examine in detail how the bold lines in Malevich's non-objective paintings communicate feelings. As we saw in Chapter 3, the combination of vertical and horizontal **implied lines** creates a grid, which helps to impart a feeling of structure and unity. Many works of art use an underlying grid for this purpose. If a composition is *dominated* by vertical and horizontal lines, then viewers will perceive an overall sense of order, predictability, and stability.

This use of line is evident in Malevich's Suprematist composition. He has tipped the blue triangle sideways, so that the viewer's eye follows its motion as it pierces the black rectangle. Overall, our eyes move horizontally as the blue triangle inserts itself, then vertically up the black column. The negative space at the top gives the viewer's eye time to hover briefly, before returning down to the weightier part of the painting—where we begin the cycle once again.

In this example, we see that a work of art with predominately vertical and horizontal lines does not have to be static or stultifying. There is still a sense of movement here; however, the emphasis on vertical and horizontal line ensures that all activity will flow logically and predictably—a ceaseless mathematical fountain; a perfect geometric engine; a powerful and beautifully-ordered system. This composition produces the compelling sensation of assured strength, vitality, and ascendance from physical bonds. This is the feeling of which Malevich speaks.

You might contrast the quiet, epic conflict between triangle and rectangle in *Suprematism with Blue Triangle and Black Square* with this positively giddy Suprematist composition on the next page. Here the little red square near the middle seems to hold it all together, like the pivotal bolt in a teeter-totter. The heavy collection of blocks at the top seem poised for a fall, but in which direction? Here *diagonal lines* dominate, creating a sense of unpredictable movement, action, and instability.

Line Shape

Note Malevich's consistent use of geometric lines in his compositions. In addition to line direction, the **shape of lines** will also have a profound impact

Kasimir Malevich, *Suprematism with Blue Triangle and Black Square.* 1915. Oil on canvas. 66.5 x 57 cm. Stedelijk Museum, Amsterdam, Netherlands.

on the feelings they convey. **Geometric lines** are lines found in geometry—arcs, angles, and straight lines that are regular and predictable. Although geometry is certainly found in nature, these lines are more readily associated with the consistency of a machine, rather than the irregular and sometimes-haphazard growth of a natural organism. **Organic lines,** that randomly change in angle, shape, or thickness, may be used to suggest unpredictability. On a subconscious level, organic lines speak of the susceptibility of all things in nature, including human beings, to erratic growth and decay.

This Chinese lattice design shown below, on the left side, features exclusively geometric lines. Although the circles are interrupted, there is no doubt they would form perfectly round shapes if completed. The zig-zag lines are also geometric and predictable—not sporadic, like forks of lightening or cracks in a sidewalk. The overall impact is one of order, structure, and stability.

The Chinese design on the lower right of the page seems more organic at first glance. The waves suggest the casual movement of water in the sea—but observe closely: the wavy lines are identical and predictable, like sine and cosine waves in trigonometry. We can easily predict how the lines would continue, if they were to extend beyond the limits of the frame.

As we saw in Chapter 3, geometric abstraction—such as the abstract water pattern in the right-hand design—creates a sense of order and perfection above and beyond what Nature herself generally exhibits. The pure geometry seen in math and science is not frequently observed by the human eye, and so it is the organic line that seems more "natural" to us.

Kasimir Malevich, *Suprematist Composition (Supremus #20)*, 1915. Oil on plywood. 72 x 52 cm. The Russian Museum, St. Petersburg, Russia.

Chinese lattice design, one-focus frame. Daniel Sheets Dye, *The New Book of Chinese Lattice Designs* (Dover Publications), p. 22.

Chinese lattice design, parallel waves. Daniel Sheets Dye, *The New Book of Chinese Lattice Designs* (Dover Publications), p. 66.

SPOTLIGHT ON LINE SHAPE: THE PLAY OF ORGANIC AND GEOMETRIC LINE IN ISLAMIC DESIGN

*Idolatry is the worship of idols; throughout history, many religious leaders have expressed concerns that the faithful were worshipping objects, depicting the holy, instead of the holy beings themselves.

**University of Southern California, Center for Muslim-Jewish Engagement, http://www.usc.edu/dept/MSA/introduction/woi_knowledge.html.

In the Islamic faith, images of Allah (a single, supreme god) are not permitted. Traditionally, figural imagery—especially of holy people, such as the prophet Mohammed—is avoided in Islam, out of fear for potential idolatry.* As a result, Islamic art is generally non-objective, featuring intricate geometric and organic shapes, combined with religious statements written in elegant calligraphy.

The patterns found in Islamic art present a complex play of geometric and organic line. The importance of mathematics has a long Islamic tradition. Ancient Greek and Roman treatises on mathematics were translated and preserved by Islamic scholars during the Middle Ages. Our numerical system, including the use of zero, originates in Islamic mathematics. This interest may be linked to beliefs emphasized in the Koran, the book Muslims believe contains the word of God, revealed to Mohammed:

> The Muslim mind has always been attracted to the mathematical sciences in accordance with the "abstract" character of the doctrine of Oneness which lies at the heart of Islam. The mathematical sciences have traditionally included astronomy, mathematics itself and much of what is called physics today. ... As for mathematics proper, like astronomy, it received its direct impetus from the Quran [Koran] not only because of the mathematical structure related to the text of the Sacred Book, but also because the laws of inheritance delineated in the Quran require rather complicated mathematical solutions. Here again Muslims began by integrating Greek and Indian mathematics....**

Left: Koran stand, date unknown. Collection of the author. Hinged at the center, the interlocking wooden panels fold open.

Right: Mohammed Azeem, Dala'il al-Khayrat leaf, c. 1690.
Main text: Arabic (black ink) with Persian translation (red ink, in the narrower lines below). Commentary in the margins. Ink on paper, 7 5/8 × 4".

Left: Koran leaf, Iran, 1400s. Auctioned by Christie's, 2005.

Right: 18th-century prayer rug, Turkey, 1700s. Walters Art Museum, Baltimore.

The page shown next to the Koran stand, from a book of prayers praising Mohammed, features a dynamic composition created solely with rectangles and calligraphy. The organic shape of the commentary, streaming out in two directions from the main text, suggests the energetic flow of faith.

The organic character of *Kufic* and other Arabic forms of writing acts as a visual counterbalance to the geometric patterns of Islamic design. Vegetal curves, called "arabesques" in the Western world, complement passages from the Koran, written in florid calligraphy. In the **illuminated** Koran pages here, note how the writing visually relates to the richly-colored and densely-decorated tapestry of forms surrounding it. The richness of the decoration is meant to reflect the spiritual value of the words.

Muslim adherents traditionally kneel in prayer toward Mecca, Saudi Arabia (birthplace of Mohammed) five times daily. By this practice, the Islamic faith is woven into their everyday lives, just as sacred words are woven through the abstract designs. The lines of the art therefore become a metaphor, a philosophical statement about the integration of faith and life.

This particular rug design symbolically "points" toward Mecca. The architectural motif suggests a *mihrab*—a small alcove in a mosque which tells worshippers in which direction to pray. Its appearance here brings the mosque—and, by extension, Mecca—to the faithful, wherever they may be.

Hector Guimard,
Métropoliain entrance,
originally placed in Paris,
France. Completed 1900.
National Gallery of Art
Sculpture Garden. Photo by
the author.

*As we have seen, the clean
geometry of Malevich's
world soon took over, and
the 1930s and '40s became
best known for sleek,
modern, geometric designs.
Even though non-objective
art like Malevich's remained
unpopular to the main-
stream, the preference for
machine-sharp shapes
dominated everything from
furniture and building design
to the contours of lamps,
clothes, and coffee pots.

**At the same time, Freud's
psychoanalytical theory also
fueled artists of the
Symbolist movement, such
as Edvard Munch.

This tile design from Medieval England, shown below, is made *entirely* of **organic lines.** Notice how active the composition looks—everything appears alive and quivering, imbued with a sense of energy and agitation. These meandering lines have little rhyme or reason to them; they "grow" organically, and there is no way of knowing where they might go, if they should leave the confines of the frame.

It should come as no surprise that the **Arts and Crafts Movement** (discussed in the previous chapter) embraced Medieval designs for their organic character. Remember that this movement swept industrialized societies around the turn of the century (late 1800s through the early 1900s), as artists looked for more natural shapes to combat what they viewed to be the insensitive, dehumanized forms of the machine-driven world.*

In France, the spirit of the Arts and Crafts Movement took shape as **Art Nouveau**, or the "New Art." The sweeping organic forms of the Paris Metro station (seen in this copy in Washington, DC) suggest an exotic plant about to bloom. The elegant lines seem to sprout out of the ground, echoing the experience of the subway riders as they ascend the stairs and emerge from their underground journey. Parisians entering the subway would find the nodding heads of the light fixtures enticing them to descend to the trains below.

This delicate, exotic glass lamp is also invitingly organic in shape. The peacock-like wings on the dragonfly appear as though they could take flight at any minute. Peacocks, dragonflies, and other dramatic creatures inspired Art Nouveau artists, who also embraced the intriguing scarab beetle motif of the Ancient Egyptians.

In Austria, the Art Nouveau movement was known as the **Vienna Secession** or **Vienna Art Nouveau**, championed by painter Gustave Klimt, whom we first met in the Introduction. Klimt and other artists of his group were "seceding" or breaking away from the official, classical style of the Vienna art establishment. They used sinuous, organic lines to symbolize the workings of the inner mind, the psyche, whose mysteries were being probed by the legendary psychoanalyst (and fellow Austrian), Dr. Sigmund Freud. Fears, desires, and the inner motivations behind human action were all reflected in the unpredictable, fluid line of Klimt's paintings.**

In the dramatic painting shown on the following page, Klimt juxtaposes death and life. The cruciform patterns on the skeletal figure of death offer a rare geometry in the scene. The quivering mass of humanity represents life in all its stages, from infancy to old age. Similarly, the patterns Klimt uses to represent life are drawn from a wide range of organic sources—from the flower-like designs at the apex, to the cellular shapes at the bottom, seen as though through a microscope. By using organic line throughout the composition, Klimt suggests the cycle of life and death that is inevitable for all organic creatures. The organic line also imparts an unpredictable energy to the whole piece, suggesting the precarious nature of life.

Left: Old English
Tile Design. Carol
Belanger Grafton,
ed., *Old English
Tile Designs*
(Dover
Publications), p. 19.

Right: Andre
Thesmar, *Mosque
Lamp*, 1891. Musée
D'Orsay, Paris,
France.

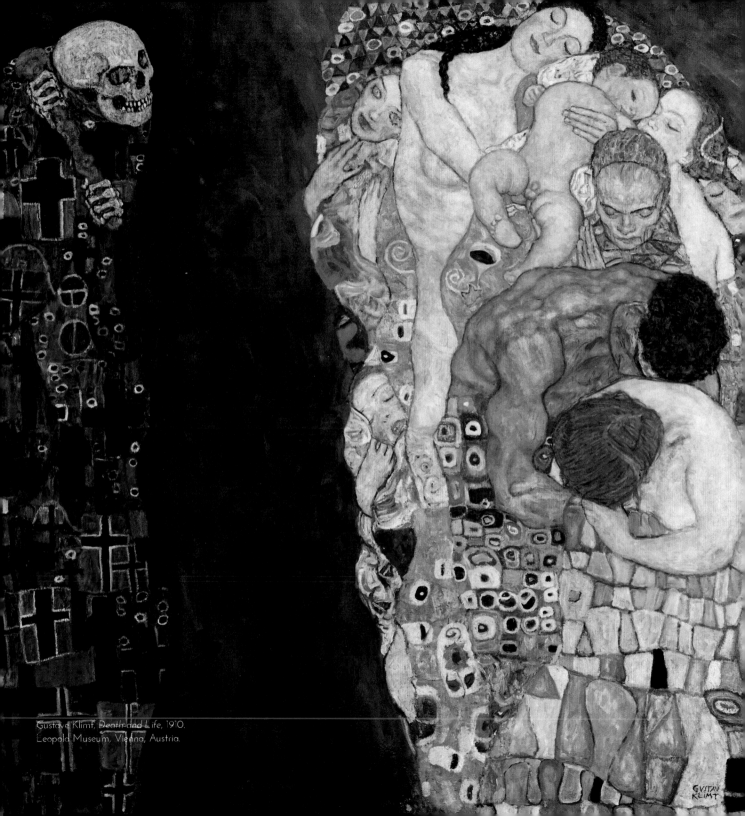

Gustave Klimt, *Death and Life*, 1910.
Leopold Museum, Vienna, Austria.

LINE TEXTURE

One of the most powerful means of communicating via line vocabulary is through *texture* (either real or implied). A **clean line** with a smooth or polished edge—like geometric line—suggests purity and precision. **Rough lines,** like organic lines, are more human—they speak of the texture of human life and experience. As tactile creatures, we respond emotionally to lines that seem coarse and fibrous. We also empathetically respond to any line which seems ripped or torn, faded or faltering. Note, for example, the rough brushwork in Klimt's painting; we can see the separate, unblended brushstrokes, which add visual texture and emotional impact.

In this diagram, note that both sets of lines share the same overall line directions (vertical), as well as the same basic line shape (overall, they are rectangular in shape, and so could be called geometric). The main variable is texture: above, the lines are clean; below, the lines are rough. In the top diagram, the clean edge registers no particular emotion; there is evidence that a ruler, computer, or other tool was used, rather than a free-hand approach. In the bottom diagram, the texture (which is implied by fuzzy, feathered, irregular edges) evokes more emotion from the viewer. We empathize with these marks as being more human, more like us, in their tactile qualities.

Textured line offers an appealing vehicle for personal expression. A group of artists came to prominence in New York City in the 1950s, creating highly abstract and non-objective artwork with rough, textured line.

Dubbed **Abstract Expressionists,** these artists used mark-making and variations of line to express essential emotions and experiences. The Abstract Expressionists presented the line as a universal language—something that everyone could understand, regardless of personal history or culture—as a sort of visual antidote to the divisive and dehumanizing impact of the Second World War.

Perhaps the best-known Abstract Expressionist is Jackson Pollock (1912–1956). He became as famous for his hard-drinking and hard-living lifestyle as for his bold approach to painting, in which he rhythmically moved over canvases on the floor—dripping and flinging paint, and using wide brushes, dipped in house paint. This method became known as **action painting.** The resulting works, such as *Number 4,* appear dense and heavily-textured. Many prize Pollock's canvases in part because the emotional vocabulary of the lines seems to echo the emotional intensity of the artist and the way he lived.*

Jackson Pollock's ground-breaking painting techniques, his bigger-than-life persona, and his early death (driving drunk, he smashed his car into a tree)

Clean lines versus rough lines. It is difficult to draw clean lines by hand without some kind of mechanical aide (from something as simple as a ruler, to a computer). Illustrations by the author.

Pollock in 1950. From photo by Hans Namuth.

*We will return to Pollock's approach to painting in Ch. 10.

Opposite page: Jackson Pollock, *Number 4,* 1949. Oil and enamel paint on canvas, 35½ x 34 3/8 in. Yale University Art Gallery.

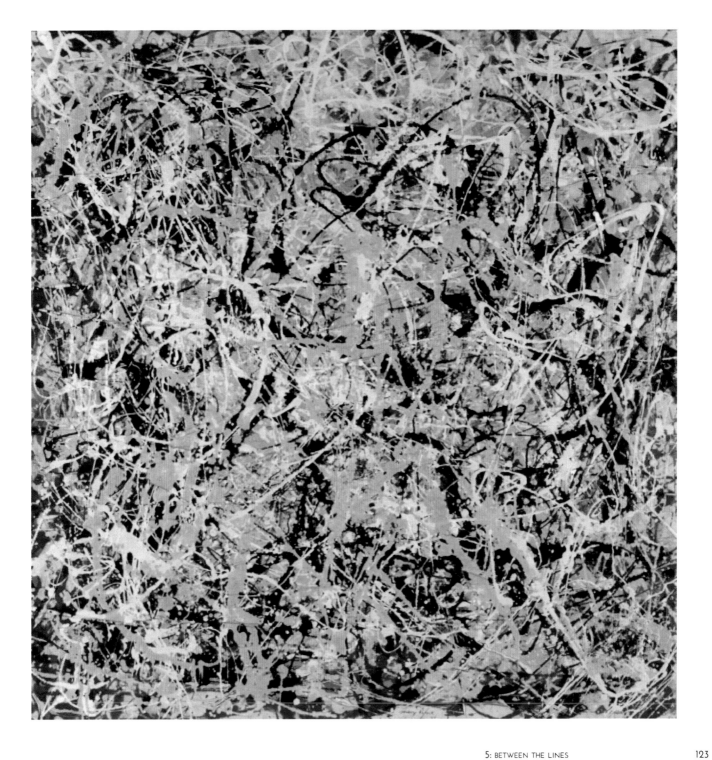

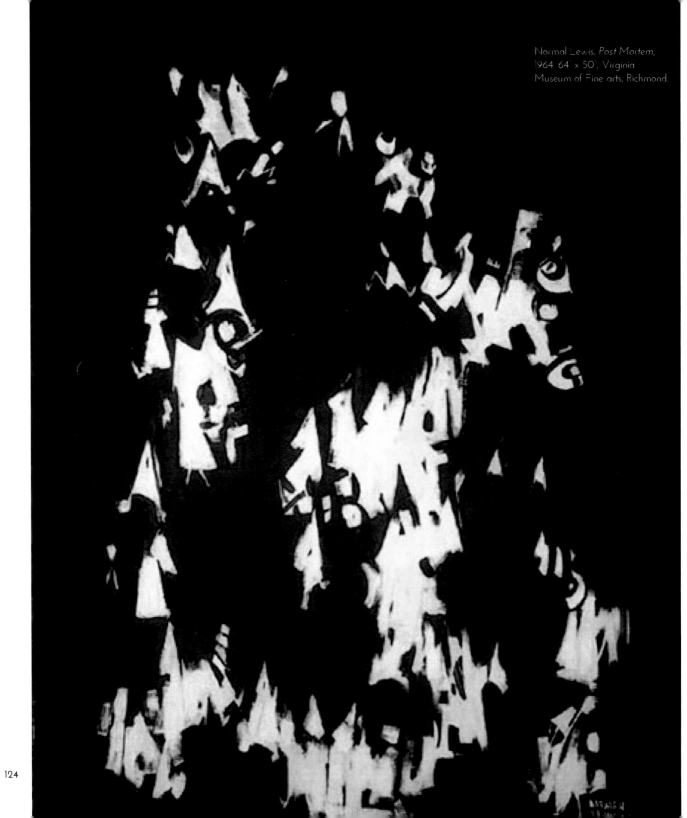

Normal Lewis, Post Mortem,
1964. 64" x 50", Virginia
Museum of Fine arts, Richmond.

ensured his lasting legacy. Regrettably, many great Abstract Expressionists of Pollock's era with less "exuberant" lifestyles have received less attention than they are due.

Norman Lewis (1909–1979) is a particularly interesting example because he began his art career painting naturalistic images during the Harlem Renaissance, but ultimately embraced a non-representational style.** Lewis's rough, emotional marks link his work to other Abstract Expressionists. However, unlike his **Abex** contemporaries, Lewis incorporated his social concerns into his non-representational work. Consider the date and title of the painting, *Post Mortem*, 1964. A *post mortem* is conducted after death to determine the cause. President John F. Kennedy had been assassinated in November, 1963; race riots rocked several cities across the nation in 1964. Lewis's painting might be read as a call for national introspection in the wake of violence and discord. The following excerpt is taken from an interview with Lewis, conducted in New York City in 1968 (the same year that Civil Rights leader Martin Luther King, Jr. and John F. Kennedy's brother, Robert Kennedy, were killed):

HG [Interviewer Henri Ghent]: Are you currently doing any experiments with color or new materials?

NL: It is a good question because I haven't worked consistently in the last year. I have just been dabbling and moving downtown where there are more available things like plastics and different kinds of new paints. I am constantly—I have thrown myself into just building this damn studio for the seven months I have been here. Just three weeks ago I got water. But just walking around Canal Street and in this area I keep wondering with the new things that I see when am I going to paint, what am I going to do. I find that civil rights affects me; so what am I going to paint, what am I going to do. I don't know. And I am sure it will have nothing to do with civil rights directly but I just hope that I can materialize something out of all this frustration as a black artist in America. And I don't think white painters have an opportunity to do it. I think it has to come from black artists.***

Lewis's concerns about civil rights echo throughout *Post Mortem*; the irregular, agitated edges of these roughly-painted shapes express the sadness and frustration that so vexed Lewis's generation, and echo through the present day.

**Lewis was part of the Harlem-based 306 Group to which Romare Bearden also belonged.

***Smithsonian Archives of Fine Art: Oral History Interview with Norman Lewis, July 14, 1968. Here Lewis raises an interesting point—whether some social issues are the sole territory of certain artists, because they belong to, or identify with, the affected group. This question, particularly as it relates to race, will be explored in the final chapter (Chapter 12).

ANALYTICAL VS. EXPRESSIVE LINE

Usually a work of art is dominated by either analytical lines or expressive lines. **Analytical** means "relating to analysis:" using reason and logic to solve problems; having the tendency to place thoughts over feelings; "using your head." **Expressive** or **expressionistic** means "relating to expression:" expressing emotions, unearthing deep feelings, responding "from the gut."

Analytical lines are generally more geometric and clean; expressive lines tend to be rougher and more organic (having an organic shape—or having geometric shapes with rough, organic-shaped edges).

In both of these works by Grant Wood, **analytical lines** dominate. *American Gothic* is named for the Gothic-styled family home behind the farmer and his wife. The peak of the home creates a strong vertical axis, which is paralleled by the rigid verticality of the couple (punctuated by the tongs of the pitchfork). Geometric shapes abound, from the triangular roofline to the perfectly-rounded treetops and farmer's glasses. Grant Wood's fine brushwork creates smooth, precise lines, further suggesting order and calm. Altogether, the analytical line vocabulary speaks of the persistence of traditional values in the Depression-era Midwest. This couple may not be the fanciest, hippest people in the world, but they are dependable and hard-working.

In the right-hand painting, we see the humble birthplace of President Herbert Hoover. A sweeping, organic line runs across the landscape, giving this composition more vigor than *American Gothic*. However, clean, geometric, vertical/horizontal lines still dominate *The Birthplace of Herbert Hoover*. The analytical lines assure the viewer that West Branch, Iowa is a safe, secure, (and tidy) little community—a fitting place to produce an American president.

Edvard Munch's *The Scream* presents a perfect example of **expressive** lines. We last looked at this work in the discussion of abstraction in Chapter 3. Note the roughness of the brushstrokes and the organic waves of emotion that echo through the body of the central figure and undulate through the water and the sky. These expressive lines compliment the **expressionistic** intent of the artist.

Left: Grant Wood, *American Gothic*, 1930. Oil on beaver-board. Art Institute of Chicago.

Right: Grant Wood, *The Birthplace of Herbert Hoover*, West Branch, Iowa, 1931. The John R. Van Derlip Fund; owned jointly with the Des Moines Art Center.

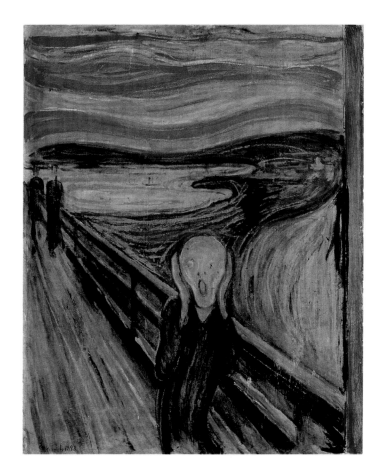

What direction of line dominates here? This is a difficult question; one could argue either case: that the vertical and horizontal lines (particularly the overall horizontal motion of the sky, and the overall vertical direction of all three figures) lock the composition in place; or, that the diagonal of the walkway and the stark orange of the railing pierce through the composition in an overwhelming diagonal. Certainly the tension between the two—vertical/horizontal structure and diagonal motion—helps to emphasize the emotional tension of the tormented figure at center. The rough, organic lines that sweep through his body show unbearable anguish— but his overall vertical direction also suggests immobility. He is quivering with emotion but is impotent to act—trapped and confined in a desperate mental space.

Note how much emotion is lost in this modified image—when geometric shapes replace the organic; clean lines replace rough; and the main diagonals are eliminated.

This diagram illustrates an essential lesson in art appreciation: the meaning of a work of art lies in far more than its literal subject matter. "What it shows" and "what it's about" are distinctly different things. Here, both works "show" a distressed figure standing on a walkway with railings, an orange sky and water. However, the original is "about" an emotional state of being. The modified copy is merely an exercise; it fails to speak to the intellect, *or* to the passions.

Left: Edvard Munch, *The Scream*, 1893. Oil, tempera, and pastel on cardboard. 91 x 73.5 cm. National Gallery, Oslo.

Right: The Scream, made analytical through clean, geometric lines. Diagram by the author.

SPOTLIGHT: *ELEGY TO THE SPANISH REPUBLIC*

Robert Motherwell was a young member of the New York Abstract Expressionist group. His most famous work is a series, painted over five decades, lamenting the fall of the Spanish Republic. Each of these enormous gestural paintings is called an "elegy," a sort of visual poem to the dead, a requiem for a democracy crushed mercilessly by General Franco's forces in the 1936-39 Spanish Civil War. Like Picasso's *Guernica* (see Chapter 3), Motherwell's *Elegies* reflect on the violence of this oppression with expressionistic vocabulary.

While Picasso chose a single, defining atrocity to stand for the larger conflict, Motherwell tackled the vast and terrible scope of Spain's suffering with non-objective imagery.* Bold, black marks crush into the negative space. The heavy vertical strokes suggest an unmovable force; the rough, organic edges chafe against a troubled field of white, blurred with slips of grey and red. Motherwell painted over 170 *Elegies* with this gripping, stark vocabulary, in which a crushed hope struggles to endure against a seemingly endless tyranny. However, this particular painting—which measures over 30 feet long—features a startling breakthrough at its center. Entitled *Reconciliation Elegy*, the work was painted the same year the Spanish people officially took back control of their government. The Constitution of 1978 was hailed as the culmination of democratizing efforts begun after Franco's death, three years earlier. The sheer enormity of Motherwell's *Elegy*, combined with the expressionistic fervor of his composition, echoes like a tremendous cry of anguish, exultation and relief. Not soon to be forgotten, the Franco era was officially at an end—but the hard road of reckoning and reconciliation still lay ahead.

*When trying to encapsulate a great horror, artists often turn to metaphor rather than literal imagery. Perhaps one of the greatest films to address the horrors of fascist Spain in WWII is the fantasy "Pan's Labyrinth" (2006), directed by Guillermo del Toro.

Robert Motherwell, *Reconciliation Elegy*, 1978. Acrylic on canvas, 120 x 363 7/8 inches. National Gallery of Art, Washington. Photos by the author.

Line Analysis

Try to analyze the line vocabulary of these two works. For each, consider dominant **line direction, line shape, and line texture.** Which is more expressive, and which more analytical? How does the choice of line vocabulary impact the feeling of each painting?

Theo van Doesburg, color design for *Dance II*, 1917. Pencil, ink, and gouache on paper. 22 x 11.4 in. Kröller-Müller Musem.

Gustave Klimt, *Goldfish*, 1901–02. Oil and gold on canvas. Swiss Institute for Art Research, Zurich.

129

DRAWING MEDIA

As noted in the introduction, one of the key decisions an artist must make is the choice of **media** (singular: medium). The **medium** is the actual, physical material that the artist uses, along with whatever techniques the artist applies to the material.*

*You might hear the word "medium" used in conjunction with acrylic paint (such as "matte medium" or "gel medium." In this context, medium is the clear fluid that is combined with acrylic paint to achieve various effects (to thin it out, give it body, etc.).

The choice of **drawing medium** directly impacts the kind of lines the artist can make. Artists often choose certain drawing materials because of their inherently expressive—or analytical—nature. For example, would you prefer to write with a mechanical pencil on paper, or a big piece of chalk on a sidewalk? Your response would depend on many factors, including what you needed to write, whom you would want to see it, and your own personal preferences about how and where you like to work. Note that your choice would include not only the material you worked with, but also the **support**—the surface (paper, sidewalk) that would receive and hold the marks left by the material.

Most drawing media are composed of **pigments** (the dry material which produces color) or **dyes** (liquid color material), held together by a **binder**. The binding agent in crayons, for example, is wax. Note that the cost of drawing materials lies in the pigment; the cheaper the material, the more it is "padded" with a binding agent.

There are many different kinds of drawing media available to artists, and each medium can produce a variety of different marks. However, most media are selected to produce a specific, desired line shape or texture. Let us take charcoal as an example.

Charcoal

No doubt **charcoal** is one of the oldest drawing media, particularly because all you need is a charred piece of wood (or bone) and a handy cave wall to get started. Today charcoal comes in various shapes for handling, and various densities (levels of compression), which determine how dark and rich a mark one can make. Generally, the short and squared sticks are more dense, and offer a heavy black mark which is difficult (if not impossible) to erase. The long, rounded sticks, known as vine charcoal, tend to make much softer grey marks, which may be strategically erased to create highlights. Like most drawing media, all charcoal smudges easily, and must be sprayed with a fixative, in order to prevent transference onto everything and anything with which the drawing might come into contact.

Drawing media: Ink (left); vine and stick charcoal (right). Photo by the author.

The most common support for charcoal is paper. Newsprint is often used by art students, because it is cheap for its size, and plentiful. However, newsprint is a more fragile support than most papers, and deteriorates most rapidly. Fine artist papers are always acid-free. Acids, which progressively "bite" or eat away at organic materials, exist everywhere in nature (including in the oils on your skin, which is why you are entreated not to touch anything in a museum).

Fine art paper varies in its amount of texture, which is created during the last stages of the process in the factory, when the nearly-finished paper is rolled through giant cylinders (drums or rollers). **Hot-pressed paper** (paper run through a series of warmed

Kathe Kollwitz, *Self Portrait,* 1924. Charcoal on paper.

rollers, which essentially iron the paper fibers) tends to be smoother, without as much "tooth" as **cold-pressed paper** (run through a series of cold rollers). Charcoal applied to a cold-pressed paper support will create rougher-textured lines than charcoal applied to a smooth, hot-pressed paper.

Regardless of the support, charcoal is most often used to create loose, textured, and expressive lines. When the edge of a piece of charcoal is applied to the paper, a fine line is produced. However, one of the great advantages of charcoal is its ability to create wide marks when held on its side. A short piece, held in the middle, can create a wonderfully thick and expressive mark with one sure, powerful stroke.

The use of charcoal to create an expressive work of art is clearly illustrated in this charcoal self-portrait, created by German Expressionist Kathe Kollwitz (whom we met in Chapter 3). Note the way she holds the piece of charcoal in her hand. Note also the potent energy of the marks which delineate Kollwitz's arm; these same strokes were made by that very arm, as she drew this work.

The Traditional Western Approach to Drawing

In drawing classes far and wide, one of the best training exercises is the charcoal **gesture drawing.** The model stands on a raised platform, holding a pose for mere minutes—if not seconds. In that brief span of time, the student must capture the essence of the pose, blocking in basic muscles and motion, areas of light and dark, and accurate body proportions. In gesture drawing, the typical student's preferred method (draw a little, erase a bit, draw a bit more, fuss a bit more, and so on) is not an option. Charcoal is the ideal medium for this exercise, given its properties (discussed above) that allow quick, broad mark-making—and discourage fussing. A "wrong" mark is corrected by placing a stronger, more assured mark over it. Charcoal does not reward the timid mark-maker!

Here are three charcoal **gesture drawings**, executed by the author as an undergraduate in a life drawing class. All were drawn from nude models who were holding their poses for brief periods of time.

Left: In this gesture drawing, the figure is defined by the negative space. The areas around the figure were quickly drawn with the thick side of a charcoal stick, allowing the untouched paper to represent the figure itself.

Right: Here, three poses are arranged on one sheet of newsprint. Whether drawing one figure or three, the artist must consider not only the problems of anatomy and proportion, but also the problem of composition. The figure (or figures) must be arranged in a dynamic way on the page, maximizing the impact of the negative space. When making a quick gesture drawing in charcoal, the student must do all of this "on the fly." Note that the figure on the far left appears lighter than the other two. This figure was sketched using vine charcoal; the middle and right-hand figures were sketched in the denser stick charcoal.

Typically, art students studying figure drawing will work from the nude model. This tradition is centuries-old in the Western world. Following the examples of the Greeks and Romans (see Chapter 1), the Italian Renaissance artists found study of the nude body to be necessary, in order to understand the interrelation of muscles and the overall structure of the human figure. Artists since the days of Michelangelo and Raphael have continued to work from the nude model as an integral part of an artist's training. This tradition brings to light several important cultural issues. Let us look at each in turn. (Along the way, we will meet a few more types of drawing media.)

Michelangelo, *Study for Adam, Sistine Ceiling.* Red chalk on paper, c. 1510. British Museum.

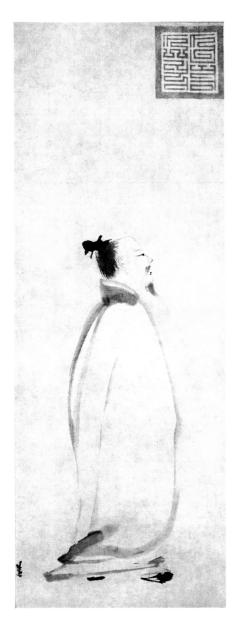

Liang Kai, *Li Bo Chanting a Poem*, mid-1200s. Hanging scroll, ink on paper. Chinese, Southern Sung Dynasty. National Museum, Tokyo.

*In Chapter 11, we will further explore expressive mark-making in Asian art.

"Just a sketch"

Drawing has been a fundamental part of an artist's education, but that is both a blessing and a curse for the medium in the Western world. Until fairly recently, drawings had long been considered a "practice" medium—the medium you use to enhance your hand-eye co-ordination and ability to "see" with accuracy; to decide compositional layouts and fine-tune the placement of figures and objects; and to flesh out rough ideas before making the "real art"—the final product in paint, marble, or other (more lasting) fine art media.

Although you will see drawings by Renaissance masters in museums today, these artists never meant for their **cartoons** (preliminary sketches, used to work out compositions for paintings or tapestries) to be shown. Renaissance artists like Michelangelo, whose study for Adam on the Sistine Chapel is shown on the previous page, often used **chalk** for their draw-ings. Like today, chalk (a mineral) was relatively inexpensive. Paper, on the other hand, was difficult to make and fairly rare in the West. Wood panels were an available alternative, and a far less expensive support than paper's predecessor in the West, which was **vellum** (treated calfskin or other fine animal hide), used for medieval manuscripts.

Even today, there is still a sense of second-class citizenship for small drawings on paper, which are often dismissed as "just a sketch." You might contrast this anti-drawing bias with traditional Eastern attitudes towards work on paper. While Michelangelo was painting his prized Sistine Chapel in Italy, Chinese and Japanese artists were making drawings equally prized by *their* patrons—not only as "finished" works of art, but as valuable testaments to the artists' skill and ingenuity. How could a medium dismissed in one culture be held as a high art form in another? The answer lies, as expected, in cultural values and belief systems. Traditional Eastern attitudes toward mark-making are inextricably linked to such philosophies as Taoism and Buddhism. Viewers are encouraged to find depth of meaning in a single mark—to look for the subtle shifts of texture and quality, as they explore the evocative qualities of line.

Liang Kai's hanging scroll offers a fine example of Chan (Zen) Buddhist philosophy in action. Although often called "brush paintings," many handscrolls and hanging scrolls, such as this work, are actually drawings. The medium is **ink,** not paint. (If you have ever tried to use paint instead of ink with a rubber stamp, you surely appreciate the difference!) Ink pigment may be bought as a powder, or as a solidified stick that must be ground on a stone, and mixed with water; or, it may be purchased as a ready-mixed liquid. In a concentrated, pigment-heavy state, the ink mark is dark and rich (note the deep tones of the Chan poet Li Bo's hair). Diluted with water, ink can make a very soft, subtle mark.

Ink can be applied with any number of applicators. In the example here, the ink is applied with a brush. Varieties of line width are achieved by the amount of pressure exerted by Liang Kai on the brush; with minimal pressure, only the tip of the brush touches the paper, and a fine line is produced. Pressing harder, the artist forces the wider portion of the brush in contact with the page, making a broader mark.

The artist may also modulate the amount of line texture by varying the amount of water in the brush. In the **dry brush** technique, the brush has little water, and leaves a dry, expres-sive, scratchy mark—picking up the texture of the paper as the brush hairs drag across the surface. With more water, a softer and less textured line is achieved—but bleeding, watery effects can possess their own distinctly-expressive qualities.

Observe the expressive variety of lines created in this brush-and-ink drawing. Expressive lines are also possible in **pen-and-ink** drawings; however, the brush often lends itself to more emotional mark-making.*

CONTOUR LINE DRAWING

Rather than "fill in" the figure with shading, traditional Asian drawings often emphasize **contour line.** Contour lines define the edges of surfaces as they meet, fold, and separate. They include both the **outline**—which marks the boundary between the object and its background (between positive and negative space)—as well as all the "inside lines," which define the contours of shapes within an object. Note the extensive use of contour line in Liang Kai's brush-and-ink drawing.

The ink drawing of a nude, above, is an example of a **contour line drawing,** executed in the unforgiving medium of ink on paper (note the mistake in the outline of the model's calf).

An affordable art-school alternative to ink brushes is stick-and-ink. Any twig that has naturally fallen from a tree may be snapped into a pencil-sized stick. Provided the stick has been broken at an angle, it can act as a quill, holding sufficient ink to create a wide variety of marks. In fact, the contour line drawing above was created in stick-and-ink, not with pen-and-ink or a brush.

This drawing is by Egon Schiele, an Expressionist artist working in the early 1900s. As with other turn-of-the-century European artists, the Austrian-born Schiele was interested in the emotional potential of contour line, found in traditional Japanese brush drawing. Note how assured Shiele's charcoal lines appear here, drawn as though without care or effort, but utterly effective and convincing in rendering the pose.

Left: Egon Schiele, *Seated Nude with Bent Left Knee*, 1918. Watercolor and charcoal on paper. San Francisco Museum of Modern Art. Photo by the author.

Above: Contour-line drawing, ink on newsprint; undergraduate exercise by the author.

Women "safely" drawing from a naked cow.

THE (MALE) ARTIST'S EDUCATION

We have noted the lowly status of drawing in the traditional Western world, and its use in training artists in anatomical study. This tradition of drawing from the nude model created a particular barrier for women students. Such exposure to the naked body was considered inappropriate for ladies. Society feared that the sight of so much flesh might be corrupting to women's moral values, and the mere notion was considered scandalous. With a separate-and-not-equal drawing education, women were placed at a distinct disadvantage in the competitive art world.

To emulate paintings, or not?

In the 1800s and earlier, setting up an artist's studio required acceptance by the art world, which included a reputation as a good, up-and-coming artist; financial backing; and the seal of approval from the national **Academy**—a sort of artist's union composed of upper-class artist-gentlemen who decided which artists were worthy of joining the ranks, and getting the big, important commissions (history paintings, portraits of the wealthy and powerful, etc.). Some academies, such as the Royal Academy in London, England, set limits on how many women could join; after the French Revolution, the French Academy barred women entirely, until 1936. Without official support, many women artists could not set up the kind of studios that would be necessary to paint large oil paintings. Drawing media offered women a friendly alternative; although often snubbed, drawings required less set-up, were less expensive to produce, and could be worked on sporadically (a helpful feature for artist-moms, given the unpredictable timing of household demands).

As a life-long single woman working with limited resources in 1700s Venice, Italy, Rosalba Carriera shows the power of drawing as an effective (and sufficiently lucrative) option to painting. This portrait of an opera star was drawn in **pastel.*** Note how much like a painting this drawing looks. In this era, in order to "stand" on

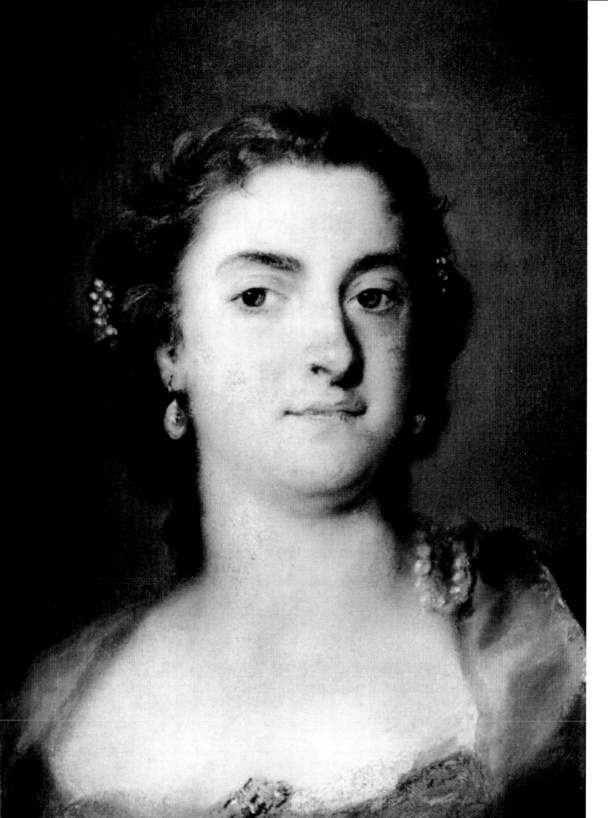

Rosalba Carriera, Portrait of
Opera Singer Faustina
Bordoni Hasse, 1730s. Pastel
on paper. Ca' Rezzonico.

its own as a finished and sellable work, a drawing had to give the illusion of paint. Carriera's mastery of the medium is undeniable here, as the painterly illusion appears complete.

By the late 1800s, attitudes in the academies had not changed—but the art market had. Radical artists who flouted Academy rules were finding new patrons, who were seeking adventurous, **avant-garde** artwork to reflect their individuality and modern tastes.* The Impressionists burst onto the art scene in the 1870s, with loose brushwork and everyday subject matter (see the discussion of Monet's scantily-painted *Impression: Sunrise* in Chapter 3). In the 1880s and 1890s, the Art Nouveau and Arts and Crafts artists brought a radical, nature-inspired look to every conceivable form of design, from jewelry and lamp shades to painting and architecture; their art, too, circumvented Academic expectations. From this experimental age emerged the highly unorthodox art of Henri Toulouse-Lautrec.

Toulouse-Lautrec came from an aristocratic family, but eschewed the insulated life of an upper-class French gentleman—preferring instead the company of the bar-room and dance-hall. Afflicted with a number of ailments, including a degenerative bone condition that prevented his legs from growing after they had broken in childhood, Henri was an artist attracted to others who seemed marginalized by mainstream society. He created insightful and sympathetic images of dance-hall performers, absinthe-drinkers, and prostitutes.

Rather than create drawings that emulated or mimicked paintings, Toulouse-Lautrec gave his pastels free reign as drawing media. Like many Western artists of his time, Toulouse-Lautrec found inspiration in Asian drawings and prints. As in Liang Kai's work, the lines in Toulouse-Lautrec's work carry expressive power. The viewer feels that he or she has been granted a "back stage pass" to the lives of his subjects. We see candid, unguarded moments, when the spotlight has been turned off, and clients have gone home.

Toulouse-Lautrec's *Alone*, which looks so much like a pastel drawing, is actually painted in oil on cardboard. Note the extensive use of the dry brush technique here, which simulates the mark of a dry drawing medium. Toulouse-Lautrec's brushwork is rough and unblended, allowing the color of the cardboard to become an active part of the composition. The prostitute's black stockings expressively punctuate the scene; she is finally alone, the rough contours of her body sinking into the bed.

The bold and expressive mark-making of late-19th century artists like Toulouse-Lautrec and Edvard Munch paved the way for expressionist artists in the next century. Kathe Kollwitz's embrace of drawing and its expressive power would surely have stunned Rosalba Carriera— who had worked so hard to subdue that unruly medium.

Henri de Toulouse-Lautrec, 1892. Musée Toulouse-Lautrec, Albi, France.

*"Avant garde" is an art term borrowed from military practice—the "vanguard" or elite fighters who infiltrate enemy lines ahead of the main force.

Henri Toulouse-Lautrec,
Alone, 1896. Oil on
cardboard. Musée D'Orsay,
Paris.

SPOTLIGHT: THE ANIMATED LINES OF WILLIAM KENTRIDGE

South African artist William Kentridge uses traditional drawing techniques in a modern media. Shooting frame-by-frame every change he makes in his charcoal drawings, his animated films convey strong emotion through expressionistic line vocabulary. His gestural, candid drawing style, rendered with heavy charcoal, opposes the expectation of animated films to be as slick and polished as possible.

Kentridge's use of the media relates to his personal background and cultural concerns. In "History of the Main Complaint," Kentridge addresses the destructive effects of Apartheid in his hometown of Johannesburg, South Africa.* By using his own likeness in the animation, Kentridge acknowledges his own part in that history, as a South African of Dutch descent. Through his unique combination of media, Kentridge engages the viewer on a personal, visceral level.

*Apartheid was the policy of racial segregation and discrimination enforced by the South African government, ruled by a minority of Dutch heritage, from 1948 to 1990. See Stanford University's site, "The History of Apartheid in South Africa," for more information: http://www-cs-students.stanford.edu/~cale/cs201/apartheid.hist.html.

William Kentridge, "History of the Main Complaint," stills, 1996.

New vocabulary in Chapter 5

Abstract Expressionism, "Abex"	Expressionist art movement beginning in the late 1940s/early 1950s
Academy	National group of established artists (1600s–1800s)
action painting	Method of painting used by Abstract Expressionists
analytical	Relating to analysis (dispassionately reasoning with logic)
Art Nouveau	Art movement of the late 1800s embracing natural forms
avant-garde	French term for the riskiest job in combat (adopted by risk-taking artists)
binder	Material used to hold pigment together in a stable form
cartoon	Preparatory sketch used to guide a painting or tapestry
chalk	Drawing medium composed of calcite and other elements
charcoal	Drawing medium composed of carbon and other elements
cold-pressed paper	Paper produced with a rough texture
contour line	Line that defines the edges and folds of shapes
drybrush	Technique in painting or brush-and-ink in which the hairs of a brush appear as scratchy, "dry" marks
expressive	Showing emotion
Expressionism, Expressionistic	Art movement of the early 1900s emphasizing emotional expression and exposing inner psychological states
geometric line	Line found in geometry (inscribing parts of, or entire, geometric shapes)
gesture drawing	Technique in which overall shapes of the figure are loosely drawn
hot-pressed paper	Paper produced with a smooth texture
illuminated	Decorated with colorful imagery
ink	Drawing medium composed of inks or dyes
Koran	Writings believed by Muslims to be God's words given to Mohammed in the 7th century
organic line	Line found in natural forms susceptible to growth, change and decay
outline	Line that defines the outside edge of a shape
pastel	Drawing medium composed of pigment with a binder
pen-and-ink	Drawing technique using a pen to apply ink
pigment	Material having color, usually ground to a powder
support	Material on which drawing or paint media is applied
Suprematist, Suprematism	Art movement of the early 1900s begun by Kasemir Malevich, advocating geometric, non-objective art
texture	Real or implied surface variation
vellum	Animal skin used as pages in Medieval books
Vienna Secession	Art movement of the late 1800s linked to Art Nouveau

6 LIGHT & SPACE

6: LIGHT AND SPACE

DRAWING TECHNIQUES TO SUGGEST LIGHT AND SPACE
THE PSYCHOLOGY OF LIGHT AND SPACE

In the previous chapter, we found that the drawn line could evoke powerful emotions in the viewer. In this chapter, we will further explore the evocative power of certain drawing techniques to suggest depth—emotional depth, as well as the illusion of spatial depth. From there, we will examine the role of light and space in art's psychological impact.

HATCHING, CROSS-HATCHING, AND STIPPLING

In drawing, lines often serve to "flesh out" the shapes of things, to suggest the mass and volume of a form. This three-dimensional effect, called **modeling**, is achieved by shading—using varying levels (gradations) of darkness to suggest the play of light and shadow upon an object, or within a space.

Left: Grayscale, with 20 variations in key.
Upper right: Hatching, drawn from the left.
Middle right: Hatching, drawn from the right.
Lower right: Three bottles with hatching.

*There are several terms that are commonly used to address the lightness and darkness of artwork. You might see the word **tone** instead of key. **Value** is also frequently used to speak of brightness; a light work of art has "high value," while a dark work has "low value." Since the term "value" can also mean "worth," it can be misleading (and potentially offensive, if taken out of context).

A gray scale charts an incremental progression from light to dark (or dark to light), omitting the potentially-distracting element of color. Note the subtle shifts in **key** from one square to the next. In photography, the term **high key** refers to images that are very bright; **low key** applies to dark images.*

Often art students will use their fingers or a blending tool to smudge a pencil mark and create a gray tone. However, this approach can often dull a potentially rich drawing—robbing it of texture and obscuring the emotional quality of the line. The shading techniques of hatching, cross-hatching, and stippling imply texture and preserve the emotional quality of line, while enhancing the illusion of depth.

In the technique of **hatching**, parallel lines are drawn close together, to create gray. Rather than draw a continuous zig-zag line (which can appear haphazard), the artist picks up the pencil (or pen or other drawing medium) at the end of each hatch line. Beginning the next line, the artist will put a little extra pressure on the pencil as it hits the page, resulting in a slightly heavier, darker mark. Towards the end of the hatch-mark, the artist tends to "lighten up," reducing pressure on the pencil prior to "lift off." As a result, each hatch-mark can feature its own subtle gradation from dark to light.

Although the process sounds laborious, artists learn (through practice) to draw hatch-marks with easy and rapid precision. Note that, for left-handed artists, hatch-marks are more easily drawn from upper left to lower right, as in the drawing above. Right-handed artists are generally more comfortable **hatching** from upper right to lower left.

Note also that the hatch lines in both drawings are slightly curved, owing to the natural motion of the hand. This curve can be exaggerated to enhance the sense of three-dimensionality in drawn objects. For example, the rounded forms of the three little bottles on the previous page are shaped by arcing hatch lines.

Crosshatching with four variations in key.

Cross-hatching is the cross-cutting of two or more sets of hatch lines at different angles. In crossing, the conflicting tracks create a grid or "X" pattern. Above is a cross-hatching gray scale; with each box, an additional set of hatch marks is added, creating a denser, darker, and richer network of crosshatching as we proceed from left to right.

In her **silverpoint** work, Seattle-based artist Alma Chaney creates a delicate network of hatching and cross-hatching lines. A trained violinist with an interest in Zen philosophy, Chaney uses line and shading to suggest not only the playing of musical notes, but also the poignant intervals between notes—moments of silence which are equally essential to the musical experience.

Silverpoint is a medium that became commonly used in the Renaissance for fine, detailed drawings. As the name suggests, marks are made by the tip of a slim rod of silver, fitted into a holding device as one might fit a piece of graphite into a mechanical pencil. The relatively soft silver must be applied to a specially-prepared ground of **gesso.***

As the silver oxidizes and tarnishes, it gains a browner and darker tone. Thus, as Chaney's silverpoint drawings age, they mark time quite literally, as well as symbolically. The variety of line—from delicate marks to rigorously-applied cross-hatching—plays across a finely-polished surface. Areas of oil paint play across these fields of hatching, and vice versa. Note that the scale of this mixed media work is small and intimate. Instead of being a grand statement about the impact of time, this hand-sized work allows the viewer to have a personal reckoning with time's passage.

*Gesso was traditionally mixed by hand, using calcium carbonate and rabbit-skin glue. Today gesso is commercially available as a synthetically-made acrylic polymer, most often used to coat canvases and wood panels prior to painting. Because the quality of the gesso is so important in silverpoint, Chaney mixes her own.

Alma Chaney, *Untitled #7*, 2012. Oil, Silverpoint, Goldpoint, 16 x 16 in. Detail at right. Photo by the artist; reproduced with permission.

Note that *Untitled #7* also includes goldpoint, in which a fine piece of gold is used, instead of silver.

*The practical meaning of *chiaroscuro* depends on the context; in technical discussions about art (especially Italian Renaissance painting), it means the gradual shift from light to dark (which is the definition we will use here). More broadly, *chiaroscuro* is used to mean the strong contrast between light and dark (for which we will use the more accurate term, *tenebrism*).

Stippling is the use of short, dotted marks to create shading. The denser and/or heavier the application of dots, the darker the image; the looser and/or gentler the application of dots, the lighter the image (see diagram, below right).

Notice that the stippling technique tends to produce a softer image overall than hatching or cross-hatching; however, the softened effect still maintains an illusion of texture and dimensionality.

The use of gradations of light and dark to create the illusion of depth is called **chiaroscuro**—an Italian word which literally means light-dark (*chiaro-scuro*).* In the stippled drawing of a vase, the gradual shift toward the darkness on the right indicates that the light is coming from the left, where we see a **highlight** on the vase. A sliver of **reflected light**, on the side of the vase farthest from the light source, helps to distinguish the object from its shadow and keeps the right side from disappearing into the darkness.

Left: vase drawn with stippling.
Right: Stippling with two variations in key.

Close-Up on Chuck Close: Stippling on a Grand Scale

This oil painting is a large-scale example of stippling. Here, artist Chuck Close used his fingertips (pressed in oil paint) to create the stippled dots. The technique adds character to the portrait of Fanny, Close's mother-in-law. Though the image looks like a photograph, photography is just the first step in the artist's process. Working from a photograph, Close scales up the image, creating a super-illusionistic painting on a grand scale (notice that Fanny is over 8 feet tall!).

If you look closely, you will see that this painting is created entirely of stippled marks. Close applied touches of oil paint with his fingertips to suggest light and shadow, as well as the fine textures of hair, skin and clothing. The texture of the stippling speaks to the richness of Fanny's experiences—a tribute to the power of many small gestures over the course of a lifetime. The large scale of the painting honors Fanny's gentle and resilient spirit, even as it reveals the wear of age. We will meet Chuck Close again, and further examine his unique approach to portraiture, in the next chapter.

Chuck Close, *Fanny/Fingerpainting*, 1985. Oil on canvas, 102" × 84." National Gallery of Art, Washington, DC.

Raphael (Raphaello Sanzio),
School of Athens, Stanza
della Segnatura, Vatican,
Rome. Fresco, 1510-11.

THE PSYCHOLOGICAL IMPACT OF LIGHT AND SPACE

In Chapter 1, we noted the Italian Renaissance interest in depicting naturalistic scenes, inspired by Greek and Roman subjects and reflecting the Greco-Roman style. In Chapter 2, we observed the use of linear perspective in Italian Renaissance painting to create the illusion of three-dimensional space. The Italian Renaissance approach emphasizes beauty and reason; the art and architecture is designed to stimulate the mind with a logical and orderly view of the world—a model of rightness and perfection to which the viewer might aspire. This mindset is reflected in the Italian Renaissance artists' use of the visual elements of light and space.

Italian Renaissance Light and Space

Renaissance light reveals the subject, so that the viewer can see it clearly; shadows are used to indicate the direction of the light source (typically, sunlight coming from above or through a window) and to suggest three-dimensionality. Light and shadow are meant to reveal, rather than obscure.

This logical approach to light goes hand-in-hand with a rational treatment of space. We have already seen how linear perspective can suggest an infinitely-deep space, reaching back toward the horizon. Italian Renaissance art also tends to feature wide-angle views, with clear, open areas. The space in more-populated scenes is often "managed" in organized groupings, with an emphasis on geometric and linear layout to avoid a tangled or jumbled look. There is plenty of "breathing room" between the viewer and the subject; we are allowed to take a step back, to take in the full view.

With its clear, natural light and deep, orderly space, Raphael's *School of Athens* offers a useful example of Italian Renaissance psychology in action. The figures of the Greek philosophers and scientists here are defined by a logical and convincing **chiaroscuro** (pronounced key-yarrow-ski-YUR-o). The light strikes the figures from above-right, creating areas of highlight and shadow. With voluminous and carefully-modeled folds, each robe suggests the presence of a three-dimensional, corporeal* figure beneath.

The placement of Raphael's painting—one of four painted above the doors of the Pope's spacious library in the Vatican—further contributes to its psychological effect. As the photos here show, the viewer must necessarily stand at a distance from the painting to really see it, given its position above eye-level on a big wall. The visitor has the requisite space to stand back and "take it all in." We are encouraged to take center-stage—a position of reassurance and command. From this vantage point, we are not compelled to be intimately, emotionally engaged.

* The term "corporeal" derives from the Latin word, *corpus* (body), from which we get the word "corpse." A corporeal figure has the appearance of a three-dimensional body. A non-corporeal figure would look flat, floating, or ghost-like—having no "body" or fleshly volume.

The use of light and space in this monumental fresco painting mirrors the philosophical standpoint of Pope Julius II, who commissioned the work. To a "Renaissance man" like Julius, the great ancient Greek thinkers—philosophers like Plato and Aristotle, as well as mathematicians and astronomers such as Euclid and Ptolemy—represented the highest human aspirations. As the leader of the Catholic Church, Julius would have considered these men to be close to God because they used "his gifts" (their mental faculties) so exceptionally, and studied nature ("his creations") so faithfully. In Julius's view, these honorable members of the ancient Athenian intelligentsia shed light on God's works, clarifying scientifically the perfection of God's design. This emphasis on light, clarity, and order is perfectly represented by Raphael's use of a large, open space (both within the painting, and within the setting of the Pope's library) and robust, corporeal figures (rendered—with *chiaroscuro*—in clear, natural light).

Left: Plato and Aristotle stand at the center of Raphael's *School of Athens*, viewed from below. Right: *Parnassus (Apollo and the Muses) and School of Athens,* two of four frescoes by Raphael in the Stanza della Segnatura, Vatican, Rome. Fresco, 1510-11.

Timeline: Renaissance and Baroque. Northern European art is shown above the line; Italian art is shown below the line.

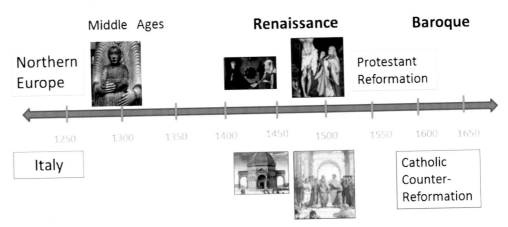

A Tale of Two Renaissances

The Italian Renaissance favored Classical idealism and a rational approach to faith. The **Northern Renaissance** featured a more visceral and emotional approach. We have already met the Italian artist Raphael, whose painting of the crucifixion of Christ is shown here, alongside a work of the same subject by German artist Matthias Grünewald. Note their actual sizes, relative to a six-foot-tall man, on the following page.

Consider, what is the psychological impact of the scale of each? What is the impact of the light and space within each work? Be sure to refer to the timeline on the previous page, in order to situate yourself chronologically and geographically.

Left: Raphael (Raphaello Sanzio), *The Mond Crucifixion (Crucified Christ with the Virgin Mary, Saints, and Angels)*, c. 1502-3. Oil on poplar, 111.5" x 65.9." National Gallery of Art, London.

Right: Matthias Grünewald, *The Small Crucifixion*, c. 1511/1520. Oil on panel, 24" x 18." National Gallery of Art, Washington, DC. Photo by the author.

In this scaled diagram, the author's father (approximately 6 feet tall) has been digitally transported through time and space to a virtual museum. Raphael's painting is on the left, while Grünewald's smaller work is on the right.

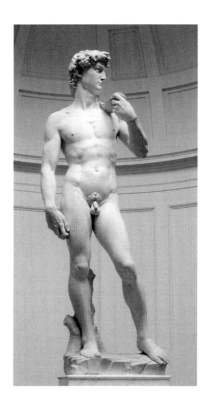 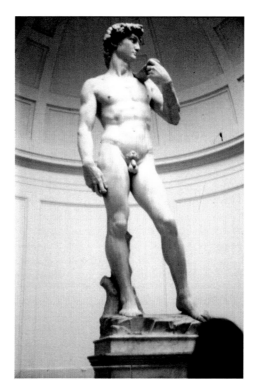

RENAISSANCE PROPORTIONS

Italian Renaissance artists—like the ancient Greek and Roman artists they emulated—wished to create artwork with perfect proportions. To do so, they had to consider from what angle the typical viewer would be seeing their work. Many large-scale works of art were designed to be viewed from a distance, by people standing below. Michelangelo's *David* is one such work, as it was originally meant to be placed up high, on the Florence Cathedral.

Michelangelo deliberately created a disproportioned body for the Old Testament hero. Viewed straight-on, David appears to be top-heavy, his scrawny legs holding up massive arms, trunk, and head. Viewed from below, at a distance, David's legs appear more appropriately-sized. Thanks to **foreshortening** (the distortion that happens when viewing something from a dramatic angle) the torso and head now appear smaller, from the viewer's perspective. The third photo shows David as he was meant to be seen by people directly below. Now his pose becomes epic, his proportions correct. He no longer appears top-heavy, yet his head is still large enough so that the viewer can clearly read his tense expression.

The Italian Renaissance interest in creating the illusion of perfect proportions was fueled by ancient Greek art and architecture. Two thousand years before Michelangelo, the Greek sculptor Polykleitos quite literally "wrote the book" on proper proportions. His canon, or treatise, informed the other great sculptors of his time, and his work remains a symbol of intellectual and moral discipline.

Michelangelo, *David*, 1501-1504. Marble. Note that the center photo was taken in 1992, when photographs were permitted in the Galleria dell'Accademia, Florence. The photo on the right side was taken surreptitiously in 2010, through a glass barrier.

BAROQUE LIGHT AND SPACE

By the mid-1500s, the Italian Renaissance style had begun to change. The Catholic Church in Italy was now fighting to quash a rising tide of dissenters in Northern Europe. Influential leaders like Martin Luther in Germany and John Calvin in France were questioning the authority of the Pope and the ability of his church to lead the faithful to salvation. Concerned by the social, political and religious threat of the **Protestant Reformation**, the Catholic Church employed artists in a new artistic approach to re-engage the faithful. The result is the **Counter-Reformation** art of the **Baroque** period, dating from the late 1500s through the 1600s.

Throughout the Renaissance era (1400s through the mid-1500s), many Northern European artists had held onto the medieval tendency toward emotionally-driven religious art. These **Northern Renaissance** artists lived in what is now Germany, France, Belgium and the Netherlands. They embraced an emotional style quite in contrast to their Italian counterparts—who had rejected any medieval melodrama in preference for disciplined, Classical restraint. In the face of Protestant competition, however, the Catholic Church was willing to "fight fire with fire." With the gut-wrenching, up-close and personal imagery of the new Baroque art, the Church sought to reignite the viewer's Catholic faith—aiming for the heart, rather than the head.

The Old Testament story of Judith and Holofernes was a popular subject for Italian Baroque-period painters. Rife with violence and intrigue, the story tells of a Jewish heroine who cons the enemy general Holofernes into drinking himself into a stupor; indisposed, he is no match for the determined Judith as she proceeds to chop off his head with a sword. Along with the work shown on the following page, Artemisia Gentileschi painted several versions of the story. This subject may have been particularly meaningful—and personal—for the artist, given her traumatic personal experiences, which are documented in Catholic court records. Not only was she sexually assaulted by a fellow painter, but during the trial she was also subjected to torture, to prove that she was telling the truth about her attacker. Judith's power and determination in the painting speaks to Gentileschi's own strength against a violent, hostile Baroque-era world.

The psychological intensity of Gentileschi's painting is conveyed not only through the horrific subject-matter; it is also amplified by the Baroque treatment of light and space. Note that the figures dominate the foreground, so that the action is "in your face" rather than at a distance. The scene appears cropped, and we are "zoomed in" to witness, up close and personal, the ghastly expression on the face of Holofernes as Judith severs his neck. In this claustrophobic space, we have no choice but to become a participant; victim or victimizer, we are a party to the action, and are not permitted the safe and comfortable distance of the impartial observer.

In stark contrast to the comforting chiaroscuro and bright sunlight in Raphael's paintings, here the light plunges from spotlight to swallowing darkness, with few mid-tones. This dramatic light-dark contrast is called **tenebrism**. Typical of Italian Baroque paintings, tenebristic light arrives from an uncertain or undefined source, such as a flickering candle, a supernatural aura, or a blaring beam aimed from somewhere "off-stage." The blackness of the background shrouds our vision, and confuses our sense of depth; the figures emerge from the darkness, the way a villain suddenly pops from nowhere in a horror movie. These visual devices work at a basic psychological level, serving to increase the viewer's anxiety and uncertainty. With the Baroque use of light and space, we are made alert, on-edge, and unquestionably involved.

Tenebrism (left) versus chiaroscuro (right). Diagram by the author.

Artemisia Gentileschi, *Judith and Maidservant Decapitating Holofernes*, c. 1612-21. Oil on canvas, 78.3" × 63.8" Galeria degli Ufffizi, Florence, Italy.

BAROQUE ART: THE PSYCHOLOGY OF SCALE

Throughout this chapter we have noted the importance of the artwork's size, relative to the viewer. The **scale** of a work of art affects the tenor of its emotional impact, and can alter the meaning of the subject. Small or insignificant things made grand in scale can suggest epic ideas and broader implications; grand events made small in scale can make them more real and personal to the viewer.

Catholic Baroque paintings like Gentileschi's Judith can be quite large, and are often designed to serve as altarpieces. Placed above the altar of a Catholic Church, altarpiece paintings can be overwhelming, both in size and subject matter. Baroque altarpieces were designed to maximize the emotional power of the Catholic ritual of the Mass. The altar of the St. Ignatius chapel, in the Church of the Gesú in Rome, is particularly theatrical. A painting of Ignatius of Loyola stands above the altar, marking the tomb of the Counter-Reformation saint. Once a day, the painting is lowered with stunning ceremonial flair; as it descends, the painting reveals an ornate, golden statue of the saint, reaching out from his niche with rock-star panache.

St. Ignatius chapel, Church of the Gesú, Rome, Italy. The painting is possibly by Andrea Pozzo, who designed the chapel in the 1600s.

Baroque artworks in museums lack the over-the-top accoutrements of their original settings. However, their grand scale is still apparent. In the scaled diagram below, note the size of the Baroque painting by Rubens, relative to a six-foot-tall man. At nearly 11 feet in width, this scene of an Old Testament hero beset by lions conveys even greater drama.

As we have seen, Baroque art often shows religious subjects on a grand scale, to reinforce their importance and implore viewers to invest psychologically in the drama. The chapel of Ignatius at Il Gesú presents the epitome of this theatrical effect—each day a booming recording of religious music signals the unveiling of the saint's colossal statue, ensuring that all the viewers' senses are engaged, and set to maximum alert.

What happens, then, when an insignificant subject receives the monumental treatment? **Pop artists** of the 1960s and 70s gained fame for using popular, consumer culture as their subject matter—from household products to household names, starlets to soup cans, soda bottles to Brillo pads. By immortalizing the trivial, Pop artists questioned society's values and teased viewers' expectations.

Pop artist Claes Oldenberg is well-known for his large-scale public sculptures of lowly objects. In *Clothespin*, 1976, shown on the next page, Oldenberg raises the humble clothespin to grand proportions. By virtue of its setting in Philadelphia—birthplace of the United States Constitution*—this giant clothespin seems to celebrate the making of great things from humble beginnings. Standing like a sentry in downtown Philadelphia, with the City Hall behind it, the sculpture salutes the unglamorous, mundane tasks of everyday Americans. A clothes dryer speaks of convenience; a clothespin speaks of a basic technology in service to a basic domestic chore—it's unsophisticated, it's unheralded, but it unquestionably gets the job done. In its grand scale, perhaps *Clothespin* presents a broader lesson on the potential power of the democratic process.

Let us look at scale from the opposite extreme: the use of small scale to draw viewers into an intimate and personal world. In the Baroque era, religious art for the home was usually small-scale, since a typical house would be too small to fit a giant altarpiece, let alone a large congregation of worshippers. A home display of religious imagery is generally intended for a small number of people—members of the family and

*Note the date of the sculpture's unveiling: 1976. This was the bicentennial year, the 200th anniversary of the Declaration of Independence.

Peter Paul Rubens, *Daniel in the Lions' Den*, c. 1614/1616. Oil on canvas, 88¼" x 130 1/8." National Gallery of Art, Washington, DC. Digitally-altered diagram by the author.

Claes Oldenberg,
Clothespin, 1976,
Philadelphia, Pennsylvania.
City Hall in background. 45'
tall.

Johannes (Jan) Vermeer, *Girl with the Red Hat*, c. 1665. Oil on panel, 9 x 7 1/16 in. National Gallery of Art, Washington, DC.

Reproduced on a printed textbook page, this painting of a well-dressed young lady by famed Dutch artist Jan Vermeer is just about actual size!

Rembrandt workshop (probably
Constantijn van Renesse), *The Descent
from the Cross*, 1650/1652. Oil on canvas,
55.91 x 43.66." National Gallery of Art,
Washington, DC. Photo by the author.

select guests—and is often used by a single person for periods of prayer and meditation. The small scale invites a private, exclusive connection between the viewer and the subject portrayed.

In the Baroque era, the country of Holland (in Northern Europe) broke away from the Catholic Church. The Dutch Protestants found the overpowering displays featured in Catholic churches to be distasteful, and chiefly limited their religious art to small paintings in the home. This painting was created in the workshop of famed Dutch Baroque artist Rembrandt van Rijn, and reflects the tastes of Dutch patrons. The **tenebrism** recalls the Catholic Baroque art we have already seen, as does the use of strong diagonal, zig-zagging lines and the compact use of space in the composition. However, the scale is much smaller. This is no altarpiece meant to "wow" a congregation. At roughly 4½ by 3½ feet, the accessible scale—together with the emotional light and space—brings a tragic religious image "home" to the viewer. You can get up close and see the ghastly-pale face of the fainting Virgin, overcome with sorrow at seeing the lifeless body of her son. Through the personal scale of the painting, her emotion becomes immediate and identifiable, as though she were a member of the viewer's own family.

As a painting made by someone in Rembrandt's employ, the work at left was likely modeled on a composition designed by Rembrandt himself. On the next page is one of Rembrandt's prints of the same subject. The technique of printmaking (which we will examine in detail in the next chapter) allowed Rembrandt to create fine details with a rich variety of expressive lines. Note how the hatching and cross-hatching marks create dramatic shadows, their texture adding intensity to the scene. As we will see in Chapter 7, the technological advance of printmaking (invented in China, and popularized throughout Europe in the 1500s) allowed less-wealthy patrons to have artwork in their homes. The accessibility and intimate scale of prints make them particularly effective for personal religious use.

Many religions encourage the practice of worshipping at home altars. Recall the Mexican Days of the Dead celebration discussed in Chapter 1; Catholic families of Mexican descent may create *ofrendas* (altars with offerings) at home, to honor departed loved ones. A home altar created for the worship of Hindu gods and goddesses is known as *puja* (or *pooja*)—a term also used

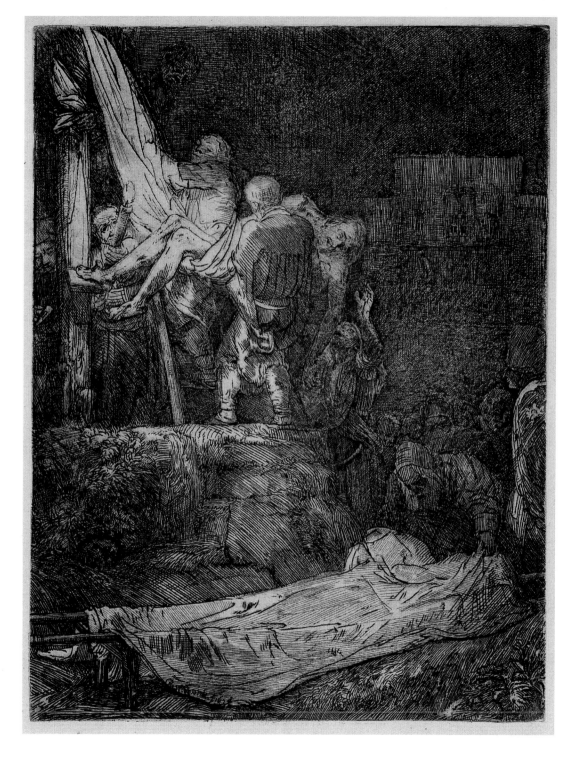

Rembrandt van Rijn,
*Descent from the Cross
by Torchlight*, 1654.
Etching and drypoint
on paper, 10 7/16" × 6
11/16". University of
Michigan Museum
of Art.

to describe the act of worship at such an altar. Note the personal size of the *puja* shown below, and the array of sacred images, objects and offerings—including flowers and incense—placed within it.

Using an intimate scale, non-religious art can also impart the same sense of a sacred, personal space. The work on the next page by San Francisco artist Tino Rodriguez addresses issues of gender identity, Mexican heritage, sensuality and spirituality in a richly-detailed tapestry of images. The artist appears as the Aztec god Xochipilli, the "Prince of Flowers," from whose mouth emerges a plumed bird. A skull-headed ballerina dances at the bottom (a reference to the Days of the Dead), while the blue-skinned Hindu god Krishna plays music. Rodriguez invites us to come close and lose ourselves in this boundary-breaking fantasy.

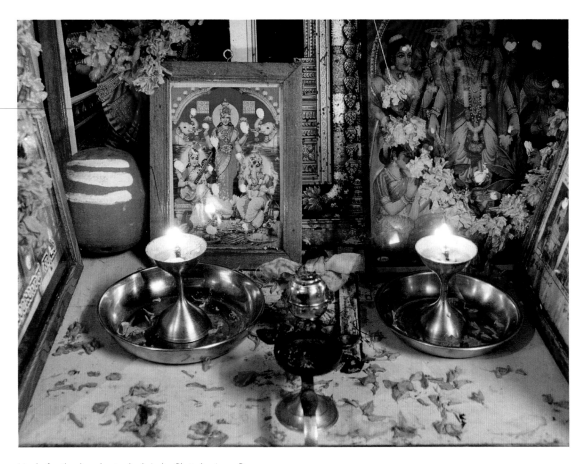

Hindu family altar, (*puja* altar), India. Photo by Jorge Royan.

Tino Rodriguez, *Xochipilli's Estatic Universe*, 2004. Oil on panel, 20˝ x 16˝. Crocker Museum of Art, Sacramento. Photo by the author.

SPOTLIGHT: SCALE AND PREHISTORIC SCULPTURE

One of the most famous sculptures in the history of the world is over 20,000 years old—and fits comfortably in the palm of your hand. Discovered over a century ago near Willendorf, Austria, the extraordinary little figure was dubbed "the Venus of Willendorf." Art historians imagined that she represented some kind of love goddess, like Venus, worshipped (much later) by the ancient Greeks. Today she is simply called *Woman of Willendorf*, an unassuming title that more accurately reflects scholars' uncertainty as to her identity and purpose. Given the abstract emphasis on breasts and genitalia, she may be a representation of a fertility goddess, a talisman to restore or maintain the owner's health, or a guardian-figure, ensuring the overall well-being of the community. There is no question, however, about her scale; at just about 4 and a half inches in height, she is a personal item, meant to be held close, by an individual.

The psychological power of having a personal art item to keep near cannot be overestimated—especially in a world that was still emerging from a great ice age. Much was beyond humankind's control; even agriculture was impossible in the harsh climate. Every animal was a wild animal, and many were equipped with thick hides and dangerous natural defenses to thwart would-be hunters. Imagine the significance of using the giant tusks of a woolly mammoth to carve a miniature mammoth sculpture. Scale here has everything to do with the universal desire to make sense of an overwhelmingly big world—and to bring it a little bit "down to size."

Woman of Willendorf,
c. 24,000-22,000 BCE.
Limestone, 4 3/8 in
(11.1 cm). Naturhistorisches
Museum, Vienna, Austria.

A big, hairy (and extinct) elephant: The skeleton of a woolly mammoth.
National Museum of Natural History, Washington, DC. Photo by the author.

Mammoth, Vogelherd Cave, Germany, c. 25000 BCE. Ivory.

LIGHT AND SPACE CASE STUDY: MARY CASSATT'S INDEPENDENT WOMAN

If ever a small painting packed a large punch, it is Impressionist Mary Cassatt's *At The Loge*, also known as *At the Opera*. Seated in the loge, or theater box, a woman looks intently through binocular opera glasses. The opera is being performed on the stage below, but clearly the woman has another target in sight, as she looks across (perhaps to another box seat?) rather than down. Borrowing from the kind of abstract space found in Japanese prints, Pennsylvania-born Cassatt has compressed the space, so that the woman in black appears like a flat silhouette in the dark foreground. The pattern of the rounded balcony further flattens the background space, so that the blurred spectators in the distant seats press nearer than they should. We become aware that one figure among the indistinct and well-dressed throng is also distracted. A man appears to be leaning onto the railing, looking our way through his own pair of spectator glasses.

Much has been written about the meaning of this work, and much attention has been paid to the psychological implications of the space and the light that Cassatt has chosen here. There is a bold intensity to the female protagonist; the strong contrast of light against dark, coupled with the tight space, creates a sense of tension. Many scholars believe this is actually a self-portrait of the independent American woman who dared to paint alongside "the big boys" of the radical French Impressionist movement. Some see this as a personal "declaration of independence," as the lady clearly disregards both the viewer and the voyeur, and asserts her own point of view.

Others see, in the hard, angular lines and stark light-dark contrast, a underlying statement of dissatisfaction. The isolating darkness of the foreground emphasizes that the subject is wholly on her own—independent, but also aloof, cut off from the social games being played around her. Look again—is the man really checking her out?—or is he instead spying the faceless (and more enticingly-dressed) blonde woman, barely visible to us behind Cassatt's black bonnet?* The ambiguity of the scene adds resonance to its psychological power. Clearly the woman in the foreground is breaking 19th-century expectations—and our presence, right up close to this unorthodox lady, makes us party to her modern daring.

*See Spencer Case, "At the Opera Revisited," Princeton, http://blogs.princeton.edu/wri152-3/s06/scase/about_the_author.html.

Mary Cassatt, *In the Loge*, 1878. Oil on canvas, 32 x 26 inches. Museum of Fine Arts, Boston.

THE PSYCHOLOGY OF LIGHT AND SPACE: INSTALLATION

The installation is both a new idea, and an old idea in art. For much of human history, works of art have been designed for placement in larger visual programs, to serve some ceremonial or practical function. For example, tea bowls in 15th-century Japan were meant to be used in a tea room, during a tea ceremony. Michelangelo's famous painting of Adam is part of an entire painted ceiling that maps out Catholic beliefs for the Pope's own chapel. Similarly, the painting above the altar-tomb of St. Ignatius at Il Gesú, Rome is meant to be "read" in the context of the church setting, with the tomb and altar below, the frame of columns around, and the statue waiting to be revealed behind. Like most traditional art, the painting is part of a "package deal," just one element in a broader installation—a complete art environment that surrounds and impacts the viewer from all sides.

However, most people don't experience art in its original context anymore; if we encounter art, it's often in a new (and often antiseptic) environment, such as a gallery or museum. The traditional display of art in its context is *not* typically called an installation; the term is used today to describe specially-designed, interactive exhibition spaces.

In a museum or gallery, **installations** create a 360-degree world of experience in the artificial gallery context. Installations are designed like self-sufficient little worlds, taking the viewer from the museum environment of hushed conversations, white walls and pedestals into a different physical—and psychological—space. Like Christo's environmental art moved indoors, installations challenge viewers to pay attention to every aspect of their surroundings. Viewers who choose to visit an installation must take a risk, and physically engage the space—they cannot simply walk past the work to see it. By entering the installation space, the viewer becomes a part of the art experience.

Take, for example, the installation shown here. The photographs, taken in the Oakland Museum (prior to its recent remodeling) cannot capture the experience of Michael McMillan's work; one must personally enter the installation in order to "get it." The viewer might at first overlook the screen door, built into the museum wall. Can we go in? Are we allowed? Can we all fit, or do we need to go in one at a time? Should we close

Michael C. McMillen,
Aristotle's Cage, 1983.
Installation, Oakland
Museum of California,
Oakland. Photos by the
author.

the door behind us, or leave it open? These questions reflect the viewer's uncertainty, as he or she encounters the artwork and negotiates his or her own space to meet this new challenge. The screen door is ratty and full of holes; it creaks as you open it. As you enter, you become immediately aware of the dim light, and the strange static sound, like the hum of transistors, or the scratching of a distant radio not quite tuned to the right channel.

The interior of the installation room is paneled with sheets of corrugated metal; behind a wire screen (an alarm sounds if you touch it) is a sprawling diorama of a junkyard, punctuated by a rusty trailer from which the sounds seem to emanate. In the distance, the "horizon" glows red, illuminating the silhouette of a distant town, and the skeletal "constellation" of a dog chasing a man in the sky.

McMillan's *Aristotle's Cage** envelops the viewer with an unnerving, somewhat creepy scene of a forgotten wasteland at dusk. Is it a study in loneliness and isolation, exposing the costs of an over-industrialized world, a land of forgotten cast-offs? Or is it a wonky celebration of self-imposed exile—an anachronistic, personal kingdom of junk, insulated from the passage

of time? The impact of this installation varies from viewer to viewer: to some, the incessant static and dark, confined space is unsettling; to others, the sounds are vaguely familiar, and suggest the presence of someone listening to the radio and enjoying the privacy of their little abode, unbothered by the outside world. Is it a post-apocalyptic bunker, a derelict hideaway, or a cozy nest of scrap metal? Meanings will emerge as the viewer spends time within the space.

Mildred Howard's *Public Eye—Private Me* presents a different environment for the viewer to contemplate. Unlike *Aristotle's Cage*, which offers (or threatens) an enclosed, private space, Howard's installation (formerly at the Crocker Museum in Sacramento) allows no privacy whatsoever. Also in contrast to the relative darkness of McMillan's enclosed installation, the placement of this girded metal structure in a window-filled room in the museum allows natural as well as artificial gallery light to flood in, from every angle. The house is filled with mirrors and glass peepholes, which offer unpredictable views of museum-goers, both inside and outside the structure. Looking in or looking out, we become self-conscious of our own peeping (catching glimpses of ourselves in the mirrors) as we spy other visitors—who can also peer back at us. Through her installation, Howard challenges the viewer to confront the uncertain boundaries between public and private space. In a world of ever-changing social media, we make and change our identities every day, with every keystroke, tweet, blog and text. What we show, what we see, and what others see is a constantly-changing house of mirrors. *Public Eye—Private Me* offers viewers a way to physically engage this issue; feelings of delight mingle with unease and exposure, as viewers realize that they are both the spectators and part of the spectacle.

*Famed student of the Greek philosopher Plato, Aristotle emphasized the importance of studying the best of this world, to imagine and strive for a greater perfection. Consider, what ironic statement might McMillan intend by calling his work *Aristotle's Cage*?

Mildred Howard, *Public Eye—Private Me*, 2003. Installation, powder-coated steel and laminated copper-plated mirrors. Crocker Art Museum, Sacramento. Photo by the author.

Spotlight: Kara Walker

For her room-sized gallery installations, Kara Walker uses a form of art popular in the 19th century, the silhouette. Traditionally used to record the profiles of loved ones, the silhouette in Walker's epic re-creations of the antebellum South* address complex racial issues. Walker's round "cycloramas" surround the viewer with nightmarish images fraught with exaggerated gestures both violent and sexual. She creates a world that appears, at first glance, to be a lyrical, sensuous fairy-tale; in so doing, she speaks of the "Gone with the Wind"-like appeal of romanticized history, where horrific realities can be made titillating and unreal.

Walker's unrelenting approach has been lauded for compelling viewers, regardless of their ethnic or personal background, to engage in the pre-Civil War legacy, and confront all the stereotypes, fabrications, and ugly truths that are wrapped into the history of race relations from the 1800s to today. The shadows on the wall become our shadows, as we occupy the installation space.

Critics include some African-American artists who fought against racial stereotypes and violence during the Civil Rights era. Members of this older generation have criticized Walker's work, claiming that her over-the-top imagery simply furthers hateful impressions, rather than challenging them. Walker's work quite literally deals with "gray areas" where good and bad, right and wrong, victim and victimizer, and the salacious and sadistic become troublingly confused. The title of the installation shown here suggests the subject is a revenge fantasy. The silhouettes keep the viewer at a distance (we can't tell for certain who or what we are seeing)—but the space and the light enshroud the viewer and make us a wary part of this epic tale.

*"Antebellum" comes from the Latin phrase, *ante bellum* (before the war). The term was adopted after the American Civil War, and is used today particularly to mean "before the Civil War."

Kara Walker, *No mere words can Adequately reflect the Remorse this Negress feels at having been Cast into such a lowly state by her former Masters and so it is with a Humble heart that she brings about their physical Ruin and earthly Demise*, 1999. Installation, cut paper and adhesive, San Francisco Museum of Modern Art. Photos by the author.

6: LIGHT AND SPACE

New Vocabulary in Chapter 6

Baroque	Term for both an art movement and era in 1600s Europe, featuring dramatic subject matter and tenebristic light.
chiaroscuro	Italian term for light-dark, describing a shadowing effect featuring the shift from light to dark, indicating the play of light on a three-dimensional object
corporeal	Having the fullness and weight of a body
Counter-Reformation	Movement initiated by the Catholic Church to combat Protestant efforts
cross-hatching	Drawing technique in which crossing sets of lines create implied texture and the illusion of shadow
hatching	Drawing technique in which parallel sets of lines create implied texture and the illusion of shadow
installation	A specially-designed space (usually in a museum or gallery) in which art is installed
key; high key, low key	Term from photography; refers to the level of light in a work of art. High key is bright; low key is dark.
modeling	Suggesting three dimensional form through shading
Northern Renaissance	Art movement/period in Northern Europe in the 1400s and 1500s, originating from similar factors as Italian Renaissance (including rising Merchant class), but featuring art with more Medieval traits (not greatly influenced by Classical art)
Pop art	Art movement emerging in the 1960s, using images from popular culture
Protestant Reformation	Movement in the late 1400s through 1600s originating in Northern Europe, critical of the Catholic Church and pressing for reforms
stippling	Technique in which small marks or dots are used to create shading
tenebrism, tenebristic	Dramatic light technique in which subjects are lit by a single beam of light, creating high contrast of key and often featuring dark backgrounds

7

THE GOOD,
THE BAD,
AND THE UGLY

7: THE GOOD, THE BAD, AND THE UGLY

STYLE—IDEALISM VS. VERISM
PHOTOGRAPHY AND PRINTMAKING

*Conversation with the artist,
San Francisco Art Institute, 2010.

"[Art] is a trick—but it's an honest trick."
—Artist Felipe Dulzaides*

The author's parents on their wedding day, 1961. White gloves were once commonplace accessories for the well-dressed woman—idealizing her hands, and hiding any signs of work, wear, or age. The author's mother is wearing the fashionable dress gloves of the era.

All art is a manipulation of some kind. Artists choose what subjects they want to show—and leave out the things they do not want. Some artists are motivated (by their patrons, by their culture, or by their own personal nature) to focus on the best, most flawless aspects of a subject. For example, a photographer at a wedding will make a great effort to get the most complimentary lighting, setting, and pose for the happy couple—or risk having unhappy clients! From all the pictures the photographer takes on that special day, he or she will select the ones that turned out the best. The best pictures, from the wedding photographer's point of view, are the most **idealized**—showing the wedding party as poised, posed, and perfect as possible. A "bad hair day" or blemish disappears through the wonders of Photoshop. Any gray skies can be brightened and blued—and any unwanted guests can magically disappear with the click of a cropping tool. Artists have always had the power to make a subject beautiful.

IDEALISM: UNIVERSAL CRITERIA

Everyone differs, to some extent, about what it means to be "perfect." Your definition of the perfect wedding, for example, will depend on your cultural background as much as your personal tastes. For one couple, a Hogwarts-themed wedding would be perfect; another couple might favor formal attire, while still another would rather wear flip-flops at the beach.

However, there are some aspects of the idealized style that are universal, and cut across almost all cultures. As we have found in Chapters 3 and 5, geometric shapes and vertical lines suggest stability and predictability; these are universally positive characteristics. Scientific studies have also shown that symmetrical features are more appealing than asymmetrical or slightly lopsided faces. Also, like many animal species, humans tend to favor the appearance of youth and health in a prospective mate. These criteria may be over-ridden by cultural or personal preferences, but they are part of humankind's basic programming. Similarly, we prefer the appearance of health and youth in nature, too—a bright, Spring day, with clear weather, green grass, and budding

flowers all contribute to an overall positive message. In the photo on the previous page, the groom and bride appear in front an ideal backdrop, with a blue April sky and green grass framing a picturesque church. The couple themselves are posed, ready for their picture; they are poised, standing tall in strong, clean vertical lines, with their outfits sharply geometric (perfectly in keeping with the early-60s style); and they are perfectly youthful and healthy-looking. Altogether, the styling reassures the viewer that this is an ideal union.

IDEALISM: CULTURAL CRITERIA

Despite the universal ways of defining idealism, culture often has the final say regarding what is and is not officially "beautiful." For example, the woman pictured here is clearly young, her skin unblemished. She is also posed and poised, holding a vertical, stable, and perfectly-balanced position. Yet, by our current standards of beauty, this Northern Renaissance lady is imperfect. Her skin is very pale, her eyebrows over-plucked, and forehead perhaps too high. Her downturned eyes and pursed lips suggest that she's tired or unhappy—a less-than-ideal state.

However, in Northern Renaissance culture, this woman would have been considered exceptionally ideal. The pale skin would have suggested her wealth and status; only poor women had to labor in the Dutch countryside, and working outdoors under the sun would cause a tell-tale tan—undesirable for a woman of her social status. The lady's hair-line and diminished eyebrows are also status symbols, reflecting refined and elegant grooming techniques. To his intended audience, Rogier van der Weyden here presents nothing less than an ideal: a demure and poised woman of high social rank.*

Even in the past 100 years in America, our definitions of an ideal woman have varied widely. Since the turn of the century, a woman's preferred shape has morphed from the corseted Gibson Girl to the sleek 20s and 30s silhouette to the 50s curvaceous bombshell. In the 1960s, Americans began to question in earnest the stereotypes of beauty, and expand the definition of the "ideal" woman to include different ethnicities, hair and skin color, size and shape. However, the issue remains deeply controversial and highly subjective.

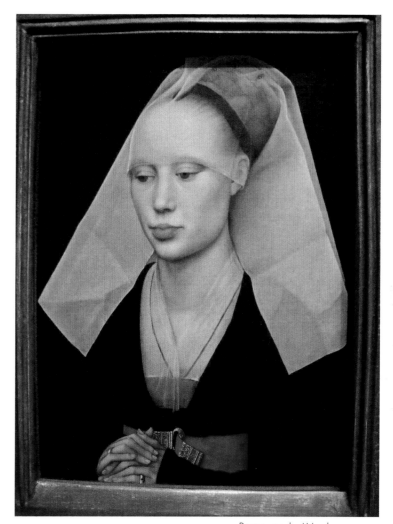

Rogier van der Weyden (1399/1400-1464), *Portrait of a Lady*, c. 1460. Oil on panel, 34 x 25.5 cm (13 3/8 x 10 1/16 in.). National Gallery of Art, Washington, DC. Photo by the author.

*You might recall Arnolfini and his fair-skinned (and pregnant-looking) bride-to-be from Chapter 1; the couple was painted by Jan Van Eyck, a contemporary of Rogier van der Weyden.

Charles Dana Gibson,
Gibson Girl, c. 1890.
Dover Publications.

OF COURSE THERE ARE MERMAIDS.

Norma Shearer in a short dress, 1927, George
Grantham Bain collection (press photo, Library of
Congress).

Marilyn Monroe, photographed by Philippe Halsman, 1952.

Idealism and Religious Art

Most religious art is idealized in style. This is unsurprising, since most cultures consider their divine beings to be perfect, without the defects of human beings. Further, many cultures prefer that any person associated with a god should look ideal as well, to appear worthy of the god's presence or blessings. The Sumerian votive figure demonstrates this preference for religious idealism. Placed in a temple, this figure would have acted as a perfect stand-in for the male worshipper, speaking to the god on the man's behalf. The wide eyes ensure effective contact with an unseen but mighty supernatural force; the figure's upright stance, simple geometry, and clean lines all suggest unwaveringly attentive worship. Note that the abstraction of the figure goes hand-in-hand with its idealized style—a work need not be illusionistic in order to be idealized.

The Hindu religion, one of the oldest in the world still in popular practice today, features many gods and goddesses, believed to have existed at the beginning of time. These beings are often portrayed with powerful **attributes**—accessories that suggest supernatural abilities and help worshippers to identify them. The goddess shown here is Parvati, wife of the god Shiva. In her multiple hands she holds cymbals and one of her two children, Skanda. By most cultural definitions, Parvati is idealized. She appears poised and vigorous. Her costume is sheer and extravagant, accentuating her voluptuous contours. Parvati's face is generically beautiful—she cannot be identified as a particular human female (which is why her attributes are important). This sculpture is typical for images of Hindu deities; depending on the era, they vary in style from illusionistic to abstract, but they share the idealized, divine appearance of calm, composed perfection.

Left: Male votive figure, 2750-2600 BCE, Sumerian culture, Mesopotamia. Alabaster, shell, and black limestone, 11 5/8 high. Metropolitan Museum of Art, NY.

Parvati, c. 1050-1100, India. Chlorite, 44 in. high x 25 in. wide. Asian Art Museum, San Francisco. Photo by the author.

Italian Renaissance Idealism

As we have seen, the art of the Italian Renaissance is renowned for its illusionistic style, providing a clear, rational space into which the viewer may mentally enter. Emphasizing reason over emotion, the artwork of 15th-century Italy recalls the ancient Greek philosophies of Plato and Aristotle. According to the ancients, true perfection lies beyond the physical world; Renaissance artists argued that, by admiring the most beautiful creations of nature on earth, one can begin to imagine the more beautiful perfection of the supernatural world beyond.

The Italian Renaissance philosophy is perfectly expressed in the idealized style. Take, for example, Michelangelo's 1499 sculpture of the *Pieta*, an image that shows Mary holding her deceased son in her arms. The subject is well-known in Catholic art, and impresses the faithful with its tragic tableau. Despite the gravity of the scene,

Michelangelo, *Pieta*, 1499. Marble, 68½ inches in hieght. St. Peter's Basilica, Rome, Italy.

Michel Sittow, *Pieta*, c. 1500. Oil on oak panel, 19.7 x 14.6 inches. Royal Chapel, Granada Cathedral, Spain.

however, Michelangelo's Renaissance sculpture is profoundly idealized. Mary's gentle features convey composure and restraint, rather than distress; she also looks quite young, given the age of her son, her face unmarred by time or tragedy. Similarly, Christ's face is peaceful, as though he is merely sleeping in her arms. The idealized treatment of the figures allows worshippers to absorb the beauty of the sacrifice depicted, and not dwell on the horror of a tortuous death. The viewer could imagine this Mary as a young mother, holding her infant child, and contemplating a sacrifice many years to come.

In contrast, Michel Sittow's Mary clings to the rigid, lifeless body of Christ with understandable angst. The countryside of Flanders in the background provides a fitting site for the figures in the foreground, all of whom appear as everyday people one might meet on a Flemish street. Christ's thin physique more accurately reflects the typical frame of a Renaissance commoner than the buff contours of Michelangelo's model. Though made at the same time as Michelangelo's work, this *Pieta* represents the culture of the Northern Renaissance, which had little connection with the Greek philosophers and their concepts of beauty. This Northern work allows viewers to relate to the subject on a personal level, and imagine that the characters shown here are dear and familiar to them, like neighbors, friends, or family. The raw, unfiltered style of these Northern Renaissance figures is called **verism.**

The Veritas of Verism

The word *veritas* is Latin for "truth." The ancient Romans worshipped Veritas, the goddess of truth, who—according to myth—lived at the bottom of a well (truly a difficult goddess to get ahold of!). From the ancient Roman perspective, truth was one of the highest and most challenging virtues. Along with *veritas*, Roman citizens were also expected to carry themselves with authority (*auctoritas*), a dignified bearing (*dignitas*), piety and respect (*pietas*), and gravity and seriousness (*gravitas*). These virtues were believed to grow with age and experience; therefore, Roman portraits were literally inscribed with the marks of time—every wrinkle, bag, and jowl speaks of the subject's moral mettle. Flaws were meant to reassure viewers that the subject's place in society had been truly earned. While their images of gods and goddesses sparkled with idealism, everyday Romans were portrayed with **verism.**

The portrait bust shown here is **veristic,** created in the preferred style for Roman portraiture—showing "warts and all," the unvarnished truth, the un-airbrushed, un-Photoshopped reality. The man is well-poised and posed, but he is far from perfect. There's an unmistakable wart near his chin, and his wrinkles are pronounced. The man's tight jaw and scowling expression make him look hard to approach. Cast in bronze, the bust has sustained some damage; originally, inlaid eyes of stone, ivory, or glass would have peered intently from under the furrowed brow. The man's sharp features may not be youthful or even healthy-looking, but his verism suggests to the Roman viewer a virtuous, capable leader.

Modern artist Chuck Close continues the Roman veristic tradition, celebrating the virtues of everyday people, in all their imperfections. As we have seen in Close's *Fanny/Fingerpainting* in the previous chapter, Close's paintings resonate with incredibly illusionistic details rendered on a grand scale. The paintings are over six feet tall, faithfully reporting every freckle, mole, wrinkle and stray hair. Unlike people in ancient Rome, however, we are socially trained to think badly of such verism. We assume that such an unflattering depiction must be mocking the subjects, designed to make them look bad.

These are the cultural expectations that Close wants the viewer to confront. Close chooses to paint himself, his friends and relatives as truthfully as possible—not to make fun of them, but to celebrate their humanity. These are not the remote, generic people of advertising and movies, the people lauded through mass media as somehow better than "mere mortals." Instead, Close's subjects are beautiful in their honesty, free of the filters and masks that might separate them from us. Here, we can identify with their humanity, and are invited to empathize with them as fellow "faulty" humans.

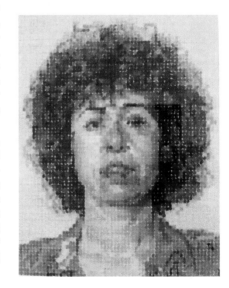

Note that Close's verism isn't always illusionistic. Close painted his friend Linda in a highly-detailed painting in 1976; in this 1977 pastel drawing, however, Linda has been made abstract. Close has broken the portrait into a grid, and "pixelated" Linda's face into fuzzy pastel dots. Although lacking detail, the portrait is still veristic. Linda's wayward hair and somewhat lopsided features pay tribute to the "real" Linda, rather than some airbrushed or artificial version.

Bust of a Man, c. 90–110 C.E., Roman Empire (rule of Trajan). Bronze, life-sized. Getty Villa, Malibu. Photo by the author.

Chuck Close, *Linda*, 1977, pastel on paper. San Francisco Museum of Modern Art.

Spotlight: Verism and the Religious Ascetic

An ascetic* is one who denies himself or herself basic human pleasures to achieve greater spiritual fulfillment. Even necessary functions, such as eating and sleeping, are voluntarily restricted; ascetics believe that simple comforts, such as the feeling of a full stomach or a soft bed, will corrupt their spiritual intensity and commitment. Ascetics often live like hermits, isolated from the distractions and negative influences of the general population.

Ascetics are celebrated in many religions for their pure devotion and willingness to sacrifice their bodily well-being for religious betterment. In the sculpture below, Buddha (Siddhartha Gautama) appears emaciated and suffering, as he attempts to reach Enlightenment through physical denial. Ultimately, according to Buddhist beliefs, Buddha decides that the path to Enlightenment lies in moderation rather than in extremes of gluttony or starvation.

Pictured at right is Donatello's depiction of an aged Mary Magdalene. According to Christian tradition, Magdelene was a prostitute who followed Christ; in penance for the sins of her early life, she became an ascetic. Donatello presents a gaunt figure, filled with spiritual intensity. Unlike many of his Italian Renaissance contemporaries, Donatello did not shy away from hard-hitting verism. Here, the penitent Mary—enshrouded in her own matted hair—challenges the viewer with a haunting and gripping gaze.

Head of Fasting Buddha, 100-300 CE, Gandhara, Pakistan. Schist, 8.7 in. height. British Museum.

*Ascetics should not be confused with aesthetics, the study of the formal qualities of artwork.

Donatello, *The Penitent Magdalene*, c. 1453–55. Wood with polychromy and gold, 74 in. height. Museo dell'Opera del Duomo, Florence, Italy. Photos by the author.

VERISM, IDEALISM, AND MORAL VALUES

As we have seen, the culture of the Italian Renaissance has had a long-lasting influence on Western perceptions of "good" and "bad." The Renaissance emphasis on beauty, order and perfection colors our views of verism, even today. We tend to think of ideal beauty as symbolic of moral goodness, while verism is associated with aesthetic and moral "ugliness." As a result of our cultural preference for idealism, Chuck Close's veristic portrayals strike many as more appalling than affirming.

In stark contrast to the Ancient Roman attitude towards portraiture—in which verism is truth and truth is virtuous—we put verism and idealism at opposite ends of the virtue spectrum. Though religious subjects may be shown veristically in Norther Renaissance art to inspire viewer empathy, the Northern Renaissance painting shown here demonstrates the typical Western use of verism to suggest a lack of virtue. The woman may be young, but she lacks poise; her pose is awkward, caught mid-action as she passes a stolen wallet to her accomplice. Her smile is crooked, her eyes heavily-lidded and a little baggy. Paired with a lecherous older man, the woman (likely a prostitute) is meant to appear as "loose" and uncouth. Verism, in this case, is used as a negative sign—the artist Quentin Massys presents these people as ugly, both inside and out.

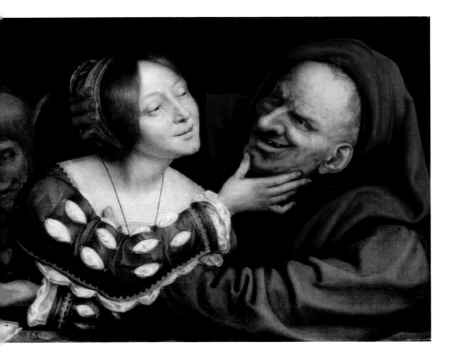

Quentin Massys,
Ill-Matched Lovers,
c. 1520/1525. Oil on panel,
17 × 24 13/16 inches.
National Gallery of Art,
Washington, DC.

VERISM VS. THE POWERFUL: NEGATIVE PROPAGANDA

Often verism has been used to criticize those in power. However, this is a particularly dangerous use of verism. Without effective democratic protections (such as freedom of the press and the right to free speech), artists who are openly critical of those in power—religious and government leaders, wealthy individuals and organizations, and entrenched institutions—can be attacked, arrested, imprisoned, or killed for their work. These dangers exist today—and unfortunately have been the rule, rather than the exception, throughout most of human history. Under repressive conditions, artists critical of the powerful have to create their work anonymously, or disguise their criticism with sly innuendo, lest they be sussed out and permanently vanished from the face of the earth.

Case Study: Francisco Goya

Spanish artist Francisco de Goya y Lucientes was a court painter—an artist authorized to paint members of the royal family and royal court. European court painters enjoyed a prominent position; not just any artist would be favored with such intimate access to the king and his home. However, Goya was less than thrilled with his position, as the house of Charles IV was filled, by all accounts, with a dysfunctional, inbred group of incompetents.

Goya's group portrait of the royal family, completed in 1801, shows that something is amiss in the Charles family. Rather than appearing as quirky, familiar touches, the veristic elements in Goya's painting come across as awkward, odd, and vaguely unpleasant.

Was Charles satisfied with Goya's work here? There is no evidence to suggest any displeasure—and certainly, at first glance, there is nothing but idealism. The family members are decked out in their finest regalia, glistening in jewels, silks, medals, and pearls. Only a critical eye might note the rather dull look on Charles's face, or the unsightly mole (no doubt accurately and dutifully recorded) on the side of the old woman's head. Surely Goya stands in the shadows out of humbleness, rather than embarrassment. No doubt Charles stands off to the side in order to showcase more effectively his wife and his male heir—but again, a critical eye might note a hint of bossy scene-stealing on the part of the queen. Was Charles that stupid, not to see Goya's thinly-disguised disdain? Perhaps; but keep in mind that we often see what we expect to see. Scathing criticism, particularly so close to home, would have been beyond Charles's experience, even beyond his imagination. Charles expected a family portrait from the official court painter in the Spanish tradition, and—at least on the surface—Goya delivered.

Goya's "day job" left little leeway for self-expression, let alone political criticism. His most powerful and politically-charged work was not commissioned by a powerful or wealthy patron, but rather was created voluntarily—fueled by his outrage at the abuses he saw around him, and felt compelled to record.

Francisco de Goya y Lucientes (Spanish, 1746–1828), *The Family of Charles IV*, 1800–1801. Oil on canvas, 9 ft. 2¼ in. × 11 ft. ¼ in. (280 × 336 cm). Museo Nacional del Prado, Madrid.

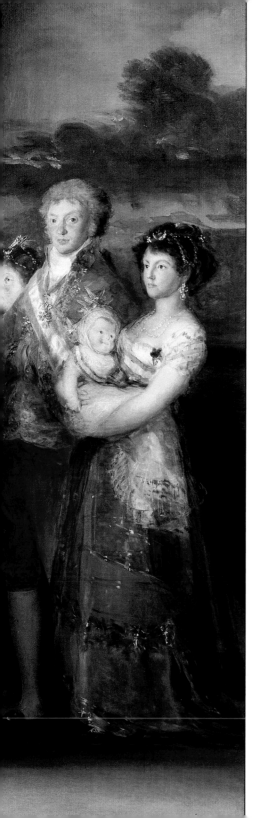

In a collection of works called "*Los Caprichos*" ('The Caprices"), Goya satirizes the foibles and failings of society's members at all levels, but zeroes in most mercilessly on the powerful: the manipulators, exploiters, abusers, and hypocrites who hold sway over the populace. *Swallow That, Dog* is number 58 in the series. Here, ghastly robed figures (representing religious agents of the Spanish Inquisition) prepare to force a giant syringe on the cowering victim. The mocking faces of the man's tormentors clearly reveal Goya's disgust with coerced religion.

A second series of prints, Goya's "The Disasters of War," confronts the evils perpetrated during the French occupation of Spain and the subsequent War of Independence. In these works, villagers are slaughtered indiscriminately while Spanish authorities fail to protect the common people. A culmination of the horrific images Goya printed, the painting on the next page documents the execution of thousands of civilians by Napoleon-backed troops. The work is striking in its unflinching verism. Goya's use of abstraction further serves to amplify the emotional impact of the starkly visceral scene. On the right side, a row of faceless soldiers appear like automatons, lining up with rifles to execute the villagers at point-blank range. Victims lie sprawled on the ground in pools of blood, the nearest to the viewer displaying a ragged bullet hole in his forehead. Among the despairing figures on the left, a man in a white shirt stands out, his arms raised in a Christ-like pose of sacrifice. The abstract, almost cartoon-like quality of Goya's figures—their expressions oversized and garishly-lit by a lantern on the ground—negates any sentimental or salacious reading of the scene. Textural details that might add lusciousness to the scenery or refinement to the figures are stripped away here, leaving the viewer without beautiful, distracting imagery for relief.

Bathing the rugged, everyday appearance of the victims in a valiant light, Goya draws a clear line between the antagonists and the heroes. The combination of verism and abstraction—together with the simple, factual title (*May 3, 1808*)—affirms the truth of the massacre. Although this *specific* scene is the artist's invention (he has engineered the composition to yield the maximum emotional impact), Goya defies the viewer of this work to question its truthfulness, or deny the horror and injustice that occurred.*

*For additional commentary on this work and its modern implications, see Sandra L. Bertman's "Art Annotations" at http://litmed.med.nyu.edu/Annotation?action=view&annid=10375.

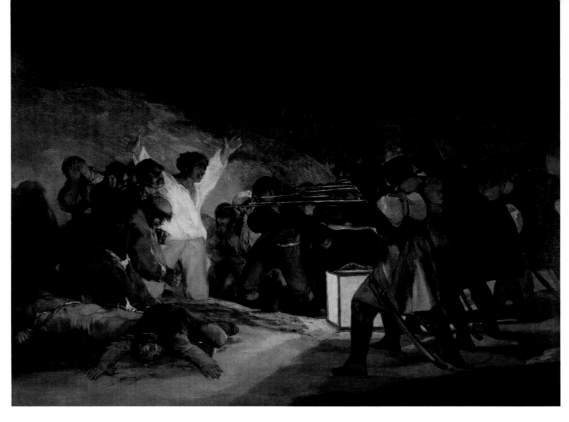

Francisco Goya, *May 3, 1808*, 1814. Oil on canvas, 104 3/4 x 136 inches. Museo del Prado, Madrid.

Francisco Goya, *Swallow That, Dog*, plate no. 58 from "Los Caprichos," 1797-99. Fourth-sixth printing (posthumous), etching and aquatint, 5 x 7 3/8 inches. Collection of the author.

VERISM AND THE POWER OF THE PRINTED IMAGE

Artists have the power to sway public opinion with powerful, veristic imagery—but only if the public has an opportunity to see the work. A painting such as *Third of May, 1808* would have been seen by just a few people in Goya's day; the technology to print a photograph in a newspaper did not exist until almost a hundred years later (long after Goya's death in 1828). Before photography, **printmaking** allowed artists to make multiple copies of an image, so that it could be more easily disseminated (distributed far and wide) in an inexpensive and easily-portable paper form.

Consider the political cartoon—a form of art that exposes the faults of powerful people and challenges their authority with merciless verism. The political cartoon gained ground with two important developments: the rise of newspapers, and the decline of absolute monarchies.

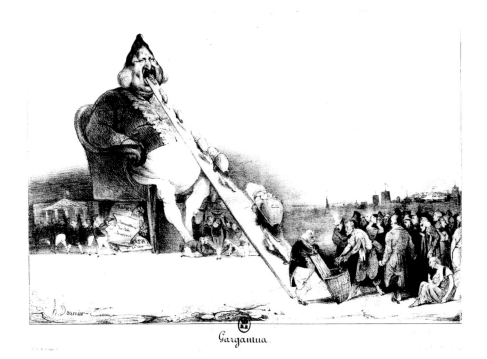

Honoré Daumier,
Garguantua, Lithograph,
1831. Bibliotheque Nationale,
Paris, France.
Note that the throne of
Gargantua/King Louis-Philip
is doubling as a toilet, as
pronouncements issue from
beneath his seat.

Gargantua

Honore Daumier was a member of a group in France known as the **Realists,** who advocated verism in their art, populism in their politics, and "speaking truth to power." As a Realist, Daumier published several cartoons critical of King Louis-Philip of France. This print shows the king as the all-devouring figure of "Gargantua," a character from a famous story by the Renaissance writer Rabelais; here Gaurgantua/Louis-Philip consumes the last scraps offered by the poor, and defecates proclamations from his toilet-throne.* The print may have earned Daumier six months in prison, but the fact that it was published at all attests to the relatively liberal policies of the king. Recall that, by the time of the print's publication in 1831, France had already decapitated a king in the wake of the 1789 Revolution. The dictator Napoleon—who had appointed himself emperor in the post-Revolution turmoil, and had also plagued Goya's Spain two decades before—was now ten years deceased. The age of tyrannical rulers had finally come to a close, at least in France, and a new age of no-holds-barred criticism had begun.

When skewering the foibles of dubiously-elected officials (such as members of the French parliament), Daumier showed his satirical wit and ironic humor. However, the artist's veristic portrayals of the French underclass were rendered with a sympathetic and somber tone.

Daumier's lithograph, *Rue Transnonain, April 15, 1834,* presents a horrific scene with "you-are-there" realism. Following an unsuccessful uprising against King Louis-Philip, the government has retaliated with lethal force. Here, an innocent family has been summarily executed; their only crime was living in the lower-class (and thus "suspect") neighborhood of St. Martin, on Transnonain Street.

* "Rabelais was a French satirist who criticized contemporary society by chronicling the dubious education of the disgusting and debauched Gargantua (who lived in a land of physical—although not mental—giants).

Honoré Daumier, *Rue Transnonain, April 15, 1834,* August–September, 1834. Lithography; image: 11 1/4 × 17 3/8 inches. British Museum, London.

Here we feel as though we are looking at a crime-scene photo, taken by an investigator moments after the bodies are found. We are on the same level as the corpses, strewn about the room. Like Goya's *Third of May,* this work is also titled by date (as well as place), lending an official, documentary tone to the piece. Unlike Goya's painting, however, Daumier's print is not composed like a staged tableau; rather, Daumier crops the image with the seemingly arbitrary cuts of a mechanically-produced snapshot—again, as though it were an impartial document, a sort of "Exhibit A for the prosecution." The evidence is presented in gut-wrenching verism, as raking light reveals a dead man, still dressed in his nightclothes, crushing the body of a child beneath him. The body of a female figure (his wife, perhaps) is angled towards the door, and the head of an older man is visible to the right, by the overturned chair. The extreme foreshortening of the central figure brings us uncomfortably close to his bloated torso, its shape cruelly mimicked by the striped pillow on the bed. The work is unquestionably intense, a veritable accusatory finger—directed straight at the king—printed in a French journal just as news of the event was spreading.

PRINTMAKING, VERISM, AND MEXICAN POLITICS

Printmaking has a long history in Mexico, fueled in the early 20th century by Leftist political concerns and the 1910 Revolution. In addition to making prints celebrating Revolutionary figures such as Pancho Villa and Emiliano Zapata, Mexican artists criticized the corrupt people and institutions that seemed in collusion to keep the common people in submission. Their work was inspired by the legendary Mexican printmaker Jose Guadalupe Posada (1852–1913). Posada's *Calaveras* imagery, celebrating the Days of the Dead (see Chapter 1), also served to comment on contemporary issues, and mock inappropriate social and political behavior. Death, of course, is the great social equalizer, and Posada readily portrayed the wealthy and poor alike as skeletons trying to look their best. Here, a *calavera* dressed in a tuxedo smokes a cigar like a fine gentleman—but he's apparently lost one of his shoes.

Posada uses a different style in his commemoration of Mexican Revolutionary Emiliano Zapata. Zapata fought for agrarian reforms, arguing that farmers should have the opportunity to own the land on which they work, and profit from their work. This print, accompanying a notice of Zapata's burial, is idealized rather than veristic; here Posada presents a posthumous celebration of a larger-than-life hero. This is not Zapata the everyman, the ordinary citizen, who would more likely receive the veristic treatment.

Contemporary artist Artemio Rodriguez (b. 1972, Tacambaro, Mexico) continues Posada's tradition of socially-conscious printmaking. Working in his studio in Los Angeles, Rodriguez creates his social commentary using traditional printing methods (including wood-block print, which we will discuss later). Rather than *calaveras*, devil figures appear often as symbols of greedy consumer culture; in Rodriguez's prints, we are all "poor devils," caught up in the quest for more.

Left: Jose Guadalupe Posada, *Lagartijo*. Etching. Right: Jose Guadalupe Posada, *The Burial of Zapata*, published by Antonio Vanegas Arroyo, 1914. Library of Congress.

Artemio Rodriguez, *All Mine!*, 2003. Linocut, 3 x 2 inches. Collection of the author.

Spotlight: Picasso's *Guernica*

It is one of the most famous and important works in the history of modern art. Pablo Picasso's *Guernica*, 1937, made a defiant political statement when it was unveiled at the 1937 World's Fair in Paris.* Though not usually a political artist, Spanish-born Picasso was moved by a war crime committed by General Francisco Franco in the country's civil war. Supported by Hitler in his bid to overthrow the democratically-elected government, Franco invited Hitler's air force to try out new firebombing tactics on the town of Guernica.

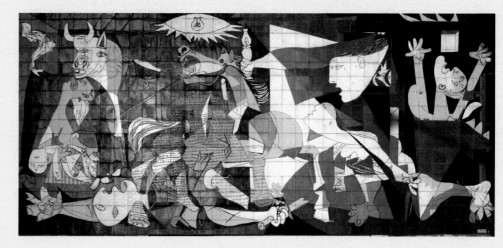

Tile copy of Pablo Picasso's *Guernica*, 1937. Public mural, Guernica (Gernika), Spain. Original in Museo Reina Sofia, Madrid.

The town was attacked on April 27th, 1937 with a merciless incendiary barrage which burned the town and its people to rubble and ashes. Reports of the carnage reached neighboring France days later, and shocking photos of the wrecked aftermath were published in French newspapers. Working in his studio in Paris, Picasso had been asked by the embattled Spanish government to create a mural for the World's Fair; fueled by the accounts of Guernica's destruction, Picasso seized upon this event as the mural's subject.

The outrage in Picasso's work is palpable. The contorted figures are rendered with symbolically abstract form: the pointed tongues suggest shrill, chilling screams; eyes dance in agitation across distressed faces. Only the flaccid figure of the baby is quiet and still, its dead eyes and limply-hanging nose drooping downwards in contrast to the keening, vertical form of the despairing mother. The bull symbolizes the wanton, destructive power of Franco and his fascist government. Picasso's **cubistic** space cuts up the figures into irregular shards; vignettes of horror are pieced together upon a shallow stage, suggesting the disjointed way that information about the atrocity reached Picasso and his fellow Parisians. The reliance on newspapers to learn the truth about the event is reflected in Picasso's exclusive use of black and white throughout the painting; newsprint is further suggested by the small hash-marks appearing in the body of the rearing horse.

Through the mannequin-like head of the fallen warrior, the wall-like angles of the background, and the bare bulb shedding cartoonish light, Picasso reveals the disjuncture between the actual event and his painting. In the true spirit of verism, Picasso does not attempt to present the painting as a record of the actual event—like the rest of the world beyond Guernica, Picasso was simply a witness from afar. Rather, Picasso presents his work as a re-creation, a symbolic interpretation of the event. Through this surreal tableau, Picasso insists on imparting the veristic truth about the danger of despots and the terrible cost of war. Throughout his life, Picasso refused to allow the painting to be displayed in Franco's Spain. Picasso died in 1973; Franco died two years later. The New York Museum of Modern Art was persuaded to yield the painting to a democratic Spanish government in 1981.

*Recall that we looked at this work briefly at the end of Chapter 3, discussing Romare Bearden's influences.

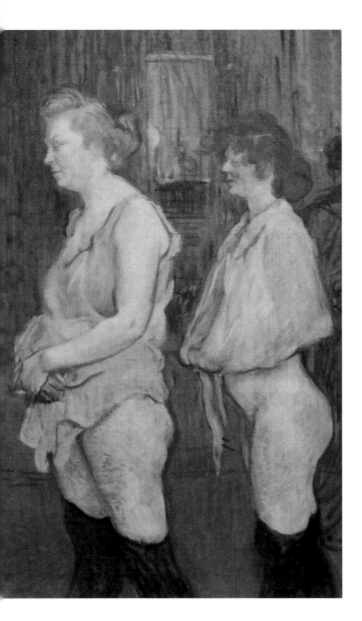

Henri de Toulouse-Lautrec, *Rue des Moulins*, 1894. Oil on cardboard on wood. National Gallery of Art, Washington, DC. Photo by the author.

VERISM AS A VOICE FOR THE VOICELESS

Picasso's *Guernica* provides a potent example of how verism can give a voice to the voiceless. When an artist feels compelled to speak out on behalf of the disenfranchised or victimized, he or she takes on a heavy responsibility. Who or what gives an artist permission to represent another's grief? South African artist William Kentridge—whose expressive animated works were discussed in Chapter 5—has admitted that there is something "vampiric" about an artist's use of others' misfortune and pain as subject matter.* Entrusted to communicate the suffering of others, the artist must use verism with care. The viewer must see that the verism comes from a place of empathy, compassion and concern—and is not intended to expose the subject to further mockery or abuse.

Let us explore the issue by looking again at the work of Henri de Toulouse-Lautrec (1865–1901), whom we first met in Chapter 5. Toulouse-Lautrec painted the Paris underworld, showing the intimate moments of performers and prostitutes, backstage and in the back rooms of the famous Parisian dance halls. In *Rue des Moulins*, Toulouse-Lautrec presents a pair of prostitutes without any "Pretty Woman" sugar-coating. As they line up with their skirts raised, the women present an uncomfortable sight to the viewer. They are not here to be ogled, nor to be morally judged. For the women, it is a routine event: they are simply waiting for their monthly gynecological exam, instituted by the Parisian government to stem the spread of syphilis and other sexually-transmitted diseases. The scene is at once degrading and mundane; there is no sense of a momentous occasion, no epic statement—instead, there is blunt factuality—the situation simply "is." The viewer is left to wonder what the future holds for these poor women. The verism here exposes the age, resiliency, and exhaustion of the women, all at once; one cannot help but be aware of the broader implications of these women's lives—there is no lifeline here, no safety net, no job training or counseling, and no retirement plan. Their lives at 24 Rue des Moulins (the brothel located at #24 Mill Street) is not likely getting any better than this.

What drove Toulouse-Lautrec to choose such raw and unsentimental subject matter? Why did he choose to speak for these women—and why did they allow him to portray them in such an exposed way? Afflicted with a bone disease that caused his brittle legs to break at a young age, Toulouse-Lautrec was stunted in height. Having been born to wealthy, high-society parents—but transgressing the "norms" of turn-of-the-century France by his very appearance—Toulouse-Lautrec was surely sensitized to the plight of others who didn't fit into mainstream society's narrow and judgmental parameters. He and the prostitutes were kindred spirits; in sharing their pain, Toulouse-Lautrec was also exposing his own.

*William Kentridge in "Art 21," 2011.

VERISM AND PHOTOGRAPHY

Despite its use as a medium by such famous artists as Daumier and Posada, prints were derided in the 1800s by Academic officials as illegitimate and common—not high art material. For many years, critics thought of photography in the same light. The camera was too readily available, giving the "rabble" the "wrong idea" that they too could make pictures. Photography was also perceived as too easy and too immediate—capturing raw, on-the-scene images that might be too hard for viewers to swallow without the "civilizing filter" of the artist's brush. In contrast to the mainstream art world's rejection of photography, Daumier was excited by its potential. He knew the potent political and social power that a photo could wield. Even today, though we are keenly aware of how photographs can be manipulated, we still want to assume the veristic integrity of a photo. Over the next few pages, we will see how several female photographers embraced this once-derided media to disturb, provoke, and engage.

Chances are, you have seen a photograph by Margaret Bourke-White already. In 1930, she was the first photographer from the West to be granted access to the Soviet Union. As we will see in the next chapter, her photo of Fort Peck Dam appeared on the 1936 inaugural cover of *Life* magazine. One of the foremost photographers of the Great Depression and Second World War, Bourke-White shared with contemporaries Dorothea Lange and Lee Miller the grit to face the toughest subjects. Miller was a fashion model before taking up the camera herself. Working separately but pulled by the same tides of war, Miller and Bourke-White both earned correspondent credentials when the U.S. entered WWII, and were on the ground in Europe at the end of the war, when the Jewish concentration camps were liberated from Nazi control.

American general and future president Dwight Eisenhower was one of several witnesses to the atrocities which were discovered upon liberation of the camps, and insisted that each camp be fully documented with still photography and video footage—lest anyone later try to deny the "unspeakable conditions [that] exist."* Bourke-White was among the first to photograph the Holocaust victims, both living and dead. The photograph here shows Bourke-White preparing to take a picture of a pile of corpses at Buchenwald Concentration Camp. Bourke-White's images bear witness to the Holocaust—and bring viewers unbearably close, to bear witness themselves.

Lee Miller, *Burgomeister of Leipzip a suicide in his office together with wife and daughter as 69th Infantry Division and 9th Armored Division closed on city. Germany, April 20, 1945.* Department of Defense, National Archives. Lee Miller's photo here juxtaposes the tastefully-appointed office of the Leipzig mayor with the tragic tableau of the mayor, with his family, sprawled on the furniture—dead by suicide. Fearing capture, many leaders of the failed Reich chose to take their own lives—and successfully encouraged (or forced) family members to join them.

Lt. Colonel Parke O. Yingst, *Life* magazine photographer Margaret Bourke-White prepares to take a photograph of a wagon piled with corpses in the newly liberated Buchenwald concentration camp, April, 1945.

*Quoted in Kristen Campbell, "Liberation of the Nazi Concentration Camps 1933-1945," http://history.sandiego.edu/gen/ww2timeline/camps.html.

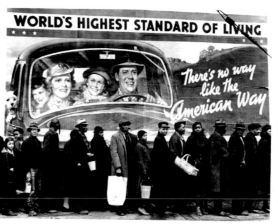

Margaret Bourke-White's choice of subjects was not limited to wartime Europe. The contrast between idealism and verism is made painfully clear in Bourke-White's *At the Time of the Louisville Flood, 1937*, which contrasts the promise of the "American Dream" and Depression-era reality. Here Bourke-White offers one of the most succinct assessments of financial hardship and racial disparity in the history of American photography.

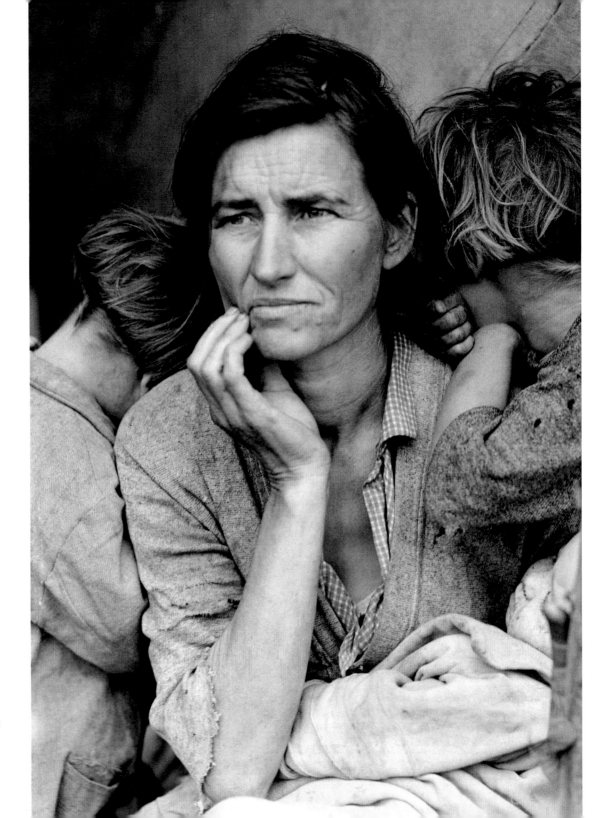

Dorothea Lange, *Migrant Mother*, 1936. Collection of the author.

VERISM AND MORAL RESPONSIBILITY

Artists can use verism to raise social awareness and increase the public's empathy for those less fortunate. However, with verism comes the risk that viewers will walk away with nothing but a feeling of hopelessness. The artist can inadvertently *define* a subject by her victimhood, so that is all the viewer sees. To ensure that their subjects' human dignity is preserved, artists often try to depict their subjects with a kind of nobility, one that is earned through hardship and perseverance.

Two American artists, Alice Neel and Dorothea Lange, both convey a combination of heroic survival and suffering through searing veristic imagery. Dorothea Lange photographed victims of the Great Depression—from rural farmers who had lost their crops and homes in the Dust Bowl, to the urban unemployed, lining up for bread and protesting the government for failing to provide sufficient support. Regarding the rural poor who had lost their homes to foreclosure, Lange stated, "Their roots were all torn out. The only background they had was the background of utter poverty. … I had to get my camera to register those things about those people that were more important than how poor they were—their pride, their strength, their spirit."*

In her famous photograph of a displaced mother and her children, Lange places the weather-beaten, careworn face of the mother in the very center of the triangular composition. Rather than appearing defeated, however, the woman appears steadfast and resilient, somehow managing to carry on despite the enormous odds against her. Lange achieves this impression, in part, by placing the camera at the woman's eye level, so that viewers must look up to her, rather than down at her. The hidden faces of the older children ensure that the viewer is riveted exclusively by her expression; her arm acts as an arrow, pointed directly to her face. The composition allows viewers to admire the heroic strength of the subject, while still expressing the enormity of the circumstances she must face.

In *T.B. Harlem*, notice how artist Alice Neel has used a low perspective, similar to the angle Lange used to photograph *Migrant Mother*, so that the viewer looks up at the subject. Also like Lange, Neel presents a suffering figure with unflinching verism; and, like *Migrant Mother*, this young man appears as a quietly enduring survivor—inciting our pity, but also our admiration. We are inspired to do more than just sympathize; we are encouraged to take social action on the subjects' behalf.

For over two decades, painter Alice Neel (1900–1984) recorded the daily lives of fellow residents in her neighborhood in Spanish Harlem, New York City. Neel's portraits reveal her neighbors' challenges and crises, conveyed through expressive abstraction. In her paintings, Neel emphasizes the contours of her figures with bold outlines, intensifying their gestures (often by making the head disproportionately larger than the body) and zeroing in on distinctive features that accentuate the sitters' individuality (as well as their flaws).

This painting poignantly captures the recovery of a tuberculosis patient, whose diseased lung has been collapsed (a procedure which required the removal of several ribs). The extenuated arc of the patient's neck serves to accentuate the quiet endurance evident on the patient's face. His gaze is unavoidable and penetrating. His emaciated frame, small hands, and delicate fingers are made abstractly undersized, to heighten the impression of physical weakness and vulnerability. As viewers, we hope that the man's mangled torso (poorly patched with a white bandage) is also an exaggeration on the artist's part—yet we fear that her rendering is accurate. Indeed, the disfigurement we see here was a routine consequence for TB sufferers, in an era when limited access to health care and delayed treatment contributed to disproportionately severe outbreaks in poor, heavily-populated neighborhoods. The work was a personal one for Neel, as the subject, Carlos Negrón, was her then-boyfriend's brother. In this work, Neel not only presents one man's struggle for survival—she is making a pointed social statement, criticizing a city that has failed to take care of its own.

*Oakland Museum of California. Explore their collection of Lange photographs at http://museumca.org/global/art/collections_dorothea_lange.html.

Alice Neel, *TB Harlem*, 1940. Oil on canvas, 30 x 30 inches. National Museum of Women in the Arts, Washington, DC.

You may view more of Alice Neel's work on the website established by her estate, http://www.aliceneel.com/.

A Question of Dignity: The Photographs of Diane Arbus

Diane Arbus, *Boy with Toy Hand Grenade*, 1962.

Throughout this chapter, we have seen that the choice of "idealism vs. verism" has a moral component. Those who choose idealism often believe that society needs to see the best and the beautiful, in order to strive for it. Artists drawn to verism feel compelled to expose humanity's faults and frailties, in order to inspire empathy for the human condition.

Each choice comes with risks—but verism is unquestionably the more perilous route. Artists who use verism in their work run the risk of coming across like a tourist or poseur—one who claims to celebrate his or her subjects, but instead sensationalizes their plight for personal gain. An artist's best defense against such criticism is to hold membership in the same class or category as his or her subjects. Toulouse-Lautrec felt ostracized by his affliction, despite his wealthy parentage, and hung out with the very prostitutes he painted—who readily accepted the diminutive, alcoholic artist as a social outcast like themselves. Alice Neel lived in Spanish Harlem; her subjects were her friends, lovers, and neighbors. Chuck Close only paints people he knows, and readily paints himself with the same veristic treatment.

What, then, to make of Diane Arbus? A lifetime New Yorker, Arbus was born in 1923 to a wealthy Jewish family. Marrying photographer Allan Arbus at age 18, Diane took up photography herself, and—outside of the commercial photos she and her husband produced—swiftly gravitated towards disquieting subject-matter. This photo, taken of an exasperated child in Central Park, reflects Arbus's interest in teasing out disturbing threads in the idyllic American landscape. In fact, Arbus had provoked the boy's apoplectic expression by taking an inordinately long time photographing him; the result is not a portrait of the boy, so much as a statement about anxiety in the modern age. In selecting this shot, among a host of smiling photos, Arbus seems to suggest that we might all be deranged little monsters on the inside, strung too tightly and poised to go off, like the child's hand grenade.

Like all artists, Arbus presents the viewer with a manipulated reality. What she has chosen to show—and not to show—impacts our understanding of the subject. Note the starkly different tone of the photographs of the boy, which Arbus chose not to print. Has Arbus betrayed the boy's confidence, exploiting a moment of frustration for her own purposes? Consider the following quote from Colin Wood—the lad in the picture, now grown up:

Left: Diane Arbus, contact sheet of Colin Wood (boy with hand grenade).

Right: Diane Arbus, *A Jewish Giant at Home with His Parents in the Bronx*, 1970. Museum of Contemporary Art, Los Angeles.

"I have to say, [Arbus] felt a real empathy with that kid—with me. My childhood was not a comfortable one. My mother and father split up when I was very young. I had asthma. I always felt like I wasn't up to snuff, and I was alone in many ways. I was a troubled boy...There's a sadness in her that she also saw in me ... this need, which was very big in me at the time, to be accepted and appreciated or paid attention to. I was not directed, but there was a collusion of some kind. There's almost this 'is this what you want?' feeling on my face."*

Arbus is perhaps best known for her photographs of people with physical differences, "misfits" viewed by society as freaks and oddities. Her photo of *A Jewish Giant at Home with His Parents in the Bronx*, 1970, compassionately conveys the challenges, both physical and emotional, faced by the oversized man and his family. Arbus's most controversial series of photos—depicting developmentally-disabled women and girls, dressed for Halloween—were also her last. The photographer committed suicide in 1971, at the age of 48.

From outward appearances, Arbus was simply an outside observer of society's dark and hidden corners. However, the depth of Arbus's inner turmoil placed her at the very heart of her troubled subject matter. Through her suicide, Arbus's "entitlement" to others' suffering was fully, tragically vindicated.

*Quoted by journalist Hugh Hart in "Post-developments/For the subject of Arbus' 'Child with a toy hand grenade,' life was forever altered at the click of a shutter," San Francisco Chronicle, October 19, 2003.

We have looked at many prints in this chapter, since artists who use verism often want their messages to reach as wide an audience as possible. Let us conclude this chapter by examining a range of printmaking techniques.

TECHNIQUES OF PRINTMAKING

What is a print? Printmaking is still very relevant in the 21st century, but many people do not really know what a print is, or how it is made. Put simply, a print is a copy of some image. To make a print, you need to transfer an image onto a surface. That surface is the print (the equipment you use, and the original source of the image, is not the print). You don't need to be able to make a thousand copies to "qualify" as a print—just one copy, one transfer, counts as printmaking.

Relief Printmaking

One of the oldest techniques of printmaking is the **relief print**. If you have ever used an inked rubber stamp on a piece of paper, you have made a relief print. A hand stamp illustrates how relief printmaking works: note that the hand has been pressed into ink, but only the *raised parts* of the hand (especially the fingertips, and the "pads" of the palm) make contact with the page, and show up on the print. Notice that, in our example here, the ink didn't get into the grooves of the hand—those areas are too low, and so they print as white (ink-less) areas. If you examine a rubber stamp, you will see the same feature—the part that gets the ink stands up and gets printed in reverse; the rest remains ink-free.

Relief print, using a hand as the matrix.

Relief print made from a hand-carved rubber stamp. Photos by the author.

Left: Making a woodblock print. The negative space is being cut out of a block of pine wood, which is relatively soft.

Inking the brayer.
Photos by the author.

In both examples shown on the previous page, the **matrix** (the source of the image, before it's transferred) is pressed into the ink, then pressed onto a surface (such as a piece of paper, a T-shirt, etc.) to make the print. This works well when the matrix is small and easy to manipulate. However, to maximize control when making large relief prints, it's common to work the other way around—bringing the ink and the paper to the matrix.*

* For flash animation of various printmaking techniques, see the interactive site "What is a Print?" created by the Museum of Modern Art, New York. The site provides excellent examples of woodblock printing, lithography, screen printing, and etching, along with animated demonstrations of each technique. Be sure to peruse the website to get a better understanding of each technical process, as well as the visual characteristics of each kind of print: http://www.moma.org/exhibitions/2001/whatisaprint/flash.html.

Block printing: Carved block of the Palace of Fine Arts, San Francisco.

Inking the block (rolling the inked brayer over the raised surface of the bloc

Using the barren to transfer the ink onto the paper.

Pulling the print.

Woodblock prints are relief prints made from blocks of wood. As with the rubber stamp, any raised areas of the wood will receive ink—so all areas intended to be white must be cut away.* The technique was mastered nearly two thousand years ago in China, but did not gain popularity in Europe until the 1400s.**

In woodblock printing, the ink is rolled with a **brayer** onto the raised surface of the block. The brayer is not sponge-y like a paint roller, so it doesn't let the ink sink down into the cut areas. Once the block is inked, the printmaker places a piece of paper over the block (making sure it is positioned correctly before letting it come in contact with the inked surface). A barren can be used to ensure a good transfer of ink—acting like the back of a big spoon to distribute even pressure on the paper.

Woodblocks can be carved and printed to create precise lines and solid shapes. However, artists can manipulate the process to produce more emotionally-expressive surfaces. Artists may choose to roll a minimal amount of ink on the wood, so that the texture of the wood grain shows through on the print. Or, when carving the block, one might allow jagged edges of wood or "orphan" pieces to remain, adding an implied rough texture. The German Expressionists often employed both tactics in making their woodblock prints.

The relief print (left) presents a reverse image of the matrix (the original block, right).

*Linocuts use linoleum as the cutting surface.

**Paper was used long ago in Asia as a support; European artists were still using vellum until the late 1400s—and without paper, printmaking is not practical.

Ernst Kirchner's print of an artist named Marzella can be compared with his painting of the same subject. Both works are expressive in their compositions; the lines in each are rough and organic. Note how Kirchner uses different media to gain the same expressive effect. The hand-colored print does not simply reproduce the painting, or vice versa. Rather, each medium presents its own possibilities and challenges.

Left: Ernst Kirchner, *Artistin (Marzella)*, 1910, Brucke Museum, Berlin, oil on canvas.

Right: Ernst Kirchner, *Artistin*, 1910, Ravensburg Museum, hand-colored print.

As Kirchner's work shows, relief prints may be made in color. One can hand-color a black-and-white print (as in *Artistin*); otherwise, printed color requires a separate block to be cut for each color.* The same piece of paper is placed over a succession of different blocks, each block individually cut and rolled with a different color (or colors). The artist must make sure that the paper is properly placed each time a print is pulled, so that the colors overlap and line up correctly; this is called **registration.** Kirchner is deliberately casual with his registration in *Dance*, giving a loose, extemporaneous feeling to the dance. Kirchner's use of the medium may be modern, but he was also being quite traditional in his choice of woodblock printing. Remember that the European printing press was invented in Germany. In *Dance*, Kirchner is celebrating both a German folk tradition, and a German innovation.

The technique of multiple-color relief printmaking was mastered in Japan. From Impressionist Mary Cassatt, to Symbolists like Edvard Munch and Expressionists like Kirchner, Western artists have been influenced and inspired by Japanese *ukiyo-e* prints. Meaning "floating world," *ukiyo-e* works feature fleeting pleasures and experiences. Subjects include actors, prostitutes, and scenes of daily life. Here, the printer Toshusai Sharaku captures a moment in time, as a celebrated actor performs as a famed Samurai. The precision of the woodcut mirrors the control of the actor, whose emotive gestures and expressions give life to the character—just as the bold patterns and colors employed by Toshusai, in turn, give life to the print.

Left: Ernst Ludwig Kirchner, *Dance (Dancer and Clown),* 1910, woodcut on paper. Right: Toshusai Sharaku, Oniji Ōtani III (aka. Nakazō Nakamura II) as Edobee in the May 1794 Production of *Koi Nyōbo Somewake Tazuna* at Edo Kawarasaki-za theater. Woodcut on paper.

*Ink can be semi-transparent, so that layering two colors can create a third color. This characteristic allows the printmaker to make a wider range of color without having to cut so many blocks of wood.

Intaglio Printmaking: Engraving and Etching

INTAGLIO: *Italian, from intagliare, to engrave: [from] tagliare, to cut....(see **tailor**)*
—*The Free Dictionary (thefreedictionary.com/intaglio)*

In intaglio printmaking, the artist cuts fine grooves in the surface of the matrix (usually, a plate made of copper, zinc, or other soft metal—or a modern alternative, like a thick sheet of plexiglass). Unlike relief printing, the ink is pressed into these grooves, then wiped gently from the surface. Rather than just make contact with the surface, the paper must sink into the grooves to make the print.

Dry paper is quite inflexible; for intaglio printing, high-quality paper should be soaked in water and then blotted (to remove excess water) to ensure maximum flexibility. When the right amount of pressure is applied, the pulpy paper fibers dip down into any shallow pits and grooves on the plate's surface. However, even using pliable, heavy-duty paper, human beings just don't have enough strength to make a good intaglio print. A printing press must be used to do the job effectively.*

*The roller of an etching press applies approximately 1,500 pounds of pressure per square inch; see http://www.worldprintmakers.com/torculo/etchpres.htm.

The most straightforward way to make a mark on an intaglio plate is simply to carve a line into the surface. In **engraving,** the artist uses a special tool called a burin to cut a groove into the plate.

Controlling the burin takes great skill; an easier alternative is drypoint, in which a pencil-like cutting tool is used to scratch into the surface. The drypoint tool creates a burr (a rough, raised edge along the path of the scratch mark) which also holds ink.

A plate must be able to withstand the pressures of the press; it must be firm enough so that the lines will not mush or collapse when all that weight rolls on top of it. This poses a challenge for printmakers, however—any material *that* tough will put up some resistance to your hand when you cut into it. In other words, it will be physically more demanding than simply dragging a pencil across a piece of paper. On the other hand, metal that is soft enough to be cut by hand—such as copper—may lose its fine lines after repeated passes through a press. Drypoint lines are particularly vulnerable to collapse under pressure, which may explain why Dürer abandoned drypoint after just a few experiments with the technique (such as the print shown on the following page).

The edge of a burin is shaped like a snowplow, to dislodge the metal so it curls up and out of the way. The handle, shaped like a mushroom cap, is cupped in the palm.

Drypoint on a copper plate.

Albrecht Dürer, *St. Jerome Seated Near a Pollard Willow*, 1512. Drypoint print, 8.4 × 7.1 inches. British Museum.

Kathe Kollwitz, Sharpening the Scythe, 1895-1905. Posthumous print, c. 1948. Etching, 11 × 11 inches. Collection of the author.

*Lines that are too deep will fail to print—the paper can't sink far enough down into the groove to reach the ink.

As an alternative to directly cutting into the plate, the **etching** technique allows the artist to cut into a soft **ground** (a waxy coating) that covers the plate. The ground offers little resistance, and the artist needs only to expose the metal of the plate below—not dig into it. The plate is then carefully placed into a tray of acid. The back of the plate is usually pre-coated in the factory, and therefore protected. The only place vulnerable to the acid, as it begins its corrosive work, is the area where the protective ground has been scratched away. Many different acids are available to "eat" or **bite** into the exposed metal: the more toxic is ferric nitrate; citric acid is nontoxic. If you have ever used vinegar to clean a stubborn teakettle, you know what a tenacious solvent acid can be. The longer you leave the plate in the acid bath, the deeper the lines are etched.* Graytones may be created by spraying a fine mist of protective coating on the plate, resulting (post-acid bath) in an area of dotted pits. This etching technique is known as **aquatint.** You might discern evidence of aquatint in the woman's blouse, in Kollwitz's print here.

Following the tradition of Albrecht Dürer and the Medieval printmakers that came before him, the German Expressionists were masters of printmaking. They found the wood block and the etching plate to hold evocative potential. In her turn-of-the century series *Peasant's War,* Kathe Kollwitz tells the story of a village that violently rebels against its overlords after the rape and murder of a local farmwoman, a young mother. In Kollwitz's gripping series, the immediacy and accessibility of the print as a medium, combined with her veristic treatment of the figures, makes for an explosively harsh social statement against the abuse of power. Here in Plate 3 of the series, an old woman sharpens a scythe—her potent, almost intimate grip suggesting the bloody vengeance to come. Note the expressive range of surface treatments evident in Kollwitz's etching. Kollwitz has used a variety of techniques to make marks on the plate (including drypoint and sandpaper); the result is a rich and evocative play of textures and shadows.

To view more of German Expressionist printmaking, tour the New York Museum of Modern Art's site, "Artists of Brücke ['The Bridge,' the name of a German Expressionist art group]," at http://www.moma.org/interactives/exhibitions/2002/brucke/.

Screen Printing and Pop Art

The most well-known form of screen printing is **silkscreen.** In screen printing, a sheet of porous material (in the case of silkscreen, a piece of silk) is stretched over a frame. The artist uses this framed screen in conjunction with a stencil. The stencil is placed inside the frame; the solid stencil parts will keep the ink from passing through the screen, and the cut-out areas will allow the ink to pass directly through the screen—to the paper, T-shirt or other printing surface below. The ink is spread across the screen in a thin, consistent coat by the use of a squeegee.

Stencils are often made of paper, but there are other means to keep the ink from passing through the screen; wax is effective as well—but harder to remove from the screen once you're done. Today machines can take a scanned black-and-white design and "cut," automatically, a stenciled screen.

Perhaps the most famous artist to use silkscreen is **Pop artist** Andy Warhol. With a background in advertising, Warhol took advantage of the commercial, impersonal look of the silkscreen medium to suggest that everything in our modern popular culture—from starlets and politicians to dictators and Coca-Cola—is marketed and sold to the public for mass consumption.

The crisp edges that stencils create seem to negate the personal mark of the artist—in a way, screen printing acts in opposition to the personal mark-making of woodcut and intaglio. Make no mistake—the artist is certainly engaged in the screen-print process! However, the *look* of screen printing often appears to deny that engagement. This "denial of engagement" was also a trademark of Warhol's style—he refused to discuss the meaning of his work in-depth, and marketed his own wonky, mythical persona as part of his art "product."

Note that actress Marilyn Monroe (pictured at the beginning

Andy Warhol, *Marilyn*, 1967. Acrylic and silkscreen on canvas. Yale University Art Gallery.

of this chapter) died just a few years before Warhol created this screen print. In 1962, the star who once sang a sultry "Happy Birthday" to President Kennedy was dead of an apparent overdose at the age of 36. In contrast to the tragic circumstances of her death, the studio head shot of Monroe which Warhol appropriates is clearly idealized. However, Warhol's deliberate errors in registration, together with the jarring colors that seem to obscure Marilyn's face, rather than complement it, appear to undermine the mythical image of the "flawless starlet" manufactured by the movie studio. Warhol seems to suggest that the Marilyn we idolized (and scrutinized) was merely a fabrication—a mass-produced commodity, exhausted by an all-consuming public.

Ernst Ludwig Kirchner,
Study of a Head, 1926.
Kirchner Museum.

*Monoprints are similar to
monotypes, in that no two
are identical. However,
monoprints use a matrix
(a plate or other surface)
that has *some* kind of
repeatable design on
them—to which the artist
then adds additional
imagery.

Lithography

Lithography works on the principle that oil and water do not happily mix. In traditional lithography, a design would be drawn on the surface of a block of limestone with an oily or fatty crayon. The block would then be treated with a watery solution of gum arabic, which would penetrate the pores of the stone and ensure that the greasy, oily marks would chemically bond to the stone's surface. The greasy marks would be cleaned away, but the area beneath would still remain oil-friendly. Oil-based ink would readily cling to these spots, and refuse to stick to the negative (water-friendly) spaces. The inked design would then be transferred to paper, with the help of a lithograph press.

The advantage of the lithograph stone is that there are no engraved or etched lines that could ultimately wear down. The endurance of the design, even after repeated inking and running through the press, ensures large, high-quality editions with minimum image degradation. Relying on chemistry rather than cutting, lithography became *the* printmaking method for printed media industries (newspapers, magazines, and books). Look again at Daumier's *Gargantua* and *Rue Transnonain*, discussed earlier in this chapter. Note that these scathing, politically-charged works are both lithographs, published in the progressive journal "La Caricature." Today, **offset lithography**—a mechanical process that mimics the traditional approach—dominates the printing industry.

The lithograph here is by Ernst Kirchner. Note the variety of textures that lithography allows. There is an immediacy to the work; you can sense the quickness and ease with which Kirchner drew on the litho stone. The marks transfer faithfully, as though Kirchner had drawn directly on the paper. The result is an intriguing and vivid portrait, which looks as fresh and spontaneous as the day it was printed.

Monotype

A **monotype** is one of a kind—and yet, it is still a print (remember that a print needs to transfer an image only once to "qualify").* In one of the most common monotype techniques, the artist "paints" in ink on a metal or plexiglass plate. Paper is then placed over the plate, and run through a press. When the paper is peeled off the plate, a transfer of the image occurs. The artist may attempt to repeat the design, using the ghost-image in the ink still left on the plate; however, that design will not be a replica of the first.

The monotype on the next page was made by Impressionist Edgar Degas. He made as series of monotypes of women bathing and dressing, commonly thought to be prostitutes (although the identities of the woman remain deliberately ambiguous). Monotype is a slippery medium, which suits the ambiguity of Degas's subjects well. Here a woman tends to her makeup. Is she a stage performer? A prostitute? Or a housewife getting ready to go out?

Edgar Degas, *Intimacy*, c. 1877. Monotype. Statens Museum for Art.

The Future of Print

Printmaking has a long and varied history, and with the introduction of new printing technologies, the medium is ever-changing. The major approaches to printmaking have been addressed here, and special attention has been given to those aspects of printmaking that link to the broader concerns in this chapter: the power of verism; its use in creating socially- and emotionally-charged imagery; and the power of printmaking in disseminating such images to a broad public. Although photography has taken printmaking's place for documenting newsworthy events, the print remains a potent medium for artists' personal expression.

In many ways, the internet has taken over many of the roles that printmaking once championed—providing a voice for the otherwise voiceless, an outlet for the socially outraged, a soap-box for politically-charged images and ideas. The viral spread of a video clip, uploaded from someone's cell phone camera, is perhaps a descendent of Daumier's lithographs. Rather than render the print obsolete, however, computers have become a tool within the printmaking process, as artists digitally manipulate imagery before going back to work the images by hand in the print-shop.

How relevant is printmaking today? Perhaps the most popular, iconic image of the past decade is, in fact, a print: Shepard Fairey's 2008 silkscreen of then-presidential candidate Barack Obama. This print is not without controversy, however. Fairey based his portrait of Obama on an Associated Press photo of

Printed street art, near 14th and U Streets, Washington, DC, based on Shepard Fairey's *Hope*, 2008.

the candidate sitting at a conference table, which the artist had cropped to isolate Obama's face. The Associated Press sued Fairey on behalf of their photographer, Mannie Garcia, claiming copyright infringement. Fairey countersued, arguing that the AP photo was used fairly, and that, as an artist, he had sufficiently changed the composition to make the image his own. From Dada to Pop, artists "borrowing" iconic images for their own purposes is hardly a new trend. However, with the proliferation of readily-available images on the internet, the issue of "fair use" becomes more and more complicated for artists who appropriate others' visual work.

Halfway around the world, Danish newspapers continue to deal with the repercussions of publishing political cartoons that show the Prophet Mohammed. Initially printed in 2005, the images were intended to criticize Muslim extremism—yet the depictions of the holy figure (in violation of Islamic tradition) incited numerous threats of violence against the cartoonists in particular and the Danish people in general.* These two cases demonstrate the continued influence of the printed image in the 21st century. Centuries after its invention, printmaking continues to raise sensitive issues about personal liberty and social responsibility. In this chapter, we have seen the work of many artists who felt morally compelled to create

*We will discuss this issue further in Chapter 12.

veristic, challenging (and often disturbing) art for the masses. In the next chapter, we will look at artists who have pursued the opposite course, creating idealized artwork to reassure the public—offering confidence instead of doubt, affirmation instead of criticism, and the assured confirmation of righteous authority.

aquatint	Technique of printmaking that allows areas of implied texture
brayer	Device that allows printmakers to roll ink onto a block
edition	Numbered set of prints made from the same matrix
engraving	Technique of intaglio printmaking in which lines are cut into a plate
etching	Technique of intaglio printmaking in which lines are cut or "bitten" into a plate by acid
ideal, idealized	Style in which the subject appears as perfect as possible
intaglio	Form of printmaking in which ink is rubbed into grooves cut in a plate; requires a press to exert pressure on the paper to pick up the ink
lithography	Form of printmaking in which prints are made from a stone initially marked with an oil-based crayon
matrix	Block, plate, or other material from which prints are made
monotype	Form of printmaking in which ink is applied to an untreated (not carved or otherwise marked) matrix, and printed.
oeuvre	French term for an artist's whole body of work
offset lithography	Modern form of printmaking used for posters and other printed matter
printmaking	Medium in which at least one copy is made through a printing process or technique
Realists	Term applied to radical artists of mid-1800s France who advocated for social reforms and democracy
registration	Lining up a paper and matrix to ensure proper placement of imagery
relief print	Form of printmaking in which a raised surface (on a carved block of wood, carved piece of linoleum, stamp, etc.) receives ink and is printed
screen print	Form of printmaking in which ink is squeegeed through a screen, on which areas have been blocked by a stencil or other barrier.
verism, veristic	Style in which the subject appears as unpolished as possible, exposing flaws
woodblock print	Technique of relief printmaking using a carved wood block as the matrix

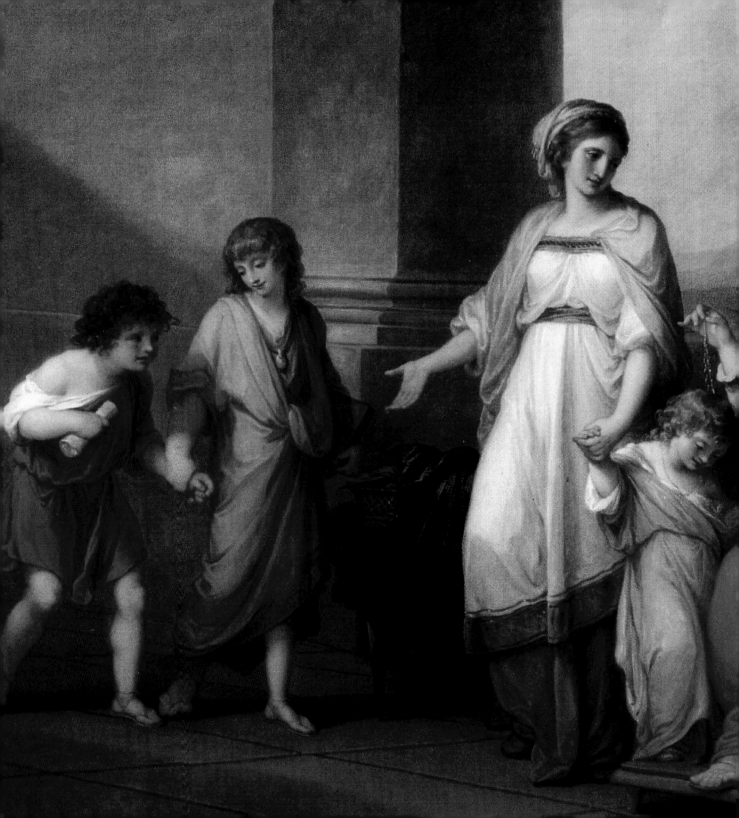

8

THE CLASSICAL STYLE

8: THE CLASSICAL STYLE

THE CLASSICAL STYLE IN ART AND ARCHITECTURE
CLASSICAL NUDITY VS. "NAKEDNESS"
CLASSICISM AND POSITIVE PROPAGANDA

*The use of irony to
challenge viewer's
assumptions and expecta-
tions will be explored in
Chapter 12.

In the previous chapter, we examined the "down and dirty" role of veristic art, bringing the public's attention to social ills, moral lapses, and neglected tragedies. Let us turn now to the alternate course: art designed to uplift, to rise above the mire of everyday people and everyday concerns, and inspire positive feelings of confidence, righteousness, and valor. This is the essence of the Classical style.

WHY CLASSICISM? THE IMPACT OF THE ENLIGHTENMENT

Jean-Antoine Houdon, Bust
of Voltaire, 1781. Marble,
20 1/4" high. Legion of
Honor, San Francisco.
Photo by the author.

The powerfully positive vocabulary of Classical art comes to us today through the **Enlightenment** movement of the late 1700s. This cultural movement—one that included art, literature, philosophy, and political discourse—swept Europe, acting as a catalyst for social changes that reverberated for years to come. The Enlightenment favored scientific reasoning over mystical thinking, ushering in a new era of scientific experiments and discoveries. Enlightenment thinkers called into question the "Divine Right of Kings"—the age-old idea that kings ruled the people because they were chosen by God, and were therefore more worthy than anyone else. People were told that the nobility were naturally better-suited to rule, better-suited to learn, and more deserving of wealth and privilege than the lower classes. Philosopher-writers like Voltaire in France began to poke holes in this fallacy, using irony and wit—tools long used by artists to disrupt and disturb the "conventional wisdom" of their time.*

The questioning attitude of the Enlightenment prompted revolution in more than one country—from America in 1776, to France in 1789, to Haiti in 1791. The people fought for presidents, rather than kings (a result achieved in Haiti and the U.S., but not in post-revolution France). Enlightenment philosophy echoes throughout our Declaration of Independence, in the assertion that "all men are created equal" and are equally entitled to "life, liberty, and the pursuit of Happiness." The Enlightenment lies at the heart of our Constitution—particularly in the Bill of Rights, the first ten Amendments—and colors our social, political, and personal attitudes to this day. It is vital to note, however, that the probing skeptic's eye—captured vividly in Houdon's *Bust of Voltaire*—does not necessarily lead to a culture-wide embrace of skepticism—or a national outbreak of authority-questioning! Although the germination of revolution comes from challenging and upsetting a fixed establishment, the *new* establishment that arises in the wake of revolution often creates its own, inflexible set of rules before long.

Even the Enlightenment was susceptible, by its very principles, to this return to conformity. For example, Enlightenment philosophers ambitiously (and perhaps arrogantly) sought to study

and classify the whole of human knowledge. This is when the first encyclopedia was written, the forerunner of today's Wikipedia, which purports to give total information for every conceivable subject. Yet, the attempt to find the answer to the question of "life, the universe, and everything" can be a door-closing process, not a door-opening one. The more one seeks to find answers, and put each answer in its own, neatly-fitted box, the more that alternative answers—and alternative questions—are discounted and excluded from the system.

The artistic style of revolution, in both France and the United States, was one that sought to clarify and *resolve* revolutionary ideas, rather than confuse the issues with muddy, complicated, open-ended questions. The revolutionaries also didn't want to appear as "yahoos," as wild and undisciplined rebels with an authority problem; they saw themselves as intellect-driven—inspired by reason, not blood-lust or vengeance. The new face of art did not break with tradition so much as bring back, in full force, a very ancient tradition. The face of the Enlightenment was a Classical face.

CLASSICAL ART, REVISITED

We took a brief look at Classical art at the end of Chapter 1, which revealed the cultural origins of our present-day preference for naturalistic, rather than abstract, art. You may recall that "Classical art" refers to the ancient art of Greece and Rome, which generally emphasizes physical power and beauty—linking the visually virtuous to the morally sound. The Classical arts and architecture were designed to separate "us" (civilized and ethically-correct people) from "them"—the uncivilized barbarians who must become like us to better themselves.*

In our brief Chapter 1 survey of Classical through Renaissance art, we focused exclusively on sculpture, in order to compare "apples to apples." Let us expand our view to look at architecture, which includes the sculptural decoration that is (or once was) attached to buildings. Sculpture which protrudes from a solid background is known as **relief sculpture**; if it extends far from the wall, it is called high relief; if it is shallow, it's called low relief. A long band of relief sculpture attached to a building is called a **frieze.** Note the high-relief friezes on the Roman altar shown here. Inaugurated in the year 9 BCE to celebrate Emperor Augustus's triumphs over Spanish and French (Gallic) "barbarians," the *Altar of Augustan Peace* provides an excellent example of Classical art, both in style and message.

Above the decorative, low-relief frieze of abundant, scrolling vines appears a procession of Roman people. The scene includes leaders of the community who have come to pay tribute to the gods, in thanks for looking after the Roman Empire so effectively—and, of course, to pay tribute to Emperor Augustus, for bringing victory, prosperity, and bounty to all Romans. To viewers at the time, the message was likely convincing (if laid on a bit thickly); today, we know from archaeological evidence that it was, in fact, too good to be true.

The job of this altar is not to present a neutral, news-reporter's view of Augustan leadership. This altar tells the viewer that the fighting is over, Rome is victorious, and Augustus will now provide peace, security, a thriving economy, and enough agricultural produce for the entire Roman population. It

*The Greeks and Romans believed that barbarians who refused to accept their ways were clearly in the wrong ("what right-minded person *wouldn't* want to be like us?"), and must be eliminated (from the artwork, from society—and from the land of the living, if necessary!).

The *Ara Pacis Augustae* (Altar of Augustan Peace), 13 BCE, Rome, Italy. Rear entrance (East side).

Top: South side of Augustus's altar.

Bottom: Back of altar (East side, detail).

does not mention that the fighting still continues at the empire's borders, or that Augustus's valiant endeavors came with significant costs, both human and financial. The *Ara Pacis* presents wholly positive propaganda. It reinforces Roman identity and righteousness. The viewer is meant to look up to the people sculpted on its walls, both literally and figuratively: these are the best of Roman citizenry, the altar says, and you would do well to emulate them. Do what they do, believe in what you see, and all will be well, just as the altar shows.

The back panel of the altar provides a useful synopsis of Classical vocabulary. First, consider the basic composition: the triangular shape that unifies the relief, together with repeated circular forms and a strong **symmetrical balance**—with the figures grouped evenly on each side—provide a sense of order and predictability. Originally painted, the relief would have been further unified through the repetition of naturalistic colors. The figures appear solid, corporeal, and full-bodied. Every aspect of the scene is idealized; the female bodies are youthful and fit; the babies are plump and healthy; the plants are in full bloom and ready for harvesting; the animals are docile and fit for sacrifice. Most importantly, the tone of the work is calm and controlled. The viewer is left with a sense of fulfillment and assuredness, not disquiet or confusion. As we will see shortly, scholars are still debating the particular identities of the female figures; however, the gist of the story is readily apparent. We need no special knowledge to see that the message is one of nurturance and bounty. With Classical art, what you see is (usually) what you get.

THE CLASSICAL FEMALE AS ARCHETYPE

Let us consider further the female figures on the East side of Augustus's altar. They represent the one aspect of Classicism that might confuse or misdirect the modern viewer: the female **archetype**.

The scene with the three figures is often called the Tellus panel, named after the central figure who has been typically identified as Tellus, or Mother Earth. However, some scholars think that the figure in the middle is Ceres, the goddess responsible for good harvests. The younger women on either side might represent the earth as well, or perhaps the beneficial winds that blow over land and sea. Note that, despite the variations in interpretation, the essence of the females' identities remains the same. They are *not* human, mortal women; they do not represent specific women, nor Roman women in general. Though they are clearly female, they do not represent "women" in any real way. Rather, they appear as **personifications**—symbols in human form—of ideas or ideals.

Personifications often take female form in Classical artwork. In some cases, the ideas or ideals the female figures represent are linked to traditional views of womanhood. For example, women were considered fickle and emotional, so the ever-changing winds that sweep over the land and sea could be represented by female figures floating on billowing cloaks.* Other female personifications might stand for characteristics associated with reproduction and child-rearing (growing, guiding, protecting, and so on). Indeed, most of the Greco-Roman goddesses existed as supernatural stand-ins for earthly concerns: Venus as the embodiment of virtuous love, Ceres and Tellus as nurturing Earth, Vesta as the warmth and protection of hearth and home, etc. They are archetypes, acting as the models for ideal virtues and concepts. Real women, in contrast, were seen in the ancient world as being far from ideal—prone to vice, unintellectual, and undisciplined. The well-behaved women standing in line on Augustus's altar reliefs present the best that women could aspire to. Note that these women are fully-clothed, not half-naked or wearing see-through gowns. They are idealized, but they are not Ideals Incarnate.

A female archetype well-known by most Americans is "Lady Liberty." As with her ancient predecessors, Lady Liberty is not a particular American woman—any more than Uncle Sam is a particular American man. Rather, she is the beautiful *idea* of liberty, the perfect ideal to which the American political system aspires, along with "the pursuit of happiness."

In the painting on the next page by Domenico Tojetti, the central female figure is a personification of America, riding westward towards the California coast. This work borrows much from Classical art, from

Frederic-Auguste Bartholi, Statue of Liberty, dedicated 1886.

*To represent more powerful sky phenomena, such as thunder and lightning, a male figure would be used.

Domenico Tojetti, *The Progress of America*, 1875. Oil on canvas. Oakland Museum of California.

its archetypical figures in Greco-Roman costumes to its Roman chariot and flying cherubs holding laurel-crowns of victory. The scene is naturalistic and idealized overall; despite the inclement weather ahead, there is no question that all is moving forward in an orderly, assured fashion, bound for ultimate success.

The tone of the piece—that all trouble will be met with the clear light of reason and the sure hand of righteousness—reflects the contemporary American sense of Manifest Destiny. Both a religious philosophy and a political policy, Manifest Destiny held that the people of the United States were destined by God to take over the entire nation, from coast to coast. The Classical style is a perfect fit for depicting (and reinforcing) such a policy. In the artist's depiction of the desperately-fleeing Native Americans, barely visible in the dark left-hand corner, you may find echoes of the Greek and Roman view of the Barbarians: "We have come to civilize you … join us, or get out of our way, lest you be justly trodden on."

The women who walk behind America's chariot each represent hallmarks of civilization, and carry an **attribute** to aid in her identification. One carries the staff of Asclepius, ancient god of healing and the medical arts (often appearing in medical symbols as the caduceus of Hermes, the messenger god—a staff with two snakes intertwined and wings at the top).* One is carrying a musical instrument, representing the arts and poetry. Another carries a right angle to represent the study of math, engineering, and architecture. Along with the figure of America herself, all the figures present ideals of progress—intellectual and cultural achievements destined to enlighten the whole nation. In no way do these female figures represent the can-do spirit of the American frontierswoman, or the creative mental might of American womanhood. The beauty of the female form is simply used as an object, to stand for the beauty of American values.

*For detailed information regarding the origin of the two symbols, see Dr. Keith Blayney's site, www.drblayney.com/Asclepius.html.

The U.S. and Nudity

Time, geographic distance, and culture separate the United States from Europe, even though much of our political and social framework has been shaped by European traditions (not the least of which being the principles of the Enlightenment, born in 18th-century France). The differences become particularly stark where the nude figure is concerned. Standards vary, of course, based on location and situational context—from significantly more tolerant (San Francisco during the annual GLBT Pride Parade) to condemning (a streaker running across the outfield during the World Series). In the former example, nudity is greeted with either nonchalance or cheers, while the uniformed police stand idly by; in the latter example, the police rush in to apprehend the inappropriate scoundrel, while the crowd rains down boos and catcalls.

Notable exemptions aside, most Americans are against the idea of public nakedness, regardless of circumstances. American sensitivity with regard to the naked body can be traced back to the country's origins. In the 1600s, many religious communities came to the "New World" to escape persecution and exercise their faith without hindrance. A few of these groups (such as the Pilgrims) were so conservative in their codes of dress and conduct that they were considered radical in their countries of origin. Their views, which excoriated any displays of forbidden flesh as lewd and obscene, come into direct conflict with the Classical traditions of the beautiful, archetypical nude.

The United States, even today, is of two minds. On one hand, we are educated in Classical history, literature, and art (although less so now than a couple of generations ago, when Latin and ancient mythology were taught in both public and private schools). We learn to see idealized, naturalistic art as truthful and good. White marble and glowing bronze are synonymous with lofty ideals and splendor.

On the other hand, we have inherited a cultural discomfort with bodily flesh, which has long been associated in conservative Christianity with debasement and sin. In this tradition, exposed bodies are to be viewed as shameful, reflecting immoral habits and wanton ways. Although sketching from the nude model is essential in the proper study of figure drawing, this practice continues to be problematic for some American students who either do not know, or do not accept, the ennobling vocabulary of Classicism. To some Americans, there is no difference, in terms of indecency, between the naked men on Market Street and the Ancient Greek sculpture shown here.

Victorious Youth, 300-100 BCE. Bronze. Getty Villa, Los Angeles. Life-sized. Photo by the author.

Naked men posing for photos on Market Street, Pride Parade, San Francisco, June 29, 2008. Photo by the author.

CLASSICAL NUDITY AND AMERICAN ART

Note that the female figures in Tojetti's *Progress of America* are all clothed. The figure with the exposed shoulder has her back turned to us, so we cannot see how much (or little) coverage she wears in the front. Tojetti surely understood the meaning of the Classical nude—but he also understood the more conservative tastes of his American patrons, and so ensured that the viewer would not catch sight of any bared breasts. Yet, for Tojetti's time, even the bared shoulder would have been considered extremely improper for women to show in public. Again, the female figures in his painting are Classical, and therefore exempt from the rules that apply to actual women.

Due to the complicated nature of America's relationship with the nude, the form and context of nudity in art become all the more crucial in its display. To illustrate this problem, let us now examine Rupert Schmid's *California Venus*, in the Oakland Museum of California. In reading the title, one might conclude that this uninhibited youth is a real "California girl," the kind the Beach Boys wished all girls could be. However, to reach this conclusion, one would have to disregard the **classicized** vocabulary that permeates not only the statue, but the entire context of the piece.

The sculpture itself is unpainted white marble—a medium that, since the Renaissance, has symbolized virtue and purity. The figure is upright, with clean lines and strong angles (not slouching, slovenly, rough or messy, which would traditionally signal a lower moral disposition). The figure is certainly idealized, with youth, vigor, and composure. Further, she appears generic, rather than specific—with a remote gaze that is neutral and impassive, rather than enticing or suggestive.

The young lady is also clearly illusionistic in style—her flesh looks convincingly soft, her muscles flex naturalistically, and the folds of her strategically-placed robe give the appearance of gathered fabric, tactile and supple. However, this illusionistic figure—one that we might reach out and touch, as though she physically existed before our very eyes—*must* remain beyond our touch, if she is to stay in the realm of Classicism. This is where the broader context plays a vital role. As a **freestanding sculpture,** sculpted **in-the-round,** the figure can be viewed from all sides; however, she remains out of reach. The sculpture was intended to be placed on a raised pedestal, ensuring that the viewer must look up to her (recall the use of elevation to

Rupert Schmid, *California Venus,* c. 1895. Marble, Oakland Museum of California. Photo by the author.
Note that this picture was taken prior to the Oakland Museum's remodeling. Venus has been taken down from her pedestal, in an attempt to "modernize" her presentation.

California Venus as placed in the Oakland Museum, third floor, 2005, prior to remodel. Photo by the author.
Since this photo was taken, the museum has been remodeled, and *Venus* taken down off her Classical perch. The display is more modern and approachable—but far less Classical. Though today's viewers can get a better look at Schmid's skill, there is little doubt the artist himself would be appalled to see the "de-Classification" of his lady.

*You might recall the discussion of the California Arts and Crafts movement in Ch. 4, which sprung from this very sentiment.

**Kenneth Clark, "The Naked and the Nude," in *The Nude: A Study in Ideal Form*, National Gallery of Art, Washington, 1956, p. 6. We will return the issue of "naked and nude" in the final chapter (Ch. 12).

suggest lofty ideals in the *Altar of Augustan Peace*). Further, this height ensures that the viewer cannot—innocently or naughtily—brush up against the young lady's "lady-parts."

In its original installation, the museum heightened the Classical language by placing the sculpture in a rounded niche, surrounded by Ionic columns. This placement reinforced the viewer's sense that the figure exists in a different, more traditional world—the Classical world, more elevated and refined than the everyday world.

Altogether, *California Venus* speaks as an archetype, an ancient tradition updated for late-19th century American viewers. She stands not as an image of California women, but as California itself. Still a young state (nearing 50 when the sculpture was created), California at the turn of the century beckoned to those on the East Coast who longed for natural beauty, unspoiled by industrialization and blessed with fresh air, warm weather, enchanting coastlines and ever-flowering countryside.* The message is clear: As Venus is the goddess of beauty and virtuous love, so California is a land endowed by Nature with endless beauty and countless virtues.

The nude in art becomes a device, then, for moral and intellectual self-improvement. Schmid's sculpture is meant to embody the youth, strength, ideals, and promise of the state of California. Viewing the statue, we are meant to be reminded of these values, and thus feel spiritually fortified and renewed.

Kenneth Clark on "The Naked and the Nude"

Art critic Kenneth Clark, writing in the middle of the 20th century, distinguished between the "naked" figure—one that shows the inevitable and embarrassing physical flaws we would call veristic—and the "nude." The nude, in Clark's estimation, is as close to perfection as one can get, given the limitations of the natural world: "We do not wish to imitate, we wish to perfect. We become, in the physical sphere, like Diogenes with his lantern looking for an honest man; and, like him, we may never be rewarded."** This quest for the ideal links Clark to the ancient Greek philosopher, Plato. Plato maintained that, for every flawed object we see, there exists a perfect existential form of that thing—a form that the human mind can (and should) aspire to imagine—but that could not possibly exist physically, here on earth. Plato also believed that few possess the mental ability to envision the greater, non-physical beauty that lies beyond the beautiful image.

CLASSICISM AND POSITIVE PROPAGANDA

The Italian Renaissance

The Classical style has a long history of powerfully effective use. As we have seen, the Classical style enjoyed a rebirth, following the Middle Ages, in the art and architecture of the **Italian Renaissance.** Italian patrons of the 1400s and 1500s found in Classicism the perfect vehicle to convey their beliefs and

values. For powerful rulers and members of the influential merchant class, such as the wealthy Medici family of Florence, the Classical style echoed the righteous might associated with the Roman Empire. For the purposes of Catholic Church leaders, Classicism could remind the faithful of the time of Christ, the noble purity of Christ's sacrifice, and the perfection that awaited them in heaven—a perfection as pure as Plato's ideal forms.* The triumph of the Roman empire could be transformed, via idealized religious imagery, into the triumph of the Christian faith, made possible through the strength of the Church.

Note the resemblance between the Roman triumphal arch built to commemorate Emperor Constantine's victories and Renaissance architect Leon Battista Alberti's Church of St. Andrea. The Arch of Constantine, located at the heart of the Roman empire in the city of Rome itself, represents a typical triumphal building. Recall that Emperor Augustus had an altar built (the size of a small house) to commemorate his military triumphs. Archways such as Constantine's were built by Roman emperors for the same purpose—to proclaim to the people of Rome the strength and benevolence of both the gods and the emperor. Armies would march under the **barrel vault** of the archway in grand processions, showing off the spoils of war—looted treasures as well as captured enemies from distant conquests. Alberti has modified the **triumphal arch** form so that it is now part of the **façade,** or face of the building. The spirit of triumph remains, although the specific message differs: now evil is defeated, Christ is victorious, and the worshippers may flow into the church cleansed of sin and loaded with the "spoils" of heavenly grace.**

Alberti believed that the ideal work of architecture—indeed, any ideal work of art—would feature three principles, working in balanced harmony: ***beauty, strength, and utility***. Beauty would be achieved by following flawless models (the best examples provided by nature), using flawless materials, and composing in proper geometric proportions. Strength too would be found in the power of mathematics—avoiding soft and fanciful frou-frou in favor of clear, rational shapes (squares, circles, semicircles, triangles, etc.). Utility means usefulness or functionality. Art and architecture must serve a purpose; it must make a point—again, clearly and directly,

Left: Leon Battista Alberti, Sant'Andrea, Mantua, Italy, 1471.

Right: Triumphal Arch of Constantine, Roman Forum, Rome. Dedicated in 315 CE.

*We have already looked in some detail at Raphael's *School of Athens*, created for the Pope's library—where Plato makes a central appearance. To refresh your memory, see Ch. 6.

**You might recall Perugino's *Delivery of the Keys to St. Peter*, from our discussion of one-point perspective in Chapter 2. This painting, located in the Vatican's Sistine Chapel, features two triumphal arches.

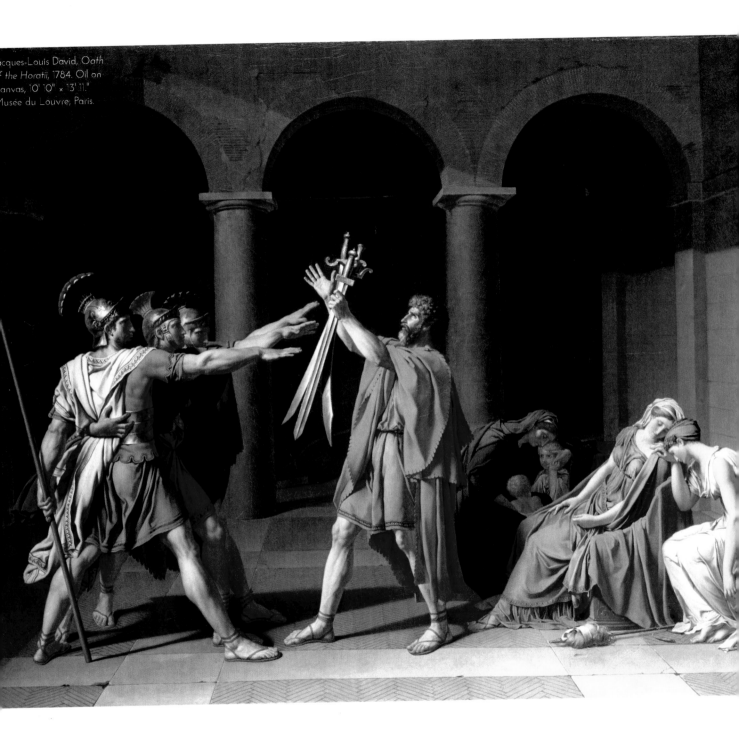

Jacques-Louis David, Oath of the Horatii, 1784. Oil on canvas, 10' 0" × 13' 11." Musée du Louvre, Paris.

8: THE CLASSICAL STYLE

without misleading or mystifying the viewer. Alberti's "three rules" are quite useful as we consider any art with Classical underpinnings. Classicism can take many forms, but all **classicizing** art will reflect some combination of beauty, strength, and utility.

Neoclassicism and the French Revolution

Let us put Alberti's rules to the test, as we examine the artwork that fueled, and was fueled in turn by, the revolutionary ideas of the Enlightenment. This work by Jacques-Louis David (pronounced "Dah-veed") provides an interesting case, as it was created during the reign of the ill-fated King Louis XVI of France, but ultimately became a symbol of the French Revolution. The subject is supremely Classical: a tale from early Roman history, in which the three brothers of the Horatii family—wishing to end Rome's ongoing war with Alba—agree to fight against three of the enemy, the Curiatii. In David's painting, the brothers are swearing on the swords held by their father, showing that they are prepared to make the ultimate sacrifice if necessary to spare Rome from any more bloodshed.

The women at right do not share the brothers' zeal, however. One of them is engaged to the enemy; another is sister to the enemy, but married to one of the Horatii brothers. Regardless of the outcome, the women will suffer terrible losses, and are already mourning what must inevitably come.

Notice how David has orchestrated the composition to bolster the men's position. In every respect, the brothers and their father dominate the scene, drawing the viewer's attention and, in effect, rallying the viewer to their cause. The ideal figures are arranged on a perfectly-ordered stage, a study in beauty in perfect accordance with Alberti's rules. The bulk of this stage is filled with the unyielding logic of geometry, from the clear cadence of rounded archways at the top (one for each brother) to the hard angles of the figures themselves (marked in blue in the diagram). This show of structural strength is juxtaposed with the soft, organic lines of the female figures (marked in orange in the diagram), whose muted-color garments seem to fade away, into the background.

Finally, the beauty and strength of David's composition yields a very clear and utilitarian message: Sacrifices must be made for the good of the citizenry. The needs of the many logically outweigh the needs of the few, or the one.* Do not let yourself be swayed by (feminine) emotions; the path to righteousness is laid by reason, not sentiment. If the Classical subject, Classicizing style, and Classicizing composition are not convincing enough, then David scores with the ultimate grand slam: a whopping 10' by 14' size. Altogether, this work of the **Neoclassical** ("new classical") style is a perfect match for the revolutionary spirit of 1780s French society—presenting a noble, high-minded call for patriotic action, in the clearest, most unassailable terms.

*If this statement rings a bell, then you might be familiar with the Vulcan philosophy of Mr. Spock, the most logical officer in Starfleet.

Diagram of geometric vs. organic lines in Jacques-Louis David's *Oath of the Horatii*.

Angelica Kauffman, *Cornelia, Mother of the Gracchi, Pointing to her Children as Her Treasures,* c. 1785. Oil on canvas, 40" x 50," Virginia Museum of Fine Arts, Richmond.

Cornelia's Treasures: Neoclassicism for Women

While David's painting offers moral instruction for male valor, Angelica Kauffman's painting, *Cornelia, Mother of the Gracchi,* presents the perfect model of good female citizenship. As one of only two women admitted to the prestigious Royal Academy in England, Kauffman presents a rare view of grand, heroic **Neoclassicism** from a woman's perspective.

As in David's painting, the story is taken from early Roman history, during the Republic (see the timeline on the next page). The Roman Republic held particular attraction for Neoclassical artists, because the Roman government during the Republic was run by two consuls, elected yearly. The Roman Empire was ruled by emperors, who were essentially dictators—a role not in keeping with Enlightenment ideals.*

The two boys on the left side of Kauffman's painting are the Gracchi brothers—the younger Gaius Gracchus and the older brother, Tiberius, who holds his hand. Enlightenment viewers educated in Classical history would have instantly recognized the Gracchi name in the painting's title—and would have known that these two lads ultimately grew up to become tribunes, elected from the common people to advocate for the rights of the lower classes.**

According to the story, their mother, Cornelia, ensured that the boys were educated in Greek philosophy. She fostered in them the values of fairness and equality, which they in turn pressed the Senate to uphold, for the sake of Rome's poor and powerless. By depicting the Gracchi as boys, and placing their mother Cornelia in the center of the composition, Kauffman makes a clear statement about where moral greatness originates. Cornelia is the hero here, for raising her children to have strong moral values. She is the ultimate good citizen, gesturing to her children as her "treasures"—her priceless contribution to society's benefit. In contrast, the woman to the right is showing off her own treasures, which are fancy pieces of jewelry. Kauffman suggests that this woman is like a little girl who needs to grow up, and follow Cornelia's selfless example.

Kauffman's painting is a virtual diagram of Enlightenment beliefs, laid out in an exceedingly ordered composition. The story reinforces the message that one must make sacrifices for the greater good; that citizenship comes with responsibility; and that every person, regardless of wealth or social status, is entitled to government representation and consideration. These same principles had been summed up just nine years earlier by a group of American representatives, declaring independence from British rule: "We hold these truths to be self-evident, that all men are created equal, that they are endowed by their Creator with certain unalienable rights. ..." Let us now return to America, and examine the case of one of our most famous citizens, who helped to write those familiar words.

*Rome's first emperor was Julius Caesar, assassinated in 33 BCE. Emperor Augustus Caesar—whom we met in Ch. 1, and whose altar we have recently discussed—came to power after Julius Caesar.
**Both men were eventually killed by the Senate, who felt threatened by the Gracchi's power-sharing policies. A more cynical audience might see a message of futility in this story; an Enlightenment audience would see men holding to their values, even unto death—the ultimate noble sacrifice.

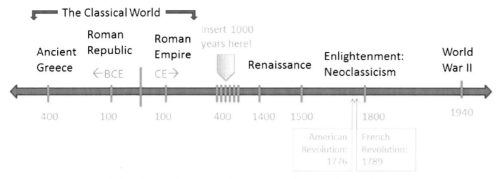

The Classical World

| Ancient Greece | Roman Republic | Roman Empire | Insert 1000 years here! | Renaissance | Enlightenment: Neoclassicism | World War II |

←BCE CE→

400 100 100 400 1400 1500 1800 1940

American Revolution: 1776 French Revolution: 1789

Timeline of the Classical world and resurgent Classicism through history.

Neoclassicism and the United States: Thomas Jefferson's UVA

The case of Thomas Jefferson is at once wholly extraordinary, and stunningly common. He was very much a man of his time, and yet he was also far ahead of his time in many respects. His story is instructive, as it illustrates how Classical art is not a depiction of truth so much as a depiction of what people believe and want to be true. What is common about our third president is what is common about us all, to some extent: there is an inevitable disconnect between the world as we see it, and the world as it actually is; between our professed beliefs, and our actual conduct; between what we say, and what we do. If ever there were an example of how reality is relative, then Jefferson is that example—on a scale that is both intimate and epic.

One of the writers of the Declaration of Independence, Jefferson was a representative from the state of Virginia. Although a slave-holding plantation owner, he wrote eloquently about the unalienable right of freedom, and had extensive influence on the shape and character of the United States Constitution—which remains a singular document of pure Enlightenment ideals. In public, he vocally opposed the kind of racial mixing that frequently occurred in the pre-Civil War South, where slaves, slave-owners, and free men and women of varied ethnicities were in contact on a daily basis.* In private, the widower Jefferson took his late wife's half-sister as a surrogate wife—a slave named Sally Hemings, with whom he had five surviving children.** He built the nation's first public university, extolling the virtues of an educated citizenry ("wherever the people are well informed they can be trusted with their own government" ***)—yet also doubted the common man's ability to govern himself.

The University of Virginia was Jefferson's brainchild, and if the design of the man is marred by vexing inconsistencies, his creation in Charlottesville represents a shining and transcendent ideal. Here is the best of Enlightenment principles, in pure Neoclassical form: the idea that learning is a universal right—achievable not through wealth or privilege, but by making knowledge accessible to the questing mind. This idea lies at the heart of every public institution; it rests on the bedrock of freedom, and is the hallmark of a true and functioning democracy. It is the reason you are both *able* and *allowed* to read these very words—without fear of being caught, denied, denigrated or punished for doing so. The University of Virginia, as a campus, represents the finest Neoclassical architecture; UVA as an *idea* represents far, far more.

Thomas Jefferson (detail), copy of painting by Rembrandt Peale, circa 1805, created for the Office for Emergency Management, 1942-1945.

*The racial segregation policies we have come to associate with Southern history arose *after* the Civil War. The system of slavery had enforced notions of white supremacy; in its absence, racist Southerners enacted segregation laws in an attempt to reassert racial dominance.
**For an extensively-documented study of Jefferson's relationship with Hemings and her family, see Annette Gordon-Reed's *The Hemingses of Monticello—An American Family*, New York: W.W. Norton, 2008.
***Letter to Richard Price, January 8, 1789. Http://wiki.monticello.org/mediawiki/index.php/Quotations_on_Education.

University of Virginia, designed by Thomas Jefferson, Charlottesville, VA. Pavilion III, with entrances to a classroom and a faculty residence, 1821.

The Parthenon, Athens, Greece, 432 B.C.E. For a riveting and decidedly pro-Greek view of the Parthenon's history, see the short film "Parthenon" by Costa-Gavras, which can be found online. The film concludes with Britain's Lord Elgin taking the remaining marble reliefs from the temple in 1800. Elgin was doubtless moved by Enlightenment zeal for Classicism; from the Greek perspective, however, his actions were rapacious. Greece remains in a bitter contest with the British Museum to get the Parthenon artwork returned.

The Parthenon, a replica built in 1897 in the city of Nashville, Tennessee. Http://www.nashville.gov/parthenon/. The recreation of the Parthenon in Tennessee, although accurate, looks somewhat goofy in its Nashville location. Jefferson did not try to recreate European architecture on American soil, precisely because such an attempt would make the U.S. look like a "wannabe" —at worst, like a child putting on Daddy's clothing. Note Jefferson's choice of white lattice and red brick throughout the campus. These "earthy" materials help to marry the buildings to their southern environment.

Jefferson envisioned the UVA campus as an "academical village," providing a complete, all-encompassing educational environment for the student. Laid out symmetrically in a "U" shape, the buildings surround a central green (the "quad")—a feature designed to foster a sense of scholastic unity and camaraderie, echoed on college campuses throughout the country today.

Originally designed as living quarters for faculty and classroom space, the series of pavilions such as the one pictured here are joined by covered **colonnades,** rows of **columns** of Greek design that reach out like arms in an academic embrace. Behind the pavilions are gardens, which separate the grand Neoclassical halls from a row of student housing, viewable in the 1856 engraving on the following page.*

*To take a 360-degree tour of the site, see UVA's website: http://www.virginia.edu/academicalvillage/.

The colonnade in front of the pavilion is capped by a triangular **pediment,** another element borrowed from Greek temple design. These Greek features are clearly seen in the famous Parthenon, the great temple dedicated to Athena in Athens, Greece. The original Parthenon is badly damaged, but its design is preserved in a replica, erected in Nashville, Tennessee in 1897. These Greek visual references serve not only to recall Greek philosophy and democratic government, but also to present the public university as a kind of sacred temple to learning.

No building at UVA speaks more eloquently about the power of democracy and education than the library, placed at the physical and symbolic center of this intellectual village. For this design, Jefferson borrowed rather heavily from Roman architecture—particularly, the Pantheon, a temple dedicated to all the gods, in Rome, Italy.

Thanks to the Roman introduction of concrete, the Pantheon (pictured on the next page) boasts an enormous **dome,** with a circular opening at the center, called an **oculus** (eye). The building's drum shape is a purely Roman invention; the porch features Greek elements we have already seen on the previous page. The **obelisk** mounted on the fountain is "borrowed" from Egypt.

Jefferson chose to create the library as a **rotunda** (round building with a dome) because of the all-encompassing connotations of the perfectly spherical shape. It suggests the totality of the world—and, filled with books on every conceivable subject, it represents all knowledge in the world (at least, all knowledge recognized and categorized as important to Jefferson).

Engraving of the University of Virginia, from the south. Engraved by J. Serz, 1856. University of Virginia Visual History Collection.

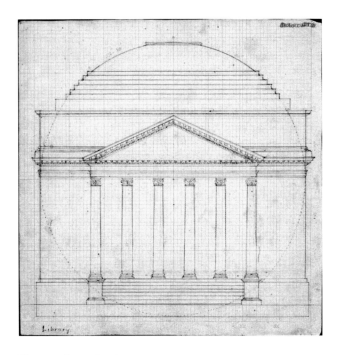

Thomas Jefferson, South Elevation of the Rotunda, University of Virginia Library. Completed March 29, 1819. Ink and pencil drawing; Library of Congress.

Positioned at the apex of the "academical village" plan, the library rotunda essentially becomes the University's brain—the core of the institution's nervous system, from which all education would endlessly flow.

Scholar Annette Gordon-Reed notes that Jefferson's choice to place a library—rather than a chapel—at the university's center affirmed UVA as "a determinedly secular institution," clearly separating Church from State. Indeed, at the time of its inception, the daring of Jefferson's plan evoked "great skepticism ... for both economic and religious reasons."*

Note the dual-column colonnade that encircles the space beneath the dome; like the two hemispheres of the brain, they encapsulate the knowledge held within, framing rows of books that once packed the rotunda.** The books do not fill the center, however; that place is reserved for the viewer, who completes the brain by his/her presence. Entry into the rotunda becomes, then, a symbolic act—a joining with the ultimate Enlightenment mind.

Modern Classicism and Propaganda

Neoclassicism was a stylistic revolution that swept both Europe and the United States, beginning in the late 1700s with the dawn of the Enlightenment. However, the tide of Neoclassicism never fully ebbed; Classical art and architecture continued to influence the design of government buildings, libraries, banks, schools, memorials, and churches throughout the 1800s.

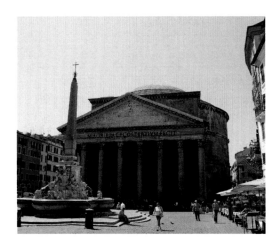

The Pantheon, Rome, Italy. 125 C.E.

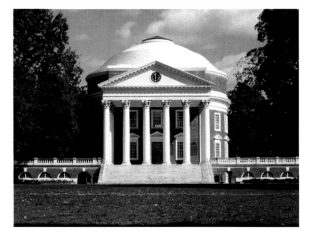

UVA rotunda, present-day.

Buoyed by contemporary events, Classicism peaked anew in the 1930s and 40s. This new classicism (a kind of neo-neo-classicism, linked to the "Art Deco" design movement) appeared more mechanized and streamlined than its predecessors, thanks to the ubiquitous power of the machine in the 20th century.

It is no coincidence that modern classicism again became the dominant style in public art, both in Europe and the United States, in the wake of a worldwide Depression and in anticipation of the Second World War. The style's usefulness in positive propaganda cannot be underestimated; its presence in and on public buildings would effectively rally public support to the national cause, in a way that other forms of art could not. Here is a visual vocabulary that is synonymous with strength and virtue, righteousness and endurance. It is a style that, as we have discussed, needs little explanation; it is clear, direct, unambiguous, and certain. It tells simple and convincing moral stories—it does not ask uncomfortable or open-ended questions.

At its best, classicism holds aloft an inspiring vision for a better society. At its worst, it becomes a tool for truth-quashing, brainwashing, and social control. Problematically, what may appear to be the former, at a particular point in time, may be judged by history to be the latter. Frequently used to express nationalistic sentiment, Classicism's ultimate message can hinge on who controls the nation, and what values they uphold. Let us conclude this chapter by examining three case studies from the early 20th century.

*Annette Gordon-Reed, *The Hemingses of Monticello—An American Family*, New York: W. W. Norton, 2008, p. 649.
** The rotunda burned in a devastating 1895 fire. The dome caved in, and the bulk of the library collection was lost, including most of Jefferson's books and thousands more, added since his death in 1826. See UVA's site, http://www. virginia.edu/uvatours/shorthistory/reconstructed.html.

University of Virginia library, rotunda interior.

Robert Laurent, *Shipping*, exterior of Federal Trade Commission building, Washington, DC, 1937-8.

Charles Alston, *Modern Medicine*, 1936. Oil on canvas, Harlem Hospital.

*See Columbia University's site, http://www.columbia.edu/cu/iraas/wpa/controversy/index.html.

**See David Lembeck, "Rediscovering the People's Art, New Deal Museum in Pennsylvania's Post Offices," Pennsylvania Historical & Museum Commission, http://www.portal.state.pa.us/portal/server.pt/community/arts_and_architecture/2805/post_office_murals/432816.

***Except by Native Americans! Again, we see that the Classical style inevitably plays favorites.

U.S.A. and "New Deal" Art

By the late 1930s, the United States had experienced nearly ten years of economic hardship, stagnant production, and social uncertainty, begun with the calamitous stock market crash of 1929. The Great Depression was marked by high unemployment rates, home foreclosures, breadlines (people lining up for hours, waiting to receive free food), and Dust-Bowl refugees—farmers and their families forced to abandon their homes in drought-stricken parts of the Midwest. In an attempt to offset this disastrous economic and social climate, the Federal Government under President Franklin D. Roosevelt established several new social agencies and programs. Altogether, Roosevelt dubbed these efforts "The New Deal," to suggest that the policies were a departure from "business as usual"—the culture of corruption, and a flagrant disregard for caution or restraint within financial institutions, which had contributed to the economy's collapse.

Designed to "reboot" the economy, the W.P.A. (Works Progress Administration, later called the Work Projects Administration) provided food, housing, and jobs to literally millions of Americans. Along with construction jobs, the W.P.A. funded music, theater, and large-scale public art projects throughout the U.S. Artists working under the auspices of the W.P.A. created sculptures and murals for post offices, public utilities buildings, schools, federal buildings, community centers, and hospitals. Locations ranged from urban to rural, coast to coast; today you can still see W.P.A. murals from Coit Tower, San Francisco to Harlem Hospital, NYC.

The murals at Harlem Hospital—many of which were painted by Harlem Renaissance artists—were initially controversial, ironically for their strong depictions of African-American figures. Hospital administrators feared the preponderance of African-Americans in the scenes might give the "wrong impression" that it was a "Negro hospital."* The work shown here, *Modern Medicine*, was painted by Charles Alston (Romare Bearden's cousin, pictured in Chapter 3), who directed the Harlem Hospital project. Alston portrays an African-American doctor prominently in the foreground, suggesting that the future of modern medicine will be both innovative and integrated.

The figures in New Deal-era artwork share classical traits: they are strong and youthful; if wearing contemporary dress (rather than Greco-Roman togas), their clothing suggests a lean and muscled form beneath. The men are strong-jawed, looking determined, in control, and hopeful for the future (note the strength of the stevedores in the Federal Trade Commission Building relief shown above). The women are robust, nurturing, and similarly determined and hopeful in demeanor. A triangular composition is often featured, along with the sleek, geometric, streamlined forms that suggest the power of productivity in the machine age. Altogether, the vocabulary seeks to reassure a troubled nation; this positive propaganda promises a better, more industrious, and fruitful future—one that eventually emerged as the U.S. ramped up production to join the Second World War.

Although not overtly political, much of the W.P.A. artwork reflects pro-labor sentiments consonant with Roosevelt's Democratic party. In Fletcher Martin's mural for the San Pedro Post Office in California (on the following page), unionized post office workers deliver hefty sacks of mail with military precision to awaiting ships and trains. The message is clear: American productivity depends on the ever-dependable, mighty men of the U.S. Postal Service. Any attempt today to spend valuable tax dollars on a mural celebrating postal efficiency would likely rile conservative critics; yet, at the time, murals such as Martin's were largely non-controversial—perceived as patriotic and uplifting, rather than wasteful or negative. Indeed, to guard against negativism, the W.P.A. officially forbade nudity and "any depictions of civil unrest such as strikes, uprisings, and warfare—unless the opponents were Native Americans."** Although not strictly followed by W.P.A. artists, such restrictions were designed to ensure an unadulterated, classicizing message, guaranteed to be well-received*** in trying times: We are righteous, we are strong, we work hard, and all will be well.

This Harlem Hospital mural, painted by Eric Mose, shows American industry on a microscopic scale. Here, a partially-painted man and a nude woman present a medical slide, highlighting technological advances that allow doctors to detect the presence of infections and disease.

Fletcher Martin, *Mail Transportation*, 1938, San Pedro Post Office, San Pedro, CA.

Hitler's Germany and Nazi Propaganda

In his attempt to purge Germany of what he considered corrupting influences, Adolf Hitler declared war on any art that did not conform to Classical, academic rules of idealism and naturalism. While Hitler targeted the German Expressionists as "degenerate," he celebrated the "pure German artists" who were working in the Classical vein. He either did know, or did not wish to admit, Germany's long tradition of expressionistic,

Freeze-Frame: American strength in tough times. Margaret Bourke-White, *Fort Peck Dam, Montana,* 1936. Gelatin silver print photograph, 13 x 10.5 inches. Metropolitan Museum of Art, New York.

This photo by Margaret Bourke-White exemplifies the mighty, can-do American spirit. Note the clean, geometric lines that dominate the composition. Fittingly, Bourke-White's striking image appeared on the inaugural issue of that great American staple, *Life* magazine. For more on Bourke-White, see Chapter 7.

Albert Speer, Reich-chancellery building, Berlin.

Flanking the porch of Speer's building: Nazi classicism.

abstract, and veristic art; instead, he imagined a "new" art for a new Third Reich, one "untainted" by foreign influences, and locked in a particularly rigid form of Classicism.*

Note the stiff, muscle-bound male nudes at the Reich-chancellery building in Berlin. Their strained postures and clench-jawed expressions might be seen as an almost humorous, over-the-top cliché of classicism, if the style were not pursued with such relentless zeal on Hitler's part—at the expense of lives, as well as livelihoods.

Hitler opened the "House of German Art" as a showroom for Nazi propaganda in classical form. The building is still used as an art museum in Munich (although with entirely different art inside). Sterile and forbidding, here classicism becomes the voice of fascism: "Submit to the state without question and without fail. Here we have separated the heroes from the degenerates, the pure from the impure. To the one, victory; to the other, extermination."

Mussolini's E.U.R. (Esposizione Universale Roma/Universal Expo of Rome)

Hitler's counterpart to the south was Benito Mussolino, dictator of Italy.** Declaring himself *Il Duce*, the leader of Italian fascism, Mussolini hoped to create a second Roman empire, with himself as emperor. In anticipation of the 20th anniversary of Italian fascism, E.U.R. was begun in 1935, with a target completion date of 1942 (the deadline was missed, due to wartime interruptions, and Mussolini was executed in 1945).

The visual references to ancient Roman architecture are clear, particularly in the **arcades** (rows of round arches) in the Palace of Italian Civilization, echoing the form of the ancient Coliseum. The chilling impact of this fascist ghost town*** is heightened by its stark, sharp-edged simplicity; organic lines are virtually banished in an all-conforming geometric grid. As in Nazi classicism, the sculptures at E.U.R. are at once potent and lifeless, robust yet frozen—heartless sentinels hailing an unseen, phantom victor. The essence of this place—at once a tour de force of modern Classical art, and an object lesson in Totalitarian Design 101—has been powerfully captured in Julie Taymor's 1999 film, "Titus." One of the darkest, most disturbing tragedies by William

*Needless to say, Greek and Roman art is not culturally linked to either Germany or Austria (Hitler's country of birth). The Germanic peoples were conquered by the Romans, and there are certainly Roman ruins in today's Germany; however, to say that "true German art" is Classical is a profound distortion of history—and reality.

**Italy, Japan and Germany were the main Axis nations fighting against the Allies in World War II.

***The city of E.U.R. is now complete, and has a residential area. The Palace of Italian Civilization is rented out for conferences and events. Nevertheless, the environment is still strangely lifeless and unnerving.

Sculpture in front of the
Palazzo della Civilta Italiana
(Palace of Italian
Civilization), also known as
the "Square Colisseum,"
E.U.R.

Shakespeare, *Titus* includes gruesome deaths and cannibalism. Choosing the Palace of Italian Civilization as the site of the opening scene, Taymor draws a clear parallel between the tragic horrors of Shakespeare's play, and the terrible perversion of Mussolini's worldview, which cost Italy dearly. At E.U.R., Classicism glorifies the past while foreshadowing a devastated future.

Museo Civiltà Romana (Museum of Roman Civilization), E.U.R.

New Vocabulary in Chapter 8

arcade	Row of arches
archetype	Symbol or idea that stands as an example for others to follow
attribute	Accessory associated with a person that helps the viewer in identifying him/her
barrel vault	Rounded ceiling over a passageway
classicized, classicizing	Having Classical (Ancient Greek and Roman) qualities
column	Ancient Greek architectural element consisting of a pillar (shaft) and head (capital). Doric columns are the simplest in design, with a bowl-shaped capital. More elaborate-styled columns stand on a base: Ionic columns have scrolls on the capital, and Corinthian columns have acanthus-leaf capitals.
colonnade	Row of columns
dome	Rounded, hemispherical roof on a round building
Enlightenment	Movement of the late 1700s reflecting philosophical, political, and social shifts in Europe and the United States towards representative government and the use of the scientific method

façade	The face, or front, of a building
freestanding sculpture	Sculpture that stands free of a wall or other vertical support (unlike relief sculpture)
frieze	An extended piece or band of relief sculpture
In-the-round	Freestanding sculpture
Neoclassical, Neoclassicism	Art movement in late-1700s Europe and the United States featuring Classical styles, motifs, and subjects.
obelisk	Ancient Egyptian architectural feature, consisting of a four-sided tower capped with a pyramid shape
oculus	Round hole or "eye" in the center of a dome
pediment	Triangle area on a Classical-styled building formed by the sloping roof
personification	The embodiment of an idea or characteristic in human form
relief sculpture	Sculpture that is supported by a wall or protrudes from a vertical surface
rotunda	Round building capped by a dome
symmetry, symmetrical	Balance in which objects or shapes are grouped in similar or the same groupings on both sides of a work of art
triumphal arch	Ancient Roman building featuring a barrel vault that allows people to pass through in triumphal procession

9 THE PUBLIC MEMORIAL

9: THE PUBLIC MEMORIAL

VISUAL VOCABULARY AND PUBLIC EXPECTATIONS
CONCERNS AND CONTROVERSIES
BALANCE—SYMMETRICAL (FORMAL) AND ASYMMETRICAL (INFORMAL)
TIME—SUGGESTING THE PASSAGE OR STILLNESS OF TIME

From Augustus's altar to Christo's *Gates*, from Jefferson's UVA to Picasso's *Guernica*, we have seen art's powerful potential to affect the public. In this chapter, we will focus on public art designed to memorialize a person, event, or concern. Public memorials are arguably the most difficult works of art to create; from initial concept to final execution, they demand much from the artist, from the viewer, and from society at large. They are often costly—economically, emotionally, and (for some) personally. As works of art created specifically for the public's benefit, memorials—and the controversies that seem to inevitably surround them—both reveal and test deeply-held cultural attitudes. One might argue that memorials speak to society's fears, hopes, delusions and divisions more than any other art form. Let us examine, then, the ways in which memorial designs speak—and possibly misspeak!—to the public.*

*Although we will examine a few examples of public memorial art from other countries, this chapter will concentrate on public memorials located in the United States, which exemplify issues of specifically American concern. It is not intended as an exhaustive study or survey of memorial design, for which one would need a significantly bigger book!

THE "PUBLIC" PROBLEM

The first problem related to the public memorial arises from that very word: "public." The public, as a concept, is a single, unified entity, suggesting a collective group of people. However, the public is composed of individuals—each with varying experiences and expectations. Although the public may share certain cultural traits, the American public is profoundly diverse—owing both to the origins of the nation (its history as a so-called "melting pot" of inhabitants, descended from native peoples, slaves, and immigrants) and its constitutional emphasis on individual liberties, outlined in the Bill of Rights. We represent a multitude of ethnicities, their origins and relations mixed, divided, discovered and hidden; a plethora of political, philosophical, religious, secular and social affiliations; and varied and intersecting occupational, gender, familial and generational roles. We live in urban, suburban and rural living environments. We share the same history, yet we recognize, ignore, deny, and celebrate a multiplicity of histories. What public, then, should the artist address? Should some segment of the public, and its particular interests, be more relevant to the artist in planning the memorial design? Is the regional public (those who live in the vicinity of the memorial) a greater "stakeholder" than the broader public (those who might visit the memorial from somewhere else in the country)? Should the memorial be concerned about what a foreign visitor might see or experience? Should it be wholly universal—easily "read" by everyone, regardless of identity or background? What does it mean, to be "universal"? Is such a design even possible?

If I am "forced" to see a work of art every day (perhaps on my way to work) dedicated to Mr. So-and-So, I would need some persuasive reason to care about Mr. So-and-So, in order for the memorial to be personally effective. I would need to know what he did, why he did it, and what it all has to do with me. If I have no reason to care, I may respond in one of several ways: I may be indifferent (ignoring the memorial entirely); I may be

Aerial view of the Washington Mall.

curious about the work (giving thought to its design, its reason for being); or, I may be offended by the work (wondering why it is taking up space that something more valuable or meaningful to me could occupy). The accessibility of a public memorial—anyone who wants to approach is free to do so—is both an essential strength, and a potential danger. Some memorials are placed in such a way as to give the viewers an option—to go and see, or not. However, a memorial that dominates a major thoroughfare cannot give viewers an "out"—you are going to see it, whether you like it or not. To avoid it would mean actively going out of your way, which would naturally cause resentment and hostility. If anyone and everyone can see a work of art, must it therefore appeal to "anyone and everyone"? Again, how is that possible, given varying expectations and tastes among members of the public?

Some memorials bear the extra burden of being the sole monument to commemorate a person, event, or concern. A "national" memorial bears a particularly strong burden, designated as *the* memorial for the national (rather than regional or local) public. We will find a number of particularly heated controversies arising from the creation of national public memorials. Note that the Mall in Washington, DC provides prime real estate for national memorials—a vast public space rolled out like a great carpet before the U.S. Capitol building, conferring power and legitimacy.*

*If you are looking for the White House, you will not find it on the Mall. If the president's house indeed "presided" over the Mall, it would suggest that the president was the "king" of the people. Instead, the Capitol building—where Congress meets—stands at the geographic head of the nation's capital—like the library at UVA.

THE "MEMORY-ALL" PROBLEM

The second essential problem related to public memorials stems from their presumed job, which is to "memorialize." This job description is vague, and open to significantly different interpretations. One might find divergent views regarding who or what *deserves* to be remembered by the public. Next, one would have to decide what *aspects* of the person, event, or concern deserve memory. As noted in Chapter 3, memory itself can be hard to pin down. What I might remember about a tragic occurrence might be different from your memory of the same event. You might recall seeing the event on the TV; I might have been closer to the event (knowing someone involved, living closer to the affected site, etc.); my memories would certainly differ from yours, and my feelings might be stronger about it. Further, I might make significantly different conclusions about the meaning of

The space shuttle
Challenger explosion,
January 28, 1986.

The launching of Challenger
was nationally televised and
watched by millions—as
was its tragic explosion
moments later. The memory
of watching this tragic event
may be crystal-clear, hazily
distant, or completely
non-existent in your mind.
How, then, should a
Challenger memorial
commemorate the disaster?

the event—my cultural background (as well as my social and political affiliations) would color how I perceive the event, process it, and interpret it. Therefore, what I would consider "worth remembering" might be quite different from your own views. Note that memory here is tied to interpretation—we cannot disconnect what we remember from how we think and feel about that memory. A memory cannot exist without some meaning—some significance, some feeling—already attached to it. This makes memory a personal matter; consequently, it can become extremely sensitive material for an artist to handle.

There is an additional problem associated with the memory-making function of memorials. What if you have *no* memory of the person, event, or concern? If your memories are from learning about the event in a history book, then a memorial cannot effectively remind you of anything—it can only rekindle a memory of having once *learned* about something. This is quite different from a personal memory! Indeed, this distance—between you and the memorialized concern—is a formidable gap for the artist to bridge. If you have neither a memory of a thing, nor second-hand knowledge through education, then the memorial must fulfill yet another role: that of educator, in order to both explain itself, *and* compel the viewer to become invested in something to which he or she has no previous connection.

One might legitimately ask whether the "uneducated" should be the primary audience for the public memorial. Should not those with "legitimate" memories take precedence? Conversely, others could argue that the educational role should come first; after all, time passes quickly, memories fade and become distorted, and the memorial must last through the ages to ensure that future generations "never forget." Still another side might rightly demand that memorials address the changes that occur over time—generations change, memories change, and so do interpretations of events. One might argue that memorials should embrace such inevitable shifts, rather than fight them; then they will remain relevant, functional, and alive.

What It Means to be "Memorialized"

Put simply, to be "memorialized" is to be placed in someone's memory via some form of memorial. However, we often have deeper associations with the word. As a society, we envision something permanent and dignified, sealed with an impermeable coating of sacredness. Of course, these expectations are steeped in culture. As discussed in the previous chapter, the United States has a long cultural tradition of Classicism. Despite over a hundred years of modernism (driven by the art of non-Western cultures, such as African tribal masks and Japanese printmaking), the naturalistic and idealized style is still the expected choice for "good, true" art. "Memorialized," then, is often culturally defined here as "classicized": speaking of timeless, noble, uplifting truths. Many Americans would therefore assume that a memorial's primary job is to unify memory into a single, decisive whole, preserved for all time, and imparting an air of quiet dignity and honor. This approach deliberately rejects the veristic and shifting nature of memory (as well as the feelings associated with memory), which inevitably change over time. Wounds heal (or fester); political and geopolitical positions shift (enemies become allies, and vice versa); and generations age, their needs and views changing with each new stage of life. In contrast, the classicizing memorial acts as a sort of *antidote* to change. Depending on the viewer, the message can be either reassuring ("true principles are timeless; we will never forget") or manipulative and off-putting ("this is the correct and official way to remember; remember this way, or take your memories elsewhere").

Controversies arise when a memorial fails to meet public expectations. The first potential controversy arises from the classicizing expectations discussed above. If one simply assumes that literal, idealized memorial art is "true," then one is apt to assume the converse: that abstract, non-literal, and/or veristic memorials are somehow "false"—and therefore undignified and dishonorable.

Lincoln Memorial, Washington, DC. Henry Bacon, architect; Daniel Chester French, sculptor of Lincoln statue. Photo by the author.

A TALE OF TWO LINCOLNS

Let us begin with two memorials commemorating a well-known historical figure whom *none* of us personally remember: Abraham Lincoln. The national memorial on the Mall, dedicated to our 16th president in 1922, presents strong classical leanings. Sculpted **in-the-round** but positioned at the back of the memorial, looking outward, Lincoln is not dressed like a Roman emperor—but he does occupy a Greco-Roman-styled temple, and is seated upon a rigidly-geometric throne in grand, heroic scale.

Author Michael Kammen describes the memorial's classical accoutrements, and its accompanying theme of uplifting unity:

> The seated statue designed for the memorial in D. C. by Daniel Chester French appeared as an interior colossus at thirty feet high (including the pedestal). The sculptor had also designed a massive, boxy throne. ... The facings for the armrests were predominantly adorned with the ancient Roman *fasces*, a symbol of unification, of course. As art critic Royal Cortissoz remarked when he composed the epigram inscribed above Lincoln's head: "The memorial must make common ground for the meeting of the North and South. By emphasizing his saving the union you appeal to both sections. By saying nothing about slavery you avoid rubbing old sores." *

*Michael Kammen, *Visual Shock; A History of Art Controversies in American Culture,* New York: Alfred A. Knopf, 2006, p. 21.

Kammen contrasts this timeless design with a decidedly less grand sculpture of Lincoln. Located in Cincinnati, Ohio, it shows the president as an approachable man of the people—awkward in his tall stature,

Statue of Lincoln by Daniel
Chester French, Lincoln
Memorial, Washington, D.C.
Marble, 30' h. Photo by the
author.

humble in both tone and scale, and overall more veristic than the bold Lincoln seated in Washington. Unlike French's Lincoln, this freestanding sculpture allows viewers to see the figure from all sides. Some praised sculptor George Grey Barnard; others equated the verism of his work with derisiveness:

> The elite in that conservative Ohio city received the image quite positively even though this was a humble, almost ungainly version of Lincoln as a man of the people, an unrefined commoner with an elongated neck, beardless, looking rather unworldly (if not world-weary), and perhaps yearning for divine guidance.... Barnard's image reflected "the mighty man who grew from out of the soil and the hardships of the earth." Traditionalists, however, and especially members of the art establishment detested the work. They were horrified, moreover, at the prospect that this ungainly rustic figure would be the visible emblem of the United States in London [a copy was slated to be sent there]. Hostile partisans like Robert Todd Lincoln condemned it as "a monstrous figure which is grotesque as a likeness of President Lincoln and defamatory as an effigy."*

Champions of Barnard's design celebrated its forthrightness; the following praise, spoken at the sculpture's dedication, comes from none other than former president Howard Taft:

> "The sculptor, in this presentment of Lincoln, which we here dedicate, portrays the unusual height, the sturdy frame, the lack of care in dress, the homely but strong face, the sad but sweet features, the intelligence and vision of our greatest American. He has with success caught in this countenance and this form the contrast between the pure soul and the commanding intellect of one who belongs to the ages, and the habit and garb of his origin and his life among the plain people—a profound lesson in democracy and its highest possibility."**

From this perspective, the D. C. memorial appears as a kind of visual fraud. This, from contemporary historian and critic Lewis Mumford:

> "In the [national] Lincoln Memorial ... one feels not the living beauty of our American past, but the mortuary air of archaeology. The America that Lincoln was bred in, the homespun and humane and humorous America that he wished to preserve, has nothing in common with the sedulously classic monument that was erected to his memory. Who lives in that shrine, I wonder—Lincoln, or the men who conceived it?"*

Which perspective, then, is correct? Which memorial is more appropriate, "real" and true? Even though the Civil War is long past, and Abraham Lincoln's legacy is fairly fixed in the history books, there is still no "final verdict," no definitive answer. These two memorials are speaking different visual languages—and the viewer will hear what he or she is attuned to hear. One presents a colossus of a man, a literal use of scale in which a greater size means a greater person—thus suggesting the strength and grandeur of the Lincoln legacy. Although the national Lincoln Memorial does not

George Gray Barnard, Abraham Lincoln, Lytle Park, Cincinnati, Ohio. Dedicated 1917. Bronze on pink granite pedestal.

*Kammen, 25.

**Quoted at the Kankakee County Museum site, http://www.kankakeecountymuseum.com/exhibits/barnard/barnard3.html.

*Kammen, 23.

directly address slavery, it evokes Lincoln's most celebrated deeds, including the abolishment of slavery and the preservation of the Union, through grandiose imagery. The other memorial presents a more expressive, psychological portrait of the man—as well as the "mid-Western values" of rolling up your shirtsleeves and doing hard work because the times demand it. The former says, "Look up, and aspire," the latter asserts that legends are made, not born—with Lincoln's crumpled attire a testament to the unglamorous but necessary work that is the cornerstone of true greatness. Both messages are legitimate and constructive for the public to hear and embrace. However, their efficacy depends on individual viewers, and the expectations (both conscious and subconscious) they bring to the work.

In essence, the creation of a memorial cuts to the heart of a society's self-identity. A memorial's design, and social reaction to it, can sometimes shed more light on the times that produced the memorial, than on the memorial's subject itself. Let us next tackle the roller-coaster story of the Vietnam Veterans Memorial.

THE VIETNAM VETERANS MEMORIAL

Perhaps we might gain better perspective on the controversy surrounding the design for the Vietnam Veterans Memorial by starting at the end of the story, and working our way backwards. Today, Maya Lin's creation, positioned on the Mall in Washington between the Lincoln Memorial and the Washington Monument, is the modern standard for memorial art throughout the nation. There are few memorials created in the 1990s or 2000s that do not owe something to the 21-year-old undergraduate student from Yale University who, in 1981, stunned the world with her competition-winning design. Those memorial designers who eschew her visual vocabulary do so consciously—making a deliberate statement in opposition her philosophy. Thus, Maya Lin's influence can be conspicuous, even in its absence.

The Vietnam Veterans Memorial was the first national memorial to famously and decisively break the classicizing mold. The design is likely familiar—even if you have not seen it, you have likely seen something indebted to it.

Most notable is the list of names—over 57,000 U.S. soldiers who died fighting in the Vietnam War (1959–1975).** That names appear is not, in itself, radical. The daring—and rather spare—innovation of Lin's design is that the list does not accompany or adorn the memorial—rather, the names are the very core of the memorial. There are no statues, columns, wreaths, garlands, or even abstract symbols to command the viewer's attention. This is a non-objective memorial design, and as such, the meaning is found through the materials and visual elements, rather than the literal imagery.

Recall, from Chapter 4, the ways in which non-objective work may speak. Space, light, line and texture all work in concert, connecting viewers to the world around them on a conscious or subconscious level. In the Vietnam Veterans Memorial, each piece of visual vocabulary is engineered to engage the viewer on a personal, intimate, and emotional level.

The Space

**Note that the idea of including all the names of the fallen soldiers was not Maya Lin's—the VVMF (Vietnam Veterans Memorial Fund) had stipulated in their announcement for the competition that applicants must somehow incorporate the names in their design.

The use of space in the Vietnam Veterans Memorial is particularly striking. Unlike the classical preference for lofty structures—raised on pedestals, stairs, or platforms—the memorial here appears as though carved from the earth, gently sloping downwards (suggesting intimacy, enveloping the viewer), before allowing visitors to move forward and ascend, both physically and emotionally.

The sheer volume of names, consuming the full surface of the two halves of the wedge shape, overwhelms the viewer with the magnitude of the loss. Arranged chronologically and accompanied by the years of the conflict, the names create a visual record of the longest war, at the time, in U.S. history. Although American

Maya Ying Lin, Vietnam Veterans Memorial, Washington, DC, dedicated 1982. Granite. Photo by the author.

involvement in Vietnam began in the late 1950s, it escalated in the following decade, coming viscerally to everyday Americans' attention in the late 1960s through the expansion of the draft, and through increased television-news coverage. The growing scale of the memorial as it nears its center suggests the growing American awareness of the conflict, as well as swelling emotions of sorrow, fear, and anger, reflected by the growing numbers of anti-war protestors, and experienced by the soldiers themselves and their loved ones.

The Light, Line and Texture

The black granite of Maya Lin's design is also decidedly un-Classical, contradicting the cultural preference for the pure whiteness of marble. Maya Lin intended the dark surface to suggest the earth that has been revealed in the excavation—evoking the idea of exposing or delving into what lies beneath, both in regards to the physical topography of the site, and the emotional state of the visitor. The smooth, reflective surface activates the space—the light of the sky bounces off the wall, as do the reflections of the viewers, whose animated presence brings life to the list of those who have passed. Seeing one's own reflection becomes both life-affirming and personal—the memorial is both "for them," and for you. Since its dedication thirty years ago, the tradition continues wherein visitors create rubbings on paper from the incised names. In transferring the name from the memorial to a keepsake, visitors are able to touch the symbolic presence of a loved one, and take a piece of the memorial—and the memory of that presence—home with them. The opportunity to find the name of a loved one, touch it, and keep it can create an intensely personal, tactile experience for a viewer.

The Controversy

Maya Lin's design was *not* universally embraced at its unveiling. As we might anticipate, given the mixed response to the Cincinnati Lincoln memorial, the non-objective and veristic nature of Lin's design was bound to signal negative ideas to those expecting the ideal vocabulary of Classicism. The lack of recognizable imagery yields a deceptively simple result, one that could be dismissed as a thoughtless joke or a deliberate, dismissive insult. The choice of placing a black shape below ground was read by some as negative political propaganda: a metaphor for the wasting of lives on a pointless and shameful war that took us nowhere but down. Critics therefore perceived Lin's memorial as a statement against American foreign policy, which was further interpreted as an anti-American statement. Worse, some veterans thought the memorial was damning soldiers for civilian deaths. Some harbored resentment that a young woman with no combat experience (let alone Vietnam War experience) was so presumptuous as to create a memorial for veterans.* Here, it seemed, was another out-of-touch artist type, defended by effete "experts" living in ivory towers, telling disgruntled veterans to "take it and like it"—or be branded ignorant and uncultured.

To quell objections from some politically-conservative groups and dismayed individuals, a compromise was reached. To the site on the D. C. Mall was added an American flag held aloft by a giant flagpole, and an idealized, naturalistic statue in bronze, showing three soldiers on patrol.

A visitor to the Vietnam Veterans Memorial, taking a rubbing of a name.

9: THE PUBLIC MEMORIAL

The Paradox

We have seen how Maya Lin's modern-styled memorial effectively functions today for viewers—and noted how far the design veers from traditional, classical memorials. Here then is the paradox: the single most influential American memorial design, and now one of the most universally acclaimed, features so many "violations" of the classical model that today's designers cannot safely tread down the same path, without risking the same wrath Maya Lin encountered thirty years ago. The expectations Lin encountered decades ago still exist, and any new memorial designers who attempt the "May Lin way" will still find themselves in a very long-boiling pot of hot water. In other words, Maya Lin's design breaks the rules, sets new rules, and is at the same time the only exception to the rule allowed by public expectations.

*Driven by prejudice and memories of fighting an enemy backed by Communist China, some also protested the fact that the competition winner was Chinese-American.

Top: Panoramic view of the Vietnam Veterans Memorial Site.

Bottom left: Frederick Hart, *The Three Soldiers*, 1984. Bronze, approximately 8' tall.

Bottom right: A flagpole marks the general vicinity of Maya Lin's memorial. However, this addition to Lin's original design, along with the statue of soldiers by Frederick Hart, remain separate visually and conceptually from the wall beyond.

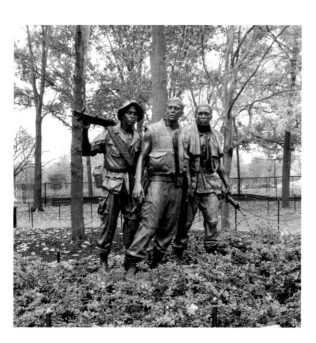

9/11, AND THE QUESTION OF CATHARSIS

Regarding the emotional impact of her memorial design, Maya Lin has said that "I really did mean for people to cry." The memorial, according to Lin, is ultimately "about honesty"—providing an opportunity to face, head-on, the cost of war and accept the full measure of this cost on an emotional level. Although painful, such an experience is necessary, says Lin, for healing: "If you can't accept the pain … you'll never get over it."* Lin's memorial is thus intended as an instrument of **catharsis**.**

War memorials—and any memorial linked to tragic loss of life—raise difficult issues about the artist's role in handling viewers' inevitably-raw emotions. The classicizing memorial aims to redirect grief into feelings of reassurance, empowerment, and overcoming. These, too, can be powerful emotions; they can move the viewer from immediate concerns and painful thoughts to a loftier, and more distant, state of mind—to thoughts of eventual accomplishment, victory, peace, or hope. The cathartic memorial, which tends to be almost exclusively veristic, takes the opposite approach. Rather than seek to sooth negative feelings, memorials like Maya Lin's seek to expose and explore them. Failure to do so, from this perspective, leads to prolonged stages of denial and debilitating grief, inhibiting the natural healing process.

Viewers expecting a wholly-uplifting memorial to sooth their grief may feel shocked, offended, and betrayed by a cathartic memorial, which seeks to raise that grief to the surface and help viewers work through it. Viewers might be reluctant to bare their pain in a public context, or may not be ready to face their own anguish. On the other hand, one might argue that those who have not been able to grapple with the intensity of their emotions may need exposure to just such a memorial—to shake loose deeply-buried, and rigidly-locked feelings. Should a public memorial act as a sort of psychological prescription for the emotionally-afflicted? Who decides what treatment and "dosage" a viewer needs? Does one continue the treatment, even after experiencing negative side-effects? Whatever the answer, the same prescription surely can't meet the needs of every "patient."

As suggested earlier, a viewer without a personal, first-hand memory of a tragedy, without a vested interest in the person or event memorialized, has no deep-seated feeling to release or explore. In this case, the cathartic memorial may address the "memory-less" by imparting some sense of the pain that others have endured, and continue to feel. Again, verism can be an effective tool in confronting viewers with an "ugly truth" of which they were previously unaware. As noted in Chapter 7, a combination of verism and abstraction can be particularly effective in reaching the emotionally-distant viewer.

However, for every viewer who "needs" to be shocked into awareness by a veristic reality, there is another viewer who must live that reality daily, and seeks some relief from the constant emotional blows she or he suffers. Does not this viewer deserve a memorial that provides relief? Or is that momentary respite just emotional bubble-wrap, keeping the viewer from the *real* relief which is only achieved after "letting it all out"? Consider that some Vietnam veterans who at first decried Maya Lin's memorial eventually grew to love it, and return to find solace there. Does that mean that its "tough love" eventually worked? Or did they need some healing time on their own, to lower their emotional barriers—so that the memorial's cathartic message could get through? Should cathartic memorials be avoided, to spare sensitive viewers additional pain—or should those viewers be encouraged to "stick it out"? The memorial sculpture *Tumbling Woman* by Eric Fischl provides an excellent 21st-century example for us to probe these difficult questions.

Tumbling Woman

The sculpture was unveiled in the lower concourse of the Rockefeller Center in New York City, just a year after the terrorist attack of September 11, 2001. The date has become synonymous with the event, so that any reference to 9/11 will immediately conjure memories, feelings, and associations for those who were at all impacted by the event.

*See the 1994 documentary film, "Maya Lin: A Strong, Clear Vision" by Freida Lee Mock.

** "Catharsis" is a Greek word, originally meaning "purging" or "purification." A cathartic experience allows one to expel all one's emotions, particularly negative emotions that are bottled up and building pressure. By purging oneself of these wild and powerful feelings, the ancient Greeks believed, one could again feel like a "cleansed," effective, and balanced citizen.

Eric Fischl, Tumbling Woman, 2001. Bronze, 37 x 74 x 50 in. As originally placed in Rockefeller Center, NY.

The list of those "at all impacted" includes millions, if not tens of millions of people. Anyone living in the United States and born in the early '90s or earlier will likely have some recollection of the horrendous day, or at least be aware of the social and political aftermath. Those too young to appreciate the full scope of the tragedy likely recall seeing, and being alarmed by, the strong reactions of older family members.

Those of us who were born in the 1970s or earlier are most likely to have the deepest, sharpest memories of the day of the attack. However, many years have passed, and much has happened (in our own lives, politically, and internationally) in the interim. The event is certainly not forgotten by most Americans, but even long-time New Yorkers (who vividly remember the Manhattan skyline as it was, before the World Trade Center towers fell) have returned to their normal routines. Their daily thoughts are no longer disrupted by sudden and terrible recollections. The panic, doubt and sorrow—and feelings of utter vulnerability—have subsided over time.

To understand the reaction to Fischl's *Tumbling Woman*, then, you must set your mind back several years, and consider the raw emotion of those people who went to work every day in downtown New York City. When four commercial airlines, packed with passengers, were hijacked the morning of 9/11/01, millions of New Yorkers were beginning their workday morning. By 9:00 a.m., one of those planes had pierced the North tower of the World Trade Center; a second hijacked plane crashed into the South tower 40 minutes later. Tourists and locals who happened to be downtown in the vicinity of these giant office buildings were awestruck by how swiftly the buildings were consumed by flames, ignited to extreme temperatures by the fully-loaded fuel tanks of the passenger jets. Standing at over 100 stories apiece, these towers dominated the skyline; for miles, the smoke could be seen billowing from the areas of wreckage.

The moments of impact were recorded by many, so that the initials scenes of carnage were seen almost immediately by TV viewers throughout the country (and the world). At first, the live broadcasts included frightful images of people trapped in the upper stories. Faced with the inevitability of burning to death, many leapt from the windows to a certain death below. However, the still photos and videos of these unfortunate people were soon omitted from aired news footage—it was too taboo, apparently, for television viewers (network or cable) to witness the last, desperate acts of these doomed victims.

Everyone hearing of the event, listening to the radio or watching on TV, had three pressing thoughts in mind: the identity of the perpetrators; the plight of the victims, both aboard the planes, and in the towers; and their own safety and security (Were there still hijacked planes in the air? Where are they headed? Will I or my loved ones be next?). To New Yorkers and anyone with family in downtown NY, these thoughts were coupled with very specific fears about friends and family: "Where is she? I can't get any calls through on the cell phone.* Was she in one of the towers? Did she get out all right?" The disaster triggered a mad scramble for information; many felt the aching, gut-punched feeling and desperate frenzy of simply *not knowing*—of being powerless and helpless.

Certainly, no one wanted to think that a loved one was one of the objects plummeting to the ground—having been blown out by the force of the initial impact, or having been compelled to jump. This, most difficult, reality is the subject of Eric Fischl's *Tumbling Woman*, a painfully veristic sculpture of a female figure appearing to land on her back. Dedicated specifically to those who died by this terrible route, the sculpture was covered a week after its unveiling, and removed. The following excerpt from a contemporary news article reveals the heart of the controversy, which you might already surmise:

Numerous news photos captured images of desperate people leaping to their deaths as the 110-story towers burned. Some passersby in Rockefeller Center, however, complained that the artist's rendition was too graphic.

An unknown victim falling through the air having jumped from a WTC tower. See "9/11: The Falling Man" by Greg Hassall, http://www.smh.com.au/news/tv-reviews/911-the-falling-man/2006/08/30/1156816955993.html.

*A massive communications array was mounted on the roof of one of the towers. After the attack, cell phone, TV, and other services were disrupted; remaining connections were overwhelmed and jammed with frantic callers trying to reach loved ones.

Left: The second plane, Flight 175, has just hit the World Trade Center's south tower. Right: Smoke billows from both towers.

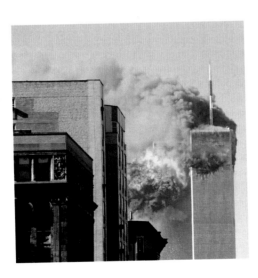

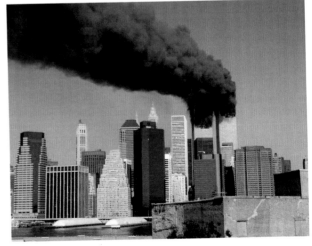

"I don't think it dignifies their deaths," said Paul Labb, who was strolling through the concourse while the statue was still visible. "It's not art.... It is very disrupting when you see it."

...

"The sculpture was not meant to hurt anybody," Fischl said in a statement. "It was a sincere expression of deepest sympathy for the vulnerability of the human condition. Both specifically towards the victims of Sept. 11 and towards humanity in general."*

The reaction from viewer Paul Labb is instructive—he clearly believes that a memorial, and perhaps artwork in general, should be dignified and affirming. Indeed, in Labb's mind, the failure of *Tumbling Woman* to meet this criteria disqualified the work as art. Labb's assertion ("It's not art") is neither unexpected nor unique; we have seen how powerful social expectations can be, in defining what is, and is not, "real" or true.

Fischl's response to the controversy reveals his cathartic goal: he wanted viewers to remember those who died this way—but he also wanted viewers to confront their own mortality. The "subject" of the work is therefore more than the falling victims of 9/11—it is that feeling of being vulnerable and helpless that so many of us have felt, when faced with the fragility and brevity of life.

Maya Lin's memorial opened the door for cathartic memorials in the 21st century, yet we see the artist's peril in actually "stepping through." In trying to speak to the viewer's pain, the artist runs the risk of offending viewers who (sometimes subconsciously) associate verism with negative propaganda. They do not want to be jarred, but rather soothed—even though jarring pieces like *Tumbling Woman*, placed in an unavoidably-public, well-traveled space, can be particularly effective by its "disrupting" approach.

The classicizing memorial is most likely to meet public expectations, and create a calm, uplifting memorial experience. The veristic memorial—punctuated by some combination of dramatic light, enclosed or lowered space, and expressionistic abstraction—is far more likely to stimulate strong emotions, and provide cathartic opportunities. However, rarely can an artist have it both ways (classicizing and cathartic); attempting to do so can be fatal to a memorial design. Let us now consider *the* memorial design for 9/11, created by architect Michael Arad (b. 1969) for "ground zero," where the towers once stood.

The 9/11 Memorial

There have been many local and regional 9/11 memorials erected since the event—some addressing the valiant efforts and loss of life among emergency responders (such as the New York Fire Department and Police Department); others specifically for the lost employees of companies leasing the World Trade Center buildings. Still others have been created for those in the hijacked airplanes, including the third plane which hit the Pentagon in Arlington, VA and the fourth which crash-landed in rural Pennsylvania.** The memorial for downtown New York City has special significance, however. Most national memorials are located on the Mall in Washington, DC, but the most important 9/11 memorial—one that will receive the most national and international attention—will be the one placed where the most destruction and loss of life occurred. This puts all the issues we have discussed thus far under a particularly powerful microscope, with all eyes (and opinions) focused on Michael Arad's design. Arad's plan would inevitably encounter unparalleled scrutiny, from its competition selection by a jury (which included none other than Maya Lin, as a non-voting member) to its intended completion date (September 11, 2011, the ten-year anniversary).

Explaining his design, *Reflecting Absence*, Arad clearly borrows from Maya Lin's approach, employing similar devices and phrasing his vision in similar terms. Like Maya Lin, Arad's aim was for a quiet, contemplative space, which allows viewers to experience a personal reckoning with the tragedy. As with Lin's design, the visitor at Arad's memorial would descend into the earth; in this case, visitors would follow a ramp that

* Jaime Holguin "September 11 sculpture covered up," Associated Press, 9/19/02, http://www.cbsnews.com/stories/2002/09/19/national/main522528.shtml

**While in flight, passengers had heard about the fate of the other airliners, and decided to rush the hijackers and force their hand, rather than allow the plane to be used as a missile against another populated target.

Original 9/11 memorial
design by Michael Arad.

would lead below the hustle and bustle of street level. From below ground, the viewer would watch the water, cascading from above, in two great waterfalls which surround the original footprints of the World Trade Center towers. A low wall inscribed with the victims' names would stand in front of the falling curtain of water.

In the following excerpted statement by Michael Arad and Peter Walker, note how the artist envisions the memorial as an emotional, cathartic space:

The pools … are large voids, open and visible reminders of the absence.

The surface of the memorial plaza is punctuated by the linear rhythms of rows of deciduous trees, forming informal clusters, clearings and groves.… Through its annual cycle of rebirth, the living park extends and deepens the experience of the memorial.

… Descending into the memorial, visitors are removed from the sights and sounds of the city and immersed in a cool darkness. As they proceed, the sound of water falling grows louder, and more daylight filters in from below. At the bottom of their descent, they find themselves behind a thin curtain of water, staring out at an enormous pool. Surrounding this pool is a continuous ribbon of names.

The enormity of this space and the multitude of names that form this endless ribbon underscore the vast scope of the destruction. Standing there at the water's edge, looking at a pool of water that is flowing away into an abyss, a visitor to the site can sense that what is beyond this curtain of water and ribbon of names is inaccessible.

The names of the deceased will be arranged in no particular order around the pools … The haphazard brutality of the attacks is reflected in the arrangement of names, and no attempt is made to impose order upon this suffering. The selfless sacrifices of rescue workers could be acknowledged

Illustration of original 9/11 Memorial design, as submitted to the competition, by Michael Arad. Note the covered ramps leading underground. See http://www.wtcsitememorial.org/fin7_sub.html.

with their agency's insignia next to their names. Visitors to the site, including family members and friends of the deceased, would be guided by on-site staff or a printed directory to the specific location of each name....*

*Http://www.wtcsitememorial.org/fin7.html.

As Arad explains, the sheer enormity of the falls, coupled with the vast rows of names, would echo the enormity of loss. Light filtering from above through a veil of water would create a shadowy space, quite distinct from the direct light and open air of the outdoors.

Although selected as the winning design, this plan was met with severe criticism from a wide range of parties. A few art critics dismissed the plan as derivative, a kind of May Lin knock-off; indeed, they found the entire group of finalists' designs to be lacking, and begrudgingly declared Arad's work as the least defective out of a weak field. Historians' critiques were sharper; like many of the approximately 5,000 designs submitted to the competition, Arad's memorial would be built directly on top of the site, burying the towers' cavernous remains. From a historian's standpoint, such an archaeological violation would be no different than attempting to pave over the battlefield at Gettysburg. Particularly aggrieved were the families of victims who were never found, their decimated and scattered remains buried beneath thousands of tons of compressed rubble.**

**See the PBS documentary, "America Rebuilds II," 2006.

Accompanying these concerns, which focus on the status of "ground zero" as an inviolate site, were the same points of contention which dogged the Vietnam Veterans Memorial design. The most crucial choice, to place the memorial underground, raised familiar concerns about negative symbolism. The site already accommodates a partially-underground museum, which houses pieces of wreckage and provides specific information about the event, for commemorative, preservation, and educational purposes. However, the placement of the official memorial underground becomes another matter altogether. The combination of a descending approach, closed space, and relative darkness contradicts three main tenets of classicism, which insists upon raised, expansive, and brightly-clear vocabulary. Victims' families, like many Americans, expected a classicizing memorial (perhaps with just a Maya Lin touch)—uplifting the hearts of visitors and heroicizing the sacrifices of the fallen. They did not expect a memorial that would plumb terrible emotional depths, suggesting the void that loss can inflict on the hearts of the grieving.

Above left: Remains of the outer shell of 2 World Trade Center.

Above right: Final 9/11 Memorial design, *Reflecting Absence* by Michael Arad. 9/11 Museum in background.

Despite Michael Arad's best intentions, the decision to place the 9/11 memorial underground symbolized to many only shame and neglect—as though the memories should be buried, like an embarrassment or an afterthought. Taken literally, the direction downwards seemed to deny the height of the towers, the heights of sacrifice, and the highest virtues, hopes, and feelings to which one might aspire. Anticipating a massive turnout of visitors, critics were further concerned that the densely-packed underground space could feel claustrophobic. Overwhelmed visitors would feel far from contemplative with strangers pressing against them, the din of their voices and constant crash of water creating a cacophony of sound. Such a scenario would indeed be veristic—perhaps even reminiscent of the frantic crush of people, clambering down the smoke-filled stairwells of the towers before they fell.

Certainly this effect would be quite different from the degree of verism Arad envisioned—but would this submerged nightmare really occur? Were these concerns logistically legitimate—or just exaggerated fears, fueled by a violation of Classical expectations? We will never know. In response to criticism, as well as the ballooning costs projected to reach $1 billion, the underground elements of Arad's design were scrapped. Waterfalls would occupy the footprint spaces, but the low wall of names would frame them from above, rather than below. Visitors could look down, into the disappearing cascades, but would not look through a watery veil into an indistinct beyond. From this new vantage point, the viewer can look up from the memorial and clearly see the vast Manhattan skyline—including the new, single World Trade Center tower—rising up, shining and triumphant. The resulting changes could be seen as a reasonable compromise, or a crippling blow to the memorial's meaning and effectiveness. In any case, the new (and final) plan still fails to resolve concerns about disturbing the historical integrity of the site.

The case of the 9/11 memorial in New York City exemplifies the hazards of public memorial design, and provides an object lesson for those who would try to make a single memorial that will be all things to all people. We have certainly found the potential benefits and risks in designing a cathartic memorial. Before we continue, let us address an important element that is integral to all art, but particularly essential in memorial design: the element of ***time***.

The new World Trade Center rises immediately behind the North Pool of Reflecting

Timeless Vocabulary

Timeless Classicism: The World War II Memorial

We have found the classicizing style to be optimum for stoic, uplifting, and reaffirming memorial designs. Although the Classical style refers to the Greek and Roman past, it has been long embraced as "timeless"—embodying an unchanging tradition, untouched by the vagaries of fashion and taste. Let us consider the visual elements that reinforce that sense of time, permanently suspended. To illustrate, we will look at the national World War II Memorial in Washington, DC, designed by architect Friedrich St. Florian and dedicated in 2004.

You will notice that the memorial is unquestionably Classical in design. It is spacious, grand in scale, and direct in meaning. In addition to the white stone, it features the round, triumphal archways, soaring eagles, and victorious wreaths of laurel found in Roman art. One archway commemorates the fighting in the Pacific Theater—the zone of combat between the Allied forces and Japan. The other, shown here, is marked for the Atlantic Theater, where the Allies fought against German and Italian troops.

The names in this memorial refer to places; the people who fought at these critical battlegrounds are inferred. Names of major battle sites are inscribed throughout. A state name is etched into each of the rectangular columns that flank the triumphal archways in a wide, elliptical colonnade. The inclusion of each state suggests the nation-wide impact of the war, which claimed the lives of over 400,000 U.S. soldiers.

The intended impact of the World War II memorial is consonant with its visual elements:

> Above all, the memorial stands as an important symbol of American national unity, a timeless reminder of the moral strength and awesome power that can flow when a free people are at once united and bonded together in a common and just cause.*

Some critics were dismayed that a 21st-century memorial should be so old-fashioned in its approach, and considered the abundance of Classical references to be heavy-handed and jingoistic. Detractors also found

Friedrich St. Florian, *World War II Memorial*, 2004.

Eagles encircling a wreath, Atlantic Pavilion, *World War II Memorial*.

View of the Atlantic Pavilion, *World War II Memorial*.

disconcerting the scarcity of human references; plaques along the entrance corridor show vignettes of military events—such as this relief, showing soldiers burying the dead–but the bulk of the memorial does not show or reference individual people. The overall result, critics argued, was a memorial that glorified war and minimized its cost.

Also divisive was the choice to place the memorial squarely in the center of the Mall, visually dividing the expanse between the Lincoln and Washington monuments. Some viewed this placement as an aggressive political statement, antagonistic to the public's use of the Mall, since the tumultuous 1960s, as a site for protest. Decrying the location of the memorial as insensitive to the Mall's democratizing purpose, critics noted that the very site was once occupied by crowds listening to Martin Luther King Jr.'s "I have a dream" speech, delivered from the steps of the Lincoln Memorial.** Erected at a time when most World War II veterans had passed away, the memorial seemed to critics almost stubbornly rooted in time—a complete rejection of Maya Lin-like modernism, immune to the vicissitudes of history, and the comings and goings of visitors.

Whether denigrated or celebrated for its classicizing approach, the World War II memorial clearly speaks Classicism's immutable language. The vertical and rounded jets of water in the central pool—so often found in traditional fountains—do not disturb the overall stillness of the piece.

The ability of the memorial to speak of time frozen, rather than fleeting, is rooted deeper than its idealized, Classical features, however. Its stand-still impact is conveyed by more basic elements: a unified front of *line* and *balance* vocabulary.

Recall, from the examples in Chapter 5, the various ways in which line speaks. As we have seen, the most stable—and therefore *timeless*—lines are **clean, vertical,** and **geometric.** Paired with **symmetrical balance,** these lines create an unmovable, intransient force.

*National World War II Memorial website, http://www.wwiimemorial.com/default.asp?page=facts.asp&subpage=intro.

**A new memorial for Martin Luther King, Jr. was unveiled in 2011, not far from the Lincoln Memorial. Designed by Chinese artist Lei Yixin, the memorial presents the civil rights leader as a giant in pale stone, arms crossed, staring stoically towards the Jefferson Memorial across the tidal basin. The nationality of the artist, coupled with King's totalitarian demeanor, provided fuel for controversy. While cathartic memorials are clearly catnip for debate, emphatically classicizing memorials like King's may also invite criticism.

Nephew James at Iwo Jima,. *World War II Memorial.*

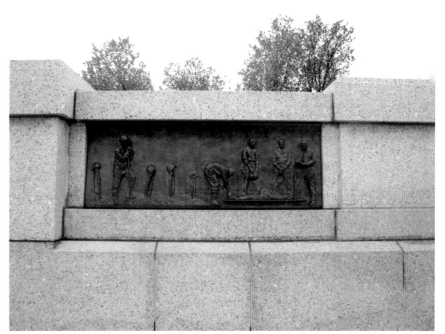

Bronze relief of a soldier's burial, *World War II Memorial.*

Time stands still:

Clean Vertical/Horizontal Geometric Line + **Symmetrical** Balance (formal balance)

Lincoln Memorial, Reflecting pool, and World War II memorial. (The Vietnam Veterans Memorial is hidden here; it is near the Lincoln Memorial, to the right.)

Aerial photo showing some of the estimated 250,000 people attending the March on Washington, August 28, 1963.
Photo by Robert W. Kelley, Time

Symmetrical balance is also known as **formal balance,** because the effect appears rather stiff and "posed," rather than spontaneous and informal. For over a hundred years, families have posed for formal portraits. Unlike the casual family snapshot, the people in these professionally-made photographs are arranged almost exclusively in symmetrical balance. Even though the photo on the next page is over a hundred years old, its basic arrangement still speaks of timeless decorum (not an easy feat, with three small children in the shot!).

Art with **radial symmetry** is symmetrically-balanced all around, as in the image on the left side of the diagram. Art with **bilateral symmetry,** on the right side of the diagram, features similarly-weighted objects on the left and right sides of the central axis.

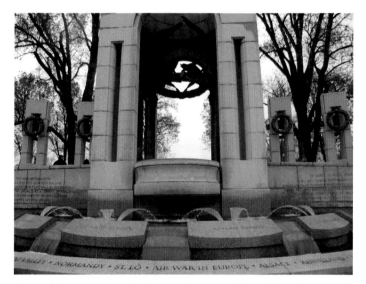

The World War II Memorial, Atlantic Pavilion, viewed from below; photo and diagram by the author.

In this photo and accompanying diagram, note how the line and balance vocabulary unite in the World War II memorial to resist time's passage: filled with clean, rectangular, circular and semi-circular forms (even the jets of water are more geometric than organic!); emphasizing vertical and horizontal direction; and unflinchingly formal in balance. As a result, time stands still; the memory of the Second World War is held in stasis—as is the notion, held sacred by generations of Americans, that the war constituted the nation's most righteous moment.

Formal photograph with
symmetrical balance and
vertical lines.
The Hogroian family, 1900,
Turkey.

9: THE PUBLIC MEMORIAL

TIMELESSNESS AND THE SACRED

Cultures throughout history and around the world have used timeless vocabulary for sacred artwork. Regardless of culture, sacred ideas are held dear, and valued as unchanging, unmovable, and eternal. Symmetrical balance, and predominately clean, geometric, and vertical lines are often used to speak most directly to those values. Note the power of timeless visual vocabulary in the diverse works here.

Artists wishing to give their art a sense of gravity and importance will borrow this vocabulary for non-religious work. *The Two Fridas* by Mexican-born artist Frida Kahlo speaks of her multicultural identity: part of her identifies with a European heritage (her father was German), represented by the light-skinned Frida wearing a traditional Western wedding dress; her other "half" is Mexican, like her mother, wearing a traditional indigenous dress. Enduring a lifetime of pain as a result of a trolley accident in her teen years, Kahlo is often identified with the intense, personal imagery of her paintings, including visual references to exposed and damaged anatomy. Here, the two Fridas' hearts are joined, but the connection is incomplete; the clamp fails to stem the flow of blood. Kahlo's on-again, off-again relationship with her husband, painter Diego Rivera, is also referenced in this piece; the Mexican Frida holds a picture of Diego—who, Frida felt, preferred the more traditional and accommodating Frida to her independent, "westernized" side.*

Through its strong symmetrical balance, vertical lines, and two dominating triangular shapes, the composition speaks of concerns that are greater and more enduring than just one woman's experiences. Issues that arise from having mixed ethnic identities can be stressful, even psychologically painful—but they are rarely fleeting.

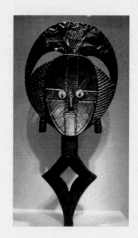

Reliquary guardian figure, Kota culture, late 19th to early 20th century. Wood, brass, copper, bone, iron. National Museum of African Art, Washington. Photo by the author.

*For more information, see the PBS site, http://www. pbs.org/weta/fridakahlo/ worksofart/index.html#.

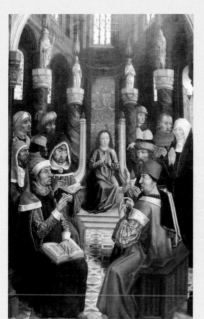

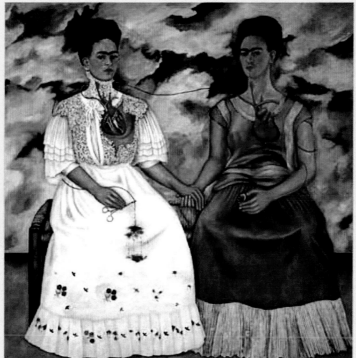

Left: Master of the Catholic Kings (Spanish-Flemish), *Christ Among the Doctors*, c. 1495/97. Oil on panel. National Gallery of Art, Washington. Photo by the author.

Right: Frida Kahlo, *The Two Fridas*, 1939. Oil on canvas, 47 x 47". Museo de Arte Moderno, Mexico City, Mexico.

Loose symmetrical balance.

*The prefix "a-" indicates the opposite or "not"—for example, "atypical" is "not typical;" "amoral" is "not moral," etc. Thus, **asymmetrical** means "not symmetrical." Asymmetrical balance does *not mean* *not balanced;* an unbalanced work of art has a composition problem.

We have found that near-perfect symmetry in a work of art can suggest powerful importance, sacredness, and permanence. A work need not be *exactly* the same on each side to be considered symmetrical, however. This design is also symmetrically balanced, but less rigidly so.

THE VOCABULARY OF TIME'S PASSING

As you may have noticed, the more one "plays" with symmetry, the more the composition appears to move, and time begins to slip. Similarly, the addition of rougher textures, diagonals, and organic lines will further suggest time's passage, rather than permanence. To see how visual vocabulary can infer the mobility of time, we will look shortly at a national memorial quite unlike the World War II memorial—featuring non-symmetrical balance and more textured, organic lines. First, however, let us examine the vocabulary of time in motion. The opposite of symmetry is **asymmetry**. A work balanced with asymmetry is **asymmetrically balanced.***

Asymmetrical balance is often more difficult to achieve than symmetrical balance. The overall visual weight of the composition must be equal, through a varied distribution of line, color, texture, etc. To put it in concrete terms, imagine balancing a big balloon against a handful of tiny sunflower seeds. In the asymmetrical design at the top of the next page, note how much weight the negative space carries, even though it might seem mostly "empty." This area, which occupies half of the composition, is necessary to counterbalance the bold shapes arising from the left corner.

As with any composition filled with variety, unity is also hard to achieve in composing an asymmetrically-balanced work. A poorly-balanced work will feel random and disjointed, as though two or more different compositions were lumped into one. Implied lines and repeated shapes (such as the trail of U-shapes in the design on the next page) can help tie an asymmetrical work together.

Also known as **informal** balance, asymmetry imparts the feeling of something unplanned and unexpected. Snapshot photos capture that sense of time caught for just a fleeting second; they are almost always asymmetrical in composition, as this snapshot shows.

Snapshot photo with asymmetrical balance and diagonal lines. Arsen and Varsenig Hogroian, 1920s, NYC. Grandfather Arsen is the little boy standing in the center of the previous family photo.

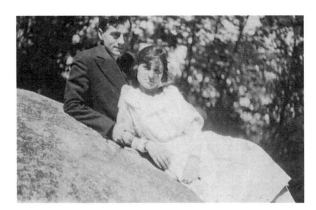

Time passes by:

**Rough
Diagonal
Organic** Line + **Asymmetrical**
Balance
(informal balance)

The Passage of Time: The FDR Memorial

Utilizing an entirely different vocabulary from the World War II Memorial, the national memorial created in remembrance of Franklin Delano Roosevelt speaks of time's passage, both through the choice of subjects depicted, and the informal composition in which they are laid out.

These choices reflect the varied and wide-ranging aspects of Roosevelt's presidency. FDR's administration lasted three terms; it began in the dark days of the Great Depression, continued through Roosevelt's New Deal policies (see the end of Chapter 8), and saw the United States through the Second World War. Designed

by Lawrence Halprin, the memorial does not attempt to speak to all of these years at once, but rather allows visitors to explore the different time periods as they stroll through the site.

The setting is park-like, the asymmetrical layout dictating no definite or required path to visitors. Stone buildings encase sculpted vignettes which show veristically the experiences of everyday Americans. The buildings informally demark the memorial's four sections, or "rooms."*

Pictured on the next page is George Segal's *The Fireside Chat*, which shows a man listening to one of FDR's regular radio talks (called "fireside chats" because, during the Depression era, families would often gather around the fireplace in the winter to keep warm and listen to the radio).** *The Breadline*, also by Segal, shows the poverty and hunger endured by many during the Depression. In each, note the asymmetrical composition of the figures in relation to the space around them.

Rough-textured boulders protrude at intervals throughout the memorial; in one area, waterfalls tumble haphazardly over the surface. In contrast to the World War II memorial, the water here moves more organically, giving a greater sense of energy, unpredictability, and emotion. In another "room," boulders lie scattered and overturned—suggesting the destruction incurred in World War II.

A long wall of weathered, bronze relief sculpture by Robert Graham provides glimpses of the various programs FDR enacted. Rather than appear as a formal, documentary list, the various acronyms and their definitions emerge from and disappear into the wall's surface, drifting like snippets of a conversation. The people aided by these programs are suggested by abstract, low relief images of faces and bodies. These too appear to ebb and flow across the surface—arising and then disappearing through the veil of time.

The memorial culminates in a larger-than-life-sized sculpture of Roosevelt and his pet dog, Fala. The most controversial aspect of the memorial, aside from its informal and sprawling layout, was whether the wheelchair of the polio-stricken president would be shown. Roosevelt himself insisted that he never be photographed or appear publicly in a wheelchair—a restriction that could be honored in a time before internet blogs and cable news.***

Lawrence Halprin, The Franklin Delano Roosevelt Memorial, dedicated 1997. Tidal Basin (just west of the Mall), Washington, DC. Photos and diagrams by the author.

In this regard, a compromise was reached—he would appear in a wheeled chair, but it would be almost completely concealed by a voluminous cloak. Many were dissatisfied by this choice, and felt that an otherwise veristic memorial should be more candid about the president's affliction. A smaller sculpture of the president, clearly seated in a wheelchair, was later added to the site.

The author's nephew, shown in photos over the next few pages, demonstrates the participatory spirit of the FDR memorial. You might recall seeing James at the World War II memorial, which invites no

The landscaping is an integral part of this memorial's design. In this diagram, the greenery has been removed to show the asymmetry of the various structural elements.

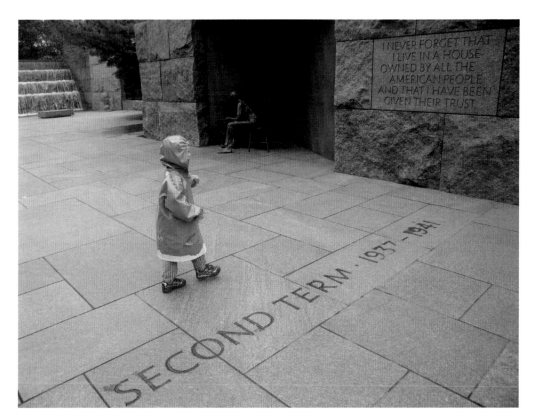

Nephew James enters Roosevelt's second term of office. Behind him is a bronze sculpture by George Segal, The Fireside Chat, in Room 2.

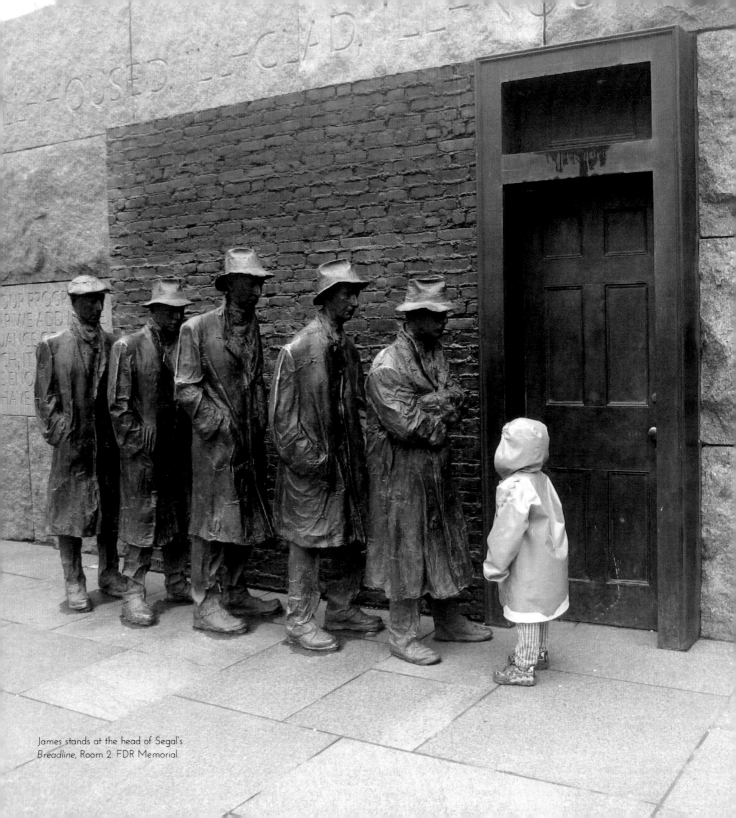

James stands at the head of Segal's
Breadline, Room 2. FDR Memorial.

Top left: Robert Graham, Social Programs, weathered bronze, 30' long.

Top right: Waterfalls evoke the turmoil of the Second World War, FDR Memorial; photos by the author.

direct interaction—even from a curious toddler. Here, in contrast, viewers are given the opportunity to explore, discover, and become personally engaged as they physically enter each of the "rooms." This approachability can be viewed as both an advantage and a drawback. Viewers here can move through, and become a part of, the slipstream of time; this makes the memorial experience personal, and thus actually *memorable*. Conversely, bringing memorialized events "down" to a personal level could ultimately debase the experience—personal can become casual, and casual can become crass and inconsiderate. The gravity of Classicism defends against any flippant or dismissive treatment of the memorial subject. Memorials such as this one must run that risk.

Certainly a colossal memorial like Felix de Weldon's *Marine Corps Memorial*—measuring a whopping five stories tall—denies any possibility of dismissal or debasement. No one is going to clamber up the soldiers' backs to have his or her picture taken. The viewer is clearly invited only to stand back in admiration and wonder at the forever-frozen moment. The sculpture is modeled on a famous photo, taken after the WWII battle of Iwo Jima. Photographer Joe Rosenthal had witnessed the victorious marines raising the flag, and asked them to recreate their poses so he could get the iconic shot.

The interactive nature of the sculpture is demonstrated by nephew James (with Fala), as well as Roosevelt's shiny fingertips and kneecap—buffed by thousands of touching hands. Elsewhere, the bronze shows a weathered, green patina.

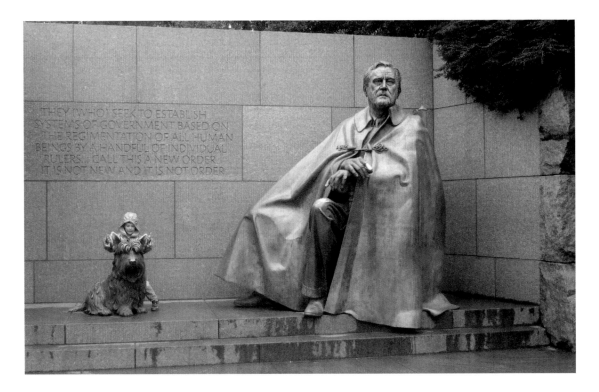

Unidentified children stand in *The Breadline*. Photos by the author, January, 2010.

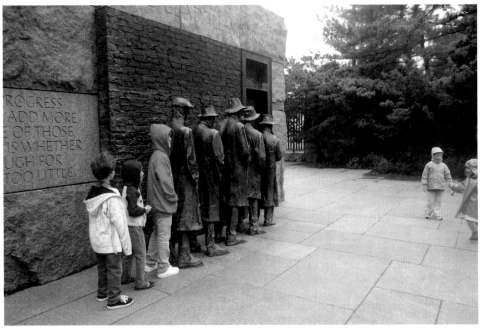

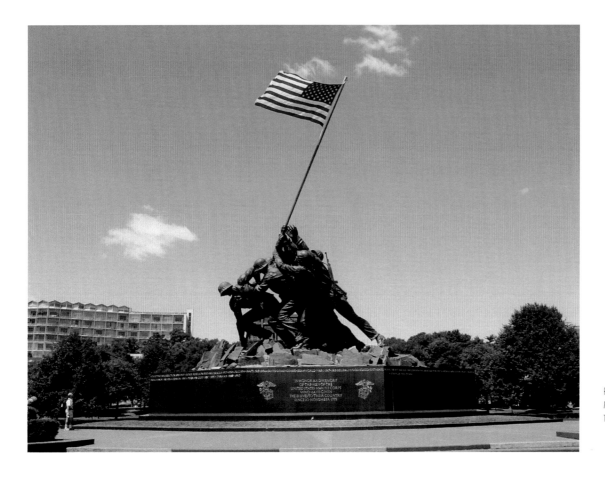

Felix de Weldon, *The Marine Corps Memorial*, 1954. Arlington, VA.

The triangular composition, grand scale, and un-weathered bronze material speaks of Classical ideals. Its loose symmetry and dominant verticality suggest timelessness, a heroic tableau that forever stands as a symbol of honor, righteousness, valor, and triumph. Standing before the monument, the viewer is encouraged to look up and feel proud to share in the ideal, American virtues the figures are meant to represent. We may identify with their symbolic message, but we cannot empathize with them; they are no longer the individuals who raised a flag decades ago, but are instead transformed, via Classicism, into the immortal embodiment of the nation itself. They will never change, nor will their intended message, even as generations come and go.

THE HOLOCAUST MEMORIAL

There is one great exception to the dominance of classicizing vocabulary in American memorial designs. Memorials of the Jewish Holocaust are almost exclusively, powerfully veristic. The extermination of six million Jews was planned by Adolf Hitler, carried out by German and Austrian soldiers, and encouraged both silently and vocally by countless citizens who were, in effect, accessories to mass murder. Although the brave and selfless individuals who dared to hide and protect Jews could be memorialized in a more idealistic fashion, the

Holocaust as a memorial subject will simply not tolerate the classicizing treatment. Given Hitler's obsession with Classical art, any Holocaust memorial that even leans in that direction risks being read as insensitive (at the very least) or denounced as anti-Semitic, fascist, and neo-Nazi.

The memorial located on the grounds of San Francisco's California Palace of the Legion of Honor exemplifies the expected vocabulary of Holocaust memorials. George Segal's *The Holocaust*, 1984, is a plaster display of barbed wire, stacked bodies, and a stricken figure reaching out for deliverance. Here verism is joined by rough textures, asymmetrical balance, and the stained, off-white color of plaster. Recall that Segal also sculpted several freestanding sculptures for the FDR Memorial. As in Washington, Segal's memorial in San Francisco communicates quiet, intense heartache.

The Center for Holocaust & Genocide Studies at the University of Minnesota has assembled an extensive collection of photos, showing more than thirty Holocaust memorials in detail. As you look through their site, http://www.chgs.umn.edu/museum/memorials/, consider the artists' diverse use of emotionally-gripping visual vocabulary—from restrained to visceral. The intensity of Kenneth Treister's work at the Miami Holocaust Memorial represents one of the more harrowing works featured on the CHGS's site.

Berlin's Holocaust memorial was deeply divisive upon its 2005 unveiling, in part because it strayed so far from the established norm. Devoid of figures, this enveloping, faceless mass of variably-sized blocks extends for an entire city block. It speaks of mass conformity and culpability—Berlin was the administrative heart of Hitler's Germany—as well as massive loss of life. The narrow, cobblestone corridors undulate and tilt; the visitor becomes disoriented, swallowed up by the oppressive mass of the space. From within, there seems almost no end in sight, no escape or relief.

Kenneth Treister, *The Sculpture of Love and Anguish*, central feature of Miami Holocaust Memorial, 1985.

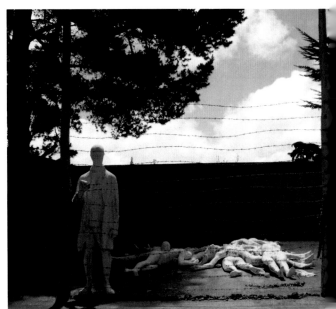

George Segal, *The Holocaust*, 1984. Plaster. San Francisco, CA. Photos by the author.

Architect Peter Eisenman's design symbolically evokes the intense feelings of the tragedy, and forces visitors to empathize with the victims while confronting their own vulnerability—and culpability. However, lacking any direct, literal reference to Jewish suffering, the Berlin memorial appeared to some critics as cold and insensitive. The clean lines and geometric shapes—which eloquently reflect the Nazi's systematic approach to mass killing—was read by some as a reflection of an impassive city, its citizens unwilling to face their role in the horror. To some, the memorial was simply too big—and its vocabulary, too minimal. For most memorials, the choice of non-objective symbolism is a dangerous one, given the potential for misinterpretation. In the particularly sensitive case of the Jewish Holocaust, the tendency of non-objective art to invite interpretation—rather than clearly spell out its intent—can be potentially damning.

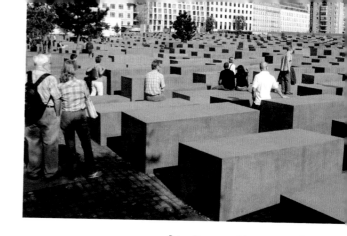

Peter Eisenman, *Monument to the Murder Jews of Europe*, 2005. 2,700 concrete slab Berlin, Germany.

As in the FDR memorial, we see the drawbacks of having an interactive memorie Here visitors feel free to sit and stand on the blocks. Should this be discouraged? How would you discourage it, if you wanted to?

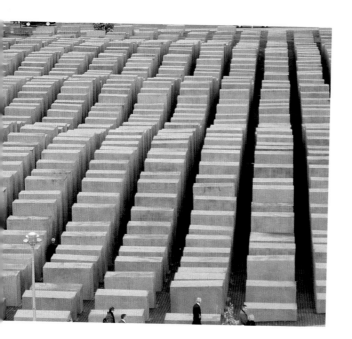

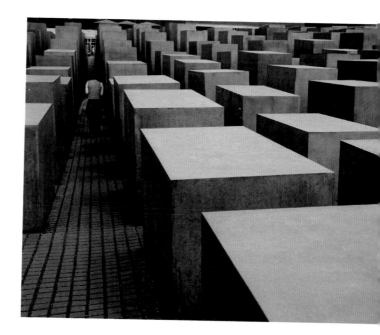

Jochen Gerz, Esther
Shalev-Gerz, *Monument
Against Fascism,* unveiled
1986. Hollow aluminum,
lead plated. Harburg,
Germany. The monument
near its full height.

THE CHANGING MEMORIAL

To this point, we have looked at memorials that suggest timelessness (the World War II Memorial and the Marine Corps Memorial, for example), and others that suggest the passage of time (the Vietnam Veterans Memorial, Arad's original 9/11 memorial design, and the FDR Memorial). Some memorials are meant to show the effects of time (allowing gradual deterioration caused by weather and wear). Others must be periodically cleaned and repaired, to resist those ill-effects. However, none of the memorials yet discussed were designed to transform completely. Let us look, finally, at a "counter-monument,"* made to become completely "undone" by time.

 The memorial shown here, placed in a public space in Harburg (a suburb of Hamburg, Germany), was designed to descend in stages into the ground, and ultimately to disappear. Created by Jochen Gerz and Esther Shalev-Gerz, the memorial—originally over 39′ tall—was dedicated in 1986; it was finally "buried" in 1993. The hulking column recalls the pervasive and twisted influence of fascism in Germany under Hitler; its sinking therefore becomes a repudiation of fascism, expressing the hope that it will ultimately vanish, not only from Germany, but from the whole world. Visitors were invited, through an inscription written in multiple languages, to write their names on the monument, indicating their willingness to "stay vigilant" against fascism's return. With the memorial gone, the visitors alone remain standing: "In the end, it is only we ourselves who can rise up against injustice."**

* The artists themselves
described this work as a
"gegen-denkmal," a
counter-monument.
**See http://
memoryandjustice.org/site/
monument-against-fascism/.

 9: THE PUBLIC MEMORIAL

"Nazis raus" ("Nazis get out"), written on the memorial by a visitor. *Monument Against Fascism.*

The column, fully lowered
into the ground. *Monument
Against Fascism.*

New Vocabulary in Chapter 9

asymmetry, asymmetrical — Balance in which objects or shapes are distributed unevenly in a work of art

catharsis, cathartic — Allowing release of pent-up, hidden, or suppressed emotions

formal balance — Symmetrical balance (a design principle that suggests formality and sacredness)

informal balance — Asymmetrical balance (a design principle that suggests casualness and candor)

10 COLOR & PAINTING

10: COLOR AND PAINTING

TECHNICAL ASPECTS OF COLOR, AND THE PSYCHOLOGICAL
IMPACT OF COLOR
PAINTING MEDIA AND TECHNIQUES

*If you are among the color-blind, not to worry—you have a lot of company! Studies show that five to eight percent of men, and 0.5 percent of women, have some form of color blindness (http://colorvisiontesting.com/color2.htm). To master color, you must learn the placement of the color names on the wheel and apply your knowledge of color theory to works of art; however, you do not need to have the ability to "name that color"! To test your perception of color, go to Archimedes' Laboratory at http://www.archimedes-lab.org/colorblindnesstest.html#testcolor.

**Artists working on a computer apply methods of additive color (the more colors you add, the closer you get to white). Artists mixing physical color materials are working with the principles of subtractive color (the more colors you mix, the closer you get to black).

Of all the visual elements, color is perhaps the most challenging—and rewarding—for artists to master. Color has an immediate impact on viewers, both consciously and subconsciously. Yet, color is also the most subjective visual element. Our view of color depends on what light enters our eyes; what our rods and cones do with that light, as varied wavelengths hit our retinas; and what our brains make of all that information. We have favorite colors (and not-so-favorite colors). To one person, a color may appear joyful, while the same color might sicken or alarm someone else. One person might find a color cozy and comforting, while the same color is stifling and oppressive to another. Some people are sensitive to color, and others pay little attention to it. Still others are colorblind, meaning their visual perception of color differs from most.* Like so many things in art, color speaks on multiple levels, and its perception depends on a complex interplay of personal, cultural, and universally-human factors.

Note that graphic artists working on their computers are not handling color *material*. Color behaves quite differently (and the terminology for color becomes more exacting) when you are dealing with pixels!** So, to simplify our discussion of this complex visual element, we will focus on the way painters use color.

THE COLOR WHEEL

The science of optics is ancient, but our modern understanding of the way light works upon the human eye took off in the 1800s. Scientists discovered that light bounces off objects, which absorb some of the color spectrum and reflect a part of the spectrum back to the viewer's eye. This is the color that the viewer sees.

The color wheel, invented in the late 1800s, arranges color systematically, providing a standardized and objective tool for color study. Some color wheels have 12 colors, as the one here; others show only the **primary** and **secondary** colors, omitting the **tertiary** colors. Regardless of the variations in color wheels, the primary colors are always equally spaced, equidistant from each other. If you think of the color wheel at right as a clock, then the primary colors yellow, blue, and red occupy 12:00, 4:00, and 8:00, respectively. Armed with these three colors (plus black and white), you can mix just about any color known to humankind.

The Color Wheel

Yellow-Orange · Yellow · Yellow-Green · Green · Blue-Green · Blue · Blue-Violet · Violet · Red-Violet · Red · Red-Orange · Orange

Hue and Color Mixing

One of the universal rules of color is that the **primaries** cannot be made by combining any other colors. No two colors mixed together can make red, for example; it cannot be "broken down" into any component colors.* You have to *start* with red, and make other colors from it.

Red is known as a **hue**—the name of the color based on its position on the color wheel. Adding another color to red will change its hue; for example, adding a touch of yellow to red will move the resulting color to 9:00 (red-orange). Adding equal parts of primaries together will produce a **secondary color.** Equal parts red and yellow combine to make orange, shown in the wheel above at 10:00. If yellow dominates the mix, the result will be the **tertiary** (third-level) color yellow-orange, positioned at 11:00. Note that colors closer to a primary on the wheel have more of that hue in the mix. So, to mix any color, look to see the two primary colors closest to it, on either side, and note if it is closer to one primary than another. To mix red-violet (7:00), for example, you would need to mix red (8:00) and blue (4:00). Since red-violet is closer to red on the wheel, you would need to add more red than blue to your mix. Of course, if you happen to have violet already mixed, you could certainly mix red and violet, and get the same red-violet result.

The Color Wheel
12 Hues

tint
shade
highest
saturation
(pure hue)

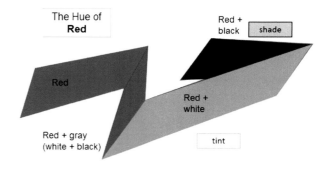

The Hue of **Red**

Red

Red + gray
(white + black)

Red +
black shade

Red +
white

tint

Adding white or black to a color will not change its essential hue, because neither white nor black "count" as colors. A white object bounces all colors of the spectrum back to the eye at once, so we see no color; a black object absorbs all the colors, reflecting no light (or color) back to us. Adding white to a color produces a pastel-colored **tint**. Adding black to a color makes a **shade** of that hue.** Adding both white and black creates a dusty, faded and subtle tone. All of these variations occupy the same "number" on the color wheel.

Saturation/Intensity

Adding white, black, or any combination of white or black reduces a hue's **intensity**, or level of boldness. A **low intensity** color does not shout out its hue; however, experienced artists can usually perceive what hue is present in dull, low-intensity colors. For example, look on the following page at *Zapatistas*, a painting by Alfredo Ramos Martinez. Many colors are present, but really there are only two main hues: the tertiary colors yellow-orange and red-orange. If you do not recognize them at first, then look at the diagram below the painting. Along the top is yellow-orange and along the bottom is red-orange, in varying intensity. The two hues are blended across the middle. The left side of the diagram features **high intensity,** pure hues, as bold as can be. As we move right, the intensity diminishes. Blends of black (down the middle) and white (along the right side) create a variety of **low intensity** shades and tints. Indeed, with the help of black and white, these two little hues make a surprisingly wide range of colors!

*If you prefer to think mathematically, consider primary colors as being like prime numbers, which cannot be divided by any number, except 1 and itself.

**Note that black has a peculiar effect on yellow: rather than just creating a shaded, darker version of yellow, black plus yellow makes ... olive green. In fact, any hue with a lot of yellow in it (such as yellow-orange) will experience a greening effect when mixed with black.

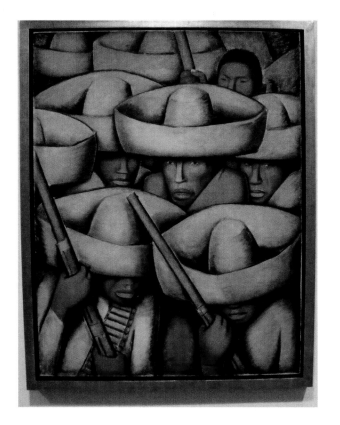

In painting, **intensity** is also called **saturation**.* A sponge that is **highly saturated** is at the point of dripping—it's full, full, full. **High saturation** color is full of pigment—pure, concentrated, unadulterated color. If you have ever used food or clothing dyes, then you have dealt with high saturation color (and you also know that a little goes a long way!). **Low saturation** is the same as low intensity—the hue is diluted, dulled-down, with little coloring pigment.

Analogous Colors

The term "analogous" comes from the Greek *analogia*—from which we also get the word "analogy" (something that is similar to, and being compared with, something else). **Analogous colors** are similar to each other, being near enough on the color wheel to have a "family resemblance." You may note that the colors used in *Zapatistas*—yellow-orange and red-orange—are analogous, occupying 11:00 and 9:00 on the color wheel, respectively. In this painting by Alfredo Ramos Martínez, the choice of closely-related hues relates to the meaning of the work. The men are rebel fighters (*zapatistas*) from Mexico's Revolution of 1910. From the artist's perspective, they are freedom fighters united to liberate Mexico from the country's oppressive leadership. These revolutionaries are presented as like-minded, appearing so similar as to be almost indistinguishable from one another. Their similarity is presented as their virtue and their strength—they are as one, a single and unstoppable force. The composition depends on analogous colors to reinforce that message. The men are as close as the colors used to depict them.

*Again, in digital applications, intensity and saturation are distinctly different components of color.

Above: Alfredo Ramos Martínez, *Zapatistas*, c. 1932. Oil on Canvas. San Francisco Museum of Modern Art. Photo by the author.

Below: Diagram of analogous color combinations (yellow-orange and red-orange) with white and black added. Diagram by the author.

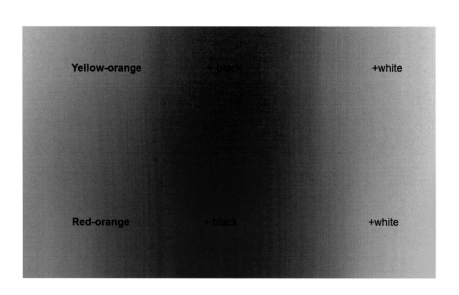

Yellow-orange + black +white

Red-orange + black +white

Color Harmony

By choosing analogous colors to dominate in *Zapatistas*, Martínez created a **color harmony**. Color harmonies are arrangements of color which create a sense of unity in a composition. For each work, an artist must carefully consider his or her color **palette** to ensure harmony; without it, the colors in a work of art can look muddled and random.

Monochrome is the simplest color harmony. A monochromatic palette consists of just one hue, with varying tints and shades. Very few works of art are *strictly* monochromatic, however; usually a hint of other colors is slipped in, to add complexity and variety.

Complementary Colors

Many artists rely on complementary color pairs to harmonize their compositions. On the color wheel, **complementary colors** occupy positions directly across from each other. Juxtaposed in a work of art, these colors appear to jump, vibrating in the viewer's retinas. They make a compelling color palette—which is why, even though they are as far apart as possible on the color wheel, they are called "complementary."

The complementary pair of blue and orange dominate Monet's *Impression: Sunrise*. Note that complementary colors need not be saturated in order to harmonize effectively with each other. The diagram of blues and oranges in *Impression: Sunrise* demonstrates how *any* shade or tint of blue is complementary to *any* shade or tint of orange. Side by side, complements sing in harmony; when mixed together, complements harmonize softly in a range of low-saturation browns and greys. Here Monet freely juxtaposes and mixes complements, creating areas of intense, vibrant sunlight and subtle haze, silhouettes, and shadows.

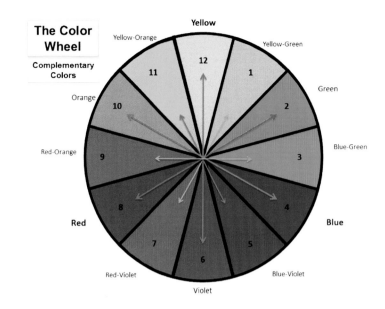

The Color Wheel

Complementary Colors

Yellow
Yellow-Orange
Yellow-Green
Green
Orange
Blue-Green
Red-Orange
Blue
Red
Red-Violet
Blue-Violet
Violet

Above right: Complementary pairs are connected by arrows.
Below left: Claude Monet, *Impression: Sunrise*, 1873. Oil on Canvas. Musée Marmottan, Paris.
Below right: Diagram of complementary colors blue and orange, used in *Impression: Sunrise*.

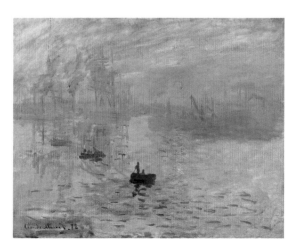

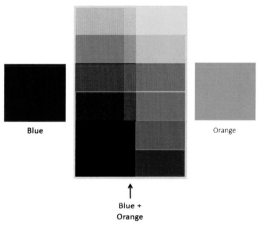

Blue

Orange

↑
Blue +
Orange

Above left: Six complementary palettes are illustrated above, each consisting of a primary | secondary, or tertiary | tertiary combination. Complementary color pairs, placed in proximity, can create eye-popping effects. The contrast between the colors in each complementary pair is called **simultaneous contrast**: simultaneously, both colors gain visual impact. Diagram by the author.

Below left: Claude Monet, *Rouen Cathedral, West Façade, Sunlight*, 1894. Oil on Canvas.

Below right: Detail of Monet's *Rouen Cathedral*.

The Impressionists and Color

When we looked at Monet's work in Chapter 3, we noted his use of abstraction to create the impression of changing light and atmosphere. Part of this impression is conveyed through Monet's **impasto** brushwork—heavy strokes of paint, creating a rippling network of textured lines (seen in *Rouen Cathedral*). Aside from the energetic and visible brushwork, the Impressionists relied on color to create their shimmering compositions. Note how touches of orange vibrate against touches of blue to denote the deep, shadowy portals of Rouen Cathedral in Normandy, France. By using strong color complements, Monet suggests the warmth of the afternoon sun as it hits the west side of the cathedral. The shadows appear as though alive, the portals acting as great pockets of vibrating heat and shifting air.

Impressionists like Monet benefited from the optical discoveries made by scientists of their day. One such discovery was the phenomenon of **optical mixing**, in which primary colors placed side-by-side appear to blend into a secondary color. For example, a small touch of blue, placed next to a small touch of red, may appear as separate primaries when viewed up close—but viewed from a distance, the two colors will appear as violet. The mixing has occurred not on the canvas, but in the eye of the viewer, which signals to the mind a more vivid *idea* of violet than the painter could ever mix.

THE PSYCHOLOGICAL USE OF COLOR

Color Temperature and Psychological Effects

The viewer's response to **color temperature** is, to some extent, universal. The sun is life-sustaining, while fire keeps us warm on a cold night; therefore, anything yellow, orange, or red tends to signal alertness, heat, and attraction. These are **warm colors.** Conversely, blue, green, and violet are **cool colors,** suggesting the lower temperatures of the ocean, ice, and nighttime.

As you see in this Impressionist-styled painting, color is an exceptional tool to convey thoughts and moods. Aside from showing the play of light on a foggy Bay Area morning, Giuseppe Cadenasso uses color to suggest a calm, reflective moment, enjoyed by the small figure in the middle distance. The soft, low-saturation purply-pinks, placed next to the soothing yellow-green offer the viewer a quiet visual respite. When warm, low-saturation colors dominate a composition, as in *Seminary Avenue, Mills College,* the result is a hushed mood—devoid of frenzy, exuberance, or shock.

Cool colors tend to recede from the viewer's eye, making a space feel more open and distant. Cool colors give us room to breathe—but too much cool, in too open a space, can seem icily unfriendly. Warmer colors seem to come towards us, lending a space more intimacy—but too much warm, in too tight a space, can make us feel suffocated and pressured. Look how the mood of Cadenasso's painting shifts when the hues are changed. The colors have retained their relative levels of intensity—but we have turned to the other side of the wheel. Now the landscape seems colder, less hospitable. The solitary figure seems lonelier now, and farther away.

Color Temperature

warm

cool

Bottom left: Giuseppe Cadenasso (1854–1918), *Seminary Avenue,* Mills College, no date (n.d.). Oil on canvas. Crocker Art Museum, Sacramento. Photo by the author.

Bottom right: Cadenasso's *Seminary Avenue,* digitally altered from warm to cool palette.

A Tale of Two Temperatures: Delacroix and Ingres

Eugène Delacroix and Jean August Ingres* were contemporaries, working in France in the early 1800s. Both were influenced by **Romanticism**, a movement in art, literature, and music that favored exotic, sensual, and dramatically-epic overtones. Ingres, however, was more of a classicist than Delacroix; he found the hot colors and violent themes of Delacroix's typically-Romanticist work to be salacious and crude.

We will return to discuss Romanticism and examine the work of these two rivals in greater depth in the next chapter. For now, take a moment to analyze the colors that dominate Delacroix's *Death of Sardanapalus* and Ingres's portrait of a princess. With an abundance of vivid orange, ruby red, and golden yellow, the temperature of the former could not be warmer—even the blues are greenish, and the greens have a warmer olive tone. The heaving mass of hot, fleshy colors draws the viewer into the drama of the scene. In contrast, Ingres's dainty lady couldn't be cooler. Her alabaster skin lacks the warm, rosy color of Delacroix's ill-fated ladies. The yellow-gold chair and small golden accents throughout the composition are no match for the dark blue behind her, or her voluminous, electric-blue gown. Although the satiny surfaces beckon, the princess herself stands as aloof, cool and untouchable as a porcelain figurine in a glass case.

*The name Ingres is difficult to pronounce for non-French-speakers. It sounds like "Ang."

Eugène Delacroix, *The Death of Sardanapalus*, 1827. Oil on canvas, nearly 13 feet by 16 feet, 3 inches. The Louvre, Paris.

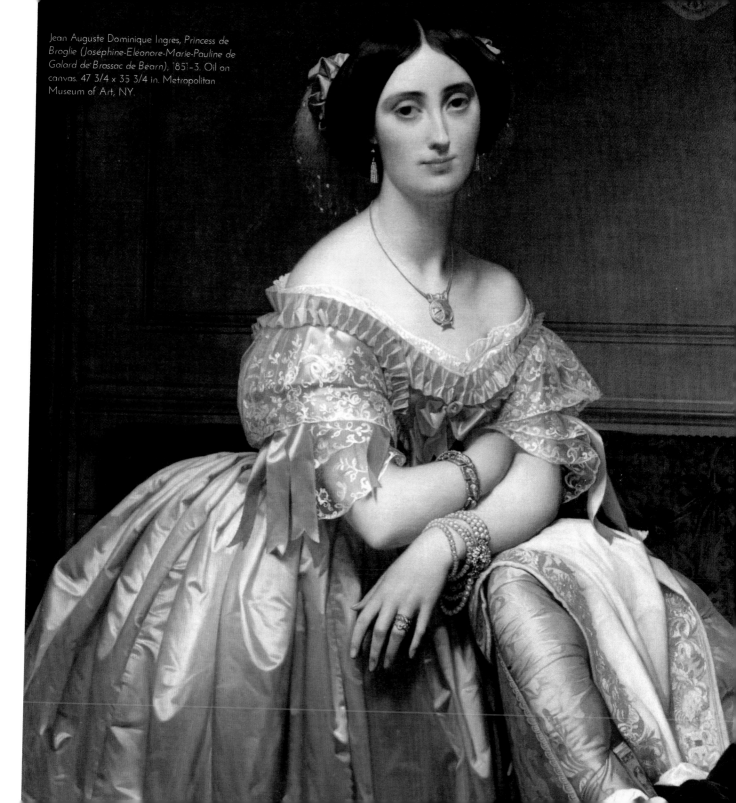

Jean Auguste Dominique Ingres, *Princess de Broglie (Joséphine-Eléonore-Marie-Pauline de Galard de Brassac de Béarn)*, 1851–3. Oil on canvas. 47 3/4 x 35 3/4 in. Metropolitan Museum of Art, NY.

The Symbolists and the Symbolic Use of Color

As a member of the Symbolist art movement, Edvard Munch (famed painter of *The Scream*) used color to speak to the (often troubled) psychological state of his subjects. Symbolist color is allegorical, rather than literal—it tells a story about how people see the world, rather than how the world objectively appears. Grass is not necessarily green, and the sky is not necessarily blue.

In *Vision of the Sermon*, French Symbolist Paul Gauguin relates a profound religious experience through the symbolic use of red. Gauguin was disenchanted with modern Parisian life; he thought that Europe, as a whole, had lost its bearings. We have seen this disaffection from many modern European artists of Gauguin's time—it is that same yearning for a simpler life, closer to nature, which inspired the Art Nouveau and Arts and Crafts movements. Gauguin's most famous works depict Tahitians as modern-day Adams and Eves—living innocently in a tropical Eden. The work here is a little closer to home for Gauguin, as it celebrates the rustic lifestyle of the rural inhabitants of Brittany (Bretagne) in northern France. To Gauguin, these folks appear uncorrupted by the spoils of civilization. Living close to the land, their way of life seems pure and straightforward, without the cynicism, artifice or superficiality associated with the modern world.

Gauguin also believed that these Bretons, like the Tahitians, were more spiritually alive than their urbanized contemporaries. Their religious devotion appeared to be deeper and more heartfelt; they seemed to accept the supernatural as real, present, and active in their daily lives. In Gauguin's imagining, these Bretons are so connected to their faith that—having just heard a sermon about the Old Testament story of Jacob, wresting an angel—the congregation sees the pair in a vision, wrestling in front of them. The heads of the faithful are bowed as they witness the miraculous image, which Gauguin sets off with a vivid red background to signal to his viewers that we (like the Bretons) are looking into a supernatural realm.

As an outsider to both Breton and Tahitian cultures, Gauguin gives us more insight into his own worldview than theirs. Although the Tahitian title of *Day of the God (Mahana no Atua)* suggests that the artist knew the local language, he never did learn it—although he identified with the Tahitian people and ultimately took up permanent residence (and a 13-year-old "bride") in Polynesia. In this work, the colors are clearly symbolic rather than natural. The pink sand and multi-colored pool suggest a primordial sea, the original source of life. A central female figure arises from this pool, while the two reclining figures that flank her appear

Paul Gauguin, *Vision of the Sermon (Jacob Wrestling the Angel)*, 1888. Oil on Canvas, 28.4 in. x 35.8 in. National Gallery of Scotland, Edinburgh.

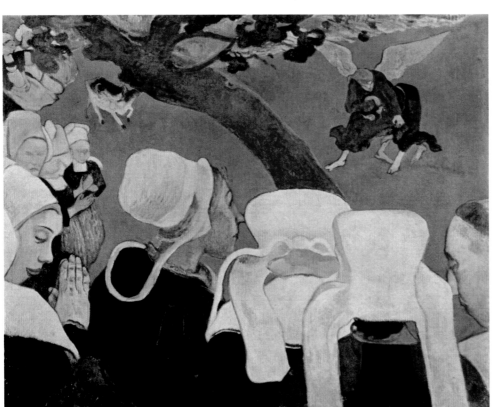

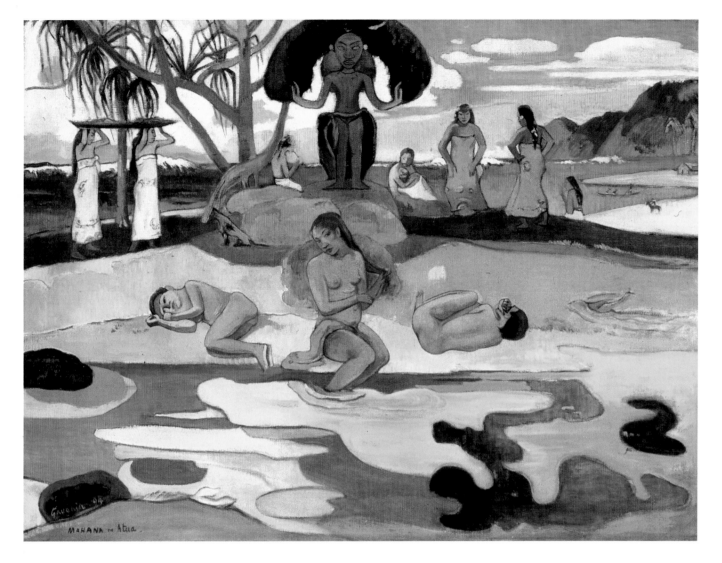

Paul Gauguin, *Day of the God (Mahana no Atua)*, 1894. Oil on canvas, 26 7/8 by 36 in. The Art Institute of Chicago.

fetus-like, yet to be born. As we move up the painting, the color palette begins to appear more naturalistic. With this shift, and the addition of simply-clothed figures in the middle ground, Gauguin suggests that Tahitian society is still in its infancy, closely tied to the prehistoric, "pre-civilized" world.

Gauguin's use of high-saturation, symbolic color is particularly appealing to today's viewers; however, the turn-of-the-century French art world vilified Gauguin's colors as crude and illogical. He died in the Marquesas Islands in 1903 at the age of 54, penniless and ostracized from the antiquated, decadent, and "over-civilized" homeland he so loathed.

The Fauves and High Intensity Color

The French Art Academy members might have successfully dismissed the "crazy" art of Gauguin, but they had not escaped the growing avant-garde tide of high-saturation color. Not long after Gauguin's death, the art establishment was plagued by an entire movement dedicated to bold color and even bolder brushwork. They were decried by one critic as *fauves*, or "wild beasts." The culprits embraced the insult, and announced themselves as **The Fauves.**

One of the leaders of the Fauve movement was Andre Derain. In *Landscape of the Midi*, Derain's color palette is both daring and joyful; there are no neutral colors here. The brushstrokes are bold and child-like, and areas of the canvas are left exposed between the marks. In an era when most painters were still dutifully building up translucent layers to create a solid, blended, brushstroke-free surface, Derain's exuberant, semi-naked canvases broke just about every rule in the book. Altogether, Derain's vivid color palette and pronounced brushwork impart a feeling of freshness and spontaneity. Like Gauguin, the Fauves presented their work as an antidote to the tired, antique mindset of the Academy. Invoking the liberation of childhood, the Fauves' use of high-intensity color invites the viewer to feel uninhibited, innocent, and childlike again.

Along with their saturated colors, the Fauves also used color complements and warm/cool contrast to great effect. Derain's *The Bathers* proves that *any* cool color can give the impression of a shadow, just as any warm color can suggest a highlight. Although at first glance the colors may seem like a riot of Lifesavers candies, the strategic placement of warm and cool colors effectively defines the planes of the women's bodies as light shines from above-right. What at first appears simplistic and discordant is, to the contrary, quite sophisticated and harmonious.

Above: Andre Derain, *Landscape of the Midi,* 1906, Oil on canvas on board, San Francisco Museum of Modern Art. Photo by the author.

Below left: Andre Derain, *The Bathers,* 1907. Oil on canvas, 52" x 78". Museum of Modern Art, NY.

Below Right: Take a moment to study this detail of Derain's *The Bathers.* As you look at each cool and warm spot on the woman's face and neck, touch with the back of your fingers the corresponding areas of your own face and neck. Consider: what feels cool, what is warm? How could standing in strong sunlight affect the temperatures you feel?

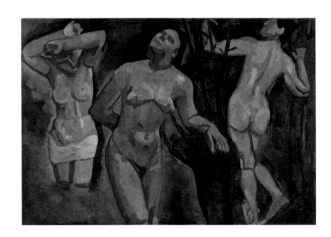

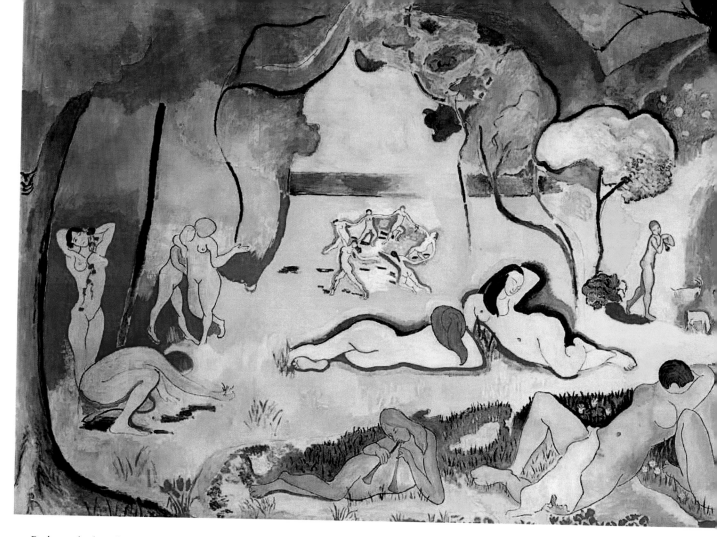

Henri Matisse, *The Joy of Life*, 1905–6. Oil on canvas, 69 1/8 x 94 7/8. Barnes Foundation, Merion, Pennsylvania.

Perhaps the best-known Fauve is Henri Matisse, whose work we examined at the conclusion of Chapter 2. Like the paintings we have seen by Derain, Matisse's work is filled with exuberant colors and brushstrokes. His painting *The Joy of Life* is aptly titled; here is an idyllic garden filled with dancing and music, flower-picking and hugging, lounging and snogging. It is a world of innocence rather than debauchery, conveyed through an interplay of tints and high-saturation color. At every turn, complementary colors pop next to each other—pink against minty green, lavender next to lemon yellow. The central figures are outlined in high-intensity ribbons of red and green, which give their silhouettes energy and dimension.

German Expressionist Emil Nolde

Although Matisse shared with the German Expressionists an interest in bold, childlike colors, the French Fauve was not a fan of German Expressionism. He found their work to be too dark and negative in tone, rather than cheery, refreshing, and life-affirming.

The work of German painter Emil Nolde offers us an interesting comparison with the Fauve work we have just looked at. Like the Symbolists, Nolde used unnatural, high-saturation colors to convey spiritual intensity. In Nolde's hands, the effect is uncanny and otherworldly. In the Old Testament story shown here, *Joseph Shows His Coat*, Joseph's brothers appear menacing as they peer down at their little brother, their livid green and yellow faces highlighting conniving expressions. The coat which sparks their jealousy vibrates in diamonds of fuchsia and blue. The threat in the air is electric and palpable.

When Nolde painted this work, he could not have foreseen the fraught times that were to unfold with the rise of the Nazi party in Germany. Nolde considered his Expressionist style to be essentially German, directly descended from the emotionally-charged religious art of the Middle Ages and Northern Renaissance. As we have seen in Chapter 8, however, Hitler had claimed Classical art as genuinely German; he saw in abstract art something backwards and impure. When the Nazis seized control of Germany, Hitler ordered a mocking, hodge-podge exhibition of all manner of abstract art—from Expressionist to Dada and De Stijl (which we will

Above: Emil Nolde, Joseph Shows His Coat, 1910. Österreichische Galerie Belevedere, Vienna.
Below: Photo of Emile Nolde.

look at next). Hitler called the show "*Entartete Kunst*"—"Degenerate Art." Nolde's paintings appeared in the show more than any other artist's work. A born-and-bred German, Nolde was held up for particular ridicule, having created art that appeared, to a classicist like Hitler, as a betrayal and insult to the German people.

There is a profound irony in Emil Nolde's story, for the artist so hounded by the Nazis for his "primitive" use of color was himself a longtime Nazi Party member. Politically isolated from the other German Expressionists, and rejected by the "Arian elite" with whom he so desperately identified, Nolde was universally shunned. He lived long enough to see the end of the Reich, however—and enjoyed post-War popularity until his death in 1956. Enthralled by Nolde's use of color to convey psychological insight, Germany had apparently forgiven their "prodigal son."

De Stijl and the Rational Use of Color

At the same time that Emil Nolde was making Expressionist paintings in Germany, a group of Dutch artists was making art with a wholly different color vocabulary, and a wholly different psychological purpose. Like Kasemir Malevich, their Suprematist contemporary in Russia,* members of the Dutch avant-garde embraced rational, geometric forms to stimulate the analytical (rather than emotional) capacity of the mind. They wanted to help modern society rise above its low, destructive instincts. In Holland, this movement was called *De Stijl*—simply, "the style."

The leader of *De Stijl* was painter Piet Mondrian. He approached his work like a scientist, insisting on a rigorously-controlled color palette and gridded arrangement of lines. Indeed, Mondrian was so strict in his "purified," rationalistic vocabulary that he ultimately rejected the use of diagonal lines in his paintings.

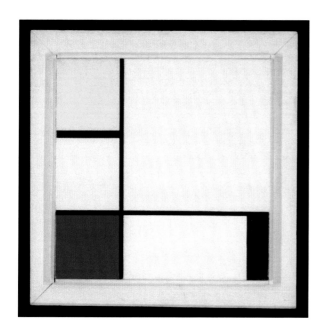

Mondrian relied on primary colors, using them in both their pure, high-saturation form, and in low-saturation tints (such as the baby blue in the composition here). To Mondrian, primaries spoke of purity—color in its most essential, unmixed form. As we have seen, the dominance of high-saturation color in a composition will produce a strong, excited psychological effect—which would undermine Mondrian's cerebral, rationalizing efforts. To maximize the clear, clean message of primary color, Mondrian used the primaries selectively—in limited quantities, balanced with areas of solid black and white.

De Stijl artists were not the first to embrace a rational color palette. Classicizing artists have long favored a combination of neutral colors (warm or cool grey, beige, and brown); non-colors black and white; and the strategic placement of crystal-clear primaries red, blue, and yellow. Nicolas Poussin's *Holy Family on the Steps* exemplifies this rational, harmonious palette. The brief appearance of secondary colors—green in the foliage and orange in the fruits—do not disturb the primary hues which anchor the composition. Cool blue is the most dominant of the three—its temperature ensuring a calm overall effect. Yellow directs the eye toward the center, where a dash of strong red holds our attention. Pink (the low-saturation tint of red) softens the composition without risk of over-warming it. Altogether, the religious subject, Classical imagery, and the analytical color palette speak of order, calm, purity, and perfection. We will return to this painting in the next chapter.

Piet Mondrian, *Composition with Yellow, Blue, Black and Light Blue*, 1929. Oil on canvas. Yale University Art Gallery.
Below: Nicholas Poussin, *The Holy Family on the Steps*, 1648. Oil on canvas, 28½ x 44 in. Cleveland Museum of Art.

*We analyzed Malevich's use of geometric abstraction in Chapter 3, and returned to study his use of line in Chapter 5.

PAINTING MEDIA

Pigments and Color

In this chapter we have focused exclusively on paintings, to simplify the complex world of color theory. Let us now examine the physical properties of paint—the medium that provides such an ideal vehicle for color.

As in drawing media, **pigment** is what gives painting media their color. Pigments are color materials ground into a fine powder, which (for most types of paint) is then mixed into a fluid solution. Many pigments originate from the ground—made from minerals and elements in rocks and dirt. Some pigments are made from plants and even ground-up bugs. Today, many colors that used to be made from semi-precious stones, such as lapis lazuli for ultramarine blue,

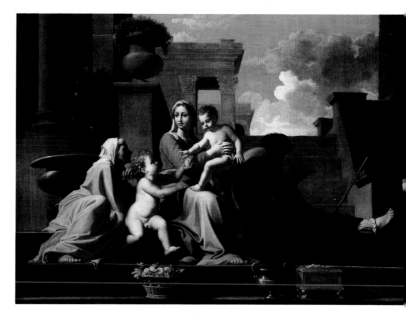

are made in the laboratory, saving the artist considerable expense. Heavier, denser pigments, such as cadmium and ochre, produce more opaque paint; less dense pigments like quinacridone yield paint with more transparency.

Ground up, pigments are powerful—they are pure, concentrated color. They are also quite dangerous to inhale; indeed, any fine particles (even particles of innocuous materials) can damage the lungs. Painters who routinely work with powdered pigments (for example, those who prefer to make their own paints, rather than purchase them from the store) do so with caution. Impressionists were the first artists to have the option of store-bought paint tubes; before the late 1800s, all artists had to make their own paint from scratch. Of course, more established and successful artists had workshops filled with underlings to do the tedious grinding and mixing for them.

Fresco

Above: Pigments used for fresco painting. Clockwise from top: raw sienna, minium, yellow ochre, lapis, and green earth. Studio of Hector Ramsay, Florence, Italy.
Below left: A piece of lapis lazuli.
Below right: *The Abduction of Persephone* (detail), Tomb 1, Vergina, Macedonia, c. 320-240 BCE. Fresco.

Fresco is one of the oldest painting techniques. The fresco in Vergina, Macedonia pictured in detail below is Ancient Greek, painted on a wall in the tomb of an unknown woman. In this piece, the god Hades has abducted the young goddess Persephone, and is taking her into the underworld to be his reluctant bride. The painter expertly sketched the hair of the unhappy Persephone, flinging this way and that, as Hades drives the chariot with speed and purpose. Fresco allows for loose, expressive brushstrokes, as well as tightly-controlled details. We will look again at this dramatic painting in the next chapter. For now, note how vivid the color appears, even after 2,300 years.

In true fresco or *buon fresco*, pigment mixed with a bit of water is applied directly onto a thin coat of lime plaster on a wall. As this painted *intonaco* (skim coat) dries, the pigments chemically bind to the plaster, and the fresco literally becomes part of the wall. This process guarantees that the color will not flake or rub off the wall over time—it is as permanent as the plaster itself (which stands up well to the elements in most warm climates, even outdoors).

LAPIS LAZULI

Although frescoes will not peel or flake off, they are not impervious to damage. A fresco's fate is forever tied to the wall onto which it is painted. Over the centuries, frescoes have been buried, burned, covered up, broken down, and blown up. Tomb paintings are usually the best-preserved among ancient frescoes, since they are protected underground, and their owners lead particularly quiet lives. In contrast, any ancient site exposed to the vagaries of history—such as the city house of Emperor Augustus's wife, Livia—will appear a little worse for wear.

Note how the artist working in Livia's house used painted frames, columns, and moldings throughout the room. These designs enliven and open up a small, windowless space. As in most ancient Roman houses, Livia's room opens to a central courtyard. Windows opening to the street were generally avoided, to

keep out the dirt and smell of the city. Thus, the artist creates painted "windows" to enhance Livia's view.

Keep in mind that, unlike a painting on canvas, frescoes cannot be easily moved when danger threatens. Some frescoes are more at risk than others. Leonardo Da Vinci's famous *Last Supper*, located in a monastery in Milan, was nearly destroyed in World War II. Medieval frescoes in Italy faced a dual threat; many were casualties of Allied bombing, but many more had already been painted over by Renaissance artists like Leonardo, eager to "freshen up the place." Ironically, some Renaissance artists' frescoes were covered up in turn. Every now and then, there is another story in the news about a Leonardo fresco that may lie hidden behind a wall. Today, layers of fresco can be removed from a wall and transferred to another surface—but only with great difficulty and expense.

The Early Renaissance artist nicknamed Masaccio ("dirty Tom") was a master of fresco painting; his "dirty" moniker hints at how messy a business fresco painting can be. Masaccio's extensive work in the church of Santa Maria del Carmine, Florence, is an excellent example of a Renaissance fresco painted for a powerful patron. The Brancacci chapel, built for a prominent Florentine family, is painted with biblical scenes personally selected by Felice Brancacci himself.

Through the power of fresco, Masaccio was able to create for Brancacci a giant, illustrated gospel book on the chapel walls. The seemingly seamless narrative does not tell the whole story, however. Frescoes are necessarily painted in patches. An artist must determine how much can be painted in a single day, before the plaster completely dries. (Skilled fresco artists know better than to bite off more than they can chew!) The next day, the artist joins a patch of wet plaster to yesterday's completed fresco section, and begins to paint the next area. Masaccio took over the Brancacci chapel assignment from a predecessor—then died at the age of 27, before he could finish the work himself. Another Renaissance painter, Filippino Lippi, later completed the missing sections. However, thanks to the artists' skill and the unique advantages of the fresco technique, the viewer sees none of the pieces of this elaborate fresco puzzle. Only careful inspection reveals the seams in this expansive, unified space.

Above: House of Livia, interior and detail of fresco painting, Rome, Italy. 1st century C.E. Photos by the author.
Below: Masaccio, Brancacci Chapel, Santa Maria Del Carmine, Florence, Italy. 1424–1428. Fresco. Photo by the author.

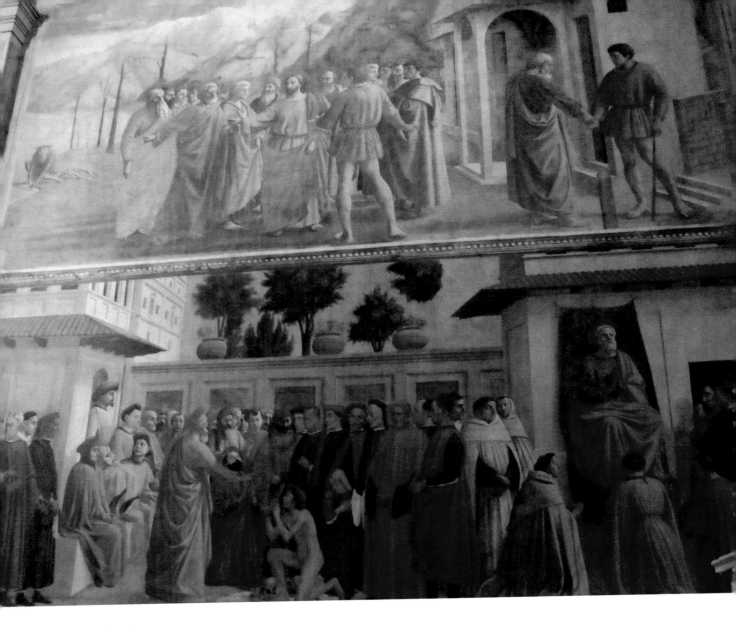

Masaccio, Brancacci Chapel,
detail, Santa Maria Del
Carmine, Florence, Italy.
1424–1428. Fresco. Photo by
the author.

Spotlight: Fresco and Diego Rivera

Mexican artist Diego Rivera learned the Renaissance techniques of fresco, and studied its use in Catholic churches, from Italy and Spain to Mexico City. Like his contemporary Alfredo Ramos Martínez, Rivera supported the Leftist political principles behind the Mexican Revolution; as both an atheist and advocate for social equality and workers' rights, Rivera sought to create secular murals to match the power and epic scale of the religious frescoes he knew so well. He often placed the figure of a worker, wearing a blue-collar uniform, at the heart of his large compositions. One of several frescoes Rivera made in the United States, and one of three painted in San Francisco, the work here reflects his social views. Everyone appears industrious and capable, working hard to create the city of San Francisco we know today (note the workmen diligently erecting the Golden Gate Bridge in the upper right corner). Since this fresco was created for the San Francisco Art Institute (then called the California School of Fine Arts), Rivera chose fresco as both the medium and the subject—a fresco about the making of a fresco. Seated on a high plank of scaffolding, Rivera presents the viewer with his backside as he examines his work. An assistant kneels next to him, applying a fresh layer of plaster to the fresco they are working on. Altogether, the painting presents Rivera's views on the value of labor: architects and laborers, artists and craftsmen, men and women work side-by-side, in a utopian vision of San Francisco's present and future.

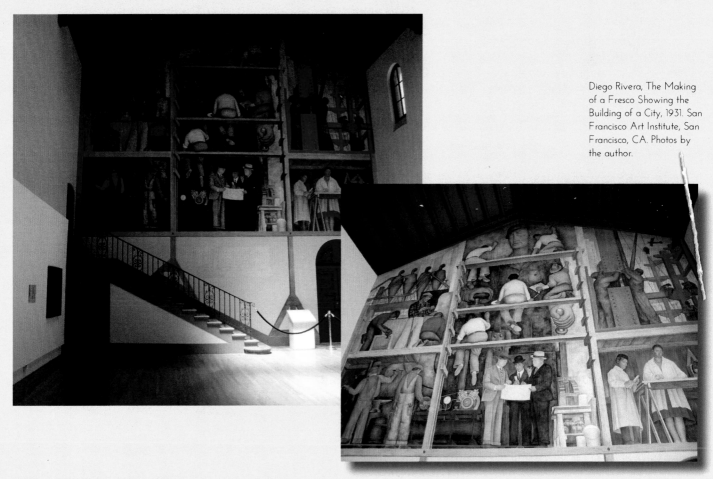

Diego Rivera, The Making of a Fresco Showing the Building of a City, 1931. San Francisco Art Institute, San Francisco, CA. Photos by the author.

*Tempura is a fried Japanese dish. Even though made with egg yolk, tempera is not a food!

**Tempera paint could also be applied to dry plaster; called *fresco secco*, this approach yields less durable painting than *buon fresco*.

Left: Mummy Portrait of a Young Man, Romano-Egyptian, c. 150-250 C.E. Tempera on linen, 22 13/16 x 10 7/16 in. Getty Villa, Malibu. Photo by the author.
Right: Mummy Portrait of a Woman, Romano-Egyptian, c. 75-100 C.E. Encaustic on wood panel, 15 3/4 x 7 7/8 in. Getty Villa, Malibu. Photo by the author.

Tempera

Like fresco, **tempera** is also an ancient painting medium.* The original recipe calls for pigment mixed with egg yolk (acting as a binder) and water for thinning. Tempera would typically be painted on wood panel,** over a layer of gesso (a chalky, water-based primer), to ensure adhesion and even application. In both its modern synthetic form and traditional, egg-based form, tempera is readily layered, producing both opaque and translucent effects. When dry, it has a satiny finish.

This ancient tempera portrait of a young man was painted onto the linen wrappings of an Egyptian mummy. When the ancient Romans seized power in Egypt two thousand years ago, the Egyptian practice of mummifying the deceased was *already* over 2,000 years old. This painting shows a cross-cultural melding of Roman and Egyptian traditions. In Rome, you would place statues of deceased ancestors in a shrine to honor them. In Egypt, you would mummify dead relatives to ensure they had a body to reclaim in the afterlife. Roman-Egyptians added portrait-painting to their mummification practices, fitting painted images of the deceased in the mummy wrappings to show what they looked like in the prime of life—and to help them return to that health and vigor after death.

Encaustic

Tempera produces lovely, smooth effects, but it cannot mimic the soft, oily surface of human skin. In an effort to faithfully portray living flesh, Roman-Egyptian artists frequently used **encaustic,** which is the mixture of pigment with melted wax. Wax provides a more fittingly tactile analog for human skin (as shown by the dummies of Hollywood stars in wax museums). The challenge for the artist is to apply each brushstroke quickly, before the wax cools and hardens. Seen in detail, an encaustic painting reveals thousands of small, quick, waxy strokes. At a distance, the result appears glowing and alive.

Note that encaustic must be applied to a hard, inflexible support, to prevent the waxy layers from cracking apart. This portrait of an Egyptian lady, well-dressed for the afterlife, is painted in encaustic on a wooden panel. In contrast, the tempera portrait of the young man was painted directly on soft, pliable linen.

PAINTING MEDIA IN THE ITALIAN RENAISSANCE

Throughout the Renaissance, Italian artists strove to create naturalistic scenes that appear persuasively lifelike. We have seen how their use of space and light reflects values of order and rationalism. It should come as no surprise that Italian Renaissance painters leaned towards a rational color palette, with an abundance of cool blue and selective notes of red and yellow. High-saturation colors were reserved for the robes of important figures, to indicate their status (note that saturation was a matter of expense, as well, given the high cost of some pigments!). To render these colors with the utmost illusionism and idealism, Renaissance artists turned to a variety of painting media.

Fresco was used throughout the Italian Renaissance for large-scale mural projects, such as the walls of the Sistine Chapel (painted in the 1400s) and Michelangelo's famed ceiling (including the *Creation of Adam* scene) in the early 1500s. As discussed earlier, fresco has long been the top choice for durability in architectural settings. For smaller projects, tempera was generally used in the 1400s, until oil paint technology found its way to Italy from Northern Europe. After oil's introduction, Italian artists embraced the medium, painting on wood panel (as was the custom in the North). Venetian artists were the first to paint on stretched canvas in the early 1500s, and this practice ultimately became the standard throughout Europe. Even today, oil on canvas remains a popular painting medium.

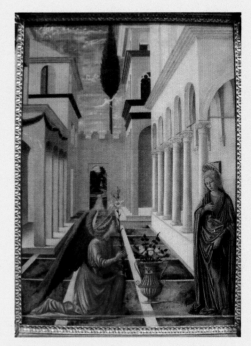

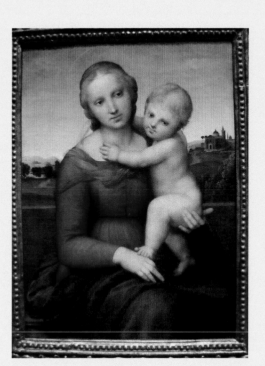

Fresco (above): Raphael (Raphaello Sanzio), *Parnassas and School of Athens*, two of four frescoes in the Stanza della Segnatura, Vatican, Rome. Fresco, 1510–11.
Tempera (below left): Fra Carnevale, *The Annunciation*, c. 1445/1450. Tempera on panel. National Gallery of Art, Washington, D.C. Photo by the author.
Oil (below right): Raphael, *The Small Cowper Madonna*, c. 1505. Oil on panel. National Gallery of Art, Washington, D.C. Photo by the author.

Water-based Paint on Paper

Water-based painting media, including modern tempera, watercolor, and gouache, are usually applied to a paper support, rather than panel or canvas. The watercolor sketches from Eugene Delacroix's notebook illustrate the traditional Western use of water-based painting to make notes and studies. Painted on-site in Morocco, Delacroix's sketches reflect the convenience of using water-based paint on paper for on-the-go work. There is no need for an expensive studio or large-staffed workshop to make watercolor or gouache paintings! However, the availability and accessibility of these media—combined with the susceptibility of paper to deterioration—were long perceived as "black marks" against them. Like printmaking and drawing, it took time for water-based paints on paper to be fully embraced by the mainstream art world as "legitimate," finished fine-art media.

Above: Eugène Delacroix, Study for *Women of Algiers*, watercolor, 1832. Below: Eugène Delacroix, *Tiger Attacking a Horse*, gouache, 1825-28, Louvre.

Delacroix's *Tiger Attacking a Horse* shows the flexibility of gouache, a water-based medium with denser pigments than watercolor, permitting more layered effects. The Romanticist artist was able to convey the dynamic motion of the horse under attack through rich, dark applications of gouache. Through one medium, we see the horse's powerful frame, its straining musculature, and its wildly-flying mane, rendered with loose, expressive brushwork.

Harlem Renaissance artist Jacob Lawrence, whom we first met in Chapter 3, used a combination of tempera, watercolor, and gouache for his potent visual essays on neglected segments of modern society. Lawrence worked as an art teacher in Harlem before eventually moving to Seattle to teach at the University of Washington. As a longtime advocate of education, Lawrence used water-based paints to express the importance of reading in *Dream Series, 5: The Library*.

Fifth in a series of works about growing up in Harlem, Lawrence here celebrates in tempera the importance of the Harlem Public Library to the community. Modern

tempera (commonly sold as "poster paint") produces a matte finish, more chalky in appearance than gouache or watercolor. Its flat, transparent look complements the dizzying pattern of negative and positive space in Lawrence's composition. Variations of blue and orange, and red and green, bounce against neutral tones of brown, black, and grey; each patch of color is textured with active brushstrokes, varying in opacity. The result is child-like, joyful, and energetic. Readily available to everyone, from schoolchildren to established artists, the tempera medium mirrors the accessibility of the books that fill the library shelves in Lawrence's work.

Contemporary artist Laylah Ali uses more symbolic imagery than Lawrence to address issues of ethnicity and power. Unlike Lawrence's expressive brushstrokes, Ali's application of gouache is smooth and brushstroke-free. There is a stark contrast between Ali's control of the painting medium—from careful color mixing to fastidious brushwork—and the bizarre and frazzled figures in Ali's work. The metaphorical power of Ali's paintings lies in the contrast between her analytical approach and the emotional content of the imagery. Ali explains, "So much of the work is about me trying to control it. Yet it still defies me." To see Ali's work and hear more about her painting philosophy, see the segment featuring Ali in the PBS series Art:21, at http://www.pbs.org/art21/artists/laylah-ali.

Oil

Although encaustic painting is still done today, the medium has been largely supplanted by **oil paint.** Oil has one advantage over encaustic (as well as fresco, and any water-based paint): an exceedingly slow drying time. Consisting of pigment in an oil-based binder, oil paint also boasts the same glossy glow as encaustic, with easier handling. Oil's great advantage can be a detriment to the impatient painter, however; depending on thickness, oil requires at least a day for a coat of paint to dry. Applying wet oil paint into a layer of still-wet oil paint is entirely possible, but the technique can yield muddy colors if the artist is not careful.

The invention of oil paint is credited to Northern Renaissance artists, particularly those working in the region of Flanders (modern-day northern Belgium) in the early 1400s. Their techniques would define traditional oil-painting practice for centuries. First, the artist would choose the support (wood panel, in the 1400s, and later stretched canvas). The surface would be primed, and the under-painting applied (a rough sketch of the composition, usually transferred from a drawn cartoon). An opaque layer of paint, blocking in the basic colors, would be applied next. After that, the artist would add increasingly "lean" layers of oil (with less pigment and more linseed

Left: Jacob Lawrence giving a demonstration at Lincoln School, NYC.
Right: Jacob Lawrence, Dream Series, 5: The Library, 1967. Tempera on board, 24 x 35 7/8 in. Pennsylvania Academy of the Fine Arts.

oil or other thinner), fleshing out shadows and details. Each layer or **glaze** would be allowed to dry to the touch, before the next was applied. The **glazing** process could be long and labor-intensive, especially for larger-scale projects like altarpieces. Well-established artists might leave all the tedious and less-essential painting to apprentices and journeymen, focusing their energies on painting the more vital details, such as facial features.

The results of this traditional oil-painting technique are still stunning, centuries later. Light penetrates and reflects back through the many translucent layers of glazing, so that the colors that meet the viewer's eye have a deep, glowing resonance. Varnish was typically applied over a finished oil painting, to bring out the glowing color even further. Unfortunately, oil-based varnishes tend to yellow over time, creating a dingy film which can obscure the oil paint beneath. Layers of varnish, built over centuries, can plunge a glowing painting into darkness.

The power of oil paint is reflected in the unsurpassed work of Dutch Baroque artist Rembrandt van Rijn, whose work we first encountered in Chapter 6. Rembrandt's oil paint appears luminescent, evoking the personality and presence of his subjects in an uncanny way. This soldier-citizen peers out at us from 400 years ago, his transfixing gaze undiminished by time. Rembrandt's skill as a colorist is also on display here; all the colors in this painting are mixed from Rembrandt's famously-limited palette of red, yellow, black and white.

Above: Rembrandt van Rijn, *Joris de Caulerii*, 1632. Oil on canvas (later transferred to panel for conservation), 40 1/2 x 33 3/16 in. California Palace of the Legion of Honor, San Francisco. Photo by the author. Below: Detail.

The Bay Area Figurative Movement

Painting has changed considerably since the Renaissance and Baroque artists' careful layering of oil glazes. Abstract Expressionists like Jackson Pollock used commercial oil paint (sold as alkyd oil in paint stores) and newly-invented, water-based acrylic paints (called latex paint commercially). Rather than following a prescribed process, the Abex painters worked in a stream of consciousness, adding and removing paint as the composition demanded. Pollock would use stir sticks to drizzle and fling the paint, or would let the paint drip directly from the can. This new approach to painting had an immediate and ultimately indelible impact on the art world; since Pollock, many painters have embraced the challenge of "painting without a net," in expressionistic dashes and drips.

While Pollock's non-objective style dominated the 1950s art scene in New York City, artists in the San Francisco Bay Area insisted on a human presence in their expressionistic paintings. These Bay Area artists came to national attention when they were featured in a 1959 exhibition at the New York Museum of Modern Art entitled "New Images of Man." New York audiences

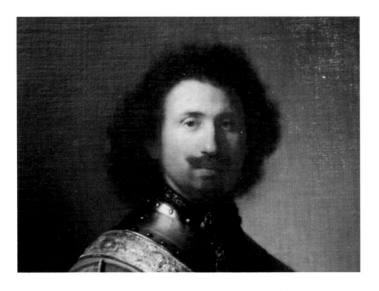

were surprised by the emphatic figures painted in bright, bold strokes. The approach of sculptors like Manuel Neri and painters Elmer Bischoff, Joan Brown, David Park, Wayne Theibaud and others became the cornerstones of the **Bay Area Figurative Movement.** The paintings feature broad, impasto effects. Heavy layers of oil paint, applied with large brushes and scraped with palette knives and trowels, yield highly-textured areas of color. Figures such as Joan Brown's vividly-painted nude possess a strong, visceral presence. Where Rembrandt's faces glow from deep within his paintings, *Girl Sitting* juts out at the viewer, the paint taking on a life and character of its own.

I loved what happened ... the physical exuberance of just whipping through it with a big, giant brush.

—Joan Brown*

Left: Joan Brown, Girl
Sitting, 1962. Oil on Canvas.
Oakland Museum of
California. Photo by the
author.
Right: Detail.

*Oakland Museum of
California.

analogous colors	Colors in the same neighborhood on the color wheel
Bay Area Figurative Movement	San Francisco Bay Area-based art movement of the 1960s featuring abstract, expressive figures
color harmony	A harmonizing, or unifying, grouping of colors
color wheel	Hues organized in a comprehensive chart to show their relationship
complementary colors	Pair of colors opposite each other on the color wheel, so named because they complement each other (they look especially vivid and impactful when placed next to each other); for example, blue and orange. Mixed together in equal parts, complementary colors cancel each other out, creating a muddy, low-saturation color.
De Stijl	Rationalist art movement of early 1900s Holland featuring geometric shapes and primary colors
encaustic	Painting medium in which pigment is mixed in melted wax
Expressionist, Expressionism	Art movement of the early 1900s featuring abstraction, intense color and rough brushstrokes to evoke inner psychological states
Fauve	Art movement of the early 1900s featuring abstraction, intense color and rough brushstrokes, suggesting a more child-like, innocent, pre-industrial approach to life
fresco	Painting medium in which water-thinned pigment is applied to wet plaster (usually on a wall or ceiling)
glaze, glazing	Traditional application of oil paint in successive, translucent layers
gouache	Water-based painting medium (pronounced *gwash*), more opaque than watercolor
high intensity, high saturation	Vivid, pure hue, without black, white, or a muddying color added
hue	Name of a color on a color wheel
impasto	Applying paint in heavy, textured, visibly tactile brushstrokes
intensity	Level of color purity or vividness; saturation
low intensity, low saturation	Pale or faded hue, with black, white, or a muddying color added
oil paint	Oil-based painting medium dating to the 1400s
optical mixing	Primary colors placed side-by-side appear to blend into a secondary color when viewed from a distance
palette	A selection of colors used by an artist in a work of art
primary color	One of the three colors from which all others colors can be mixed: red, yellow, and blue (not to be confused with additive primary colors, in which red, blue and green *light* are the primaries)
Romanticism, Romanticist	Art movement of the early 1800s often featuring exotic and violent subjects and dramatic compositions, exploring the dark side of human nature.
saturation	Level of color purity or vividness; intensity
secondary color	One of the three colors mixed from an equal combination of two primary colors: green (from yellow and blue); orange (from red and yellow); and violet (from blue and red)

shade	Hue combined with black to create a lower-saturation color; for example, midnight blue (blue mixed with black)
Symbolism, Symbolist	Art movement of the late 1800s featuring symbolic color and images to address modern anxieties and concerns
simultaneous contrast	Contrasting effect that occurs when complementary colors are placed side-by-side, making both colors look more vivid
tempera	Painting medium in which pigment is mixed with an egg-yolk-based binder
tertiary	Colors positioned between primary and secondary colors on the color wheel. Tertiary colors are made from a primary and secondary color, or from two primary colors unevenly mixed; for example, blue-green (blue mixed with green, or blue mixed with a lesser quantity of yellow)
tint	Hue combined with white to create a lower-saturation color; for example, pink (red mixed with white)
watercolor	Water-based painting medium (in pan and fluid form)

11

PUTTING IT ALL
TOGETHER

11: PUTTING IT ALL TOGETHER

ANALYTICAL ART VS. EXPRESSIVE ART

PATRONAGE AND THE ARTIST'S CHOICES

What is the job of the artist—is it to create art that inspires and invigorates?—soothes and delights?—or challenges and disturbs the viewer? As we have seen throughout this text, the answer depends on multiple factors, including the artist's personal values, and society's influence on those values; the amount of personal freedom the artist enjoys; and the extent to which society in general, and a patron in particular, dictates the parameters of the work. In early 1800s Spain, Francisco Goya made very different artwork, depending on his intended viewer. For aristocratic patrons, including the king and his family, Goya created idealized, dainty paintings celebrating luxury and leisure, such as *The Marquesa de Pontejos*; later, for himself, he created searing, darkly-veristic indictments of human folly and hypocrisy. *Pilgrimage to San Isidro* was originally painted on a wall in Goya's home, and shows religious pilgrims pretending to holy. Two hundred years later, Spanish-born Pablo Picasso created his epic *Guernica*, decrying the violent rule of dictator Francisco Franco. However, he was working safely in France, and was already famous for his radically-styled Cubist works; unlike Goya, Picasso did not need to appease a power-wielding patron in order to survive.

Expressive art often erupts in small pockets of resistance against powerful, authoritarian forces—and thrives in societies that emphasize personal freedom, philosophical exploration, and individualism. Favored by "underdogs," expressive artwork has rarely been adopted by powerful

Above: Francisco Goya, *The Marquesa de Pontejos*, c. 1786. National Gallery of Art, Washington. Photo by the author.
Below: Francisco Goya, *Pilgrimage to San Isidro*, 1821-23. Oil on plaster (transferred to canvas), 54.3 x 171.7 in. Prado Museum.

institutions to motivate the public; the visual tools of expressionism are too volatile, and aroused passions can be hard for those in power to direct and control.

As we examined in Chapter 8, the more analytical vocabulary of Classicism is generally used by those in power to motivate—and sometimes mollify—the populace. Analytical art is not without emotion; however, the feelings raised by expressive art differ significantly from the feelings inspired by analytical art—like the difference between fitting the last piece of a thousand-piece puzzle into place, and watching that same completed puzzle go flying through the air in a thousand directions. Expressive art can be likened to a hand fervently reaching toward some uncertain goal; analytical art, to a hand firmly clenched, the target acquired.

In Chapter 1, we found how Buddhist beliefs can impact an artist's rendering of the landscape. In traditional Chinese and Japanese painting, Chan/Zen Buddhist philosophy is often reflected in loose, expressive brushwork and the dynamic use of space. Both works here represent a deliberate effort by the artists to challenge the more elaborate, decorative tastes of the ruling class. Early in his career, Hasegawa Tohaku created sumptuous, detailed paintings to decorate the palaces of Japanese warlords; his later work, such as *Pine Forest*, presents a radical, expressive shift. Here we find a strong combination of visual devices that add unpredictability and drama to a composition: strong light-dark contrast; asymmetrical balance; an emphasis on rough, organic line; and a floating, uncertain space. Altogether, these elements greet the viewer with the unexpected, driving the viewer to question where she or he is going, and what might come next.

Similarly, Shih Tao subscribed to the Chinese *Literati* movement, which opposed the palace-friendly art of the Qing Dynasty. The *Literati* were monks, artists, and scholars who used the brush as an extension of their Chan beliefs. Painting was to be used to unify the forces of spirituality, humanity, and nature—not to serve the Emperor's pleasure. The spontaneous, expressive brushmarks in Shih Tao's *10,000 Ugly Ink Dots* speaks of spiritual intensity rather than human authority. The tongue-in-cheek title suggests the ironic wit of the Chinese monk whom his contemporaries dubbed "Bitter Gourd." As Shih T'ao suggests, the result is not traditionally beautiful; however, the effortless confidence of the Chinese monk's mark-making is nothing short of breathtaking. As with all great expressive painting, appearances are deceiving; the truly appreciative viewer knows the effort, experience, and intensity of focus required to make a work like *10,000 Ugly Ink Dots* looks so easy.

Hasegawa Tohaku, *Pine Forest*, late 1500s. Ink on paper screens, 5' tall. Tokyo National Museum.
Below: Shih T'ao (Monk Bitter Gourd, 1642-1707), *Ten Thousand Ugly Ink Dots*, Qing Dynasty. Handscroll, ink on paper. Soochow Museum.

Spotlight: Women and Patronage

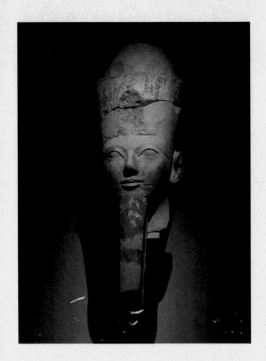

The history of art is largely the history of those in power—the men (and the few women) with the authority and means to commission artwork. Art historians are still unraveling the often-hidden history of female patronage, or the commissioning of art by women.

Powerful female leaders have appeared throughout history. Hatshepsut ruled Ancient Egypt for decades. Countless sculptures were made during her reign, depicting the ruler in male guise (with the customary false beard) to show her legitimacy as king. The work here shows Hatshepsut in the form of underworld god Osiris, her reddish skin another indicator of the traditionally-male power she had assumed (in Egyptian art, men were typically painted in red ochre, women in yellow ochre). This sculpture was originally part of Hatshepsut's funerary temple, to indicate her assured place in the afterlife, alongside the Egyptian gods. Much of the work commissioned by Hatshepsut was defaced or destroyed after her death, but subsequent rulers could not eradicate the history of this unusual patron.

In the European Middle Ages, the education and influence of women of means often depended on the open-mindedness of their fathers; most were simply married off to secure a political or financial relationship between families. Fortunate daughters were taught to read and write. For young women without means, the Church offered one of the few routes towards literacy and social mobility. Within a nunnery, women could potentially rise to the powerful role of abbess—who would preside over the workings of the nunnery and act as a representative of the Church.

Left: Osiride head of Hatsheput, 1503-1483 B.C., found at Deir el-Bahri, Thebes. Painted limestone. Metropolitan Museum of Art, New York City.
Right: Anonymous, Hitda codex, scene of Christ and the woman taken in adultery, c. 1020. Darmstadt, Hessische, Landes und Hochschulbibliothek, cod. 1640, fol. 171.

This page from a codex, or bound book, was commissioned by Hitda, Abbess of the nunnery at Meschede, Germany. As the patron, Hitda determined which passages of the bible she wanted in her book, and which scenes would be illustrated. This page presents the gospel story a woman caught in adultery and saved by Christ from an angry mob that includes religious leaders. Here, the unknown artist—likely following Hitda's direction—presents the adulterous woman sympathetically, as she is manhandled by the crowd. As a religious leader herself, Hitda may have been moved by this cautionary tale about the abuse of power against the powerless.

THE ANALYTICAL VOCABULARY OF TRADITIONAL TRIBAL ARTS

Throughout this text, we have looked at various traditional art forms made by tribal cultures. Although the arts vary by region and culture, we find some general commonalities in the way that art is made and used. In most rural, traditional societies (be they African, Andalusian, or Appalachian), community concerns tend to outweigh individual expression. That means that artists make art to serve a community need, and the standard set by their forebears is the standard against which they are judged. New ideas and materials may find their way into the work, but the art is still prized for doing its "job," above all.*

For example, this male *chi-wara* headdress sculpture, which we discussed in Chapter 3, was created by a Bamana artist to ensure a good harvest when it is worn and danced together with the female *chi-wara*. It was carved to specifications laid down centuries ago, in order to be recognizable to any Bamana viewer. There is certainly room for individual innovation in traditional African societies, of course; recall Kane Kwei's unorthodox coffins in Ghana (also in Chapter 3). However, Kane Kwei's decision to create representational coffins was still made in response to indigenous, festive Ghanaian funeral traditions. In short, the community members' values dictated many of the decisions of the artist, rather than the other way around.

Traditional, tribal arts also shared a similar negative perception in the West, until recent times. Western viewers were likely to see strong, negative emotions in tribal art that were never intended by the original artists. Indeed, the bulk of traditional art is designed to prompt positive and affirming feelings. Tribal arts often reinforce the idea of power, especially the power of deceased ancestors and other spirits to assist the living. Artwork designed to facilitate those otherworldly efforts are generally idealized (the spirits' work is considered beneficial and effective—therefore, verism would be inappropriate). Along with idealized features, these works tend to possess many other characteristics of analytical art, including an emphasis on smooth, vertical/horizontal, geometric lines; symmetrical balance; natural lighting; and clear, organized, open space.

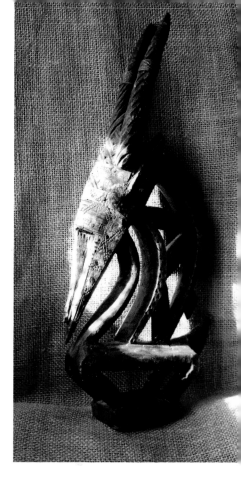

Take, for example, this ancestor mask, created about a hundred years ago by an artist of the Chambri people of the Sepik region, in Papua, New Guinea. Likely worn as part of a coming-of-age initiation ritual, the mask would help the dancer act as a conduit for the spirit world. The spirits would be called upon to guide young men or women to take their place in adult society, and accept adult responsibilities.

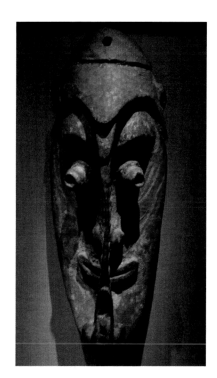

Rarely in our culture do we imagine our dead relatives in abstract terms, so the facial features here might seem far more disconcerting to us than to the Chambri people. Our discomfort is intensified by the mask's spotlighted display in a dark museum (necessary to protect its paint from damaging light). Originally, like the *chi wara* figure, this mask would have been seen only in the light of day, outdoors, worn as part of a costume. Despite

*Note that these "traditional" rural societies are rapidly changing—and expectations about art are changing with them.

Left: Spirit mask, Chambri people, Middle Sepik region, 19th–early 20th century. Wood, pigment, human hair, clay, boar tusk, shell, fiber, cloth. DeYoung Museum, San Francisco. Photo by the author.
Right: Male *Chi wara* figure, Bamana culture, Mali. Carved wood with nailed metal and thread decoration. 16 3/4 x 7 in. Collection of the author.

first impressions, this mask does not represent the cathartic purging of unchecked emotions; it provided a powerful guide toward correct and proper behavior.

The *Linguist staff* is an example of more worldly power than the Chambri spirit mask. Carried by the spokesperson ("linguist") for the ruler of the Fante people in Ghana, staffs such as this are topped by a sculpture which illustrates a well-known Fante saying. The linguist's choice of staff reinforces whatever political message the ruler wants to emphasize. This staff shows two men at a dining table; Fante viewers would recognize a proverb which says, "Just because you are hungry doesn't mean the food is yours for the taking." Like all proverbs, the saying is not meant to be taken literally. Those who might try to question the ruler's authority—and attempt to grab power themselves—are meant to take special note of this staff. Again, a rational visual vocabulary is reinforced by strong symmetrical balance, reliance on geometric forms, and open, organized space. The work is analytical above all; it expresses ideas in a clear, dispassionate way, delighting the mind with metaphor—but not exciting the passions with drama, suspense, fury or fear.

WESTERN ART: A TIMELINE OF ANALYTICAL AND EXPRESSIVE ART THROUGH THE 1600S

The Ancient World

Ancient art is most likely to reinforce the power of an earthly ruler, backed by supernatural powers that assure the ruler's absolute authority. Therefore, the bulk of ancient art is analytical, rather than expressive. Ancient Egyptian art offers a typical example. Although Egyptian imagery appears mysterious and titillating to many modern viewers—and decaying mummies add a creepy fright factor—the essence of Egyptian art is clear,

calm, and life-affirming. The rulers of Egypt wanted their transition to the afterlife to be 100% by-the-book, and 100% effective. Geometric order, clean lines, and rigorous accuracy would ensure that the magical properties of the artwork "worked" properly. The afterlife was meant to be a seamless continuation of this life: rulers would continue to be fed by servants at sumptuous feasts; they would ride, hunt, relax, and rule, just as before, but in the blessed presence of the gods.

This relief sculpture is known as a funerary stele—a carved slab that acts as a grave marker for the deceased. Commemorating an Ancient Greek woman named Iostrate, the stele seems, at first glance, to have little in common with the Egyptian funerary sculpture on the next page (which we first examined in Chapter 1). The little alabaster depiction of Pepi II as a miniature man-child, seated on his mother's lap, is also a funerary piece, found in the adult king's tomb. Both sculptures also present a woman in the afterlife, seated regally; one is the mother of a god-king; the other is likely the daughter of an important and wealthy Greek official. In both, geometric order and clean lines suggest the certain fulfillment of the women's afterlife needs. The Greek lady examines a jewelry box, presented by a servant; she is beautiful,

Left: *Linguist staff*, Fante peoples, Ghana. Mid-20th century. Wood, gold leaf. National Museum of African Art, Washington, DC. Photo by the author.
Right: Grave relief of Iostrate, 4th century BCE, Royal Ontario Museum.

forever youthful, an eternal ideal. Similarly, Queen Ankh-nes-meryre remains forever a young mother—the miniaturized figure on her lap appearing, like Iostrate's attentive servant, as an attribute of her eternal, honored status.

We have seen some interesting parallels between ancient Egyptian and Greek art, as both use analytical vocabulary to affirm the fortunate status of the deceased. Early Greek art certainly owes much to the style of the nearby Egyptians; however, the Greeks' eventual embrace of a softer naturalism (over the hard-edged, stylized geometry of the Egyptians) points to a markedly different culture. Although boasting a representative form of government and citizenship for all land-owning men, ancient Greece was not a democracy in the modern sense—however, it was far more egalitarian, and far less socially-stratified, than ancient Egypt. Humanistic values are reflected in the Greek woman's approachable form; she is an ideal, but a more relatable ideal than Queen Ankh-nes-meryre. Recall that the Greek gods were envisioned as more human-like and familiar than the gods of ancient Egypt or the ancient Near East. In the Greek myths, the gods were always playing "fast and loose" with human affairs. For much of Ancient Greek history, the gods were shown as beautiful people, and humans were depicted in their image, to suggest their aspirations for moral and civic perfection.

By the 300s BCE, Greek culture had begun to shift. Centuries of multicultural contact, conquest, and infighting brought a new expressiveness to Greek art. This period, known as **Hellenistic Greek,** features greater

Left: Pair statue of Queen Ankh-nes-meryre II and her son Pepi II seated. Egyptian, Sixth Dynasty, reign of Pepi II. Alabaster, Height: 15 1/4 in; Brooklyn Museum of Art.
Right: *The Abduction of Persephone* (detail), Tomb 1, Vergina, Macedonia, c. 330-240 BCE. Fresco.

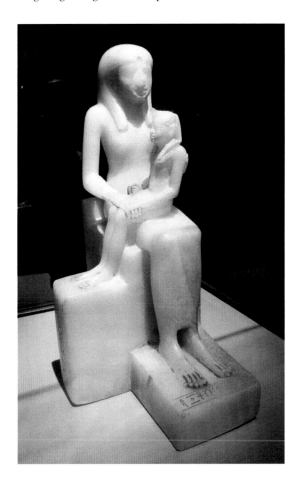

verism in some works of art, and more dramatic compositions. The detail from a tomb painting at Vergina, Macedonia reflects this new Greek style. In this fresco, Hades (god of the underworld) has captured Persephone, daughter of the Earth goddess. Persephone's disappearance makes her mother despondent, and the earth begins to wither in the throes of winter. Persephone ultimately returns and her now-jubilant mother brings the joyous eruption of springtime. The story is considered a metaphor not only for the seasons, but also for human death and rebirth; just as Persephone was able to return to the land of the living, so the Greek occupant of this tomb hoped that she, too, would be reborn to a pleasant afterlife. There is no soothing or quiet repose in this tomb, however; unlike Iostrate's stele, the imagery here is filled with drama and suspense. Poor Persephone turns like a corkscrew in Hades' grasp, her hair flying out in all directions. The face of Hades, wearing a grim and determined look, is framed by a mass of wild, curly hair, depicted through loose, gestural brushstrokes. The space is tightly jumbled, and diagonals dominate a zig-zagging layout. The corpse of the deceased was likely propped up on a bench inside the tomb, in order to watch the drama of the story unfold on the three walls around her; directly opposite, the dejected, seated figure of Demeter, the earth goddess, would have mirrored the deathly demeanor of the tomb's occupant—presenting, altogether, a highly-charged, unearthly tableau.

The ancient Romans admired and copied the works of the Greeks—both the stoic, heroic sculptures like Iostrate's stele, and more dramatic Hellenistic fare. However, not surprisingly, original Roman art—made to publicize the mighty achievements of the emperors—leaned toward analytical, rather than expressive, vocabulary. As we observed in Chapter 7, Roman patricians preferred verism in their portraits, to convey their wealth of experience—but idealism ruled in most other contexts (see Chapter 8).

Notre Dame, Strasbourg Cathedral. Death of the Virgin (Dormition), from tympanum of south transept. c 1230.

Medieval Art

As the center of the newly-Christianized Roman Empire shifted eastward to Byzantium (modern-day Istanbul, Turkey), the illusionistic style of Ancient Rome began to turn towards a more abstract, symbolic form. The Byzantine Empire continued many of the Greco-Roman traditions, but developed a new visual vocabulary to suit the needs of the Emperor and the Church. Meanwhile, Germanic tribes in Western Europe (the Goths, Celts, and others) brought their own abstract style to the region formerly held by Rome. Italian Renaissance artists, driven by a love of Classicism, would later dismiss all Medieval art as odd, misshapen, and unskilled—associating Medieval abstraction with the "barbarians" of the "Dark Ages."

In addition to the abstract style, some Italian Renaissance artists were also unnerved by the level of emotion that could be found in so much Medieval art. Commissioned by the Catholic Church to engage viewers on a personal level, Medieval artists often employed expressive vocabulary in their Church paintings and sculptures. The compressed space, organic lines, and strong diagonals in the Death of the Virgin relief on Strasbourg Cathedral all serve to intensify the palpable grief on the faces of the apostles. Twisting and turning in a space

decidedly too small for them all to fit, all gaze at Christ's mother, helpless and despondent, as Christ himself holds a child-like figure in his arms, symbolizing her departed soul.

This Northern Renaissance painting depicts the same subject. Note how this anonymous German work also features an unnaturally-tight space, as the veristic faces of the mourning apostles cluster around Mary's deathbed. Like the Medieval work, this Northern Renaissance painting is designed to hit the viewer personally. We are meant to recognize these people as our friends and neighbors; we are invited to join them in their distress. The artist has even left a space on the bench for us to kneel at Mary's bedside, and wait for Christ to come for her.

Left: *Death of the Virgin*, anonymous German artist, late 1400s. Oil on panel. Legion of Honor, San Francisco.
Right: Detail. Photos by the author.

From Renaissance to Baroque

The 1400s in Europe witnessed dramatic economic, political, and cultural changes. Kings continued to rule, and the Pope in Rome was considered the ultimate religious authority among European Christians. However, international trade and new technologies ushered in the era of the powerful merchant class. In Northern Europe, the patrons purchased art that reflected their Medieval-leaning tastes, as the German *Death of the Virgin* attests. In Italy, humanistic ideas led to a budding resurgence of Classical philosophy, literature, and art. The result, in a nutshell, is two rather different artistic Renaissances, as noted in Chapter 6: in the North, flat, patterned, and often more expressive compositions, with direct ties to Medieval art. In Italy, rationalism in visual form: beautiful, practical, strong, and well-ordered illusionism.

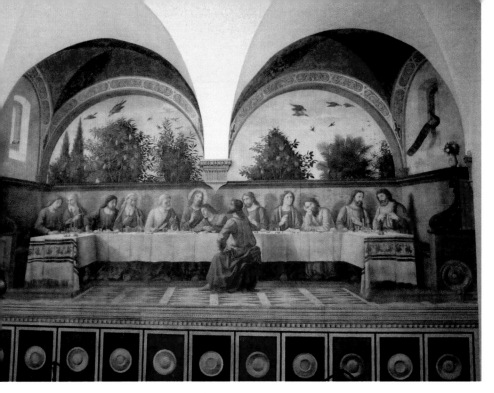

Here, in a small dining room (refectory) of the monastic Church of All Saints in Florence, Italy, a quintessentially Italian Renaissance fresco of *The Last Supper* appears on the far wall. Painted by Ghirlandaio, the work possesses every element of analytical vocabulary. In contrast to the compressed, jumbled space in Northern Renaissance art, here every disciple has his own spot around the spacious, u-shaped table. The one-point perspective is clear and rational, so that—when viewed from a distance—the scene appears to be an extension of the refectory. The soft folds in the garments and tablecloth, as well as the leafy edges of the foliage in the background, provide organic punctuations to an otherwise overwhelmingly geometric order.

The space in Ghirlandaio's composition is open and logical, giving the viewer room to stretch and breathe. Indeed, the seated figures occupy less than half of the painted space—the rest is grand arches (mimicking the actual architecture of the refectory) and a delightful garden scene.* The light is also clear and naturalistic; in the actual refectory,

Top: Ghirlandaio, *Last Supper*, Ognissanti (All-Saints Church) refectory, 1480. Fresco, 157.5 x 346.6 inches. Photos, by the author.
Bottom left: *Last Supper*, viewed from across the refectory.
Bottom right: *Last Supper*, diagram.

*The Northern work, by
contrast, gives the viewer
nowhere to go—the disciples
in *Death of the Virgin* pack
the room, their haloes
overlapping in waves of
gold, crammed against the
back wall.

a window on the left wall is the only true light source; rather
than compete with it, Ghirlandaio chose to paint a smaller
window right next to it, and let the shadows of the disciples
fall logically to the right.

The softness of Ghirlandaio's light parallels his choice of
color palette. Neutral colors dominate, while beautiful pastel
garments glow from all corners of the table. Golden hues
are picked up in the archway decoration and the lemons in
the tree outside. Even a peacock appears in a window on the
right, although its colorful feathers are not on full display.

In contrast to the rugged verism in the Northern *Death
of the Virgin*, here idealism reigns. You can almost hear the
birds chirping in the greenery; each petal is perfectly-formed,
each fruit is ready to be plucked and enjoyed. In keeping
with Ghirlandaio's ordered composition, the disciples are
exceptionally well-behaved—especially considering one has
just been accused of betrayal. Their emotions are evident,
but restrained; they question and fret, with Judas (clearly
isolated from the rest) showing a subtly defiant pose, and
John resting his head quietly on Christ's shoulder. Although
young apostles are joined by senior members of the fellow-
ship, all are idealized—complexions are smooth (disrupted
only slightly by a wrinkled brow, as in the detail shown on
the next page); faces are composed, hair neatly in place; and
bodies appear healthy and robust, seated comfortably with
minimum twisting or contorting. Every aspect of the work

Top left: *Last Supper*, view
of the garden "outside."
Top right: View of two
windows, one real and one
painted, informing the
shadow placement.
Bottom right: A peacock in
a niche.

Top: Ghirlandaio's *Last
Supper*, view of two
disciples.
Bottom: Tintoretto, *The Last
Supper*, 1592-94. Oil on
canvas, 143.7 x 223.6 inches.
San Giorgio Maggiore,
Venice, Italy.

is affirming and reassuring, an inspirational scene to aid the
monks' spiritual, as well as physical, digestion.

Rise of the Baroque

As we have seen in Chapter 6, the Protestant Reformation
began in the North in the 1500s, and was met by an aggressive
Counter-Reformation campaign waged by the Catholic Church
(whose power base, of course, is the Papacy in Italy). This
religious culture war is marked by dramatic, intense artwork
throughout Europe, known as the **Baroque** style. This move-
ment toward expressiveness—seen in diagonal lines, tenebristic
light, warm colors, and compressed and illogical space—was
not a radical departure for Northern artists; however, it rep-
resents a seismic shift from Italian Renaissance art. A hundred
years after Ghirlandaio painted the calmly cerebral *Last Supper*
on the preceding page, Tintoretto created this *Last Supper* for
the church of San Giorgio Maggiore in Venice, Italy.*

Originally placed to the right of the church altar, this paint-
ing represents a cavalcade of activity, drama, and mystery (one
wonders how officiating priests at San Giorgio could compete
with this sensation-filled extravaganza and keep the worship-
pers' attention). In this composition, Tintoretto seems to refute,
point for point, the rationalism of Ghirlandaio's era. Geometric
clarity has been supplanted by the organic lines of the figures,
highlighted by a supernaturally-glowing light that arcs over the
disciples' heads. No longer is the vanishing point placed neatly
at the composition's center. The table is incredibly long, and
its perspective lines draw the viewer's eye deep into the space,
to the dark corner of the room.** From our vantage point,
we seem to hover over the spectacle, like the ghostly angel-
spirits that loom, barely visible, in the rafters. We seem to hear
the clatter of dishes (alms are being distributed on the right),
accompanied by the exclamations and isolated conversations
from the disciples at left—creating a din that almost drowns
out Christ's distribution of holy bread at the center. The lamp
light seems supernaturally-fueled, as it casts dramatic shadows
in front of figures who twist and turn around the room.

* Gateway to the East *and* North, Venice held a pivotal position in the Renaissance; artists in this city (including the famous Titian)
were among the first Italians to embrace a more dramatic Baroque style.
**Tintoretto likes to throw the vanishing point in distant corners—you might refer back to his painting of *Vulcan Surprising Venus and
Mars* in Chapter 2.

ANALYTICAL VS. EXPRESSIVE: A MORAL QUESTION?

Round 1: Poussin vs. Rubens

The next and final chapter will address art controversies, concentrating on recent American history. However, the root of many of our society's current art controversies may be traced back to this very old question: assuming the job of art is to make society better, what, then, does society need to "get better"? Do we treat society's ills with soothing rest and comfort?—or does society need to swallow its medicine, no matter how bitter or unpleasant it might be? As we have seen, Western art has swung like a pendulum between more analytical and more expressive art—with analytical art being a particularly effective tool for those in power. With the Baroque, era, however, we start to see the foundations of the modern era, as more people become stakeholders in European society's future. Artists, now viewed as increasingly-independent agents (rather than just tools of the powerful) are asked to take a philosophical stand—and stand behind their work accordingly.

The first round of debates centers on the divergent philosophies of the French artist Nicolas Poussin, and his contemporary, the Flemish master, Peter Paul Rubens. Followers of Poussin were called "Poussinists;"* followers of Rubens, "Rubenists." The former were steadfast in their defense of analytical art as the morally-superior approach; the latter embraced expressive art as both visually engaging, and morally justified.

Let us compare Rubens to Poussin, using two paintings we have seen before: *Daniel in the Lions' Den* and *The Holy Family on the Steps*. Rubens's use of grand, dramatic scale was discussed in Chapter 6, and Poussin's rational use of color was examined in Chapter 10.

Here we see two entirely different approaches, from choice of subject matter, to style, to visual elements and principles of design. Overall,

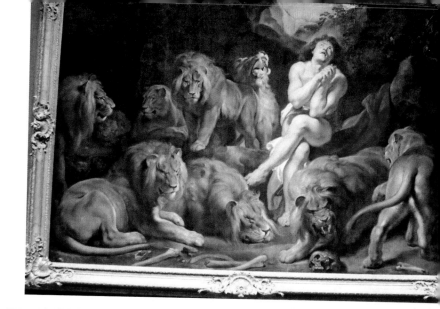

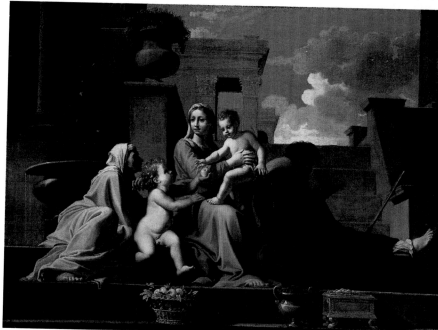

* Poussin is roughly pronounced as "Poose-*Anne*," with the "nne" mostly silent. "Poussinist" is pronounced "Poose-in-ist."

Above: Peter Paul Rubens, *Daniel in the Lions' Den*, c. 1614/1616. Oil on canvas, 88 1/4" x 130 1/8." National Gallery of Art, Washington, DC. Photo by the author.
Below: Nicolas Poussin, *The Holy Family on the Steps*, 1648. Oil on canvas, 28 1/2 x 44 in. Cleveland Museum of Art.

the two works present entirely different mindsets. Like many artists of the Catholic Baroque, Rubens believed that strong, dramatic imagery would awaken the hearts of the faithful. The traumatic scenario Rubens presents here, with Old Testament hero Daniel stuck in a den full of ferocious lions, is conveyed with warm colors, diagonal lines, and compressed space. Viewers are meant to feel as though stuffed in the den along with Daniel, overwhelmed by the beasts snarling in their company. Thus Rubens suggests that, in straights as dire as this, how could rescue *not* be a miracle?

In contrast, Poussin creates a perfectly-rational composition for his biblical figures. According to the New Testament story, Mary, her husband Joseph, and her sister Elizabeth fled to Egypt, in order to protect the lives of young Jesus and John the Baptist.* Nowhere is the desperation of their plight evident here. Mary is the perfect model of strength and composure under duress. Her youthful form sits at the apex of a strong triangle. Rigorously clean, geometric shapes surround her, framed in vertical and horizontal lines. Resting on their journey, the group conveys peace and harmony, rather than fright or exhaustion. For Poussin, no drama is necessary—salvation and rescue are never in doubt. To suggest otherwise, from Poussin's perspective, would be to sensationalize something sacred, and cast faith into doubt.

After the Baroque era, analytical art returned in force in the late 1700s, as Enlightenment ideals of scientific reason and democratic equality found voice in Greco-Roman imagery. From Angelica Kauffmann's *Cornelia* to Thomas Jefferson's design for the University of Virginia, the arts emphasized the importance of a rational education in producing a responsible, moral citizenry (see Chapter 8). Neoclassical art of this era presents a veritable encyclopedia of analytical vocabulary, with smooth, vertical lines arranged in symmetrically-balanced, rationally-colored, logically-spaced, geometrical compositions.

Despite the dramatic lighting on Edmonia Lewis's sculpture, in *The Death of Cleopatra* Neoclassical restraint prevails over the poignant image of Cleopatra, dying of a snakebite after her lover Marc Antony's defeat. As an African-American artist of the Civil War era, Lewis wanted to present the Egyptian queen as noble, even in death—not as a scandalous vixen causing a Roman general's downfall. The idealized Cleopatra becomes a timeless image of tragic grace.

Above: Diagram showing line direction and division of space in paintings by Poussin (left) and Rubens (right).
Below: Edmonia Lewis, *The Death of Cleopatra*, 1876. Marble. Smithsonian American Art Museum.

*According to the account in the Book of Matthew, Herod had threatened to kill all young boys, to safeguard against the prophecy that one would rise to challenge his authority.

Round 2: Ingres vs. Delacroix

The turmoil of the Napoleonic era ultimately undermined that late-century enthusiasm for the ideal, however. With the early 1800s came a new style in Europe, and a renewed fight between the Poussinists and the Rubenists. The next big dust-up between analytical and expressive art began as the Neoclassical style began to wane in France—along with the assurances of the Enlightenment. 1800s France was supposed to enjoy a post-Revolution democracy—instead, they got a dictator (Napoleon) followed by the monarchy's return. At the same time, France's colonial ambitions in Africa (shared by many other European countries) were equally intriguing and worrisome to French society. Political and social uncertainty, combined with exotic influences from foreign lands, culminated in a new style, called **Romanticism**—exemplified by Delacroix's *Death of Sardanapalus*. In Chapter 10, we examined this work's boiling-hot color palette. Now, let us turn to the other passionate, over-the-top expressive elements of this Romanticist *pièce-de-la-resistance*.

First, the subject-matter: this scene of violent mayhem is based on an ancient tale, popularized by a Lord Byron play. In this scene, an Assyrian king named Sardanapalus is about to be defeated; rather than let his enemies get

Eugène Delacroix, *The Death of Sardanapalus*, 1827. Oil on canvas, nearly 13 feet by 16 feet, 3 inches. The Louvre, Paris.

their hands on his treasures, the doomed king orders that all his "possessions" (from slave women to gold vases and Arabian horses) be destroyed. The brooding figure of Sardanapalus sits in the shadows, overseeing the carnage.

Delacroix's painting has everything a Romantic French audience could want: an exotic, foreign locale; beautiful, scantily-clad women, swooning in death-throes; and a melodramatic morality tale about the inevitable fall of the corrupt and powerful.* The artist goes overboard here, packing the composition with "eye-candy"—luscious flesh, shiny gold objects, and silken sheets—that suffocate the viewer with the king's excess. The figures are idealized, so that the viewer can marvel at the beauty that the king so wantonly wastes. Diagonal, organic lines wiggle and zip throughout the composition. Everything here is writhing. The twisting, contorted bodies convey both physical stress and psychological agitation. The result undoubtedly titillates the viewer, engorging the senses even as it repels the moral sensibilities. With this push-and-pull of horror and attraction, Delacroix successfully encapsulates the dangerous dark side of human nature.

Classicists like Ingres were appalled by Delacroix's impassioned, painterly mayhem. Like Poussin, two hundred years before him, Jean-Auguste-Dominique Ingres could not fathom how confronting the "dark side" would benefit society. Also like Poussin, Ingres was working in an era when intense, expressive art was gaining favor over rationalism in the mainstream art world. Thus, even a Poussinist like Ingres could not resist a few Romantic touches. The work by Ingres here is unquestionably fueled by the Romanticist era (the early 1800s)—it includes dramatic flourishes and an exotic locale—but it still emphatically resists the kind of sensational drama that Delacroix championed.

Jean-Auguste-Dominique Ingres, *Oedipus and the Sphinx*, 1864. Oil on canvas. Walters, Baltimore.

*Not surprisingly, Sardanapalus is a fictional character, invented by the ancient Greeks to suggest the bestial nature of their enemies to the east. 1800s French society was receptive to the stereotype of a dark-skinned, lusty "baddy" from the "barbarian side" of the world.

Ingres painted the story of *Oedipus and the Sphinx* throughout his career (his first version was completed in 1827, and now rests in the Louvre). The ancient Greek story of Oedipus is rife with tragedy and horror, yet Ingres chooses to illustrate the moment in which the hero triumphs by using his analytical faculties. In this version in Baltimore, we do not see a man doomed to kill his father and unknowingly marry his mother—the man who was left for dead, his feet nailed together, by his parents to (unsuccessfully) forestall the prophecy. Nor do we see Oedipus, realizing in shock what he has done, gouging out his own eyes. Instead, we see him solving the riddle of the sphinx—which so many unfortunates before him had failed to do (note the bones and corpse's foot peeking out from the sphinx's cave). Standing in a pose of geometric rectitude, Oedipus here is the model of reason, defeating the personification of irrational, destructive power. Armed only with reason

(his spear-tips pointing downwards), Oedipus stands fast, his victory assured. The body of Oedipus himself, wrapped in a red cloak, provides the only warmth in an otherwise cold and desolate place.

MODERN TIMES, WORLD WARS AND THE QUESTION OF HUMAN NATURE

Our chronological review of the most analytical and expressive movements in Western art history has brought us to the Modern, industrial age. As the quick pace of urban life seemed to overtake agrarian traditions, modern Western art responded with two distinct voices: one, invigorated by the new century—and the new, modern world—on the horizon; the other, anxious about what vital human qualities were slipping away with the old world, and what terrible realities were appearing at our doorstep. Old systems of patronage (backed by the church and the crown) were breaking down, as was the influence of art academies, who once cornered the market on which art was "in," and which artists were "out." Armed with a printer's press, Daumier rocked French society with unblinking verism. The invention of the camera put the power of picture-making in the common person's hands. Impressionists made painted "snapshots" of Parisians at leisure, with offhand brushstrokes and impetuous color, and exhibited in a "Rejected Artists' Show." In short, the art world burst wide open and in a thousand directions during the tumultuous last decades of the 1800s. Rather than attempt to encapsulate every movement of this new, modern era, let us highlight the most emphatically analytical, and the most ardently expressive.

Early Modern Expressionism: The Symbolists

The distorted forms of Edvard Munch, the tropical colors of Gauguin, and the wild visions of Van Gogh all speak to the passionate hopes, dreams, and nightmares of the *fin-de-siècle* era.* In Chapter 5, we examined the expressive line vocabulary of Munch's *The Scream;* in Chapter 10, we looked at Gauguin's symbolic use of color to express a intense psycho-spiritual experience. Let us take a moment to look at one of Vincent van Gogh's most psychologically-engaging works, *The Night Café.*

In several letters to his brother, Van Gogh himself wrote about his goals for this work. He spoke about deliberately changing the actual colors of the café, to invest the space with greater symbolic, emotional meaning. Here the dark denizens of society, those too drunk to get home and the prostitutes too poor to have a home, mingle under the blazing "eyes" of harsh, accusing lantern light. The proprietor stands, ghostly, behind a garish green pool-table, which seems to take on an anthropomorphized form—its legs poised

*Fin-de-siècle is French for "end of the century"—particularly, the end of the 1800s.

Vincent van Gogh, *The Night Café,* 1888. Oil on canvas, 28 1/2 x 36 1/4 inches, Yale University Art Gallery, New Haven, CT.

Ernst Ludwig Kirchner, *Self-Portrait as Soldier*, 1915. Oil on canvas,
27 1/4 x 24 in. Allen Memorial Art Museum, Oberlin, OH.

like an animal's, like some escapee from Disney's "Fantasia." Colors are high-saturation, brushstrokes are impasto and rough. The space climbs up the canvas, the perspective askew, at once beckoning and repelling the viewer. Attempting to create an "atmosphere like a devil's furnace," a place where "one can ruin oneself, go mad or commit a crime,"* Van Gogh was entirely successful.

The German Expressionists

We have turned many times to the German Expressionists throughout this text—from the ill-fated painter Franz Marc (Chapter 3), to the gripping charcoal drawings and prints of Käthe Kollwitz (Chapters 3, 5 and 7), to the psychologically-intense religious images of the controversial Emil Nolde (Chapter 10). For many German Expressionists, World War I was a turning point; those who survived the war returned as different men, their confidence in human nature irreparably shattered. Take, for example, Ernst Kirchner's 1915 self-portrait in uniform.** Kirchner painted this disturbing image after being discharged, having suffered a mental breakdown. The severed hand symbolizes emotional injuries that cannot be seen—the diminutive naked woman, pleasures and comforts that can no longer be enjoyed. A distorted, red portrait appears behind the artist, but his empty blue eyes are looking elsewhere.

*Quoted by W.W. Meissner, *The Annual of Psychoanalysis*, v. 22,
edited by Jerome A. Winer, Chicago Institute for Psychoanalysis (1994),
p. 127.
**We looked at Kirchner's prints in Chapter 7.

The Rational De Stijl

Kirchner's expressive work stands in stark contrast with that of Dutch artist Piet Mondrian. In Chapter 10, we explored the rational color compositions of the De Stijl artist. Mondrian moved away from rendering objects naturalistically, and embraced pure, non-objective shapes. His emphasis on pure and uncorrupted perfection (along with his choices of clean, geometric line and rational color vocabulary) reflect the victory of the analytical over the passionate.

In Mondrian's 1937 essay, "Plastic [Representational] Art and Pure Plastic [Non-representational] Art," the artist presents his vision for a harmonious world, achievable only when humankind finds equilibrium between instinct and intellect:

> In spite of world disorder, instinct and intuition are carrying humanity to a real equilibrium, but how much misery has been and is still being caused by primitive animal instinct. How many errors have been and are being committed through vague and confused intuition? Art certainly shows this clearly. But art shows also that in the course of progress, intuition becomes more and more conscious and instinct more and more purified. Art and life illuminate each other more and more; they reveal more and more their laws according to which a real and living balance is created.*

Written as the Second World War was about to begin, Mondrian's words are strikingly optimistic. He believed that art like his could help society achieve its much-needed balance.

Mondrian approached his own art like a scientist, trying to create equilibrium among the various geometric forms and rational colors. Mondrian's quest to create the perfectly-balanced work is revealed in his unfinished piece here, which shows the artist's process. In *New York City 2*, the color tape—in yellow, red, blue, black and white—is affixed to the canvas with thumbtacks. Mondrian would have moved the lines up and down, left and right, shortening and lengthening sections until (through a balanced marriage of instinct and reason) the correct proportional arrangement would emerge. Again, the artist's scientific approach yields paintings that emphatically refute human frailty, destruction, or moral failure. To Mondrian, the evils of life would be solved by the most profoundly perfect visual equation, and the balanced minds that could appreciate it.

Post-WWII Expressionism

Mondrian was confident that the world could achieve social, psychological, and thus moral equilibrium. However, the horrors of World War II were sufficient to shake many artists' confidence in humankind. Literally on the front lines of the war's destruction, some European artists were stricken by the depravity of which humans were clearly capable. Irish-born Francis Bacon

* Piet Mondrian, "Plastic Art and Pure Plastic Art," 1937, published in Herschel B. Chipp, *Theories in Modern Art*, University of California Press, 1996, pp. 349–362.

Piet Mondrian, *New York City 2* (unfinished), 1941. Oil, charcoal, graphite, thumbtacks, and commercially-produced paper laminate and paper tape on canvas. San Francisco Museum of Modern Art. Photo by the author.

Francis Bacon, *Oedipus and the Sphinx after Ingres*, 1983. Oil on canvas, 78 x 58.1 in. Berardo Museum Collection, Portugal.

*Total losses, including both military and civilian deaths, are estimated at 60 to 70 million—a number which defies both imagination and reason—marking the deadliest war of all time. To put that number in perspective: it is more than the entire population of the planet, in the age of the Egyptian pharaohs.
**DB Artmag, "Francis Bacon: A Portrait," http://dbkunst.medianet.de/dbartmag/archiv/2003/e/14/2/140.html.

was living in London during the war, and was one of millions who sought refuge in the subway during the Luftwaffe's frequent bombing raids. Bacon's personal life might explain, in part, his inclinations toward expressive art-making; the son of an itinerant gambler and drinker, Bacon was well aware, from a young age, of humanity's dark side. However, given the stunning death toll of the Second World War,* Bacon's poignant statement—"We all have to be conscious of the possible catastrophe which could hit us at any given moment of the day"**—carries the weight of more than just personal baggage.

Human vulnerability and frailty is given exceedingly disturbing form in Bacon's work at left. Although deliberately referencing Ingres's famous composition, Bacon's work is far more expressive. Post-war abstract artists admired Ingres for valuing form over function—that is, for placing compositional strategies (such as triangular layout and geometric line) over storytelling. Bacon here follows Ingres's lead, but turns Ingres's analytical vocabulary on its head.

Abstraction renders the sphinx's face a ghastly blur; she looks now at the viewer, not Oedipus, as though we are next to face her terrible test. The abstraction of Oedipus's face allows him to become everyman, his generic white tank top and shorts making him decidedly modern. The ghostly form that glides in menacingly from the doorway is one of the Fates—its bloody visage foretelling unavoidable tragedy to come.

A rational Oedipus no longer appears in the middle of a symmetrical composition, ready to solve the sphinx's riddle; instead, Oedipus's bandaged foot—circled in the center for emphasis—suggests that the past and future are inextricably linked. His parents' horrific attempt to keep him from straying onto the path of the prophecy backfires (recall that they ordered his feet to be nailed together); the wheels of fate are already set in motion.

Diagonal lines rake across the composition, from the lunging, off-balance figure of the hero, to the vengeful form of Fate. The space is flat, the walls and door appearing at wonky angles, asymmetrically-balanced and in constant, unsettling motion. Neutral blue-grey is set off by a warm, Pepto-Bismol pink, which dominates the composition. Solid planes are contrasted against rough, fleeting brushstrokes, undermining the viewer's sense of tangible reality. It seems as though, any minute now, the walls of this strange stage will collapse inwards, and the door will fall off, into the black abyss beyond. Only the sphinx seems fixed on her pedestal, suggesting that perhaps the only thing that truly persists in this world is humanity's irrational compulsion for chaos.

Based in New York City, the Abstract Expressionist movement of the late 1940s also emerged in response to the Second World War. Some Abex artists came to the city in their escape from Hitler's forces. Trained in earlier Expressionist styles, these European refugees explored a new, non-objective approach to expressionism in the States. In some ways, the Abstract Expressionists were seeking a solution to "the human question" from the opposite direction of Mondrian—excavating downwards, into the primal and instinctual, rather than rising upwards, toward purity and balance. As discussed in Chapter 5, New York action painters like Jackson Pollock and Norman Lewis used bold, expressionistic mark-making to explore the most basic human forms of expression. The results are raw, visceral, and visually complex.

As noted in Chapter 10, at the same time that the New York Abex circle was gaining attention on the East Coast, Bay Area artists were embarking on a new expressionistic style that would ultimately be dubbed "The Bay Area Figurative Movement." The untitled work on the next page by Elmer Bischoff was painted in the earliest phase of the Bay Area Figurative Movement, and has much in common with the New York Abex artists. Here, the high-intensity red paint, thickly-applied, resonates against green, yellow-green, and yellow. The biomorphic shapes suggest insect or plant life, but we are left to decipher these seemingly ancient symbols on our own.

Elmer Bischoff, *Untitled*, 1948. Oil on canvas, San Francisco Museum of Modern Art. Photo by the author.

Stephen De Staebler, *Black Figure Stele*, 1975. Stoneware with colored stains. Oakland Museum of California. Photo by the author.

Spotlight: Three-Dimensional Expressionism

Just as Bay Area Figurative artists like Joan Brown and Elmer Bischoff were exploring expressionist vocabulary in paint, Northern California artists in the 1960s also began experimenting with expressionistic techniques in clay. Artist Stephen De Staebler creates totemic, figural work, suggesting ancient ruins excavated from the earth. In his sculptures, rough textures, organic forms, and warm earth tones entice viewers to reconnect with their own, earth-bound humanity. According to De Staebler:

> The tie between the earth and ourselves is so essential that it is usually obscured by our obsession with separateness. I have tried to find a visual equivalent for our ties with the whole. The earth's landscape has been my starting point, with clay—earth—the medium.
>
> —Stephen De Staebler, quoted by the Oakland Museum.

In De Staebler's works, the viewer is presented with a paradox: the forms appear ancient—crackling and crumbling back into the earth from which the clay originated; yet, once fired, clay is resilient and lasting, its elemental potency reinforced by the symmetry of the works and their dense, compressed use of space. They are at once powerful and fragile, cohesive and broken.

The tension between power and fragility is forcefully evoked in Louise Bourgeois's enigmatic and terrifyingly beautiful sculpture, *Maman*. Standing over 30 feet tall, this bronze and steel "mother" is held aloft by precariously-thin legs. Guarding her precious cargo of eggs, the spider is both threatening and threatened. Compelled to draw near her, the viewer is both enthralled and repulsed by *Maman*'s spindly embrace. Throughout her long career, Bourgeois (1911-2010) created highly tactile sculptures and installations which address humankind's perceptions, fears, and needs.

Louise Bourgeois, Maman, 1999, at the ZSG Landing Gate, Zurich.

The Visual Language of Ambiguity

Most of the artists discussed in this chapter chose to present a clear, emphatic statement in their work—whether to exhort society to improve itself through order and reason, or to compel society to face unseen feelings through cathartic release. However, there are many artists who deliberately mix analytical and expressive vocabulary to provoke an **ambiguous** response. An ambiguous work places the viewer in an uncertain position, a threshold space, between divergent and possibly incompatible possibilities.

Why would an artist want to send viewers a mixed message? The answer lies in the nature of being human. So often we must deal with uncertainties in life, both in our day-to-day experiences, and in pivotal, epic moments. Life is full of conflicting emotions, needs, and concerns. There are things we should do, things we want to do, and things we need to do—and these forces can compete in our minds, causing conflict. By confronting the viewer with ambiguity, artists suggest that some things in this world simply cannot be reconciled.

Watteau is a French artist of the Rococo era whose work falls in an ambiguous, emotional grey area. Following the drama of the Baroque, the Rococo was the last, great, unbridled celebration of the aristocracy before the sober reforms of the Neoclassical Enlightenment. The Rococo period is best known for its sensuous delights, a world of powdered wigs, masquerade balls, and Cinderella finery. Like the work of his contemporaries, Watteau's paintings present an idyllic world of pastoral leisure, with sumptuous gardens and lovely ladies being courted by flirtatious young men. Yet, there is in Watteau's work an underlying tone of sadness—a

*Jed Pearl, Antoine's Alphabet (New York: Knopf), 2008, p. 142.

Jean-Antoine Watteau, The Foursome, c. 1713. Legion of Honor. Photo by the author.

softly-spoken word of caution that life's pleasures can't last forever. In *The Foursome*, three well-to-do young people, perhaps taking a break from a masked ball (there is a mask in one of the young lady's hands), engage a passing guitar-player in conversation. The soft, organic line of the seated figures echoes the soft foliage behind them, while the standing entertainer remains starkly vertical in his satiny-white clothes. His baggy costume suggests that he is a clown, hired for the amusement of the others. Unlike the other three, his back is to the viewer, so we can only guess at his expression. The seemingly endless space is uncertain, too—is it a garden, a forest, or some kind of Eden?—as is our relationship to the foursome. We can assume the player will move on; the ball will end. The viewer is allowed to enjoy this pleasant retreat, while it lasts. As art critic Jed Pearl writes, "Perhaps it is Watteau's idea that all painting is this mingling of the clear and the unclear, the definite and the vague, as confused, as many-sided as the vexatious imagination itself." *

REVIEW OF ANALYTICAL VS. EXPRESSIVE ART

The following synopses will provide you with a "snapshot" look at the most analytical, and expressive, visual vocabularies. Note that most artwork features a combination of characteristics from each list, and is neither wholly analytical, nor wholly expressive. In this chapter, we have focused on extreme examples of each.

Analytical art appeals to the rational mind. The artwork is designed to engage the viewer's curiosity, while it reassures the viewer of an ordered, predictable universe—one that provides answers, rather than unnerves the viewer with unanswerable or disturbing questions.

The most analytical (rational, cerebral, or pensive) vocabulary includes:

STYLE: More naturalistic, idealized, classicizing.

LINE: Predominantly clean, geometric, vertical/horizontal.

BALANCE: Symmetrical.

SPACE: Open, roomy, clear and organized; seen from a distance.

LIGHT: Even, clear; showing chiaroscuro; suggesting a natural, logical light source.

COLOR: Overall low saturation, predominantly cool, neutral colors; selective use of primary colors.

Expressive art triggers a "gut" reaction in the viewer; before the conscious mind can process the work, the viewer's instincts react to the psychological power of the line, color, space, light, etc. Expressive art places the heart metaphorically above the head. It often suggests strong feelings that lie beneath the surface, behind the observable and expected. Therefore, expressive art suggests an uncertain, unpredictable universe, one that asks more questions than it answers.

The most expressive (irrational, emotional, or passionate) vocabulary includes:

STYLE: Abstraction that heightens emotion; symbolic rather than literal; veristic.

LINE: Predominantly rough, organic, diagonal.

BALANCE: Asymmetrical.

SPACE: Closed, tightly-packed, unclear, chaotic; close-cropped, viewed up close, tight frame.

LIGHT: Strong contrasts of light and dark (tenebristic); obscured; unnatural, illogical, unclear source.

COLOR: Overall high saturation; predominantly warm colors; minimal use of neutrals.

12

CONTROVERSIES

& ART

12: CONTROVERSIES AND ART

PUBLIC EXPECTATIONS AND THE MODERN ARTIST
CONTROVERSIES IN NON-OBJECTIVE ART
CONTROVERSIES IN NUDITY AND NAKEDNESS
CONTROVERSY AND THE SACRED

White House Grounds 4.22.'89

Above: Two men in high silk hats, one
with Kodak camera, on the White
House grounds, Washington, D.C.
Library of Congress.
Below: Paul Cezanne, *Self Portrait*, c.
1875. Musee d'Orsay, Paris, France.

EXPECTATIONS ABOUT THE ARTIST

Artists today have a very different reputation from their pre-Modern predecessors. Artists used be seen as workers doing an important job according to well-defined instructions, like a plumber or electrician. Plumbers are not expected to be eccentrically original (no one wants to hear, "you'll never guess what happens when you run the dishwasher!"). For most of human history, artists were expected to use "the usual" tools to make "the usual" artwork. In contrast to today's stereotype of the lone modern artist, working in isolation in pursuit of some personal vision, most artists worked alongside others in workshops, sharing materials, labor, and a common goal.

Where, then, does our contemporary stereotype of the loner-genius-wild-visionary artist come from? There are many suspects, but one of the most unassuming culprits is the invention of photography, which opened the door for artists like the Impressionists and Paul Cezanne. Photography was still an experimental medium in the mid-1800s, but by the late 1800s this novelty had become a household item. Artists were presented with an exciting but also terrifying prospect: the traditional job of picture-making was becoming obsolete. Some artists decided to use photography as a tool to enhance the illusionism of their work. Others, like the Impressionists, felt liberated by the camera; if this new device could capture the surface appearance of things, then artists were free to express those ineffable qualities that the camera might miss—the warmth or cool of the air, the flickering of light, or the passage of time. The Symbolists, and later the Expressionists, sought to go beyond the Impressionists, and probe the inner psychological world of their subjects.

It seemed that photography had broken all the rules, when it came to creating images from life. Yet many art critics were dismayed when painters and sculptors began breaking rules in response to photography. To most critics, as well as the general public, the work looked strange, misshapen—as though the artists had forgotten their hard-earned rendering skills. The Impressionists didn't set out to become outcasts from the mainstream art world, but they wound up ostracized, just the same. The path was being laid for a new kind of artist, one who revels in being different from the norm. French artist Paul Cezanne was perhaps the first to walk defiantly down that path.

Cezanne was born to a wealthy family in Aix-en-Provence in rural France. His earliest works were dark and brooding (*The Strangled Woman*, 1872, says it all in the title). He chafed under the hand of a disapproving and distant father, and felt alienated from just about

everyone he met, including the Impressionists he worked with in Paris and even his wife and son (whom he also kept in Paris, rather than introduce them to his parents). After the death of Cezanne's father, the painter inherited the estate—yet insisted on wearing tattered old paint clothes and hanging out with the working-class townspeople of Aix. Late in life, he painted the local mountain, St. Victoire, over and over, never satisfied by his work. The mainstream art critics derided his style as artless and crude, but Cezanne developed a following with the next generation of brash, young painters. Reaching legendary status by the end of his life, Cezanne died in 1906 after suffering declining health, and painting his precious mountain in inclement weather. With his death, Cezanne created the pattern on which many famous modern artists are modeled: the erratic, irascible loner, the misunderstood visionary—martyred for his art.

There is something undeniably attractive in this narrative, which promises to give us an intimate window into an artist's tortured soul through his or her artwork. Take, for example, the French artist Vincent Van Gogh. Outside of a small group of fellow-artists, Van Gogh was virtually unknown in his lifetime; a longtime sufferer of mental illness, he died at the age of 37, victim of a gunshot wound. What is celebrated about Van Gogh is not just his expressive art work; it is the fact that he cut off his own ear, and supposedly killed himself. Evidence now suggests that he was accidentally shot by someone else, unfamiliar with firearms.* This evidence would probably have come to light sooner, but the story of a hunting accident doesn't fit the pattern of "tortured artist-martyr" as well as the "suicide angle." As the saying in Hollywood goes, never let the truth get in the way of a good story.

It is no wonder that Vincent Van Gogh became far more popular in death than he ever did in life; his story satisfies the modern appetite for the personal and personalized. Indeed, the dawn of the 20th century saw an ever-increasing interest in individual, intimate details. Sigmund Freud taught us to examine our psyches, to find out what subconscious desires drive us. Labels on household cleaning products taught us to examine what dirt might be hiding in our crevices. Mass marketing appealed to new, individualistic values that drove consumer culture throughout the century. Today, the checkout aisle magazines tell us more than we could or ever should know about celebrities' lives, while trying to sell us more than we could or ever should buy for our hair, skin, and cellulite.

Consider the parallels between Van Gogh's posthumous fame and the story of Jackson Pollock. In contrast to Van Gogh's obscurity during his lifetime, Pollock became an art-world star—a "rebel without a cause"—for 1950s Cold War America. Yet, both artists had tapped into emerging art movements. Van Gogh shared an interest in Japanese art with many avant-garde European artists (notice the Japanese print on the wall behind Van Gogh in his self-portrait). Pollock understood the post-War drive towards a new, abstract language, reflecting a world at once more splintered and more connected than at any time in history. The powerful art that each of these men produced is taken as more than just art—the artists themselves have become symbols of the modern renegade, the maverick who doesn't have to play by the rules. By extension, the artwork itself has become like a relic, a piece of

Above left: Paul Cezanne, Montagne Saint Victoire, 1888-90, oil on canvas. Private collection.
Above right: Paul Cezanne, Montagne Saint Victoire, 1904-1906, oil on canvas.
Below: Vincent Van Gogh, Self Portrait with Bandaged Ear, 1889. Oil on canvas, 23.8 x 19.7 in. Courtauld Gallery, London.

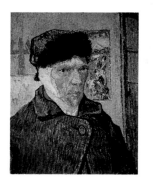

*See Van Gogh: The Life by Steven Naifeh and Gregory White Smith, Random House, 2012.

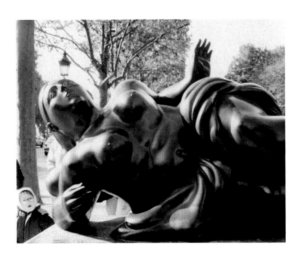

Pollock

Signature of Jackson Pollock.

*Note that *looking* daring and actually *being* daring are quite different things. Warhol's wild Pop Art criticized society and its celebrity-making/breaking ways—without taking any stabs at the big-money people who would ultimately buy and sell Warhol's work.

A little French boy marvels at a sculpture by Fernando Botero, one of 31 bronze statues by the artist along the Champs Elysées, Paris. Temporary exhibition, November 1992-January 1993.
Such bold—and boldly naked—art would never line a main thoroughfare in our nation's capital—not even for a few months. To the French (and visiting tourists), it was a fun diversion, a visual delight without scandal or controversy.

the man's greatness and rebel status in physical form. A collector says he "owns a Pollock"—not that he owns a *painting* by Pollock. You can't get more intimate, more personal than that.

By mid-century, the art world—those institutions and individuals with the power, influence, and finances to promote new art movements—had fully embraced art that looked daringly avante-garde.* Artwork had a new, mythic power—but only if the artist himself (and occasionally, herself) was also ordained to be mythically powerful—in other words, the artist had to be Cezanne-ified. Once vilified by art academies and exhibitors alike, art with puzzling abstraction began to dominate the market—from New York galleries to *Life* magazine, which featured Jackson Pollock in 1949 and excitedly proclaimed him "Jack the Dripper."

The subtitle in the *Life* article asked, "Is he the greatest living painter in the United States?" The question was deliberately provocative; the typical *Life* reader was expected to respond with a decisive "You've got to be kidding me!" Note that "Jack the Dripper" is a pun on the notorious 19th-century London slasher, Jack the Ripper. The reference connects Pollock to something far outside social norms, suggesting his methods are like a wild and deranged, knife-wielding, blood-spraying killer. Through *Life*, Pollock was officially Cezannified.

Although Modernism was the hands-down winner over Academic art by the end of the 20th century, artists themselves suffered a price. Over the decades, the public was trained to expect perplexing, vexing art from incomprehensible oddballs. Although most artists wish to be understood, the public often assumes that, when it comes to modern art, there is nothing there to understand—or the meaning is so strange and obscure as to be irrelevant. Few artists would dedicate their lives to playing tricks on viewers—and yet many viewers imagine that abstract artists are simply testing the public's gullibility, and laughing (at them) all the way to the bank.

American cynicism about modern artists and modern art is compounded by a longstanding cultural tradition that has kept art largely segregated from the public sphere. Here, we must *go somewhere* to see art. Throughout Europe, buildings have been "wearing art on their sleeves" for literally thousands of years. Sculpted fountains grace public parks; statues line roadways, leading to decorated triumphal arches. In Europe, the city pedestrian cannot walk ten steps in any direction before coming across some aesthetic creation, designed specifically with the public in mind. When people expect to see art, they are culturally-primed to engage it positively, talk about it thoughtfully, and appreciate it fully. Conversely, when public art is unexpected and unfamiliar, misunderstandings and controversy are more likely to follow. Thus, when art meets viewer, the viewer's expectations will have a tremendous impact on what happens next.

QUESTIONING EXPECTATIONS: DADA AND POP

In the early years of the 20th century, modern-styled, abstract art found only a few champions in the art world. As we have seen, the French Impressionists were derided for their loose brushwork and unorthodox color palettes. The fractured space of Cubism was also a head-scratcher to many viewers. An article from *American Art News* chronicled the American public's response to Marcel Duchamp's Nude *Descending a Staircase* (shown on the next page), when it was displayed along with other modern European work in the 1913 New York Armory Show.

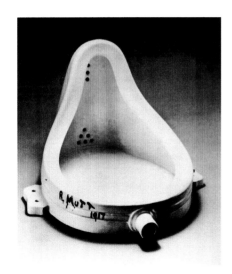

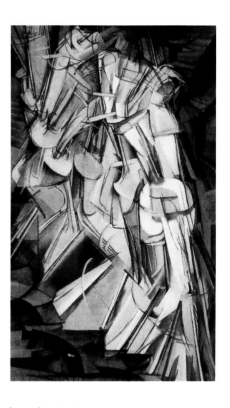

Viewers assumed it was a gag or a game; the magazine invited viewers to send in "a solution" to the puzzling artwork and win a $10 prize. A letter sent to the magazine by one of the "contestants" sums up the attitude of many: "he either has defective eyesight, inability to record the impressions, or is seeking notoriety."**

Marcel Duchamp may have painted *Nude* in the Cubist style, but he was also a member of the Dada art movement, whose members included the collage artist Hannah Hoch (introduced in Chapter 3) and Kurt Schwitters (Chapter 4). You might recall Duchamp's infamous *Fountain* (also in Chapter 4), the urinal signed by the artist as "R. Mutt."

Fountain was rejected by the New York-based Society for Independent Artists in 1917, but that didn't prevent *Fountain* from reaching an American audience. New York photographer Alfred Stieglitz admired the piece, photographed it, and displayed it in his gallery. To many viewers, the work confirmed their worst expectations about modern artists—here was an artist, throwing in their faces something that belonged in a men's room. Duchamp understood the public's confusion about modern art, and wanted to use *Fountain* as a launching point for a public conversation about what is art, what isn't art, and why. At the same time, Duchamp was tackling the assumptions and expectations of the art world itself. By submitting the work anonymously, Duchamp forced the Society for Independent Artists to judge *Fountain* on its own merits, divorced from Duchamp's reputation and star-power.

By the early 1900s, the artist and the artist's work had become one and the same. The artist's identity—or perceived identity—was inextricably bound to the work and *its* perception. Knowing this, Duchamp made his identity its own work of art, creating an alter-ego called Rose Selavy. Aided by Dada photographer Man Ray, Duchamp appeared in Hollywood-style head shots, made up as a sophisticated, mysterious starlet. The photo on the next page is even signed, "lovingly, Rose Selavy." Her name is a pun for the French phrase, "*c'est la vie*"—meaning "that's life." With a wink, Duchamp teases the viewer for wanting to own a piece of the artist—as if such a thing were really possible. In the end, that's life—it's just an illusion, a trick of make-up and costume—and of course, the camera, which continues to impact the course of art-making.

Pop artists of the 1960s continued Duchamp's discussion about public expectations and modern art. Using mass-produced imagery and mimicking mass-printing techniques, Pop artists like Andy Warhol and Roy Lichtenstein questioned what the public values and why. In *Masterpiece*, 1962, Lichtenstein speaks both to public perceptions and the increasingly out-of-touch art world. Already a favorite of the exclusive New York art scene, Lichtenstein was well aware of the public's view of artists when he painted this tongue-in-cheek "masterpiece." Here, a stereotypical art star is identified by his serious jaw-line and hip, black turtleneck sweater. The blonde-haired, blue-eyed beauty declares his work a masterpiece, and we are encouraged to agree—even though we can only see a corner of the canvas, and the back side at that. There is no context (are we in an art studio? A gallery?)—nor, Lichtenstein suggests, is one required. The important thing is that "all of New York" comes "clamoring"—who needs to know more?

Above left: Marcel Duchamp, *Fountain*, 1917.
Above right: Marcel Duchamp, *Nude Descending a Staircase (No. 2)*, 1912. Oil on canvas, 57 7/8 x 35 1/8 in. Philadelphia Museum of Art.

** "The Armory Puzzle," *American Art News*, March 8, 1913. Fine Arts Library, Harvard College Library. For more, see Michael Leja's *Looking Askance: Skepticism and American Art from Eakins to Duchamp*, Berkeley: University of California Press, 2004.

When Lichtenstein created this painting, he was embarking on what would become his "signature style," the comic-printed look that appears to deny the individual mark of the artist. Ironically, anyone visiting a New York gallery in the 1960's could see Ben-Day dots, meticulously painted on a canvas to appear like a printed half-tone, and proclaim, "Oh, that's Roy Lichtenstein!" In *Masterpiece*, Lichtenstein hints that some collectors may not even care what his work is about, because all they want is his name. To the art world, he is a just a commodity. To the public, he is just another artist-type in a black turtleneck, making megabucks for ludicrous, dime-store "masterpieces."

CONTROVERSY AND NON-OBJECTIVE ART

Given the American public's discomfort with modern art, the display of abstract or non-objective art in public venues is particularly tricky. Artists like Mexican muralist Diego Rivera and Dutch *De Stijl* artist Piet Mondrian argued that art should be seamlessly integrated with people's daily lives. They believed that art should not only visually engage viewers, but also socially engage them. Beginning in the 1960s, Minimalists like Robert Irwin and Christo and Jeanne-Claude pursued a similar course, encouraging viewers to physically interact with their environments, and become emotionally (as well as socially) invested in their world.

One of the largest modern art movements to reach out to the public was the **Bauhaus** in 1920s Germany. Founder Walter Gropius envisioned the Bauhaus as the ultimate "house of building,"* where artists, architects, engineers and craftspeople could come together to design and furnish clean, modern structures for the public good. Office buildings and factories alike would feature natural lighting, open spaces, clean lines, and invigorating geometric proportions.

With Hitler's takeover of Germany, the Nazis closed the Bauhaus, proclaiming its philosophy to be tainted by Judaism and Bolshevism, and arrested and killed many Bauhaus artists. Like so many European artists who were declared enemies of Hitler's Germany (because of their Left-leaning views, sexual orientation, Jewish

Above left: Rose Sélavy (Marcel Duchamp). 1921. Photograph by Man Ray. Art Direction by Marcel Duchamp. Silver print. 5-7/8" x 3-7/8". Philadelphia Museum of Art.
Above right: Roy Lichtenstein, Masterpiece, 1962. Oil on canvas. Gagosian Gallery, New York.
Below left: Walter Gropius, The Bauhaus, Dessau, Germany, 1925-26.
Below right: Bauhaus interior.

background, etc.), Walter Gropius fled Germany and ultimately made his way to the United States. Here, Gropius continued working in the Bauhaus tradition, influencing architects across the country with his bold, futuristic building profiles. Although Gropius died in 1969, his work would shape the visions of the next generation of architects. Indeed, one might argue that industrial design in the Gropius vein, appropriately dubbed "The International Style," has forged the American public's single, most enduring connection with modern, non-objective art. At every downtown street corner in every major U.S. city, you will see complex compositions of intersecting planes and geometric volumes—like Mondrian's *Composition,* written in three dimensions. We accept and take for granted the non-objective play of glass, steel and concrete that Gropius used for the "house of building" headquarters in Dessau—because we see (often less-skillful) versions of it everywhere.

As we begin our discussion of controversial, non-objective public art, it is not a Gropius building that takes center stage—it is the artwork within. Gropius's John F. Kennedy Federal Building in Boston was completed in 1966, just three years after the president's assassination. Gropius's design suggests a 1960s can-do optimism—the desire, in Kennedy's words, "to set sail on this new sea because there is new knowledge to be gained and new rights to be won and they must be won and used for the progress of all people." In the same speech, Kennedy challenged the U.S. to put a man on the moon, saying, "We choose to go to the moon in this decade, and do the other things—not because they are easy, but because they are hard…"** Positioned at the end of a long corridor, Robert Motherwell's Abstract Expressionist mural, *New England Elegy,* sought to capture that bold, determined spirit, while lamenting the loss of the man who personified it, for so many.

Motherwell's vocabulary is far from the clean, ordered realm of Walter Gropius or Piet Mondrian. As an Abstract Expressionist, Motherwell uses bold marks thrust across the canvas, as though summoning and purging energy from some deep and ancient source. Motherwell's work was intended as a symbolic memorial to both the invigorating power of Kennedy's futuristic vision, and the arresting trauma of his untimely death. Unfortunately, upon its unveiling Motherwell's mural was met with confusion and distress.

The title identifies the work as a funeral lament (the word "elegy" suggests melancholy reflection, and "New England" refers to the president's roots as a former Massachusetts Senator and House Representative). Motherwell's powerful brushstrokes announce the entryway to the building from the concourse, their horizontal direction at odds with the verticality of the structure. By their direction, they compel the viewer to pause, as though a visual gate has descended. The organic edges of the two thick, gestural marks recall Chinese and Japanese brushwork; their expressionistic energy is confident and decisive—yet the stray splatters, jutting off at odd angles, suggest a course interrupted, and jarring emotions that will not be contained.

*A name fashioned from two German words (*bauen,* to build, and *haus,* house). "Bauhaus" is pronounced "[] (as in, bow wow) + "House."

** From Kennedy's speech to Rice University, Houston, Texas, Sept. 1, 1962. Modern History Sourcebook. http://www.fordham.edu/halsall/mod/1962JFK-space.html). The U.S. did indeed put three men on the moon in 1969—a fact to which we return later in this chapter.

Above right: Piet Mondrian, *Composition with Yellow, Blue, Black and Light Blue,* 1929. Oil on canvas. Yale.
Below left: Walter Gropius, architect. John F. Kennedy Federal Building, Boston, MA, completed 1966. Photographed by Carol M. Highsmith.
Below right: Robert Motherwell, *New England Elegy,* 1966, in John F. Kennedy Federal Building, Boston, MA. Photographed by Carol M. Highsmith.

The public and critics alike were not predisposed to "reading" the non-objective art symbolically. They looked for a picture in the dark mass of paint—as though the work were a hidden-picture puzzle:

> … It became everyone's Rorschach. Office workers began to see in the top black band the outlines of a gun stock. Then reports got around that the title was actually The Tragedy of President Kennedy's Death.

> Where did it all lead? To the experts, of course. Shown a photograph of the painting, Boston Museum of Fine Arts Assistant Curator Thomas N. Maytham, noting the massive angular shapes, suggested that "one black blotch may represent the profile of the President's head, a very direct and specific depiction of the most brutal moment of the tragedy, when Kennedy was struck by the bullet. The lines near the 'profile,' " he said, "represent either the trajectory of the bullets or spatters of blood. It is hideous in one sense," he concluded, "because it doesn't try to walk around the issues." Which was more than Maytham could claim when he later recanted, pleading ignorance of the actual title. *

* Author unknown, "Murals: Assassination in Boston," Time, August 26, 1966, http://www.time.com/time/magazine/article/0,9171,842697,00.html#ixzzOkjaZmCKZ.

**Boston Globe, August 12. See Michael Kammen, Visual Shock, p. 210, footnotes 68 and 69.

***Kamen, 210.

Upon hearing that the work illustrated Kennedy's assassination, viewers naturally let their imaginations fill in the details. The horizontal band of blue readily became the Texas sky, black blobs became brains dislodged by the bullet, etc. Some misinformed viewers were outraged at Motherwell's apparent vulgarity and insensitivity. Headlines blared "Art Furor" and "Reaction: Confused … Appalled."** In many ways the controversy was fueled by local newspapers, but the speed of the controversy's ignition rests in a volatile—and familiar—mix: an emotional, tender subject; a publicly-displayed work of modern art; and a public skeptical (and in this case, misinformed) about the artist's intent. Tellingly, the controversy dissolves as the formula loses its key ingredients. Today, the subject of Kennedy's assassination rests in a distant, tumultuous past, and the title (real or imagined) is no longer a hot topic of discussion. The public may still be skeptical, but that is all—the result is apathy, not controversy, as author of Visual Shock Michael Kammen relates:

> When I interviewed indifferent visitors [to the federal building] in 2004 … [l]ocals and tourists had no idea what the mural represented, either literally or metaphorically. The predominant response: indifference to a pure abstraction.***

The controversy of Richard Serra's Tilted Arc differs from New England Elegy in that Motherwell's intent was misconstrued and miscommunicated; in contrast, Serra's intent was (at best) understood, but philosophically rejected by a public holding a fundamentally different view of the role of art in society. As a Minimalist, Serra intends his metal structures to stimulate viewers' attention to the light and space around them. Rather than reaffirm what the viewer already knows about his or her environment, or create a space that increases comfort or security, Serra seeks to undermine assumptions about solidity, mass, and motion. He juxtaposes heavy forces to create an uneasy equilibrium. The metal shapes are often at odds with each other and their surrounding environment, carefully balanced but uncomfortably (and sometimes aggressively) in flux.

A slab of Cor-ten steel, 120 feet in length, Tilted Arc emphatically contradicts the flow of New York City's Federal Plaza—an open space that, prior to Tilted Arc's construction, allowed workers direct access to several adjoining government buildings. The tilt and curve of the arc runs counter to the curved design of the ground; the height (12 feet) limits the pedestrians' view of the surrounding buildings, underscoring the geometric rigidity of this public space. The steel of Tilted Arc also turns rust-colored with age—a direct reference to the slow passage of time, and a further commentary on the relative nature of permanence.

Those who vehemently disliked the Arc—and successfully petitioned for its removal—focused their criticism on the art's failure to beautify the space. The hulking metal structure looks like a cumbersome relic. It gives the impression of having always been there—and despite its rusting appearance, it promises to continue, indefinitely, as an impassive, immobile presence. The Arc is also an active agent, directing (indeed, forcing) the

Richard Serra, *Tilted Arc*, Federal Plaza, NY, 1981.

movements of all who encounter it. In many ways, the sculpture acts a metaphor for the Federal Government itself—a point which makes the role of the plaza particularly significant. Federal Plaza is not just a place to relax, enjoy concerts, and let children play; it represents to many workers a small but vital respite from the mind-numbing, psychologically-draining demands of government work. *Tilted Arc* not only called attention to this fact—its presence seemed to embody the unyielding, inflexible mindset with which the Federal Government is associated. Those who spoke against *Tilted Arc* at the 1989 public hearing, held to determine the sculpture's fate, blamed both modern art and the government for the controversy. The following statement made by Federal worker Danny Katz is particularly revealing:

> The blame falls on everyone involved in this project from the beginning for forgetting the human element. I don't think this issue should be elevated into a dispute between the forces of ignorance and art, or art versus government. I really blame government less because it has long ago outgrown its human dimension. But from the artists I expected a lot more.

> I didn't expect to hear them rely on the tired and dangerous reasoning that the government has made a deal, so let the rabble live with the steel because it's a deal. That kind of mentality leads to wars. We had a deal with Vietnam.

> I didn't expect to hear the arrogant position that art justifies interference with the simple joys of human activity in a plaza. It's not a great plaza by international standards, but it is a small refuge and place of revival for people who ride to work in steel containers, work in sealed rooms, and breathe re-circulated air all day. Is the purpose of art in public places to seal off a route of escape, to stress the absence of joy and hope? I can't believe that this was the artistic intention, yet to my sadness this for me has been the dominant effect of the work, and it's all the fault of its position and location.*

In his reference to Vietnam, Mr. Katz suggests the deep wounds that *Tilted Arc* opened for some viewers. As with the Vietnam Veterans Memorial, detractors felt that they were being hustled—as if they were being sent to Vietnam all over again, with false promises from the establishment that "We know what we're doing, take our word for it." In particular, it seemed that the government was saying, yet again, "We made the decision

* "Richard Serra: The Case of Tilted Arc," http://www.cfa.arizona.edu/are476/files/tilted_arc.htm.

* "Richard Serra: The Case of Tilted Arc," http://www.cfa.arizona.edu/are476/files/tilted_arc.htm.

for you; now you have to live with it." Indeed, those in the GSA (U.S. General Services Administration) who commissioned Serra should have known his work for the plaza would be large, metal, and in some way startling or jarring, if not discomforting. Serra's reputation was well-established. However, it became Serra's misfortune that his intent should become conflated with the government's reputation for faceless, bureaucratic insensitivity. Ironically, an artist who particularly focuses on the viewer's experience was denigrated for failing to consider the viewer's experience.

Defenders of Serra's sculpture argued that the needs and interests of the broader New York public was being unfairly outweighed by a minority from the narrow segment of New Yorkers who worked around Federal Plaza. As in the case of the public memorial, we again encounter the fundamental—and often controversial—question: For whom is public artwork truly made? In the case of *Tilted Arc*, is the work just for government workers in the plaza? If so, why? If not, why not? The defense of *Tilted Arc* by professor Joel Kovel of the New School for Social Research, New York, suggests a more positive message in Serra's work, as a sort of object lesson for society at large:

> This very hearing proves the subversiveness, and hence the value, of *Tilted Arc*. Its very tilt and rust remind us that the gleaming and heartless steel and glass structures of the state apparatus can one day pass away. It therefore creates an unconscious sense of opposition and hope.
>
> This opposition is itself a creative act, as, indeed, this hearing is a creative act. I would submit that the true measure of a free and democratic society is that it permits opposition of this sort. Therefore, it is essential that this hearing result in the preservation of Serra's work as a measure of the opposition this society can tolerate.*

Seeking compromise, some suggested that Serra's *Arc* simply be moved. However, as a site-specific work, like Christo's *Gates* in Central Park, *Tilted Arc* would lose its meaning if relocated to some other space, such as a hilltop or pasture. The work was designed to challenge viewers, not to be innocuous. In that regard, one might say that *Tilted Arc* was too successful for its own good.

CONTROVERSY AND NUDITY

In Chapter 8, we examined the importance of the Classical visual vocabulary in culturally distinguishing "nude" figures from potentially-offensive "naked people." Despite critic Kenneth Clark's clear delineation between the two categories—righteous nudity and scandalous nakedness—the dividing line has often proved to be problematically blurry throughout American history. Into this haze, time and time again, charges controversy.

Take, for example, the nude Greek figure completed by Hiram Powers in 1844. Called *The Greek Slave*, the marble sculpture exudes a definite Classicism. The subject refers to contemporary concerns: in the early 1800s, Greece was attacked by Turkish forces, prompting a political outcry from both Christian Europe and the United States. In this work, a captured Greek woman appears in chains, about to be auctioned as a slave. Thus, Powers presents a blameless innocent, disrobed against her will—standing not for a particular victim, nor for Greek womanhood in general, but rather for the entire stricken nation. She appears as a solitary woman stripped bare, but she is meant to personify the Greek state, wronged and ravaged. Critics at the time praised her demure and noble bearing, even under such dire circumstances—like a tragic heroine of Classical mythology.

Powers made several copies to tour Europe and the U.S. With its stirring and inspirational subject—and the unstated assurance that her nudity was classically ennobling—the sculpture's 1847–48 tour around the U.S. was a certified blockbuster. Abolitionists were particularly attracted by the apparent anti-slavery subject; clergymen encouraged parishioners to see the work, to be morally inspired. Note, in this 19th-century engraving of *The Greek Slave* on exhibit, the conspicuous attendance of a little girl. Although the potential for controversy

was present—and there were certainly detractors—Powers's nude was fairly well-insulated from charges of corrupting the public (both young and old). Today, however, the "Classical defense" does not necessarily hold water. To some, any unclothed figure is unsuitable for children, regardless of its Classical style. Further, some feminist critics today see not a Classical ideal, but rather a controlled, subservient doll, whose chains do more to direct the eye to her privates than conceal them.*

Indeed, Western art history has a long tradition of featuring demure, generic beauties who simultaneously deflect and invite the viewer's gaze (and sexual appetite). Titian's *Venus of Urbino* exemplifies the type: lying in bed naked in a sumptuous Renaissance apartment, she is attended by servants who pick out her clothes from a chest (soon, we are to presume, they will dress her).

Titian's treatment of the oil paint exudes luxury, from the silken sheets to the soft, furry lapdog and the velvet curtain. Her torso is impossibly long, her wrist languidly drooping as though boneless, her face perfectly circular. She is a courtesan, but a fantasy courtesan—a woman who exists solely for leisure and pleasure. She is the ideal, unchallenging alter-ego to Toulouse-Lautrec's veristic prostitutes—forever young, alluring, yielding, and available. With a wink, Titian calls her Urbino's "Venus," as though the ancient goddess of love and beauty has rented out a Venetian villa to start an escort service.

Left: Hiram Powers, *The Greek Slave*, 1847. Marble, 65" high. Corcoran Gallery of Art, Washington, DC. Right: Contemporary engraving of The Greek Slave on display at the Dusseldorf Gallery, NYC. Print by R. Thew.

*See Aly Johns-Robinson and Glenn Everett, "Hiram Powers' Greek Slave," http://faculty.stonehill.edu/geverett/rb/ebbhpgs.htm.

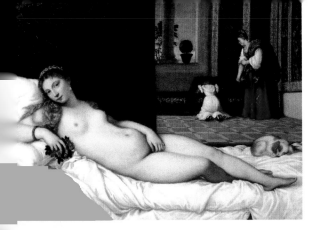

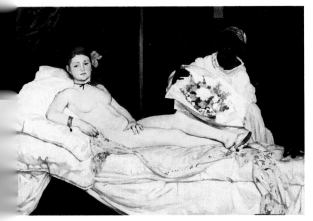

Top: Titian (Tiziano Vecellio), *Venus of Urbino*, 1538. Oil on canvas, 47 × 65 in. Uffizi, Florence, Italy. Bottom: Edouard Manet, *Olympia*, 1863. Oil on canvas, 51.2 × 74.8 in. Musée d'Orsay, Paris.

*Slavery had been abolished in France, but racism certainly remained; viewers responded negatively to the prominent presence of the African woman, with one critic calling her a "hideous Negress" (*Le Monde Illustré*, May 13, 1865). For a more in-depth discussion of the symbolism in *Olympia*, as well as the critics' reaction, see Phylis A. Floyd, "The Puzzle of Olympia," http://19thc-artworldwide.org/index.php/spring04/285-the-puzzle-of-olympia.

French Realist painter Edouard Manet was well aware of the Classical love-goddess tradition when he painted *Olympia* in 1863. A contemporary of Daumier, Manet was also a proponent of verism, and was philosophically opposed to the sumptuous fantasy-making of the Academic establishment. As Manet was already an established artist, his reputation was sufficient to claim an exhibition spot in the French Academy's annual show, the Salon of 1865. *Olympia* was his submission: a deliberate, in-your-face rejection of everything the Academy valued.

Like Titian's *Venus of Urbino*, Manet's *Olympia* features a naked woman on a bed, attended by a servant in contemporary surroundings—yet these are two fundamentally different paintings. Gone is the demure, generic lovely with the body of soft putty; here is an actual woman, her body short, taught, and alert. The object of the viewer's desire no longer returns a coy, sidelong glance; instead, *Olympia* gazes right back at the viewer, cool, calm, and in total control. Most disturbing for 19th-century viewers, however, is the difference in style: the veil of idealism has been lifted here, and Titian's sumptuous, naturalistic details have been reduced to rough abstraction. Soft, tactile surfaces are absent; in their place are hard, sharp edges. This is no fantasy sex-doll, no amalgam of sensuous parts made into an appetizing whole.

Manet's model is clearly recognizable as a particular woman, Victorine Meurand. With her specific features and body type, lying in a pose that provides both restricted and exposed views of her anatomy, viewers must necessarily conclude that she is a real prostitute (although Meurand was not—in fact, she was an aspiring artist when she posed for Manet).

Olympia's power rests in more than just her attitude. That she has an African servant—a clear status-symbol in mid-century French society*—speaks to her high income. To well-to-do viewers, here was a blatant social challenge: how could a "lowly" prostitute earn such high-class perquisites? Manet was specifically targeting members of the upper-class, male audience who would have frequented the Salon to show their sophistication and high social standing—while frequenting, in private, the apartments of high-priced call-girls like "Olympia." Adding insult to injury, Olympia ignores the flowers that you, the viewer (playing the role of the smitten John) have brought her. There is no romance here, and all your pleasure must be paid for in advance. There is no free eye candy for the viewer to enjoy, no luscious surfaces rendered in oil paint, to turn every object into a delectable morsel. The flowers are abstract patches of color, the sheets are sharp folds of gray and white, and the drapes are slices of shades of green. Viewers felt robbed, insulted; upon its unveiling, some thought it was a joke on Manet's part—"We know Manet knows how to paint, so what is this?" they asked. To many, *Olympia* was an obscenity, a vulgar, "dirty" mockery of Titian's tasteful Classicism.

Never have we seen with our eyes such a spectacle nor such a cynical effect: this Olympia, a sort of female gorilla, grotesque in India rubber outlined in black, on a bed, in a state of complete nudity, apes the horizontal attitude of Titian's Venus: the right arm rests on the body in the same fashion, except for the hand, which is flexed in a sort of shameless contraction.

—Amédée Cantaloube, *Le Grand Journal*, May 21, 1865 (T.J, Clark, *The Painting of Modern Life*, 94).

Nudity and the Nazi Aesthetic

In the case of art in Nazi Germany, the difference between nakedness and nudity was written in sharp relief. Abstract nudes were considered naked, and denounced as primitive and disgusting—the visions of sexual degenerates and perverts. Naturalistic nudes, on the other hand, were praised for upholding the standards of strong German womanhood. In this photo, propaganda minister Joseph Goebbels is seen touring the initial "Degenerate Art" ("*Entartete Kunst*") exhibition of 1937. Hundreds of works—pulled from modern art museums and confiscated from artists and the private homes of German Jews—were hung up for ridicule. From Dada to De Stijl, the works were lumped together, and accompanied by derogatory graffiti on the walls which mocked the abstractions as something only mentally sick people would paint. Note that the two paintings visible in this photo are both by German Expressionist Emil Nolde.

Abstract nudes like Otto Muller's *Bathers* were held up by Nazi critics as evidence of moral sickness. Demonized as corrupting and salacious, Muller's nudes were ironically meant to suggest a return to wholesome, Eden-like innocence. Note that these abstract nudes are fundamentally different, in attitude and intent, from Manet's *Olympia*—though they would be considered equally "naked" to some critics. Muller's Expressionist figures represent humanity without the need for artifice, enjoying simple pleasures in a lush landscape. They are not divorced from the natural world, but are rather an extension of it. The flat, childlike application of color presents a rejection of "civilized," "grown-up" sophistication. The flash and polish of industrialized life is completely foreign to this world. Both the visual vocabulary and pacifist tones were completely antithetical to Hitler's aims and beyond his understanding. Abstract art that was not destroyed outright was sold to foreign collectors, to generate more funds for the Nazi war machine.*

Culture Wars: Art and the Question of Obscenity

Since the debut of Duchamp's celebrated urinal, questions about indecency have become only more pressing and complex. Who is to decide, which works are modern-day Olympias, using shocking imagery to challenge our cultural values—and which are simply artless, crude obscenities? If an obscenity is a thing which is found offensively indecent, then how many people must be offended for the work to qualify as obscene? Which people are to decide if the work is "artless"? Should people without any art education get a vote? The issue of obscenity reached a crisis point about 20 years ago, when the questions took on a decidedly more political dimension. Conservative lawmakers turned their sights on the National Endowment for the Arts, a federal agency responsible for supporting visual and performing arts throughout the U.S.

In 1990, four artists who had individually received funds from the NEA were stripped of their monetary awards by members of Congress, who had deemed their work obscene. Dubbed the "NEA Four," the artists contested what was known as the "Decency Clause," written into the NEA's funding bill by conservative Senator Jesse Helms. Ultimately upheld by the Supreme Court, the clause would prevent the federal agency from funding "obscene" art:

> [N]one of the funds … may be used to promote, disseminate, or produce materials which … may be considered obscene, including but not limited to, depictions of sadomasochism, homoeroticism, the sexual exploitation of children, or individuals engaged in sex acts and which, when taken as a whole, do not have serious literary, artistic, political, or scientific value.**

Top: Goebbels touring the 'Degenerate Art" show, Munich, 1937.
Bottom: Otto Muller, *Bathers*, n.d. Lithograph. Yale.

*The Nazis may have hated the artwork, but they understood its market value. The buyers of such works were likely motivated by a desire to keep the work from being destroyed; however, by contributing to the Nazi coffers these collectors raised a host of ethical issues that we are still dealing with today. Survivors of the Holocaust would later visit museums outside Germany, and be shocked to see artwork that once hung in their family homes. This Nazi-looted art slowly made its way back to the rightful owners or their descendants—but the journey remains incomplete.

**Department of the Interior and Related Agencies Appropriation Act of 1990 (Pub. L. 1010-121, Title II, 304(a), 103 Stat. 741).

Helms crafted the language—ultimately known as the Helms Amendment—with particular artists in mind. In addition to the "Four" (Karen Finley, John Fleck, Holly Hughes and Tim Miller), several more high-profile artists had engendered Congress's wrath—including Andres Serrano and Robert Mapplethorpe (to whom we will turn shortly). Karen Finley presented critics, the public, and the courts alike with a particularly unpleasant "obscenity problem." In her solo performances, Finley would embrace the **abject**—a deliberate self-abasement, physically representing the abuse to which Finley found women routinely subjected. Her rapid-fire delivery of spoken-word poetry—which stripped down everyone and everything with vicious, raw language—was accompanied by a visceral physical performance. Smearing her naked body with chocolate syrup and cake, a symbol of female domesticity, Finley evoked the idea of mud or feces. This conflation of fluids—wholesome meets gross, unseemly or taboo—became a popular theme among censored artists of the era. The artist's body becomes a visual battleground to showcase the conflict between the socially visible and the invisible. Bared but sullied, artists like Finley would comment on society's tendency to publicly acknowledge and openly celebrate undeserving things, while hiding, shaming, and ignoring more essential (but decidedly unpleasant) issues and problems.

From conservative critics, Finley's work prompted the same reaction that Manet's *Olympia* elicited over a hundred years earlier. Having not seen her work, but hearing plenty, columnists Rowland Evans and Robert Novak dismissed Finley in a May, 1990 article as "the chocolate smeared young woman"*—whose performance was just the kind of smut that would and should get the NEA in trouble. On the opposite side of the political spectrum, some critics denounced Finley's work as anti-feminist, using high-handed political patter to justify the perpetuation of sexist stereotypes and violent anti-woman attitudes. As defender Martha Wilson explained at the time of the controversy, "because she often takes on the persona of the victimizer—the rapist, the abusive father—people get confused. But I have seen Karen make whole rooms of people cry."**

The fight between the NEA Four's supporters and detractors, as well as ensuing skirmishes about obscenity in the arts, became known as "The Culture Wars." This particular issue is far from resolved, and continues to erupt in controversy, up to the present day.

Nudity and "Porn": The Case of the Dinner Party

Since its completion in 1979, *The Dinner Party* has been both praised and maligned by critics. To some, it is an emphatic statement of women's empowerment. To others, it does women no favors, reducing their historical accomplishments to a kitschy buffet with naughty-shaped plates. Although Judy Chicago has created work with a wide range of themes since the 1970s, she is still identified with this seminal feminist installation.

To understand Chicago's work, one must revisit the challenges faced by female artists forty years ago. *The Dinner Party* was engineered to address major disparities that continued to plague the art world—and society in general—through the end of the century. One such disparity was the virtual absence of women in art history. As discussed in Chapter 5, Western women throughout history were cut off from the official routes of recognition. Barred from artist's workshops, prevented from studying the nude, and restricted in Academy membership, women had few opportunities to gain recognition. Art historian Linda Nochlin famously asked "Why Have There Been No Great Women Artists?" in a ground-breaking 1971 essay—answering that the question itself is based on the false assumption that, "if great women artists existed, we would have heard of them." Nochlin argued that established women

*Jerry Tallmer, "Reunion of the N.E.A. Four," Downtown Express, v. 16 no. 48, Apr. 23-29, 2004, http://www. downtownexpress.com/ de_50/reunionofnea.html.
**Michael Kammen, *Visual Shock*, 315.

Judy Chicago, The Dinner Party, 1974-79. Place settings for Virginia Woolf, author, and Georgia O'Keeffe, artist. Ceramic, porcelain, textile, 576 x 576 inches (48 feet). The Brooklyn Museum, NY.

artists have been systematically ignored and discounted; scholars, not looking for them, unsurprisingly did not find them.*

Female artists of the 1970s encountered age-old obstacles in getting the art world's attention. In the tradition of the great (recognized, male) artists of the Renaissance, Chicago took as her last name the city in which she worked—just like Jan of Eyck and Leonardo of Vinci. Also in the great Renaissance tradition, Chicago employed a workshop of women to embroider the place-settings and sculpt the ceramic plates for *The Dinner Party*. Chicago intended the workshop approach as an homage to the kind of cooperative art-making that women have engaged in for centuries, such as group quilt-making, weaving, cooking, etc. However, given that Chicago directed the designs, and her name is the only one famously connected with the project, one might argue that her choice reflects the model of the Renaissance master-artist workshop more than the cooperative women's model.

To Chicago, the entire undertaking was to be a kind of historical correction. In a tip of the hat to the Last Supper paintings of the Old Masters, Chicago creates a literal "place at the table" for 39 neglected women of history, with 13 seated on each side of an equilateral triangle. Within the triangle, the names of 999 additional women are written on floor tiles.

The tabletop is a showcase for traditional women's work, long dismissed as non-art or "low art" forms: in addition to embroidery and pottery, the traditional role of women in preparing and serving meals for the family is suggested by the place settings. Such small, humble, everyday tasks are raised to heroic proportions; measuring nearly fifty feet per side, *The Dinner Party* is a phenomenally large installation. Its unwieldy dimensions throw down a challenge, as though Chicago is saying, "try to ignore *this!*"

Even more conspicuous than the size of the table, however, are the anatomical shapes of the plates. Rendered in flowery colors and abstractly embellished, the vulva imagery is unmistakable. Here lies the crux of the controversy: what does it mean to identify these women of history with, and by, their female biological parts? To Chicago, it was an assertion of the beauty and power of their womanhood—refuting those who devalue women because of their sex. To some feminist critics, it was painfully essentialist—emphasizing what separates women from men (both in terms of gender roles and biology), rather than showing what makes them alike and equal. Some found the work heavy-handed and superficial—overly-moralizing, over-wrought grandstanding. To others, it was just tasteless and vulgar.

According to some members of Congress, it was outright pornography—although one might argue that, plainly anatomical as they are, the plates could only titillate the most imaginative viewer. Promised in 1990 to the University of the District of Columbia for placement in its new library, *The Dinner Party* was left homeless when Congress threatened to rescind UDC's funding if the work was installed.** Students outraged at apparent federal censorship stormed the administrative building in protest, and the police were called in. The installation remained largely in storage for the next 15 years—touring in sections only—until the Brooklyn Museum found it a permanent space in 2007.

As a gay male artist working in 1970s and 80s New York, Robert Mapplethorpe was palpably aware of society's sensitivity in the areas of sexuality, obscenity and nudity. Mapplethorpe's photos brought both acclaim and controversy with their crisp, artful arrangements—of subjects ranging from exquisitely-formal flowers in a vase, to sadomasochistic acts between men. Least controversial were Mapplethorpe's impeccable black and white flower studies. Like Georgia O'Keeffe's abstract flower paintings of the early 1900s, Mapplethorpe's flowers might be interpreted in a gendered, biological way—although not as graphically or directly as Judy Chicago's plates. For her part, O'Keeffe insisted that her flowers were in no way intended to be "read" as penises or vulvas. Nevertheless, artists later in the century found inspiration in works like *Music, Pink and Blue* (1915) and credited O'Keeffe for her early audacity and daring.

Lydia demonstrates Mapplethorpe's interest in using classicized vocabulary to examine the nature of beauty. In this photograph, bodybuilder Lydia Cheng appears in a truncated view. Arms upraised and face cropped, Lydia becomes an abstract study of perfect anatomy—a form worthy of the ancient Greek sculptors. Yet that is

*As recently as the 1990s, art history textbooks included just a handful of women: Gentileschi, Cassatt, O'Keeffe, and Kahlo. To read Nochlin's essay, see http://www.miracosta.edu/home/gfloren/nochlin.htm.
**Keep in mind that the District of Columbia does not have conventional representation. Its budget and its laws are ultimately determined by the Federal Government; it has no governor, Senator, or Representative in Congress—and of course, there are no state representatives for the District, since it is not a state.

Left:
Georgia O'Keeffe, *Music:*
Pink and Blue, 1915.
Center: Robert
Mapplethorpe, *Lydia,* 1985
Yale Art Gallery.
Right: Robert Mapplethorpe,
Untitled #1-5, 1985. Yale
Art Gallery.

*Note that in the 1970s, the
American public commonly
viewed homosexuality as a
deviant sickness. Psychiatrists
still classified homosexuals as
mentally ill. Florida
legislators unsuccessfully
attempted to prevent gay
people from teaching in
public schools—erroneously
equating homosexuality
with the tendency for
pedophilia.
**The following
Guggenheim site shows the
photo; follow the link at
your own discretion: http://
www.guggenheim.org/
new-york/collections/
collection-online/show-full/
piece/?search=The%20
Robert%20
Mapplethorpe%20
Foundation%20
Gift&page=1&f=Major%20
Acquisition&cr=5

all Lydia has become: a form, without real substance or identity. Robbed of arms and legs, Lydia's formidable physique no longer speaks of physical power. Rather, Mapplethorpe presents the essence of beauty, divorced from the physical—the ideal of which Plato spoke (though surely without a female bodybuilder in mind!).

Given his eclectic body of work and American attitudes toward homosexuality at the time,* Mapplethorpe's photographic portraits of friends' children were automatically fodder for moralistic scrutiny. The furor resulting from the display of *Rosie* undoubtedly shaped the wording of the Helms Amendment. In the infamous photo, Rosie (a little girl) is photographed by Mapplethorpe at her home, with her parents' permission. Her expression is uncertain—a little surprised, perhaps startled. The setting is emphatically Classical, as Rosie sits in a simple dress, knees drawn up, on a stone bench with Roman accents. The moment is frozen in a formal, almost rigid layout. What distinguishes *Rosie* from any Classical work, however, is the fact that the otherwise-clothed sitter is clearly not wearing underwear. ** Indeed, this fact led to the arrest of the director of the Cincinatti Contemporary Arts Center, which was one of several venues throughout the U.S. and Europe to host a posthumous retrospective of Mapplethorpe's work. Faced with charges of pandering child pornography, the director was acquitted in 1990. The defense had successfully persuaded the jury that the work did not constitute pornography, having called in art experts to testify regarding Mappethorpe's artistic skills and intent. The jury looked at the entire content of the retrospective, and was persuaded that photographs such as *Lydia* demonstrated the artist's sustained, intellectual interest in re-defining the Classical nude—rather than a depraved interest in naked body parts.

With works such as *Rosie*, Mapplethorpe was questioning the ever-changing and often-contradictory parameters of fine art. If *Rosie* is beautiful but Rosie's exposed privates are not, then does the vulgarity lie in the circumstances surrounding the photo; in the fact that the circumstances were documented by the photo itself; in the potential for the photo to be used for vulgar purposes, regardless of the artist's intent; or in the mind of the viewer, who feels at once angered, protectively outraged, and uncomfortably guilty at glimpsing such a taboo sight?

Nudity and Race

Mapplethorpe's most controversial works appear in the "X Portfolio," which includes naked images of men. Particularly problematic is a subset of photos depicting naked African-American men—a collection that Mapplethorpe called the "Black Book." On one hand, the men appear as Classical male nudes: they are generic and un-individualized, with the subjects' faces often turned (or cropped) so that their bodies take visual precedence. They are youthful and muscular, and they are elegantly posed. Unlike the marble statues of "accepted"

Classical beauty, however, the figures are not white (with all the term implies). Further, although they are presented as lovely, sensuous objects, they are certainly not female.

By depicting African-American men with Classical vocabulary, Mapplethorpe tests the viewer's expectations regarding what is, and is not, beautiful. From this perspective, Mapplethorpe's work, such as the untitled photo next to *Lydia*, successfully confronts racist assumptions. Here is a beautiful, black figure—made no less masculine for his beauty, and no less beautiful for his blackness. However, a white artist cannot use a nude, black body without raising serious issues. Rendered faceless, the subject, Kevin Moody, becomes nothing more than a lovely object, presented for the viewer's appraisal and ultimately sold to a well-heeled buyer. No matter how tastefully posed, the subject inevitably implies the sordid history of slavery, where naked "bucks" were admired for their desirable physical qualities while on display at the auction block. Mapplethorpe was surely aware of this issue, and that a room full of sensual (as well as outright sexual) photos of black men might perpetuate, rather than challenge, the stereotype of black male hyper-sexuality. The question remains, whether the artist had a right to tackle these stereotypes in the first place.

This particular controversy raises more than the issue of race and nudity; it exposes the problem of **agency**—the right and ability to speak for oneself. In a free society, an artist *must* have agency—but may an artist feel free to speak for an under-represented group to which she or he does not "belong"? As an artist, Mapplethorpe believed in testing—and thereby forcing an open discussion of—social attitudes regarding race and sexuality.

Yet it seemed to some critics that the ends did not justify the means; Mapplethorpe was using African American men to show how society (and more specifically, the art world) uses African-American men. Despite the high-minded intent, in the end, the result seemed to be the same: the black man had been used, and the white man had profited.

The frustration of being spoken for and spoken about—but seldom having agency to speak for oneself—is reflected in Glen Ligon's installation, *Notes on the Margin of the Black Book*, 1991–93. Ligon uses Mapplethorpe's X Portfolio in his own work, adding commentary "in the margins"—in black frames hung above and below Mapplethorpe's framed photographs. Ligon's work speaks to his experiences as an artist who is both African-American and homosexual. Using text as an art form, Ligon shows what it is like to be socially marginalized and stuck in the "margins" of the art world—which, even in the 21st century, is slow to include female artists and artists of color in the superstar ranks. In *Notes in the Margin*, the message is twofold: Ligon asserts his own agency, while hinting that the only way he can get the viewer (and the art world) to listen is by presenting himself through the African-American figures that Mapplethorpe "gave" him.

Note that a similar controversy of sexuality, race, and agency arose with Judy Chicago's *Dinner Party*. The 1970s feminist movement had been criticized for discounting the concerns of women of color. Critics pointed to the dearth of female African-American and Latina artists in feminist art shows. In the case of the *Dinner Party*, Chicago was criticized for the plate she designed for Sojourner Truth. A former slave, preacher, and abolitionist—and the only African-American woman with a place setting—Truth did not receive the same anatomically-suggestive imagery as almost every other woman at the table. Perhaps, sensitive to potential misunderstandings, Chicago wanted to skirt the very issues of race and sexuality that Mapplethorpe had so blatantly addressed. Her decision, however, made Truth's plate a strikingly obvious deviation from the norm. Critics asked, "Why is she the exception? Is a woman of color so fundamentally different from other women?"

Jamaican-born artist Renee Cox addresses the issues of nudity and women of color in *HOTT-EN-TOT*, 1994. The title of the photograph refers to an unfortunate victim of the colonial era, a South African woman "discovered" in the early 1800s. Dubbed the "Hottentot Venus," Saartjie (Sarah) Baartman was "admired" for

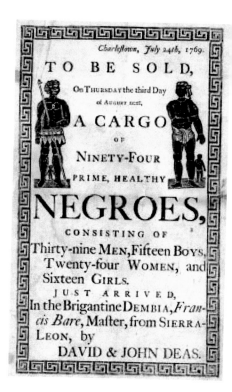

Slavery auction advertisement, Charleston, South Carolina, 1769.

Above: Illustration of Sojourner Truth's plate. Judy Chicago, *The Dinner Party*, 1974-79, Brooklyn Museum.
Below: Renee Cox. *HOTT-EN-TOT*, 1994. Brooklyn Museum.

her large breasts and buttocks, and was paraded around London as a kind of freak show attraction. Although her "handlers" claimed that Baartman was compensated for being put on display, her exploitation and indignity did not end with her death. Pieces of Baartman—including intimate pieces of her anatomy—were kept in jars and displayed as "scientific evidence" for years after her death. For her tribute to Baartman, Cox found costume breasts and buttocks in a Halloween shop (there were a variety of skin colors to choose from), and photographed herself, wearing these appendages over her naked body. Rather than present herself as a mute victim, Cox controls the camera here, and makes sure that *this* Venus looks directly back at the viewer. Like Olympia, *Hottentot Venus* exposes society's stereotypes as well as the problematic history of the female nude on display.

CONTROVERSY AND CONTEXT

As we have seen, the artist's intent can be crucial to the public's understanding—or misunderstanding—of controversial work. Knowing who the artist is, and where he or she is coming from (philosophically and culturally), the viewer can often make a more informed assessment of the art. However, the identity of the artist is rarely stamped directly on the artwork, and most artists want to be identified through their work, not through some label. Although Glen Ligon is conscious of his art world reputation as "the gay Black artist Glen Ligon," he hardly wants viewers to think, "Ah, I'm looking at gay Black art" when approaching his work.

Divorced from helpful context, however, artwork dealing with troubling or taboo topics can face real danger. Take, for example, *How Ya Like Me Now?*, a large painting on tin created in 1989 for a public art project in Washington, DC.

Here was a billboard-sized likeness of African-American politician Jesse Jackson—made blonde-haired, blue-eyed, and fair-skinned—erected along a downtown D.C. street. Jackson had made several unsuccessful runs for the presidency; many supporters blamed would-be voters' racist discomfort with an otherwise viable candidate. As both the nation's political center and a city with a population that is over 50% African-American, the District provided an exceedingly relevant context for the artwork's placement.

Yet, the city is not known for its contemporary public art; without a proper "art context," *How Ya Like Me Now?* was particularly vulnerable to misinterpretation. Indeed, with no other works around to suggest a theme, and with no gallery walls in the vicinity to signal "this is art," viewers were uncertain just *what* they were looking at. Perhaps most importantly, viewers didn't know that the artist, David Hammons, is himself African-American, and intended the piece as an indictment of American politics—*not* as a criticism of Jackson. Art historian and critic Richard Powell, who arranged the display with the Washington Project for the Arts, describes what followed:

There was a bus stop near where we were installing the piece ... and all day the people who had been gathering there had been asking us about what we were doing. But at some point late in the day, we encountered some hotheads, who saw that the other people working with me were white. They were totally uninformed about the context of the piece, and they apparently thought it was 'signifying' about Jesse Jackson, so they got agitated. They decided we were imposing ourselves, our values, and our images on the public domain, and they didn't want to see it. So a riot broke out, and these roughhouse types knocked the piece off the platform it was mounted on. Fortunately, no one was hurt, and the piece wasn't destroyed or significantly damaged. We were able to bring it back into the WPA [Washington Project for the Arts] gallery, and we installed it there.*

Note the role of agency in this controversy; according to Powell, those who attacked the piece felt that someone else was trying to speak for them—someone without a shared identity and perspective. Believing that the incident was also part of the art and its meaning, Hammons opted to place sledgehammers, like those used in the attack, in the WPA gallery show. Hammons's addition of the flag to the gallery installation suggests that the entire episode is quintessentially American—it speaks of American politics, American freedoms, and American frustrations (particularly with regards to racial issues).

*Richard Powell, quoted by Tom Patterson, "Art and the Black Aesthetic: Richard Powell," Duke Magazine, Duke University, http://www.dukemagazine. duke.edu/alumni/dm17/art.html. Jackson spoke in support of the work not long after the attack.

Above left: "Hottentot Venus" in a caricature by William Heath, 1810.
Above right: David Hammons, *How Ya Like Me Now?*, 1989. Painted tin. Display at Washington Project for the Arts, with sledgehammers and flag. Middle right: Jesse Jackson, 1983.

IRONY AND THE SACRED

Semiotics is a term borrowed by art history theorists from the field of literary criticism. In short, it is the study of signs and their meaning. Semiotics recognizes that signs have power—and a single sign may say different things to different people at different times. With each sign comes a host of expectations, inferences, and attitudes, which can vary widely from viewer to viewer. Many controversies erupt over the use—and perceived abuse—of sacred signs.

The Flag

* A controversial game-changer in American sexual attitudes and practices, the Pill (the hormone-based contraceptive, taken orally) gained wide use in the 1960s. Slowly, state laws banning contraception were struck down. In 1973, the Supreme Court decision on *Roe vs. Wade* legalized abortion.

**See the PBS site, "Timeline: Civil Rights Era," http://www.pbs.org/wnet/aaworld/timeline/civil_03.html.

Perhaps no sign in America is more powerful—and more loaded with expectations, inferences, and attitudes—than the American flag. To many, the flag is synonymous with America, the country; to harm the former is to wish harm upon the latter. To some, the flag is a symbol of America as a society—the people and their diverse values, beliefs, problems and promise. Some see the flag as a manifestation of America as a geopolitical entity—a system of government, a military might, and an economic force, playing a dominant role on the global stage. To some, you cannot fly the colors enough, as an evocation of national pride and patriotism; to others, adoration of the flag is a dance with idolatry—a form of nation-worshipping, with America as the god of infallible righteousness.

The late 1960s was a time of massive social change and upheaval in the United States. Unsurprisingly, the American flag became a lightning rod for controversy, as artists manipulated the stars and stripes to comment on the divisive concerns of the era: the Vietnam War and the draft; the Civil Rights movement; and "women's lib" and reproductive rights.* The red, black, and green *African-American Flag* by David Hammons challenges assumptions of national and personal identity. Like many artists of color in the 1960s, Hammons was asking, "If the flag represents America, and America has rejected me, then is it really *my* flag? If it's not mine, then whose is it? And if it's not mine, then can I make a new flag, to represent *my* America?"

To understand the frustrations of artists like Hammons, one must recall the intense, bitter social conflicts of the 1960s. In 1964, the "Freedom Summer" drive to register African-American voters in the deep South was met by intolerance and fatal violence. In 1965, Martin Luther King, Jr. led a protest in Alabama for voter rights, which was met by club-wielding police with attack dogs and tear gas. The same year, race riots broke out in the Watts neighborhood of Los Angeles, leaving 34 dead. In 1968, King was assassinated.** A year later, Faith Ringgold painted the flag on the next page.

In the case of *Flag for the Moon: Die Nigger,* the identity and intent of the artist are crucial. An African-American woman born in Harlem in 1930, Ringgold is no stranger to segregation, discrimination—and controversy. In 1970, Ringgold organized "The People's Flag Show" at Judson Memorial Church in New York—featuring Ringgold's work, as well as flag-based works by other artists. To Ringgold, the flag belonged to the people; it was their symbol, to define and do with as they saw fit. On the charges of "desecrating the flag," Ringgold was arrested.

The words are chilling, crude, and deliberately offensive: "Die" emerges from the field of stars; an all-too-common racial epithet—one thrown repeatedly at Civil Rights activists as they marched—takes the place of the stripes. As noted earlier in this chapter, President John F. Kennedy had encouraged Americans to set their sights high; to many African-American supporters, he represented an American future without racial inequality and divisiveness. In his 1962 speech to Rice University, Kennedy had spoken of landing Americans on the moon; in 1963, Kennedy was dead. Americans did indeed land on the moon in 1969—but their arrival did not coincide with any grand reconciliation of races. To commemorate this bitter reality, Faith Ringgold presented *Flag for the Moon.* Painted the year of the moon landing, this flag bluntly indicts America for the racist attitudes that seemed pervasive, to the very core of American identity. To Ringgold, the America that could triumphantly plant a flag on the surface of the moon could not fix its basic human rights problems right here on earth.

The question of flag desecration ultimately found its way to the U.S. Supreme Court—propelled by Dread Scott's *What is the Proper Way to Display a U.S. Flag?*. Scott took his name after the slave Dred Scott, who lost a pivotal 1857 Supreme Court case which upheld slavery as constitutional. Installed in a 1989 show at the School of the Art Institute of Chicago, the installation set off a firestorm of controversy, with viewers weighing in, on all sides of the question. The most obvious answer to Scott's titular question is "not on the ground"—which most Americans are taught at an early age. In direct violation of this sacred rule, the installation invites not only audience participation, but audience flag-stomping. In an altar-like setting, Scott places the guestbook—a common solicitor of feedback in all art galleries—at the sacred center. If the flag represents American freedoms and values in theory, then the guestbook ostensibly stands for those freedoms in action.

Dread Scott's argument is that, by placing the flag on the ground, he is making a statement about American values and rights—essentially, he is exercising his First Amendment right to free speech. By writing in the book (having possibly just walked on the flag to do so), the viewer is also freely exercising his or her First Amendment rights. Ultimately, the work is a test—of the viewer, of the law, and of American values. To reinforce this idea, Scott places above the guestbook a photo-collage of two different flag "displays." Above, the flag is burned in an anti-U.S.A. protest; below, flags are draped over the coffins of U.S. service members killed overseas. In this juxtaposition, Scott seems to ask, "which is vile expression, and which is noble expression? Which is heroic, and which is tragic? Who decides, and who enforces the decision? Whose freedoms did these servicepeople die to protect?"

Following is a sampling of the comments written in the guestbook, which reflect the range of feelings (and interpretations) the installation elicited:

I am a German girl. If we Germans would admire our flag as you all do, we would be called Nazis again … I think you do have too much trouble about this flag.

In Russia you would be shot and your family would have to pay for the bullets. But once again what do you expect from a nigger named "Dread Scott"?

Dear Dread, Like someone who viewed the exhibit, I began reading other people's comments standing next to the flag, but gradually moved to standing on it. As someone raised to be iconoclastic (at least I thought I was) it was an interesting moment of self-awareness, which (I think) is the

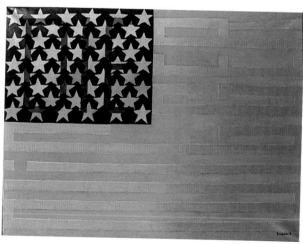

Left: David Hammons, *African-American Flag*, 1990. Right: Faith Ringgold, *Flag for the Moon: Die Nigger*, 1969, from The Black Light Series. Oil on canvas, 36 x 50 in. Collection of the artist.

Top: Dread Scott, *What is the Proper Way to Display a U.S. Flag?* 1988. Installation for audience participation, 80 x 28 x 60 in. School of the Art Institute of Chicago exhibition, 1989. Bottom: *What is the Proper Way to Display a U.S. Flag?* Detail of image hanging over the guestbook.

*Dread Scott transcribes several more guestbook entries on his site; see http://www.dreadscott.net/whatis.html.

**To overturn the Supreme Court ruling, the U.S. Congress would have to make an amendment to the Constitution. Attempts have been made in fits and starts since the '89 ruling, but have never gotten far in the legislative process.

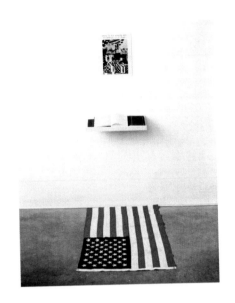

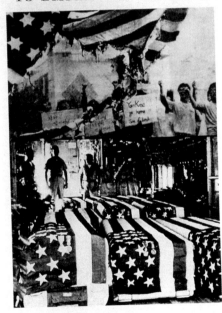

WHAT IS THE PROPER WAY TO DISPLAY A U.S. FLAG?

whole purpose of the display. Perhaps when human life and liberty is really valued above property (and symbols) in America we will all have more allegiance to the principles of "liberty" and "justice" for all. Congratulations on your courage in getting arrested to test this crazy law. P.S. Kudos to the gallery for their courage. Why is it OK to "Knowingly maintain on the ground homeless people but not the flag"???

Hi, the flag is now folded on the shelf. I have the right to unfold it, but the veterans are here and I'm afraid to. Is it right (is it American) for me to feel afraid to exercise my rights?

Right now a lady is on the ground crying because of what you have done. I feel you did something wrong and I feel you should be put in jail or have something done to you for this. I love my country and it hurts me to know that [you]don't. I hope you feel good about yourself for what you are putting people through. You're an asshole.*

In the 1989 case *The United States of America vs. Dread Scott et al.*, the Supreme Court struck down the flag desecration law as a violation of the First Amendment. The ruling was the final word in the flag controversy,** but hardly the last battle of the Culture Wars.

Religious Figures

Some of the most difficult art controversies revolve around religious iconography. Sacred signs are held especially close; religious symbols are often deeply connected to an individual's values, worldview—and very identity. Thus, an apparent attack on a person's religion is often viewed as an attack on the person as well. Viewers offended by art on religious grounds often take the offending artwork quite personally.

Given the psychological power of religious symbols for the faithful—their ability to provoke instant and intense spiritual emotions—artists work with religious imagery at their peril. Religious feelings are not only personal but also complex, contradictory, and variable, even among people of the same faith. In other words, the same religion can mean widely different things to different believers—raising the stakes even higher.

Perhaps the single-most infamous American work to confront religious faith is Andres Serrano's 1989 photograph. The photo's initial appearance is both enticing and unnerving. We are not certain what we are seeing; the figure of Christ appears surrounded

by bubbles as though submerged, hazily hovering in a deep, red-orange glow. Viewers familiar with Christian symbolism might assume some reference to the Blood of Christ, the glow perhaps suggesting a supernatural halo or promise of resurrection. The work's title tells an entirely different story, however; with *Piss Christ*, Serrano bluntly informs the viewer what is really in the photograph: a common plastic crucifix has been submerged in a container of urine—the artist's own, no less. The red is just a camera trick, a color gel placed over the lens.

Viewers were outraged. The meaning seamed both clear, and clearly insulting to Christians: a faithless artist saying "this is what I think of you and your Christ." The work was reduced, in the public discourse, to its title—and the urine story behind it. Few detractors actually viewed the work; most who *did* see the work only looked long enough to see if they could recognize the fluid as urine. A copy of the photo was ripped up on the floor of the Senate, as members of Congress pointed to *Piss Christ* as "Exhibit A" for reigning in the NEA.

Amidst all the controversy surrounding Serrano's work, the actual imagery of the photograph was largely overlooked. Despite the crassness of the title, the glowing crucifix still asserts a dreamlike, ethereal presence. Some Christian viewers—including several Catholic priests—defended this ironic juxtaposition as a symbol of faith itself. Here is the beauty, mystery, and uncertainty of belief—against which rises the crude intrusion of the real world, with its ugliness, dollar-store cheapness, and disillusion. Some critics praised the photo as a reflection of Christ's physical debasement at the hands of his tormentors, contrasting human lowliness with divine light.

In interviews, Serrano himself referenced his own conflicted feelings toward the Catholic faith in which he was raised:

> I am drawn to Christ but I have real problems with the Catholic Church. I don't go out of my way to be critical of the Church in my work, because I think that I make icons worthy of the Church. Oftentimes we love the thing we hate and vice versa. Unfortunately, the Church's position on most contemporary issues makes it hard to take them seriously. … I am not a heretic. I like to believe that rather than destroy icons, I make new ones.

Yet again, the issue of agency is relevant. Note Serrano's insistence that he has the right to speak about the Church, because it is part of his own identity:

> One of the things that always bothered me was the fundamentalist labeling of my work as "anti-Christian bigotry." As a former Catholic, and as someone who even today is not opposed to being called a Christian, I felt I had every right to use the symbols of the Church and resented being told not to.*

The meaning of a work can in fact hinge on the very question of identity and the "ownership" of contested imagery. The question of the artist's right to use religious imagery for personal, social or political purposes takes on particularly perilous dimensions in depictions of the Muslim prophet, Mohammed. As noted in Chapter 5, Islam traditionally bans any images of religious figures. Any attempt to show the face of Mohammed is considered blasphemous—at once an insult to God, to the

*Quoted in an interview with Coco Fusco, "Shooting the Klan: An Interview with Andres Serrano," originally appearing in *High Performance* magazine, Fall 1991; reprinted by the Community Arts Network, http://www.community-arts.net/readingroom/archivefiles/2002/09/shooting_the_kl.php.

Andres Serrano, *Piss Christ*, 1989.

faith, and to the faithful. Conservative Muslims extend this prohibition to non-believers; a violation is taken as a sign of blasphemy on the part of non-Muslims. Extremist clerics have called upon believers to punish those artists who defy the ban, citing their acts as an offense to God, an evil that requires eradication. Free-speech advocates have decried these efforts to impose religious rules on non-adherents. In defiance to what they viewed as coercive infringement of civil rights and forced religion, several artists from Denmark joined together in publishing political cartoons—featuring the prophet and critical of Islamic extremism—in *Jyllands-Posten* and other Danish newspapers. The publishers hoped that, by showing a united front, the individual artists might avoid being singled out for attack. The repercussions of the initial 2005 publication still resonate: Muslim critics seek an apology and redress for what they view as an unjustified assault on their religion; the artists continue to receive death threats; and the issue remains hotly controversial.

CONTROVERSY AND THE HOLOCAUST: THE CASE OF "MIRRORING EVIL"

In 2002, The Jewish Museum in New York hosted an exhibition entitled "Mirroring Evil: Nazi Imagery/Recent Art."* As noted in the discussion of Holocaust memorials in Chapter 9, viewers have come to expect representational, veristic art to address the horror and devastating scope of the Holocaust. In a nod to the new century, and in acknowledgement of new directions in the art world, this exhibition chose a dangerously unconventional approach. Rather than use imagery that clearly exposes Nazi propaganda and its terrible cost, the artists used irony to explore the very power of propaganda to undermine our moral compass. Rather than tell viewers about the evils of Nazi imagery, these artists *used* the imagery in subversive ways, challenging viewers to question what they see and take for granted. Thus, the artwork has implications not just for the Nazi past, but for potential evils in contemporary society. Using highly-charged symbols to explore complex, sometimes contradictory concepts—while speaking to an audience largely unfamiliar with such a modern approach—the artists entered a firestorm of controversy.

The Double Man

One of the exhibiting artists was Christine Borland, who presented an installation called *L'Homme Double* ("the double man"). At first glance, it appears to be a room full of clay portrait busts. The pedestals, although not entirely classical in style, nevertheless are clean, simple, and effective in raising the heads to the viewer's level. Upon closer inspection, we find that the framed photographs on the walls feature the same subject—we are looking at various images of the same man. For the most part, the portraits are idealized; the man appears youthful, vigorous, poised and calm. Taken as a whole, the room seems to be a study of this man—viewed from every angle, as though we have encountered some perfect specimen who warrants our full attention and appraisal, if not our admiration.

The bitter irony of Borland's work is that this man is none other than Doctor Josef Mengele. Borland invites us to study this man as a specimen (ostensibly of good, German manhood), knowing that this man was a high-ranking member of the insidious SS who sadistically experimented on Jewish victims as though they were lab rats—slowly torturing thousands to death in the name of "science." Yet, this monstrous man was celebrated in Nazi Germany as an exemplary doctor with a handsome face and a winning personality. Never brought to justice (he died as an old man in South America), Mengele represents the most vexing form of evil—that which parades as upstanding and righteous.

This is the "double man" that Borland seeks to expose. By giving him the "classical treatment," she suggests that evil can easily appear admirable. By replicating his appearance throughout the room, she also hints at

*For The Jewish Museum's exhibition website, which includes details about the show, artist biographies, and catalogue essays, see http://www.thejewishmuseum.org/home/content/exhibitions/special/mirroring_evil/mirroring.html.

a kind of laboratory study—the scrutinizing gaze of the doctor, now held by viewers as we peer back at our sick "subject."

Borland's approach is intriguing, emotionally chilling—and, arguably, quite effective. However, many museum-goers (including some who had lost relatives to Mengele's "experiments") were outraged. How dare the artist present this monster as some kind of hero? Hurt and bewildered by what appeared, to them, as a memorial to a "great man," these viewers were neither looking for, nor likely to embrace, the artist's use of irony.

Top: Christine Borland, L'Homme Double (The Double Man), 1997. Clay, steel, wood, acrylic, documents. As installed in Migros Museum, Zurich. Bottom: Josef Mengele (1911-1979), Argentine identification photo, 1956.

LEGO Concentration Camp

If Borland's ironic use of Nazi imagery—including the Nazi preference for classicizing vocabulary—was offensive to some viewers, then Zbigniew Libera's *Correcting Device: LEGO Concentration Camp* was an inconceivable travesty. Libera was born in Poland, the first country to be invaded by Hitler—and one which seemed, from the artist's perspective, all too ready to give up its Jewish citizens for slaughter*—Libera sought to expose the process by which innocent people become collaborators in genocide. Rather than focus on one evil man and the irony of his social acceptance, Libera explores the social mechanisms that prime our minds—from a young age—not only to tolerate evil ideas and actions, but to embrace them readily as our own.

Laid out on a table, they appear as actual LEGO boxes; the logo of the well-known children's toy manufacturer appears in the upper left corner of each, accompanied by a statement in bright yellow: "This work of Zbigniew Libera has been sponsored by LEGO." The word "sponsored" is accurate; LEGO had offered artists free LEGOs to use in their artwork. The company sued Libera unsuccessfully, with the court finding that the artist had fulfilled the conditions of the free-LEGO "sponsorship"—he

*The Jewish population was almost completely wiped out in Poland, a predominately Catholic country. Three million Polish Jews were killed, with roughly 50,000-70,000 survivors.

Zbigniew Libera,
*Correcting Device: LEGO
Concentration Camp,*
detail, 1997. Gallery Wang,
Oslo, Norway.

had, indeed, made art from the product. In the upper right corner, a number indicates that this is one set in a series. Rather than a cheerful scene of a pirate ship or a castle, however, each box cover shows a scene of institutionalized cruelty.

To critics who decried these "toys" as unfunny perversions, Libera seemed to be acting "cute," attempting to ruffle a few corporate feathers while making light of the Holocaust. Libera countered that there is indeed nothing cute about the way children are inculcated to accept violence and hate as "normal" and expected. *Correcting Device* suggests that we are taught from an early age to seek the approval of authority figures, and will go to any lengths to get it. Even as adults witnessing an abuse of power, we are predisposed to accept the reassurance proffered by officials in charge—represented here by the official LEGO stamp—that it's all "OK." Libera explains his approach as a reaction to his own country's troubled history, and links the concentration camps to other "correctional facilities" accepted today as "normal":

> My ability to work with objects is taken from everyday urban contemporary life. In my study of the development of correctional devices and educational toys, I see such devices reveal more about a society and its mechanisms for creating and enforcing its norms than any study of society could.

> *Lego,* a construction made partially from various Lego kits, takes us into a village with a mental hospital, Stalin's prison, World War II and Bosnian concentration camps. Thus, I feel I mix historical with contemporary references to represent our world, our little inferno, as built and sanctified by norms....

> During an academic conference in Brussels in December, 1997, an agitated audience, who felt that the *Lego Concentration Camp* was a real toy which was available for sale, demanded that I comment about why I constructed it. My response then, as it is now, was: "I am from Poland. I've been poisoned."*

* Excerpted from Zbigniew Libera's artist's statement, University of Minnesota Center for Holocaust & Genocide Studies, http://www.chgs.umn.edu/museum/exhibitions/absence/artists/zLibera/.

**Both TV advertisements featuring "the real thing" slogan can be found on YouTube:
Coca-Cola: "It's the Real Thing" (1969-70) http://www.youtube.com/watch?v=dDSnjjdGh5M
Coca-Cola: "Can't Beat the Real Thing" (1990-91) http://www.youtube.com/watch?v=GVag7D85b24

It's the Real Thing

In the early 1990s, Coca-Cola returned to an advertising slogan that has served the company well, particularly since it appeared in an award-winning TV ad in 1969. The original ad showed young people, peacefully assembled on a hilltop, singing "I'd like to teach the world to sing, in perfect harmony..." The slogan, which is sung "in perfect harmony" as the ad fades out, is the refrain, "It's the real thing ..." The 1990s ads included the refrain again, but this time one-upped the slogan for its ill-fated "Coca Cola Classic" product, asserting, "Can't beat the real thing."**

To Alan Schechner—another artist to draw controversy in the "Mirroring Evil" show—such product "branding" is more than just corporate gamesmanship. It reveals a troubling trend in modern times, one that takes on particularly unsettling dimensions in the internet age: the manipulation of "reality." Take, for example, the Coca-Cola slogan. One could argue that there is nothing "real" about Coke, if "real" means having any beneficial or nutritional properties. If Coca-Cola, which has no substantive value, is heralded as "the real thing," then what is the false thing to which it is being compared? Diet Coke, which is devoid of calories as well as any nutritional value, was touted by Coca Cola in the early 90s as "even *better* than the real thing"—because

Coca-Cola ad, showing the text:

COCA-COLA
SYRUP • AND • EXTRACT.

For Soda Water and other Carbonated Beverages.

This "INTELLECTUAL BEVERAGE" and TEMPERANCE DRINK contains the valuable TONIC and NERVE STIMULANT properties of the Coca plant and Cola (or Kola) nuts, and makes not only a delicious, exhilarating, refreshing and invigorating Beverage, (dispensed from the soda water fountain or in other carbonated beverages), but a valuable Brain Tonic, and a cure for all nervous affections — SICK HEAD-ACHE, NEURALGIA, HYSTERIA, MELANCHOLY, &c.

The peculiar flavor of COCA-COLA delights every palate; it is dispensed from the soda fountain in same manner as any of the fruit syrups.

J. S. Pemberton,
Chemist,
Sole Proprietor, Atlanta, Ga.

it contains no sugar. Thus, a corporate product, made valuable by its absence of value, is touted as even more real than something with no real "realness" to begin with.

In a computer-driven information age—when everything can be digitally altered to make the false seem true, and the truth seem somehow tainted and questionable—objective "reality" appears to be in real jeopardy. Schechner confronts this crisis head-on in *Self-Portrait at Buchenwald: It's the Real Thing*, 1991–93. A digital image in which the artist (b. 1962) appears in a concentration-camp uniform as one of the Jewish victims at Buchenwald, *It's the Real Thing* is clearly fake. The informed viewer knows there is *no* way Schechner, born twenty years after the Holocaust, could have possibly been present at the notorious Buchenwald camp. The digital insertion is deliberately rough and unconvincing; Schechner stands out (or *should* stand out) like a sore thumb. Most jarring to modern-day viewers, however, is the ridiculous can of Diet Coke that Schechner holds, like a bizarre product-placement, in his "self portrait." A fake gleam, which Schechner has added to highlight the edge of the can, adds another corporate gimmick to the visual obscenity. Obviously, the last thing a group of starving concentration-camp survivors needs is a can of Diet Coke. Like Libera's *LEGO Concentration Camp*, this work uses the trappings of corporate advertising, but is certainly not a real ad for a product.

Of all the works in "Mirroring Evil," Schechner's digital piece was perhaps the most reviled, and the least understood by the public. On the surface, it seems like a tasteless parody of a photograph at Buchenwald, taken by Margaret Bourke-White.* Yet, in this plainly-doctored photo lies a cautionary message with disturbing ramifications. The "Mirroring Evil" show was held 57 years after Bourke-White's photo was taken—at a time when many survivors of the Holocaust were dying of old age. With their passing is lost any first-hand evidence of their suffering. Although personal recollections can be recorded, there is no stronger "reality" than seeing, in person, the tattooed numbers on a Holocaust survivor's arm. As second-hand evidence (in the form of photographs, films, old uniforms, etc.) must inevitably take the place of living proof, what happens when we, as a society, have lost faith in the "reality" of real evidence? Schechner's "self-portrait" is an obvious lie, to anyone even vaguely familiar with Holocaust history. Will the lie be so clear in another 20 years?

In many respects, Schechner anticipated the future of internet technology, in which information

Left: Coca Cola ad, date unknown. The Coca-Cola Company has had a long history of advertising its soda as a beneficial tonic. Below: Alan Schechner, *Self-Portrait at Buchenwald: It's the Real Thing*, 1991-93. Digitally-manipulated photograph. See Alan Schechner's website, http://dottycommies.com/holocaust01.html.

*We first discussed Bourke-White's concentration camp photos in Chapter 7. Note that Bourke-White was one of several photographers invited by General Eisenhower to photograph Buchenwald, to ensure that no one could later deny that it ever existed. Schechner is suggesting that such documentation may not stand up to 21st-century manipulation—or the 21st century's distorted view of "reality."

Margaret Bourke-White,
*Emaciated male prisoners
lying in bunks*, April 13,
1945. Life Magazine.

can "go viral," and be disseminated so quickly and broadly that the whole (internet-connected) world knows almost instantaneously. The problem is that lies and truth spread at equal speed, and they are increasingly difficult to distinguish. Surely, the claims of a diet-soda manufacturer cannot measure up to the same standards of "reality" as the historical evidence of the Holocaust. *Self-Portrait at Buchenwald* is particularly frightening because, with seemingly little effort, Schechner has undermined this once-unquestionable reality-check. Raising his Diet Coke, Schechner asks, if you buy that this is the "real thing," then what other corporate lies are you willing to swallow? Are you not capable of "buying into" another Holocaust, mistaking a mass-produced lie as "the real thing"? How can you be sure?

CONTROVERSY AND THE 21ST CENTURY

Although some of the controversies discussed in this chapter are decades old, the issues that drove them are still very much alive in contemporary American society. The public harbors negative expectations about the artists' intent, when confronted with art that is in any way unappealing, strange, or disconcerting. Artists whose work is "protected" behind gallery walls (where the context is clearer, and the intent more easily conveyed) do not necessarily reach a wider public that might genuinely benefit from seeing their work. On the other hand, artists who put potentially troubling work into public spaces risk censure as being "out of touch" or insensitive to the very people the artists had most in mind when designing the work.

With the internet taking center stage as a primary communication tool, attempts by artists to reach a wider public through cyberspace have increased markedly over the past decade. The proliferation of social networking sites, along with the relatively anonymous mask of avatars and screen-names, has emboldened internet users to share more of themselves and their lives online. Artists are no exception to this trend. However, as Alan

Schechner's art suggests, artists may risk the most when they personally appear in their work—and risk even more when the internet becomes a tool for the audience to "target" the artist.

As the final work of art for discussion in this text, consider Wafaa Bilal's *Domestic Tension*, a month-long performance in May, 2007. The now-defunct FlatFile Galleries in Chicago had jettisoned the original title—*Shoot an Iraqi*—as too violent, albeit entirely accurate. As the original title suggests, Bilal's performance gave internet viewers an unprecedented opportunity to explore the implications of the ongoing war in Iraq—and, if they chose, take a direct part in "shooting an Iraqi" (the artist himself, who was born and raised in Iraq). By going to the "Domestic Tension" website and logging into the chat room, the viewer could use his or her mouse to direct the motion of a remote-controlled paint-ball gun, aimed into the enclosed space of the gallery to which Bilal was confined for the entire month. A longtime artist, Bilal decided to subject himself to this ordeal after an unmanned American drone killed his brother in Iraq. He wanted viewers to explore, psychologically and morally, their attitudes, expectations, needs and fears regarding a distant, uncertain enemy. Through the chat room—and the gun—viewers shared their feelings, both hostile and friendly. Some slipped easily into a dehumanizing, racist mindset, typing crude diatribes against Bilal and relentlessly targeting him, as though he were just part of a video game. Some became palpably aware of the consequences of their (and others') actions; they made a concerted effort to keep the gun aimed at the wall. For them, participation had become something more profound than they had anticipated. Ultimately, this was the "shock value" of *Domestic Tension*: the shock of self-awareness. For any artist, that is, indeed, "the real thing."

Wafaa Bilal, *Domestic Tension*, 2007. FlatFile Galleries, Chicago. See Wafaa Bilal and Kari Lydersen's *Shoot an Iraqi; Art, Life and Resistance Under the Gun*, San Francisco: City Lights, 2008, p. 116.

NEW VOCABULARY, CHAPTER 12

abject	Self-debasement, often by making reference to bodily functions and other taboo, repulsive images or materials
agency	The power and authority to speak for oneself
Bauhaus	German art movement of the early 1900s, calling for workers' equality and the integration of art and society, at all levels
Pop	Post-WWII art movement gaining attention in the 1960s for the use of imagery and materials found in popular culture.
semiotics	The study of signs and their meaning

CREDITS

Copyright © picsishouldshare (CC BY-SA 2.0) at http://commons.wikimedia.org/wiki/File:Starbucks_1.jpg.

Garrick Mallery, "An Eyewitness Account by the Lakota Chief Red Horse," *Picture-Writing of the American Indians (10th Annual Report of the Bureau of American Ethnology)*. Copyright in the Public Domain.

Copyright © JohnnyOneSpeed (CC BY-SA 3.0) at http://commons.wikimedia.org/wiki/File:Itsukushima_Shrine_at_high_tide.jpg.

Copyright © Cacahuate (CC BY-SA 3.0) at http://commons.wikimedia.org/wiki/File:Map_of_Asia.svg.

Copyright © Jean-no (CC BY-SA 3.0) at http://commons.wikimedia.org/wiki/File:Holbein_Ambassadors_anamorphosis.jpg.

Copyright © Konstantinos Plakidas (CC BY-SA 3.0) at http://commons.wikimedia.org/wiki/File:Roman_Empire_Basemap.png.

Copyright © Salvador Alc (CC BY-SA 3.0) at http://commons.wikimedia.org/wiki/File:D%C3%ADa_de_muertos_1.JPG.

Copyright © Jean-Michel Rousset (CC BY-SA 3.0) at http://commons.wikimedia.org/wiki/File:Kane_Kwei_Carpentry_Workshop.jpg.

Copyright © Calliopejen1 (CC BY-SA 3.0) at http://commons.wikimedia.org/wiki/File:King_Menkaura_(Mycerinus)_and_queen.jpg.

Copyright © AlkaliSoaps (CC BY 2.5) at http://commons.wikimedia.org/wiki/File:WLA_metmuseum_Marble_statue_of_a_kouros_youth_2.jpg.

Copyright © cjn212 (CC BY-SA 2.5) at http://commons.wikimedia.org/wiki/File:WLA_brooklynmuseum_Queen_Ankhnesmeryre_II.jpg.

Copyright © Till Niermann (CC BY-SA 3.0) at http://commons.wikimedia.org/wiki/File:Statue-Augustus.jpg.

Copyright © AlkaliSoaps (CC BY 2.5) at http://commons.wikimedia.org/wiki/File:WLA_metmuseum_Virgin_and_Child_in_Majesty_1150_2.jpg.

Copyright © David Gaya (CC BY-SA 3.0) at http://commons.wikimedia.org/wiki/File:Michelangelos_David.jpg.

Giorgio Vasari, *Lives of the Artists (Volume I)*, trans. George Bull, pp. 31, 38, 46–47. Copyright © 1988 by Penguin Group (USA) Inc.

Copyright © Clayton Tang (CC BY-SA 3.0) at http://commons.wikimedia.org/wiki/File:Sistine_Chapel_North_and_East_Walls.jpg.

Copyright © Lolapps (CC BY-SA 3.0) at http://commons.wikimedia.org/wiki/File:LargeFair.jpg.

Copyright © Nazmiyal (CC BY-SA 3.0) at http://commons.wikimedia.org/wiki/File:Antique_rug_42432.jpg.

Copyright © Mike Peel (CC BY-SA 2.5) at http://commons.wikimedia.org/wiki/File:Benin_Bronzes_at_the_British_Museum_2.jpg.

Excerpt from: "Fertility Figure: Female (Akua Ba)," http://www.metmuseum.org/Collections/search-the-collections/50004860. Copyright © by Metropolitan Museum of Art.

Copyright © Brooklyn Museum (CC BY 3.0) at http://commons.wikimedia.org/wiki/File:Brooklyn_Museum_1997.101.1_Doll_Akuaba_(2).jpg.

Arthur Lubow, Excerpt from: "Edvard Munch: Beyond The Scream," Smithsonian. Copyright © 2006 by Smithsonian Institution.

Jack Flam, *Matisse and Picasso: The Story of Their Rivalry and Friendship*, pp. 34. Copyright © 2003 by Perseus Books Group. Reprinted with permission.

Source: http://www.agra-alliance.org/section/people/farming_culture. Copyright © by Alliance for a Green Revolution in Africa. Reprinted with permission.

Pablo Neruda, Excerpt from: "Ode to Bicycles," *Selected Odes of Pablo Neruda*, trans. Margaret Sayers Peden, pp. 282–286. Copyright © 2011 by University of California Press.

Copyright © Baskoner (CC BY 3.0) at http://commons.wikimedia.org/wiki/File:Turntables_and_mixer.jpg.

Copyright © Delaywaves (CC BY 3.0) at http://commons.wikimedia.org/wiki/File:ChristoGates.JPG.

Excerpts from: "Running Fence," http://christojeanneclaude.net/projects/running-fence?view=info#.UWdOLVc3fIM. Copyright © by Christo and Jeanne-Claude.

Copyright © Morris Pearl (CC BY-SA 3.0) at http://commons.wikimedia.org/wiki/File:Gates_f.jpg.

Copyright © Delaywaves (CC BY-SA 3.0) at http://commons.wikimedia.org/wiki/File:ChristoGates.JPG.

Copyright © Dani 7C3 (CC BY 3.0) at http://commons.wikimedia.org/wiki/File:CentralParkWithGatesFrom2000feet.jpg.

Marcel Duchamp, Excerpt from: "The Richard Mutt Case," *Art in Theory (1900–2000): An Anthology of Changing Ideas*, ed. Charles Harrison and Paul Wood, pp. 252. Copyright © 2004 by John Wiley & Sons, Inc.

Copyright © Gtanguy (CC BY-SA 3.0) at http://commons.wikimedia.org/wiki/File:Fontaine_Duchamp.jpg.

Copyright © Ivanoff (CC BY-SA 3.0) at http://commons.wikimedia.org/wiki/File:Daisen-in2.jpg.

Copyright © Marie-Lan Nguyen (CC BY 3.0) at http://commons.wikimedia.org/wiki/File:Raku_chawan_MBA_Lyon_E554-186.jpg.

Rikyu, Excerpts from: "Verses of Sen-No-Rikyu," *Cha-No-Yu: The Japanese Tea Ceremony*, ed. A. L. Sadler, pp. 106–107. Copyright © 2001 by Tuttle Publishing.

Copyright © shooting brooklyn (CC BY-SA 2.5) at http://commons.wikimedia.org/wiki/File:WLA_metmuseum_Power_Figure_Male_Nkisi.jpg.

Copyright © Jim Heaphy (CC BY-SA 3.0) at http://commons.wikimedia.org/wiki/File:Dirk_Van_Erp_lamp.jpg.

Excerpts from: "The Quilts of Gee's Bend," http://deyoung.famsf.org/deyoung/exhibitions/quilts-gees-bend. Copyright © 2006 by Fine Arts Museums of San Francisco. Reprinted with permission.

Copyright © Andre Natta (CC BY 2.0) at http://commons.wikimedia.org/wiki/File:Gee%27s_Bend_quilting_bee.jpg.

Kasimir Malevich, *The Non-Objective World: The Manifesto of Suprematism.* Copyright © 1959 by Dover Publications. Reprinted with permission.

Copyright © Sailko (CC BY-SA 3.0) at http://commons.wikimedia.org/wiki/File:Kazimir_malevich,_suprematista_costruzione_di_colori,_1928-29.JPG.

Copyright © University of Southern California, Center for Muslim-Jewish Engagement.

Copyright © Walters Art Museum (CC BY-SA 3.0) at http://commons.wikimedia.org/wiki/File:Turkish_-_Prayer_Rug_-_Walters_811.jpg.

Copyright © Claire H. (CC BY-SA 2.0) at http://commons.wikimedia.org/wiki/File:Andr%C3%A9_Thesmar_-_Lampe_de_mosqu%C3%A9e.jpg.

Copyright © Alma Chaney. Reprinted with permission.

Copyright © Alma Chaney. Reprinted with permission.

Copyright © 0ro1 (CC BY-SA 3.0) at http://commons.wikimedia.org/wiki/File:1_Estancia_del_Sello_%28Vista_general_I%29.jpg.

Copyright © Rico Heil (CC BY-SA 3.0) at http://commons.wikimedia.org/wiki/File:David_von_Michelangelo.jpg.

Copyright © Simo ubuntu (CC BY-SA 3.0) at http://commons.wikimedia.org/wiki/File:Altare_Chiesa_del_Ges%C3%B9.jpg.

Copyright © Marie-Lan Nguyen (CC BY 2.5) at http://commons.wikimedia.org/wiki/File:Chapel_S._Ignazio_Gesu_Rome.jpg.

Copyright © Robert Dunlea (CC BY-SA 3.0) at http://commons.wikimedia.org/wiki/File:City_Hall_8-Feb-2005-RAD.JPG.

Copyright © Jorge Royan (CC BY-SA 3.0) at http://commons.wikimedia.org/wiki/File:India_-_Family_altar_-_7090.jpg.

Copyright © Don Hitchcock (CC BY-SA 3.0) at http://commons.wikimedia.org/wiki/File:Willendorf-Venus-1468.jpg.

Copyright © Thilo Parg (CC BY-SA 3.0) at http://commons.wikimedia.org/wiki/File:Mammut_Vogelherd.jpg.

Copyright © Cornischong (CC BY-SA 3.0) at http://commons.wikimedia.org/wiki/File:Michelangelo_Pieta_ret_w.jpg.

Copyright © Marie-Lan Nguyen (CC BY 2.5) at http://commons.wikimedia.org/wiki/File:Fasting_Buddha_BM_OA1907.12-28.1.jpg.

Copyright © Papamanila (CC BY-SA 3.0) at http://commons.wikimedia.org/wiki/File:Mural_del_Gernika.jpg.

Hugh Hart, Excerpts from: "Post-developments / For the Subject of Arbus' 'Child with a Toy Hand Grenade,' Life Was Forever Altered at the Click of a Shutter," *San Francisco Chronicle.* Copyright © 2003 by Hearst Corporation.

Copyright © Nicholas Smith (CC BY-SA 3.0) at http://commons.wikimedia.org/wiki/File:ScreenPrintingColors500px.gif.

Copyright © Autopilot (CC BY-SA 3.0) at http://commons.wikimedia.org/wiki/File:Obama_progress_street_art.jpg.

Copyright © Quinok (CC BY-SA 3.0) at http://commons.wikimedia.org/wiki/File:Roma6705.jpg.

Copyright © Sailko (CC BY-SA 3.0) at http://commons.wikimedia.org/wiki/File:Ara_pacis_fregio_lato_ovest_1.JPG.

Copyright © Manfred Heyde (CC BY-SA 3.0) at http://commons.wikimedia.org/wiki/File:Ara_Pacis_Relief_Pax.jpg.

Copyright © Giorgio Martini (CC BY-SA 3.0) at http://commons.wikimedia.org/wiki/File:Statue_of_Liberty_from_base.jpeg.

Copyright © MarkusMark (CC BY-SA 2.5) at http://commons.wikimedia.org/wiki/File:11BasilicaSAndrea.JPG.

Copyright © Alexander Z. (CC BY-SA 3.0) at http://commons.wikimedia.org/wiki/File:RomeConstantine%27sArch03.jpg.

Copyright © Timothy Jarrett (CC BY-SA 2.0) at http://commons.wikimedia.org/wiki/File:Pavilion_X_UVa_2007.jpg.

Copyright © Harrieta171 (CC BY-SA 3.0) at http://commons.wikimedia.org/wiki/File:2006_01_21_Ath%C3%A8nes_Parth%C3%A9non.JPG.

Copyright © Rafi B. (CC BY 2.0) at http://commons.wikimedia.org/wiki/File:Building_Nashville_-_Tennessee.jpg.

Copyright © KlausF (CC BY-SA 3.0) at http://commons.wikimedia.org/wiki/File:Rom_Pantheon_mit_Obelisk.jpg.

Copyright © Karen Blaha (CC BY 2.0) at http://commons.wikimedia.org/wiki/File:Rotunda_UVa_dome_room_hidden_bookcases.jpg.

Copyright © Los Angeles (CC BY-SA 3.0) at http://commons.wikimedia.org/wiki/File:San_Pedro_Post_Office_Mural.JPG.

Copyright © Heinrich Hoffmann / Bundesarchiv, Bild 146-1979-105-02 (CC BY-SA 3.0 DE) at http://commons.wikimedia.org/wiki/File:Bundesarchiv_Bild_146-1979-105-02,_Berlin,_Ehrenhof_der_Neuen_Reichskanzlei.jpg.

Copyright © Bundesarchiv, Bild 183-H27141 (CC BY-SA 3.0 DE) at http://commons.wikimedia.org/wiki/File:Bundesarchiv_Bild_183-H27141,_Berlin,_Neue_Reichskanzlei,_Statue_%22Partei%22.jpg.

Copyright © Simon Müller / Bundesarchiv, B 145 Bild-F000899-0005 (CC BY-SA 3.0 DE) at http://commons.wikimedia.org/wiki/

File:Bundesarchiv_B_145_Bild-F000899-0005,_M%C3%BCnchen,_ Haus_der_Kunst.jpg.

Copyright © Blackcat (CC BY-SA 3.0) at http://commons.wikimedia. org/wiki/File:Roma_2011_08_22_Museo_Civilt%C3%A0_ Romana_colonnato_fronte.jpg.

Copyright © Jorge Royan (CC BY-SA 3.0) at http://commons. wikimedia.org/wiki/File:Berlin-_German_Jewish_Holocaust_ Memorial_-_3212.jpg.

Source: Carol M. Highsmith, http://commons.wikimedia.org/wiki/ File:Washington,_D.C._-_2007_aerial_view.jpg. Copyright in the Public Domain.

Michael Kammen, *Visual Shock: A History of Art Controversies in American Culture*, pp. 21. Copyright © 2006 by Random House, Inc. Reprinted with permission.

William Howard Taft, 1917. Copyright in the Public Domain.

Michael Kammen, *Visual Shock: A History of Art Controversies in American Culture*, pp. 25. Copyright © 2006 by Random House, Inc. Reprinted with permission.

Michael Kammen, *Visual Shock: A History of Art Controversies in American Culture*, pp. 23. Copyright © 2006 by Random House, Inc. Reprinted with permission.

Copyright © Robert J. Fisch (CC BY-SA 2.0) at http://commons. wikimedia.org/wiki/File:UA_Flight_175_hits_WTC_south_tow-er_9-11_edit.jpeg.

Copyright © Michael Foran (CC BY 2.0) at http://commons. wikimedia.org/wiki/File:WTC_smoking_on_9-11.jpeg.

Excerpts from: "Sept. 11 Sculpture Covered Up," http://www. cbsnews.com/2100-201_162-522528.html. Copyright © 2009 by Associated Press.

Michael Arad and Peter Walker, Excerpts from: "Reflecting Absence," http://www.wtcsitememorial.org/fin7.html. Copyright © by Lower Manhattan Development Corporation.

Copyright © Kafziel (CC BY-SA 3.0) at http://commons.wikimedia. org/wiki/File:WTC3.jpg.

Copyright © Saschaporche (CC BY-SA 3.0) at http://commons. wikimedia.org/wiki/File:National_september_11_Memorial_%26_ museum.jpg.

Copyright © Ad Meskens (CC BY-SA 3.0) at http://commons. wikimedia.org/wiki/File:Lincoln_memorial_seen_from_washing-ton_memorial.jpg.

Copyright © Christopher Hollis (CC BY-SA 3.0) at http:// commons.wikimedia.org/wiki/File:US_Marine_Corps_War_ Memorial_%28Iwo_Jima_Monument%29_near_Washington_ DC.jpg.

Copyright © Spigidbe83 (CC BY-SA 3.0) at http://commons. wikimedia.org/wiki/File:Miami_Beach_Holocaust_Memorial_01. JPG.

Copyright © Mark Fosh (CC BY 2.0) at http://commons.wikimedia. org/wiki/File:Holocaust_Memorial_Berlin_visitors.jpg.

Copyright © Ralf Schulze (CC BY 2.0) at http://commons. wikimedia.org/wiki/File:Holocaust_Memorial_Berlin_001.jpg.

Copyright © Jorge Royan, "[Image]:German Jewish Holocaust Memorial," http://commons.wikimedia.org/wiki/File:Berlin-_ German_Jewish_Holocaust_Memorial_-_3212.jpg.

Copyright © Postdlf (CC BY-SA 3.0) at http://commons.wikimedia. org/wiki/File:Osiride_head_of_Hatshepsut_2.jpg.

Copyright © cjn212 (CC BY-SA 2.5) at http://commons.wikimedia. org/wiki/File:WLA_brooklynmuseum_Queen_Ankhnesmeryre_II.jpg.

Copyright © Cancre (CC BY-SA 3.0) at http://commons.wikimedia. org/wiki/File:Notre-Dame,_Strasbourg,_Dormition_of_Virgin_Mary. JPG.

Piet Mondrian, Excerpt from: "Plastic Art and Pure Plastic Art (Figurative Art and Nonfigurative Art)," *Circle: International Survey of Constructive Art*, ed. J. L. Martin, Ben Nicholson, and N. Gabo., 1937.

Copyright © Roland zh (CC BY-SA 3.0) at http://commons. wikimedia.org/wiki/File:B%C3%BCrkliplatz_-_Louise_Bourgeois% 27_%27Maman%27_2011-06-15_16-49-30.jpg.

Copyright © Gaf.arq (CC BY-SA 3.0) at http://commons.wikimedia. org/wiki/File:Bauhaus-Dessau_innen.JPG.

Excerpt from: "Murals: Assassination in Boston," Time. Copyright © 1966 by Time Inc.

Michael Kammen, *Visual Shock: A History of Art Controversies in American Culture*, pp. 210. Copyright © 2006 by Random House, Inc.

Source: Danny Katz, "Richard Serra: The Case of Tilted Arc," http:// www.cfa.arizona.edu/are476/files/tilted_arc.htm.

Copyright © Emma7stern / Bundesarchiv, Bild 183-H02648 (CC BY-SA 3.0 DE) at http://commons.wikimedia.org/wiki/ File:Ausstellung_entartete_kunst_1937.jpg.

Excerpt from: "Department of the Interior and Related Agencies Appropriation Act of 1990." Copyright in the Public Domain.

Richard Powell (quoted by Tom Patterson), Excerpt from: "Art and the Black Aesthetic: Richard Powell," *Duke Magazine*. Copyright © by Duke University.

Selections from "What is the Proper Way to Display a US Flag," http://www.dreadscott.net/artwork/photography/ what-is-the-proper-way-to-display-a-us-flag.

Copyright © Knulclunk (CC BY-SA 3.0) at http://commons. wikimedia.org/wiki/File:Hammons_flag.jpg.

Coco Fusco, Excerpts from: "Shooting the Klan: An Interview with Andres Serrano," *High Performance, vol. XIV, no. 3*. Copyright © 1991 by API/High Performance.

Zbigniew Libera, Excerpts from: "Zbigniew Libera," http:// www.chgs.umn.edu/museum/exhibitions/absence/artists/zLibera/. Copyright © by Regents of the University of Minnesota.